Honest Horses

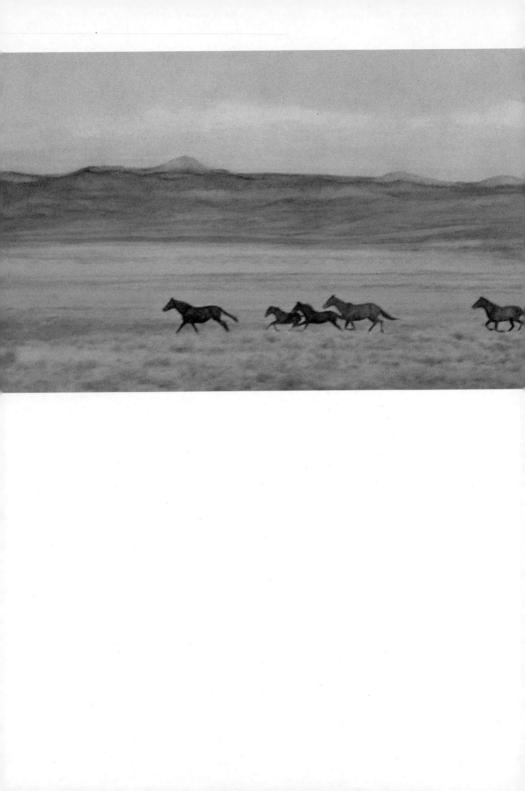

Honest Horses

Wild Horses in the Great Basin

Paula Morin

UNIVERSITY OF NEVADA PRESS/RENO & LAS VEGAS

University of Nevada Press, Reno, Nevada 89557 USA

Copyright © 2006 University of Nevada Press

Photographs copyright © by Paula Morin

Library of Congress Cataloging-in-Publication Data

Morin, Paula, 1945–

Honest horses : wild horses in the Great Basin / Paula Morin.

p. cm.

Includes bibliographical references (p.).

ISBN 0-87417-631-x (hardcover : alk. paper) —

ISBN 0-87417-673-5 (pbk. : alk. paper)

1. Wild horses—Great Basin. 2. Wild horses—Great Basin—History.

3. Wild horses—Great Basin—Pictorial works. I. Title.

SF360.3.U6M67 2006

599.665'5097—dc22 2005026718

The paper used in this book meets the requirements of American National
Standard for Information Sciences—Permanence of Paper for Printed Library
Materials, ANSI Z.48-1984. Binding materials were selected for strength and
durability.

15 14 13 12 11 10 09 08 07 06
5 4 3 2

ISBN-13: 978-0-87417-673-5 (pbk : alk. paper)

FRONTISPIECE: *Racing with Horses.*

For Marc and Ian

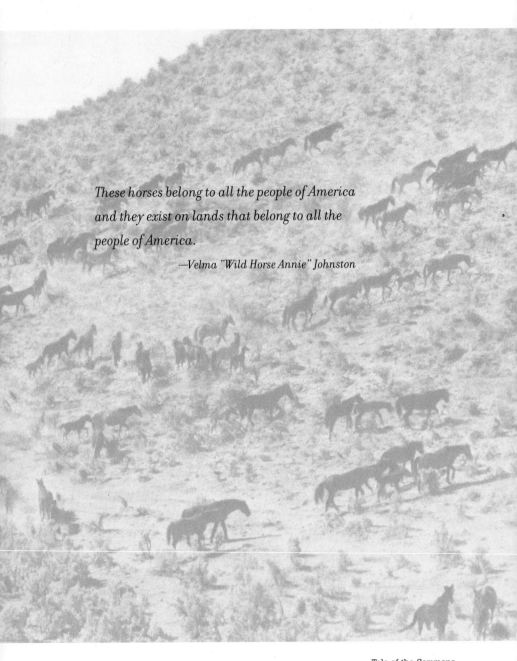

*These horses belong to all the people of America
and they exist on lands that belong to all the
people of America.*

—*Velma "Wild Horse Annie" Johnston*

CONTENTS

Leland Arigoni Sunny Martin
Sheldon Lamb Katie Blunk
Ed Depaoli Joyce Brown
Don Pomi Dave Dohnel
Cliff Heaverne John Sharp
Gene Nunn Bryan Neubert
Dave Cattoor Richard Shrake
Tom Marvel Tom Hartgrove
Al Cirelli Jr. Frank Cassas

Conclusion, 295
The Future of the Wild and the Tame

Wayne Burkhardt Steve Davis
Irwin Liu Temple Grandin
Bob Morris B. Byron Price
Dan Flores Waddie Mitchell
Stephen Budiansky

Afterword, 349

ILLUSTRATIONS

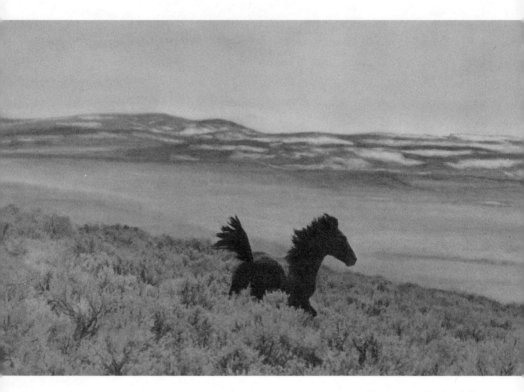

Voyager on a Sagebrush Sea

PREFACE

I

This book presents sixty-two narrative conversations concerning the significance, meaning, and impact of wild horses in the Great Basin: their history and behavior, their nature and role on the landscape, and their relationship to the cultural fabric of the American West. Wild horses have been a lightning rod for controversy for generations, especially with respect to their purpose and place on the open range that is their home. At the heart of this dilemma are not only the horses themselves but the landscape of the open range as well, particularly how we in modern American society perceive the interplay between the land, animal, and human communities connected with it. How should the range be used and by whom? How should all living creatures who depend on it for sustenance be considered and nurtured? The drama of the wild horse within this milieu is bombarded by perplexing and often paradoxical viewpoints that strike at the heart of our national identity and values in many guises—cultural, environmental, political, economic, emotional, aesthetic, and ethical.

Although a plethora of articles and books have been written about wild horses, these tend to be filtered through technical jargon or political agendas, on the one hand, or sentimental and special interest rhetoric, on the other. It is not my desire or intention to offer a solution to the current or past issues surrounding wild horses, or even to provide my personal interpretation of them. Rather, I have tried to present an arena in which the realm of wild horses can be discussed by the people who know them best, in their own words and on their own terms. The narratives presented here are all from people who have worked with and known wild horses intimately in many contexts on and off the range. They represent a broad spectrum of personalities, perspectives, and expertise. It is my hope that this grassroots ensemble will enable readers to understand the rich and colorful legacy of wild horses in the Great Basin from the ground up. I also hope

this approach will illustrate the labyrinth of dilemmas surrounding these horses more directly and personally than has otherwise been presented up until now. Last but not least, I hope this dialogue will help the general reader to appreciate the nature and significance of horses in general—and wild horses in particular—through time and space. For regardless of the varying ideologies used to portray it, the wild horse remains a vital part of our human experience, a presence etched into our collective consciousness. The current circumstances of wild horses underscore the dignity of their ongoing survival and illustrate the predicament of all creatures who compete for sparse resources in a remote and unforgiving environment.

Although I hope this book presents historical facts and scientific information that will intrigue skilled horsemen and serious scholars, its primary aim is to acquaint a general audience with the real versus the perceived equine heritage of the Great Basin. Readers who seek a thorough scientific review, precise technical language, and up-to-the-minute data will not find these here. Likewise, those desiring definitive solutions to unresolved issues and conflicts will be disappointed. It is my conviction that the nature and practice of horsemanship and stewardship are as much about art and philosophy as about science, and are dictated as much by intuition and experience as they are governed by legal sanctions or federal regulations. Furthermore, our cultural and ecological understanding of the relationship of wild horses with their environment is a dynamic and ongoing process. In this perspective, one should never overlook human influences (visionary and flawed) or underestimate the mysterious forces of Mother Nature, which remain eternally beyond our best scientific efforts to outwit or control them.

In the process of reading these conversations, the reader should also not be surprised to discover contradictions or repetition in the information and perspectives expressed by various individuals. Between the lines of the dialogue that follows, however, a certain pattern will emerge. The tapestry created by these voices reveals an underlying pattern of a rich equine tradition, one that continues to shape and influence the horse-

human relationship against the ever-changing backdrop of the high desert. This tradition has much to teach us all.

While setting out to do research for this book, I reminded myself that the general public, typically eager to do what is proper and good on behalf of animals and nature, has a tendency to swallow whole whatever incomplete or alarming reports about wild horses it may see, hear, or discover through the media, on the Internet, or even via common hearsay. This is not to disparage the role of journalists, who have the challenging task of reporting on the complex subject of the social climate and environmental fabric of the contemporary American West. Nevertheless, the media often draw from or perpetuate certain stereotypes about the western lifestyle and worldview that can in turn be manipulated or misinterpreted in other arenas or for other purposes. Some common examples are worth considering in this context, especially as they relate to the wild horse: federal agencies are ineffective stewards of our natural resources; the government has a hidden agenda to eradicate all wild horse herds from public lands; most cowboys mistreat animals as an expression of their "redneck machismo"; ranchers routinely exploit the landscape and livestock for personal gain; many wild horses are abused by the wild horse adoption program; sheep, cattle, and saddle horses overgraze the range but wild horses never do; all wild horse gatherers are evil by nature; any wild horse is a good horse; left to themselves and returned to nature's way, the range and the horses that roam there will prosper. And so on. If this book inspires readers to reconsider these or other such notions, it will have achieved at least one of my purposes.

II

It was my father who instilled in me a love for all things equine. That may have been due to his French Canadian heritage, his Montana boyhood, his sense of adventure and kinship with the outdoors, and his fondness for spinning tales to his high-spirited daughter. Many of my most cherished childhood memories are of days spent alongside my father at champi-

onship horse events, horse races, and polo matches in the San Francisco Bay area. As I grew older, my mother's preferences took priority and I was persuaded to forsake my affection for horses for more proper, ladylike pursuits such as piano lessons, social etiquette, and, naturally, boys. Thirty years ago my father passed on, and among the personal possessions he left to me were a well-worn jockey quirt and a story he had written featuring a wild pony named Le Vent. The call of the horse resurfaced then, and, like my father's memory, has never left me.

My first attempts to capture wild horses on film were motivated by a naïve desire to indulge my private fascination with the mythic heritage of the American West. It was not until many years later, as my knowledge and understanding of the history of horses and the region matured, that the themes expressed in this book began to surface. The pivotal inspiration occurred one windswept day in 1997 as I was photographing a lone stallion on a ridge of Nevada's Calico Mountains. An epiphany moment passed swiftly in the encounter between this horse and me. Each of us remained wary, yet mutual curiosity impelled our approach. Surprisingly, he didn't bolt. Instead, he remained in place and allowed me to make several exposures. One might even say he posed. Standing there, framing an image, I experienced a split-second awareness of the immensity of the high desert. There was nothing above, beyond, or around this horse and me but miles of sagebrush, never-ending silence, and a clear and shining sky. The connection between horse and landscape seemed to leap through the viewfinder. The concept of home range took root in my being in its most profound meaning.

I have had many exchanges with wild horses since then, all memorable, and each one, like that pivotal cornerstone encounter, revealing the general through the particular: general in that I am challenged to ponder the balance between all horses and the environment, singular in honoring the bond of one specific horse to its unique locality. In my lexicon, the relationship of the wild horse with its habitat is both poetically and realistically inclusive. It embraces plant and animal communities, human ecologies,

and cultural history. Each has a share in the life and spirit of the Great Basin.

III

Culturally speaking, the wild horse of the American West is an exalted symbol of our national consciousness, an icon of mythical proportions. On the one hand, the mustang manifests all that is grand and glorious on the frontier of the landscape and our imagination. Other wild creatures fascinate us too, obviously, and also are considered archetypes of the modern psyche, but nothing trumps the wild horse for poetic metaphor, emotional passion, and mystical splendor. What is more evocative than the image of a lone stallion and his band running unbridled across the open range? Whose mind and heart do not resonate to the beauty of form and freedom of spirit that all wild horses signify?

On the other hand, this charismatic, intoxicating symbol of the horse is juxtaposed with a more perplexing and less flattering image. In this version, wild horses are a conundrum at best. Sturdy and valiant, certainly; they live in nature where only the strong survive. Once removed from the range, however, there is really nothing singular about them. Most wild horses are indistinguishable from the average stable horse, and in fact share the same general equine bloodlines. While it is thrilling to encounter a band of free-roaming horses on the range, on closer inspection they are not always as sound or as beautiful as we desire or conceive them to be. Furthermore, although these horses exhibit behavior specific to a wild state, they are not an indigenous species such as the elk, antelope, or deer. Nor are they endangered or rare, as are the wolf, grizzly bear, and eagle. Even less can they be considered true "wild" animals. Only the plain and stocky Przewalski's Horse of Mongolia fits the scientifically rigorous definition for a bona fide wild horse.

Quite frankly, wild horses in America are in-between animals. Regardless of how many generations horses have lived on the range, feral is the accurate description for them. They are domestic animals that have returned

to live in a wild state. Cats, pigs, dogs, and horses will all turn feral given the time or the opportunity.

My purpose in raising these distinctions is neither to endorse nor to disparage either version. Wild horses have inspired my creative work for well over ten years. While I have been aware of the issues, theories, and ideologies that surround them, these never attracted me for their own sake. My intent is to travel the corridor between polarities, to penetrate the world of wild horses while imposing my personal projections on them as little as possible. As a visual artist I have sought to observe and photograph horses in their natural setting. As an oral historian I have wanted to learn about them through the direct personal experiences of those who know them best.

Despite my intentions, and as anyone who has worked with wild horses knows, it is nigh on impossible to maneuver through their complex milieu without being bombarded by the controversies and emotions that swirl endlessly around them. Perhaps nowhere in the United States are these dynamics more glaring than in the Great Basin, especially in the state of Nevada, where most wild horses live. This arid region is being developed at an alarming rate, creating a socio-environmental crisis where scarce or threatened resources must be shared by an ever-increasing number of claimants.

I have no wish to further the agenda of any of the myriad agencies, organizations, and individuals engaged with wild horses or active in the debate over their future. My commitment in compiling this book was to remain between the political and ideological extremes. Consequently I chose to contact people who had an intimate, long-standing history of working with either the horses or the habitat or both, and who were willing to share their knowledge, experience, and insights with me. Each participant agreed to contribute his or her understanding of the region or familiarity and association with wild horses (often it was a combination of both) gained by virtue of their profession, proximity, avocation, or lifestyle. That each one was willing to speak candidly and thoughtfully with an outsider

such as myself is a professional privilege and personal pleasure that I will cherish forever. Each of these conversations was genuine and open-ended, and embraced a broad range of personal insight and professional expertise. Although the narratives can be read in no particular order, the ensemble has been arranged in sections to illustrate what I consider to be two critical themes: stewardship and horsemanship.

Our modern society is an urbanized one. For the first time in recorded history, perhaps, the majority of men and women in America no longer have a direct, sustained contact with or relationship to the land. To me this makes us, at least in one sense, exiles in our own country, strangers to our collective selves. Scientists and moral philosophers have written at great length about the concept of stewardship and its relevance to our social character and quality of life. My understanding and application of stewardship here imply the basic duty and primary necessity for human beings to protect and foster the integrity of all creation. Like the innate human longing for peace, stewardship begins in one's heart.

Likewise, horsemanship involves philosophy, ethics, art, and science. Whether one raises horses close to home or admires them at a distance, their welfare demands our attention. It is a truism that whenever humans treat horses justly, we are graced by their trust. Despite the recent media spotlight on the phenomenon of "horse whispering," the art of horsemanship is not a new discovery. Historically, horsemanship is a discipline, a relationship, and a tradition that must be consciously lived and applied. Only then is it worthy to be passed on. Moreover, as all seasoned horsemen and horsewomen know, we must recognize the limits of our knowledge and competence if any worthwhile horse-human relationship is to endure— much less prosper.

In the Great Basin the two themes of horsemanship and stewardship are linked historically, culturally, and environmentally. An awareness of both is crucial to developing a mature understanding of the equine heritage in the high desert as it is now and as it continues to unfold. While these themes often overlap in theory and practice, they are articulated separately

in the first two sections of this book. They are then synthesized in the final section that forms the conclusion.

IV

Geographically the territory of the Great Basin crosses five state borders (Utah, Nevada, Oregon, Idaho, and California). Although wild horse herds roam federal lands throughout the area, Nevada forms the nucleus of this vast region and is rightly considered the heart of mustang country. At present, 85 percent of Nevada is federally owned public land (most of it administered by the Bureau of Land Management, or BLM, where 60 percent of all wild horses in the West reside on ninety-two designated herd management areas [HMAS]). Additional feral and estray herds also roam free on other government and tribal lands within the state. Because so many wild horses are concentrated in Nevada, and because active concern over their status has always been focused there, most of the contributors to this project have at one point or another called Nevada home.

Culturally, the mustang is present everywhere in the Great Basin, particularly in Nevada. The state is peppered with street and highway signs, territorial markers, and business, public, and other place-names highlighting the influence of the wild horse. Nevada is the historic birthplace of the national campaign founded by Velma "Wild Horse Annie" Johnston that spawned the 1959 and 1971 federal laws protecting wild horses, and is still the home base for Wild Horse Organized Assistance (WHOA), the national advocacy group that Annie founded. In the north, Reno's Livestock Events Center hosts an annual National Wild Horse Show, a competitive performance event attended by wild horse owners from around the West. The city is also the western headquarters of BLM's National Wild Horse and Burro Program, and of the politically independent National Wild Horse Foundation. The Palomino Valley Wild Horse and Burro Center, the major holding, sorting, and shipping facility for wild horses once they have been removed from the range, lies only a few miles beyond Reno's burgeoning suburbs. Recently, Nevada developed a wild horse training program in its

state prisons, and the state is the location of several other local, regional, and national horse advocacy groups and private sanctuaries. In southern Nevada, the nation's first national wild horse range was formed and designated on Nellis Air Force Base. Last, but not least, Nevada is the only western state with its own public agency, the Nevada Commission for the Preservation of Wild Horses, formed specifically to promote wild horse protection and management.

Despite the colorful history and obvious presence of wild horses throughout the Great Basin, their significance and impact are not always well understood by the general public, either in or beyond the region. Most of what the public sees and hears about wild horses falls at the extreme ends of what is actually known about them. To further complicate matters, the controversies that swirl about free-roaming horses may obscure other more complex and more pressing concerns. Even more disturbing is the fact that conflict and confusion have been known to infect the very government agencies and federal representatives in direct charge of their care. When tensions between stakeholders and federal agencies occur (which is also part of the historical pattern), decision-making efforts on all levels are frustrated if not aborted entirely. Certain extremist groups (albeit a minority) have been known to use these conflicts for their own advantage. When these conflicts between people unfold in the form of a full-blown civil lawsuit, wild horses are the ones affected. "Irony" is too gentle a word to use for this situation. It is a consummate tragedy that ideological battles and power struggles within, between, and beyond government circles and special interest groups more often than not harm the very animals these entities claim to be protecting.

My time spent exploring the equine heritage of the Great Basin has broadened my knowledge about the wild horse saga in the American West, from the emergence of the first tiny dawn horse, *Eohippus*, to the presence of its distant and much-traveled descendants today. It has deepened my affection and appreciation for all horses, wild and tame, and has intensified my admiration for the ancient, powerful bond linking horses and

humans. It has made me less prone to judge quickly and more willing to wrestle with serious ecological and moral choices that are often heart-wrenchingly difficult to unravel and discern. I have come to understand that there are no easy answers to the myriad dilemmas posed by the presence of free-roaming horses on the open range. How best to steward our natural resources for the common good, how to shoulder the immense responsibility for the qualify of life of all creatures who share a limited and fragile resource, and how to distinguish the real from the imaginary nature of wild horses are questions that each individual must ponder in the singular solitude of mind and heart. I have tried in this book to serve as an unobtrusive witness to this process and I am honored to be joined by sixty-two others who support my desire for this process to occur in the public arena. If, as the poet Rilke wrote, it is by living the questions that we one day find ourselves walking into the answers, then for all who admire, respect, and strive to enjoy what is noble and enduring about the wild horse, it is our duty to make it so.

V

The Conversations

The field research for *Honest Horses* was not intended as a survey of opinions or issues per se, but as an inquiry into the dynamics of the traditions surrounding wild horses that are rooted in the region. The primary participants are all established Great Basin residents who were selected for their long familiarity with wild horses and the high desert landscape and culture. Exceptions were made for certain individuals included in the conclusion because of their very specific understanding of the equine, human, and natural ecologies of the American West, or because their awareness of the themes of horsemanship and stewardship overshadowed their place of residence.

Because I do not want to compromise the unique perspective of the participants, I have provided only brief descriptions of each one preceding

their narrative account. For readers who want to know more, profiles of all the contributors are included at the end of the book. My desire is to side-step our normal tendency to categorize or prejudge individuals based on preconceived ideas about profession, education, identity, or lifestyle. I hope that readers will meet and appreciate each participant as I did, through the process of an open and candid conversation.

Image and Word

The hand-painted black-and-white photographs that appear in this book were selected from the original series made for the *Honest Horses* traveling exhibit sponsored by the National Endowment for the Arts, U.S. Forest Service, and Nevada Arts Council. The images were made over a three-and-one-half-year period during which I photographed wild horse herds in Nevada, Oregon, Idaho, and California. A handcrafted technique unique to the medium, hand-painted photography emerged in the middle of the nineteenth century and remained popular until the 1940s, when a stable color film process (Kodachrome) became commercially available.

Since this book is intended to serve as a compendium of knowledge and insight about the wild horse heritage in the Great Basin, the photographs are meant to be viewed as a component of the compilation rather than as specific illustrations in the conventional sense. The images reflect my en-counters with the horses, which were in turn informed by research and refined through the various conversations. Image and word should be ap-proached as complementary expressions of one creative phenomenon, each embellishing the other. I am but one in a line of artists, photogra-phers, poets, writers, and historians who have attempted to capture and portray a glimpse of the nature of wild horses. I prefer to think of my con-tribution as the result of one sojourner's response to these elusive animals and the landscape rather than as an attempt to provide a definitive state-ment or comprehensive view of them at any one time or place.

Finally, to paraphrase a remark made by an established resident of the high desert, there have been far too many words spoken about wild horses

but too few voices heard. If memory serves, the writer Mark Twain, himself a Nevada resident, once made a similar comment, to the effect that when someone speaks too loudly it is hard to hear what is being said. I hope read-ers will approach this book not simply as an object to learn from or look at, but will take time to pause and reflect on the silent relationships that may emerge between images and words. Perhaps then a fresher meaning, truer shape, and deeper appreciation of wild horses in the Great Basin will un-fold and take root.

ACKNOWLEDGEMENTS

Nothing emerges in a vacuum, say mystics and scientists. For a visual artist, entering the complex world of the wordsmith was a challenge that I could never have accomplished alone.

Thanks go to the entire staff of the Nevada Arts Council for their unhesitating support of *Honest Horses*, especially Director Susan Boskoff and former Community Arts Coordinator Suzanne Channell, who immediately endorsed my idea to apply the interplay of creative image and word as a means of exploring the sensitive cultural milieu of wild horses on public lands. I am equally indebted to the National Endowment for the Arts and the U.S. Forest Service for granting major funding to produce a national traveling art exhibit of the same name. Dean Graham of the usfs Northern Intermountain Region and Anthony Tighe, government specialist at nea, provided initial inspiration and goodwill that persisted throughout the duration of my work.

I'm grateful to Margaret Dalrymple of the University of Nevada Press for encouraging me to develop my oral history interviews into a full-length narrative for this book, and to the Western Folklife Center for sponsoring panel discussions on the perception and reality of wild horses at the 2001 National Cowboy Poetry Gathering. Thanks also to Melinda Conner, whose talent as a copy editor ensured that my writing style was as grammatically correct as it was personally genuine. Special thanks go to Byron Price and Michael Martin Murphey for their early confidence and continuing friendship, to Don Frazier, whose financial gift allowed pivotal portions of research to proceed; and to Robin and Steve Boies for financial support of the visual component of the book.

I came to Nevada on a hunch that I might uncover a wild horse heritage that could illuminate the significance, meaning, and impact of wild horses across the landscape of the Great Basin in particular, and the American West in general. Little did I imagine the dynamic community that awaited me. The hospitality and acceptance I received have enriched my life be-

yond compare. I'm especially grateful to the initial contributors whose insights formed a touchstone for my project, since each of them had not much more to go on upon meeting me than a solid handshake and a look in the eye. Eventually, there came a point in my fieldwork when I had more referrals to contact than there was time to interview them, and more discussions than I could include in the finished manuscript. For those whose conversations do not appear here, my apologies: editorial prerequisites prevailed.

No practical arrangements could have occurred without substantial assistance from the local, state, and national offices of the Bureau of Land Management. BLM Nevada State Director Bob Abbey and the entire staff of the National Wild Horse Program cooperated generously. In particular, wild horse specialists Jim Gianola, Gary McFadden, and Tom Pogacnik gave freely of their time and expertise. Their intimate perspective on the wild ones in general and the role of BLM in particular was invaluable.

An artist's life can be as isolating and unpredictable as it is enriching. This project required me to proceed through a minefield of political opinions, special interest agendas, academic posturing, media attention, and personal histories embedded in the wild horse milieu, while striving all the while to remain neutral and encourage candor. The task was delicate, and the burden was often made heavier by uncertain financing combined with family trials precipitated by my mother's aging and death. There were several moments of wondering whether the light at the end of the tunnel toward which I was clearly headed was a freight train or the sky.

A circle of cherished friends begins with Fr. Bernard Sander OSB, who inspired me to heed the call of the horse with a spirit of hope. Also Fr. Hugh Feiss OSB for his insights on an applied theology of the land, and the Benedictine community of Ascension Monastery, Idaho, for their prayers and hospitality. Their support sustained me as I fulfilled the demands of an intensely felt commitment.

The loyalty of an extended family—Jack and Rebecca Parsons, Leo and Claire Rhein, Albert and Louise Huener, Alice Wolf, Linda Merchant,

Carey Behel Ach, Marcia Britton, and Mary Karen Fippinger have blessed my life through good times and bad. I'm indebted to my grandmother, mother, and father for instilling in me a conviction that a life lived fully and faithfully in search of truth and beauty is a life to be shared, and to my two sons for their forbearance and love. Finally, I'm grateful for my equine partner, Doc, whose honest companionship introduced me to the mysteries of the horse-human bond, and whose loss formed the crucible for this work.

Honest Horses

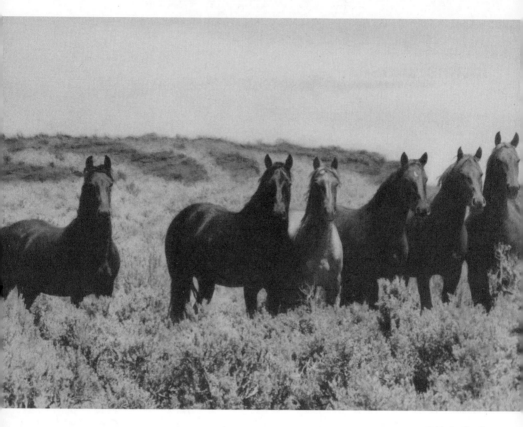

Bachelor Band

Introduction
The Trail of the Dawn Horse

The ancestor of the modern horse appeared about sixty million years ago in the subtropical woodlands of North America. This tiny animal, about the size of a fox, belonged to the genus *Hyracotherium*; in common usage it is more simply and poetically referred to as *Eohippus*, "the dawn horse." Across the shifting prehistoric panorama, in many stages and not in a straight line, descendants of the dawn horse evolved into the genus *Equus*, which eventually emerged as the forerunner of the species of horse we know today.

Fossil remains reveal that *Equus* roamed across a broad portion of the North American grasslands up until the end of the last Ice Age, joined by such ancient companions as the saber-toothed tiger, the mammoth, the mastodon, and the giant elk. About ten thousand years ago, as their habitat in North America began to shrink and change, equids moved northward across the Bering Strait and into Eurasia and Africa. Over the course of a few more millennia they were domesticated by humans, who skillfully bred them into the form accepted as the modern horse. Although some scholars now muse over the nuances of this story, one mysterious portion of the tale is generally acknowledged as etched in the annals of equine history: were it

not for a chance encounter with humans on the steppes of Asia, *Equus caballus* most likely would have followed the footsteps of its Ice Age companions into extinction.

From this auspicious moment, the fates of horses and humans were intertwined. Through the centuries, horses adapted well to domestication and served humanity valiantly in transportation, war, and commerce. Warm- and cold-blooded breeds were developed and valued according to the needs, purposes, and preferences of their human associates. Thus it was that, by the end of the sixteenth century, high-quality European-bred horses accompanied Spanish explorers, colonists, and missionaries on the long journey to the Americas. It is inviting to romanticize the reentry of horses to their ancestral North American homeland (I'm as prone to be fascinated by this providential moment as anyone). In fact, however, both the horses and the habitat had altered vastly in form and substance by the time the reunion occurred. Nevertheless, the habitat definitely suited them still, and it was not long before many of these transplanted colonial horses escaped or were abandoned, free to readapt to life on the wild American prairies. A little later on, in an even more powerful historical and cultural moment, these free-roaming horses were confronted by the indigenous tribal peoples of North America—an encounter that completely transformed tribal lifeways and worldviews in a little more than 150 years. Like others, Native Americans tamed horses for their social and personal use in hunting, warfare, and transportation. They did so with what can only be described as uncanny intelligence and skill, and a remarkable sensitivity to the fundamental personality and character of the horse. The Sioux, Cheyenne, Comanche, Blackfoot, Crow, and Salish were renowned for their horsemanship; the Nez Perce excelled at animal husbandry and developed sophisticated expertise in the breeding and handling of high-quality stock.

By the mid-nineteenth century, American wild horse herds were observed all the way from the midwestern prairie to the Pacific coast. Their numbers were estimated in the millions, and their presence gave birth to a

new name: mustang, from the Spanish *mesteno*, or "stray." The sight of these horses stirred the hearts and minds of the early frontiersmen who witnessed the scene. Imaginations were seized, tales were spun, and rumors spread from campfire to campfire. Rooted in experience yet ignited by the dreams of these men, the saga of the wild horse combined the frontier human longing for adventure with a craving for acquisition. The dawn horse had shape-shifted again, this time into a mythical figure of the American West.

For the most part the interior Great Basin remained unexplored during the early period of Europeans' westward exploration, largely by virtue of its harsh climate and isolation. The Spanish explorers of the 1700s avoided it altogether, as did Lewis and Clark. When frontiersman Peter Skene Ogden ventured down the Humboldt River in 1830 he was seeking beaver, not science, and horses were a long way from his intent or his imagination. It was explorer John Charles Frémont who named the basin in 1842, aptly perceiving the shape of the land but missing its scale (not one large bowl but many). Although Frémont noticed thousands of horses in the California grasslands, he appears not to have encountered any in the interior basin. As for native peoples, the indigenous high desert tribes were few and far between: the land north and east was Shoshone territory; north and west was claimed by the Northern Paiutes; south and east by the Southern Paiutes; the land of the Utes lay farther east along the Utah plateau. How, or even if, these resident tribes utilized horses prior to 1850 is largely unknown.

What is known is that horses arrived in the northern Great Basin as part of the first influx of miners and homesteaders. Thousands of emigrants ventured through the region en route to the gold fields of the Sierra foothills or greener pastures across the Cascades, bringing with them large numbers of domestic livestock. As some of these horses strayed or were abandoned, they formed numerous wild bunches. In southern Nevada and Utah, horses appeared earlier, via well-traveled trade routes and Indian

migration trails. Up through the 1820s, for instance, merchants drove thousands of horses, mules, sheep, and cattle (as well as Indian women and children destined for the Mexican slave trade) back and forth on the Old Spanish Trail from Santa Fe to Los Angeles. Many of these animals escaped or were stolen en route, and outlaws found hiding places for captured herds at distant water holes and in hidden desert canyons. It is interesting to consider that although the Shoshone peoples established a reputation as purveyors and traders of the horse throughout the West (with one band morphing into the Comanche in the process), they appear not to have engaged in any local trading per se. Perhaps some of that is due to the fact that most of the tribal people of the Great Basin were poor. When these interior tribes first encountered horses they occasionally used the animals for transportation; much more often, however, they eagerly consumed them.

By the early twentieth century, as settlement stabilized and pioneer communities were formed, horses became a natural extension of the settlers' agricultural orientation toward the landscape. Large- and small-scale ranching operations raised saddle horses on the range as part of their livestock program, and these animals often interbred with existing wild bunches. Just as often, if not more so, wild herds were husbanded by knowledgeable stockmen who turned out high-quality stallions to improve the wild herds along with their own. In addition, the U.S. Army remount program offered a stable economic incentive. Prior to the end of World War II, many ranches bred registered horses to meet the strict specifications of the U.S. Cavalry and then sold them either to the American military or to other foreign armies. After the remount program was disbanded, those horses that had not been claimed, rounded up, and sold turned feral as well. Throughout this period tens of thousands of animals—sheep, cattle, and horses—roamed free on the public domain. In the Great Basin, efforts to manage and cull mustang herds generally remained local and private, although a few fortunes were made capturing wild horses when timing and opportunities were right. One notorious entrepreneur was Bill Brown, a

southeastern Oregon sheepman who dabbled in the wild horse trade and reportedly sent five thousand five-year-old sorrel geldings to France in a single shipment. Other well-known Nevada wild horse runners include artist, writer, and working cowboy Will James, whose isolated horse trap, described in his novel *Sand*, is listed on the National Register of Historic Places; the infamous "Barnstorming Mustanger" Ted Barber, who captured thousands of horses in the northern Great Basin by fixed-wing airplane; and entrepreneur Will Barnes, who worked with the U.S. Forest Service to reduce Nevada's overpopulated herds to offset their impact on the habitat prior to 1910 and reported his exploits in national magazines.

Such sensational examples aside, in the ordinary scheme of things there was always a demand and an appreciation (one might even say a love) for a good horse in the West. The adventurous and the less fortunate saw an outstanding wild horse as both a prize and an incentive simply because it was free for the taking. Local residents who knew how to find these horses took pride in looking after them on and off the range. When a quality colt was captured, it was gentled, used, and cared for, usually over a lifetime. Under these circumstances many herds remained healthy, well managed, and even sought after. Several were renowned for producing animals that were sturdy, keen, and quick, horses that went on to win ribbons as well as the affection of their owners and trainers. Many of these horses and their owners remain anonymous, but this regional heritage remains today among Nevada's Curly horses, Oregon's Kiger herd, and several Utah bands. It is celebrated through exceptional and thoughtful horse gentlers such as Pat Heaverne and Tom and Bill Dorrance, and handed down by the gifted horsemen who contributed their insights to this book.

After World War II the capture and sale of wild horses was driven by another market: the commercial pet food industry. The use of fixed-wing airplanes also facilitated larger-scale horse-running enterprises whenever herd numbers escalated. There was a definite dark side to many of these operations, as unscrupulous operators utilized inhumane methods

or employed unsavory characters to get the job done as quickly and inexpensively as possible—and for the most profit. Many less reputable individuals demonstrated lack of respect for the nature of the wild horse and imposed cruel and brutal treatment on them as they were captured and handled.

One witness to these activities was a Reno ranch woman named Velma Johnston, otherwise known as "Wild Horse Annie." Raised in rural Nevada, Annie was no stranger to the nature of horses or the reality of life on the range. She also recognized the difference between skilled and unskilled horsemen, since both her father and her husband gathered and trained wild horses. Annie had an undaunted respect for the dignity of the horse and a low tolerance for animal suffering. One day she happened on a truck filled with freshly caught and bleeding wild horses, many of them colts, en route to the sale yard. The trauma Annie experienced that day fired her determination and propelled her to initiate a campaign to celebrate all wild horses of the West and protect every mustang from cruel treatment, harassment, or death by malicious intent. For more than twenty years Annie worked tirelessly to implement her vision. Eventually her efforts galvanized the public psyche, shaped the imaginations of thousands of children, and transformed the manner in which this nation perceived the wild horse. At home in Nevada, her cause was furthered by a network of supporters that included her assistant Dawn Lappin (now director of Wild Horse Organized Assistance, the organization Annie founded); Congressman Walter Baring; photographer Gus Bundy; and a behind-the-scenes chorus of ranchers, range riders, mustangers, and local residents who had observed the situation from the inside out. The drama and the exploitation of wild horses were soon portrayed in *The Misfits*, a provocative movie starring Clark Gable and Marilyn Monroe that accelerated national concern on a grand scale. Today, more than thirty years after the passage of the 1971 Wild Free-Roaming Horses and Burros Act, the success of Annie's vision is evident. The force of her personality and her uncanny sense of timing forged a powerful grassroots movement on behalf of a just cause—a movement that

not only emerged victorious but continues to prevail. "Remarkable" seems too small a word to describe her influence on these events.

The 1971 act assigned the protection of wild horses and burros on pub-lic lands to the secretaries of the interior and agriculture, with primary re-sponsibility to the Bureau of Land Management (BLM). Since mustangs re-main on other federal lands, government agencies responsible for these herds, namely the U.S. Forest Service and National Park Service, typically coordinate or share efforts with BLM. Some feral herds reside on private, state, or reservation-owned lands that are exempt from federal control (an exception is the wild horses on Nevada's Sheldon Antelope Range, which are managed by the U.S. Fish and Wildlife Service). Most stray and feral horses on Nevada state lands are controlled either by the state Department of Agriculture or by Native American tribal governments. These agencies' different regulations and approaches often account for contradictory efforts in caring for and managing the animals. Tourists and newcomers to the state often find such matters bewildering until they educate themselves about the nature of the assorted jurisdictional boundaries and their related issues.

As for the BLM, the agency developed a penchant for dysfunction soon after assuming control over the welfare of the wild horse. In hindsight this seems understandable. The bureau was caught off guard when the act was passed, and its employees were completely unschooled in horse hus-bandry, much less wild horse ecology. For several years the agency did little more than try to figure out where the horses were. In Nevada, always a magnet for wild horse controversies, a long-standing conflict soon arose over verifiable numbers, geographical boundaries, and grazing allocations that fueled power politics inside and outside the agency for years, dividing friendships and generating special interest lawsuits and public disrespect. BLM's National Wild Horse and Burro Program, the department officially responsible for implementing wild horse care and management, has also seen its share of internal storms and power struggles. Today, although some residual scars and personality conflicts remain, BLM seems to have learned and applied some good lessons from these experiences. Like any bureau-

cracy, the bureau is encumbered by its own weight and is made up of flawed human beings. In spite of its problems, however, it continues to employ many devoted wild horse specialists, wranglers, and consultants who over time have demonstrated skill, awareness, and courage when working with mustangs. With few exceptions, the BLM employees I have met work tirelessly to promote the health of the habitat and the horses. Theirs is not an easy task.

Thus we come to the present and the continuing dilemma of what to do with wild horses on and off the range. With no natural predators, wild horse herds multiply at an average of 18–24 percent each year, quickly overgrazing any landscape, regardless of size, if their numbers are left unchecked. Uncontrolled horse populations are a threat not only to themselves but to the habitat itself and to the other creatures who share the range with them. Currently BLM is continuing its efforts to bring horse numbers down to an appropriate and sustainable level. But many of its prior attempts to reach appropriate management levels (AMLs) in herd management areas have been thwarted by radical protection groups, particularly those unfamiliar with the harsh climate and tender environment of the Great Basin, where water is scarce, grass is combustible, and distances are long. Moreover, once horses are removed, other pitfalls await them. Marketing strategies and holding facilities for BLM's adoption program have been refined and improved to benefit the animals; however, the fact remains that not every wild horse is suitable for adoption, and the program cannot be expected to place all of the excess horses in appropriate homes with qualified people. The implications of how best to care for and manage these horses pose complex, difficult, and awkward questions for local residents in particular and for our society overall.

One pattern seems clear. From the steppes of ancient Asia to the sands of Africa, from European explorers to Native American tribal nations, from outlaws and rustlers to ranchers and cowboys—and federal bureaucracies and animal advocates—North American free-roaming horses have

a perennial association with humans. Short of the Second Coming, there is nothing to suggest that this cycle, not to mention our responsibility within it, will or should change.

How that will be accomplished is another matter entirely.

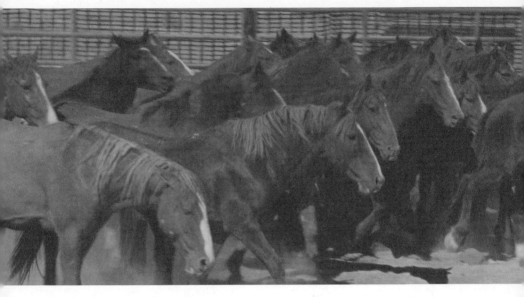

Stallion Pens

Stewardship

The Shadows Have All the Room

The Great Basin is a land of stark and fragile beauty. Not one but a series of many basins, the region is etched by more than 160 mountain ranges oriented north to south. One geographer noted that, viewed from above, the mountains seem to head north like a bunch of caterpillars on the move. It is a region rich in minerals, plants and animals, and vast unbounded space. Depending on your nature and temperament, it's the kind of space that makes you feel giddy and free, solid and rooted, lonely and scared, or all of the above. One cowboy described it to me as "Alaska without the trees."

Because the basin is deeper in the middle than at the edges, water flows toward the center rather than outward to the ocean—a concept that takes some getting used to. Rivers meander inward, eventually evaporating into dried-up lake beds or "sinks," which the Spaniards called *playas*, the locals call "flats," and visiting motorists find monotonously frustrating to drive in or around. Visitors have always been dismayed by the landscape, a fact expressed in the many metaphors by which the territory is known. Early Spanish explorers dubbed it the Northern Mystery. Western writers Mary Austin and Wallace Stegner described it, respectively, as the Land of Little Rain and Mormon Country. Big Empty, Sagebrush Ocean, American Out-

back, and the Void are a few other colloquial terms. My favorite comes from a line in a folk song: "Where the shadows have all the room."

As the crow flies, the Great Basin stretches east from California's Sierra Nevada to Utah's Wasatch Front of the Rocky Mountains, north to the Snake River Plateau and Columbia River Basin, and south to the Mojave and Sonoran deserts. At its broadest point it is 900 miles long and 570 miles wide, and it incorporates most of the state of Nevada, the western third of Utah, the lower third of Idaho, the southeastern portion of Oregon, and the eastern corridor of California. Elevation changes are astonishing—many peaks are ten thousand feet tall, and most valleys lie at four thousand feet. Death Valley, below sea level, is the deepest, driest, and hottest spot. Plant and animal cycles fluctuate according to elevation, moisture, and season. Keep it in mind: apart from an isolated thundershower that may last only a few minutes in one isolated location, for the most part there is no consistent summer rainfall. All the native bunch grasses are palatable to herbivores, which makes the presence of such invasive species as cheatgrass and halogeton an environmental tragedy. In the high mountain meadows are glorious groves of aspen. Bighorn sheep are native to the rocky crags of the high country, desert tortoise to the low. Add together an average annual precipitation rate of nine inches, unpredictable weather patterns, fragile soil, isolated water sources, and a tendency for wildfires to leap across vast distances in a heartbeat, and you wind up with a rare and vulnerable country.

Across this territory the wild horse shares space with indigenous wildlife and domestic livestock. However, unlike wildlife, which are hunted, and livestock, which are harvested, there are no natural predators to control wild horse populations. The overgrazing that usually results combines with the scarcity of water to make growing herds of ungathered mustangs a threat to the habitat as well as a danger to themselves. Although wild horses are protected by law and revered by many, the problem of how to care for them begins at home, on the range.

The experience of wild horses and their environment, as revealed

through history, science, and heartache, is shared in this section by folks very familiar with the natural and equine ecologies of the Great Basin. Some of them are connected to wild horses through their profession or by government policies; others work directly on the land or with the horses themselves, often primarily on their behalf. Still others are familiar with the interplay of wildlife, wild horses, and the habitat. Their stories reveal a common theme of stewardship and the consequences of dealing indiscriminately or recklessly with the perennial cycles of nature.

Tom Pogacnik: National Wild Horse and Burro Program, Reno, Nevada

Wild horses are a cultural symbol of our pioneering past, but too often the public becomes so enamored by their mystique that they lose all perspective. This is especially true with some advocate groups, who fail to recognize there are certain things we can and can't do with these animals. We can't protect every individual horse, for one thing. It's not feasible, and it's not appropriate either. Or take family band units; some people tend to humanize them. Yes, wild horses have different behavior patterns, but the term "family" as we understand it means nothing to them! Survival in the wild means the individual comes first, and only after that comes survival of progeny. A scared mare will take off in any dangerous situation. She won't wait for her foal, and a stallion won't let her go back for the foal either. There are some groups who want BLM to gather an area band by band rather than by the population. Others think we should turn back the same stallions with the same mares to keep one band together. Well, the fact is that all horses form new bands anyway. So whenever anyone says such-and-such is a family unit, it's not the kind of family to hold up as an ideal, because daddy's got two or more mates and thinks nothing of killing his offspring if the situation arises.

When the 1971 act passed, there was no intention of removing excess animals or maintaining them for the rest of their lives. The language of the law did infer that wild horses were disappearing from the landscape, because at the time there was a fear they could become endangered. We've

since learned they weren't endangered at all. Yet, once wild horses started to be seen by the public as a cultural icon, it became a battle over who should determine the excess, or even if there was one; and if there was an excess, then it occurred because either BLM didn't give the horses enough habitat or there were too many cows taking the habitat away from them. Folks said, "The reason there's winterkill is because BLM doesn't give wild horses enough winter range outside the mountains." Or, "Mustangs run out of water because herd management areas don't contain enough water sources." In that kind of thinking, there's no such thing as a bad wild horse because society makes them that way!

Now, gathering and removing horses from the range is stressful, there's no two ways about it. But the techniques used, plus the expertise of the crew and helicopter pilot, minimize that immensely. The old-fashioned way of gathering by horseback was one of the most stressful methods. It was tough on the mustangs, the cowboys, and the saddle horses. Wranglers usually always got hurt, and so did their mounts back then. So the entire operation is hard. You've got to have a good pilot, first of all. On our early roundups there were some pilots who couldn't maneuver a single horse into a trap. They'd fly around for more than a day and still only get twenty horses, and when those horses came in, they would be all lathered up or sore footed simply because they'd been herded so many times without success.

Nowadays we try to restrict running horses to twelve miles. The contract crews are very experienced. Sure, BLM could substitute their own wranglers for the working cowboys if we had to, but the helicopter pilot can't be pulled. First of all, they're flying in a very dangerous situation—low and slow—and they're trying to move animals, which takes flying experience as well as know-how about horse behavior and livestock herding. We're dependent on our pilots, so any time we have to search for a new one everything gets more difficult. We've gathered 175,000 wild horses since the 1970s, and the pilots who have done most of that work are Jim Hicks and Cliff Heaverne. There are two other pilots who work in Utah and Wyoming.

But in Nevada, in one year, we'll remove as many horses on only *one* herd management area as the entire state of Utah does in, say, two or three years.

In the 1980s, there was a lot of controversy surrounding wild horse roundups. Sometimes animals were gathered and a vet wouldn't see them for days. Many times horses died from an injury that happened en route in the trucks. Nowadays every horse is seen by a vet within twenty-four hours of arriving at Palomino Valley, and each contract contains pages of requirements that must be fulfilled. Every one of those regulations points to an earlier disaster, to something that didn't go right.

Some folks are also under the impression that wild horse populations are self-determining. The term "density dependent" is a wildlife concept which says that when habitat becomes limiting with certain species, their reproductive rate falls off and the mortality rate with older animals increases so the population stabilizes with the environment. Well, that works with native species that evolve within a particular habitat, but wild horses are an introduced species in a habitat that evolved without them, without any natural predators, so it doesn't work the same. Wild horses are also highly competitive animals and able to adjust to any habitat, whereas most wildlife are limited to very distinct areas. If their habitat degrades, they can't go anywhere else and survive; therefore their populations are gradually reduced. But a wild horse will go into any habitat—say, a riparian area— and if that habitat degrades he'll move up in the hills and be just fine. If the hills decline, he'll go up the mountains and do fine there. When the mountain declines, he'll go back to the riparian area. And so on. All during this time horses continue to reproduce; their numbers keep expanding as they move.

There are very limited areas where predators are effective in controlling mustangs. Yes, big cats do take down colts and yearlings, but mountain lions in North America are basically ambush hunters. They can't control wild horse populations because wild horses prefer being out in the open. Horses are like antelope in the sense that their defense is "sight and

flight"—they see the threat and they run! In heavy timber they can't see a threat and run, so wild horses don't like timber country. Lions are an effective control where the only available water is in pinyon-juniper country or up in rocks where horses have no choice but go there to drink. But as long as there's forage and water in the lowlands, wild horses won't go in the trees where there are predators. The Montgomery Pass herd on the California-Nevada border is an example. As soon as that herd found another water source, they moved away from the previous area to escape the lions there.

Several groups have formally stated opposition to the BLM adoption program. They want to shut it down because it allows us to remove horses. They also pressure us to reduce other competitive uses. They've got the notion there is no such thing as an excess wild horse, and it's the government's fault for not allocating the habitat properly so horses can move around and adapt to any or all extremes. To me, that amounts to an attitude that says we should manage our public lands on the fly and readjust our strategies as the situation unfolds. The 1971 act was set up as part of a multiple use scenario; the language specifically states that. There's also a big campaign to make livestock look bad and replace all cows with horses. One prominent member of an advocacy group said to me once, "So what if ranchers lose their range? There's a lot of other folks with cows."

I recognize there is a certain public mistrust of BLM. We've made a lot of mistakes, and because of our track record some people are under the impression we want to remove every horse on the range. I don't know if that's just a rallying cry to get the public to sympathize with their cause or if they truly believe it. The truth is people who work in our program are dedicated to these horses. They don't want to see them gone, and what they really don't want is to see the horses suffer.

Just for the sake of argument, let's say BLM removed all the livestock and wildlife in the existing wild horse herd areas but still preserved the habitat, the riparian areas, and the watershed conditions. Four years from now,

those horses would double in number. So instead of 50,000 wild horses on public lands with 10,000 foals a year, now you've got 100,000 horses and 20,000 colts a year. If you have 20,000 colts being born annually, what are you going to do with them? When we pose this question, some people say, "Fertility control will keep the numbers from increasing," or, "Density dependence will keep them in balance." Like I said, things don't work that way. As horse populations grow, they continue to expand even as the habitat is being destroyed and the wildlife are gone.

On the Nellis Wild Horse Range there was an original appropriate management level set for one thousand head of horses. After one extended period of time we removed almost ten thousand horses! The animals were in terrible condition and those horses continued to breed. The populations weren't declining. They stayed at a level of complete resource impoverishment, and their numbers never reached a critical mass where the population died back to anything in balance. What would those herds be in balance with? The habitat they destroyed? They used up all the water and forage; there was nothing left. I don't believe that's what the public wants for wild horses. Frankly, I don't want that type of situation to be representative of my historic culture—resource degradation, destruction of wildlife habitat, huge animal mortalities—just to preserve a cultural icon. But our society seems stuck in this mode. We defoliate the mountains or we mine the ground to death, and we then set aside a couple of mountaintops to create a wilderness. Or we obliterate riparian areas by urban development and set aside a few streambeds to protect wetlands. Do we want a similar phenomenon for these horses? To exploit the idea of them and allow their numbers to increase until they destroy the range and die in massive numbers so we can then protect them again? I'd much prefer to see them handled as a stable part of the environment.

Right now there are several areas in Utah where the wild horse population is healthy. There is forage available and lots of ground cover, the horses run in normal-size bands, the stallions are aggressive in protecting

their herds, there is livestock use in the winter, and the horses are on the range all year. It's a classic view of what wild horses could be, but they are in small numbers.

Whenever I hear folks say, "Let nature take its course," it's usually people who have never seen what causes these animals to die. This is not a quiet death where the horse walks off into the sunset, falls to the ground, and gently passes on. This is a situation where a horse is thrashing around, trying to get up and struggling for survival, or coyotes are chewing on it while it's still alive because it's too weak to get up. Yes, that's nature, and it happens with elk and deer and grizzly bears and wolves all the time. But wild horses are not native, so to even speak of a naturally occurring situation is a misnomer. These horses are escapees from either one particular historical period or another, or from some other part of the culture or another. They are dependent on us.

I think the wild horse is a symbol of luxury. This is an animal that is not being managed as an ecological or economic benefit, and it supersedes other species which do give those benefits. The public must consider if it's willing to accept what it means to intensively manage the mustang. Can people accept their mortality? Can they accept humane destruction when necessary? The way we're headed—total protection of these horses—there will eventually be a big problem. For some it may be okay to keep the plight of the wild horses out of sight, out of mind. To me that's a callous view: "If I don't see them starve, it's not painful." Well, it may not be painful for that one individual, but it's definitely painful for the animals and those of us who see this up close. People must realize these horses are going to die in large numbers, and from a horrible slow death, because society has turned its back or excused themselves by saying, "Let nature take its course." The alternative is to accept responsibility and support the people who make the program work.

No matter what choices are made in environmental management, there will always be some sort of negative consequence. As society changes, cer-

tain habitats will disappear, and certain species will, too. We're trying to do something so complicated in the West. We can't begin to preconceive all the intricacies of the interrelationships between the soil, the waters, the plants, and the animals. We can either do nothing, or we must assume responsibility and accept the financial cost to manage our impact on this environment. In my view, it's a responsibility we absolutely must accept.

James A. Young, Ph.D.: Range Historian, Reno, Nevada

Before the Pleistocene age, not that long ago in geologic terms, all the rivers of the Great Basin drained to the ocean. All the vegetation, from the top of the Sierra Nevada to the California coast, stretched clear to the Rocky Mountains. Those immense rivers drained to the Pacific and created large river valleys. Based on fossil evidence we know that on the mountain slopes here there were once inland redwoods, while on the lower slopes there were oak willows. In between were ponderosa pine, Douglas-firs, things like that; and on the valley floors were vast grasslands. That was the Miocene age, fifteen to twenty million years ago. Conditions in the Great Basin back then have been equated with the Serengeti Plain in Africa today. Seventeen species of primitive camels have been described. We had rhinoceros and most of the evolution of the early horse. The true mint, the *Salvia*, grew on the valley floor as well.

During the Pleistocene age the granites of the Sierra Nevada and the volcanic cone of the Cascades began to thrust up. As that occurred, the westerly winds that once flowed across our area and over to the Rockies were gone. As a result, we became a desert here. As the ice formed, the ocean level dropped three hundred meters (almost one thousand feet), and as those mountains thrust up, they exposed the Bering Land Bridge. We sometimes think of the Bering Land Bridge as a trail, but it actually was a continent, an immense shelf that stretched one thousand miles from north to south. What happened? We lost many of our animals! The camel, the horse, and several other North American animals went to Asia where they

continued their evolution. Humans, on the other hand, came across from the other direction. Here in the Great Basin, the vegetation that was left was made out of a little bit of this and a little bit of that. It was wreckage, really.

On the west side of the Sierras the glaciers extended a long way down. On the eastern side the edge of glaciation stopped just this side of Truckee. Alpine Meadows, Squaw Creek, and Donner Creek all came down and blocked the Truckee River in its flow. It was like an ice cube in a glass. When the water got high enough it floated the glaciers, letting all the water out at one time, and there were huge floods. So the mountains shut off the drainage, and water couldn't go to the ocean anymore. Immense lakes formed.

An early geologist described the Great Basin then as a collapsed arch: the basin is lower on the east and the west and highest in the center. The highest mountain ranges (like the Rubies and the Toiyabes) all had glaciers, and water drained to the two corners. One formed Lake Bonneville, which became Great Salt Lake, and the other formed Lake Lahontan. They were the size of our Great Lakes! When the Pleistocene ended, those lakes largely evaporated. They dried up, the salts blew off, and they refilled. Native fish went into the springs or up the rivers and evolved into new forms. It was a fascinating time.

As it grew colder and wetter, the vegetation moved down toward the lake margins. Five-needle pines like the bristlecone once grew on the shores of Lake Lahontan, for instance. Funny things happened. The three-needle pines (like the ponderosa, the Jeffrey, or the Doug-fir) all disappeared. On our higher peaks now there are five-needle pines, but then there's a big gap where there won't be any trees at all. Then you come to the pinyon-juniper forests, and at last down to the sagebrush. The sagebrush originally came around the North Pole; it also evolved in central Asia. If you cut off the big root crown of a sagebrush and compare the *Artemisia terialva*, the important Asian sagebrush species, with *Artemisia tridentata*, our big sagebrush, they look exactly the same. Theirs isn't as big and woody; that's the only difference. There are also species of winterfat, so important on the range, in Asia as well as the Great Basin.

Nomadic agriculture (the domestication of sheep, goats, cattle, and horses) also occurred in central Asia. I think this applies to what happened here. What did the first humans who came across the Bering Land Bridge domesticate? It was the dog, the turkey, and the chicken. They didn't domesticate any large herbivores here. By the time of European contact on the Great Plains, the American bison was the most abundant large mammal on earth. There was nothing in Africa or anywhere else like it. In the Great Basin, buffalo herds occurred consistently only in the northeast valleys, around the Bear River and so forth. There is no evidence they got down into the central area of Nevada at all. Based on archaeological work we also know that buffalo traveled across the Snake River plain to the Columbia Basin, and through eastern Oregon down as far as Susanville. Then they retreated back.

When Peter Skene Ogden first came to the Great Basin in the 1820s, he traveled with about three hundred horses and about one hundred trappers and their wives. These people were what you might call the epitome of mountain men, but they almost starved to death when they came through Nevada. The only large herbivore that persisted through the Pleistocene was the pronghorn, and it changed through five different species to become the animal we have today. The pronghorn is halfway between a deer and an antelope (deer shed their antlers every year but antelope don't, and pronghorns shed only the outside). The antelope is also the only large herbivore that eats sagebrush all seasons of the year. Yet the antelope doesn't *have* to eat sagebrush: there are large numbers of pronghorn in central California valleys and on the southern tip of the Great Plains where there is no sagebrush. However, it is important to remember that the pronghorn *can* digest sagebrush. So, although there were no concentrations of large herbivores in the Great Basin prior to European contact, we did have herbivores in terms of the jackrabbits (the jackrabbit is really a hare whose population cycles about every seven years).

Now, as these immense lakes dried up, all the salts that dissolved over millions of years remained, leaving vast salt deserts. The vegetation there

now—for instance, on the valley floors around Fallon—is greasewood. The saltbushes and such plants as shadscale also cover hundreds of thousands of acres.

We have two insects in the basin. The Mormon cricket is a flightless grasshopper that moves in bands. They don't care what's there in front of them, because whatever it is they'll eat it. Mormon crickets are a cyclic insect, and they enjoy big survival rates during dry years (just north of Reno, people had hell with them last year!). So, whenever there's a drought, it not only has an effect on vegetation, but Mormon crickets come with it. There are also harvester ants, which are big-time seed-eaters. What significance are ants? If you look down from a small plane, you can see how many harvester ant nests are on our landscape.

All the small animals here have a great advantage because they're highly adapted to the environment. They don't drink any free water; they get their water metabolically from what they eat. Also most of them (kangaroo rats, mice, and critters like that) are nocturnal. They burrow underground where the humidity is higher. In the desert valleys, green feed is available for only a short period of time, but if you have a good seed crop, seeds are available in the soil the entire year. So that's what they eat.

In his journals Ogden wrote it was easy to find forage for three hundred head of livestock. Now, if you think about it that would take a lot of feed. However, they couldn't find any water that was fit for human consumption, and they almost starved to death for lack of big game. (Remember, the pronghorn were here!) Later, when John Frémont discovered Pyramid Lake, his hunters killed desert bighorns, which were also quite abundant near that area.

At the time of European contact, the horse was well north of the Great Basin. The Nez Perce were breeding for color patterns by then, and animal husbandry was going on up there. But if any horse wandered down this way, the Indians here considered it a good meal. Those interior tribes were in many ways a jackrabbit culture then. So the Great Basin was one of the last western environments to be utilized by domestic livestock, because when

the first Europeans came through they thought it was hell! Only a few settlers noticed all the grass, and they stayed.

Even though there were probably shrubs in all the plant communities when Europeans arrived, the evidence shows there was definitely a predominance of grass. But when settlers began to graze their livestock in the basin, the cattle didn't prefer sagebrush. Cattle don't like to eat sagebrush, for one thing, and if they do eat too much of it they'll die. This is because cattle, sheep, and goats are ruminants, and ruminants have an anaerobic (no oxygen) digestion chamber. It's one of the great evolutionary developments that allow them to utilize coarse forage. Horses, on the other hand, have a cecum, which accomplishes the same digestive process but isn't as good when compared with a ruminant. (That's why you always have to walk a horse when it has colic. Or why, during drought years, a wild horse eats its own manure. The manure isn't very well digested, so there are still nutrients there.)

Due to livestock grazing, shrubs increased. Mule deer, which were once a tiny population, have a muscular ruminant system and are able to browse shrubs, so they increased tremendously. There are two interesting factors: one, livestock grazed out the grasses, and grasses are necessary to carry fire; two, when grasses aren't there, there's nothing to compete with shrub species. So, if you don't have fire to kill shrubs, and you don't have plants that compete with them, it allows shrubs to increase. The key to grass and shrubs is the frequency of fire. In timber country, fires scar trees, and we learn intervals between fires that way. In the Great Basin, there aren't any trees, so there's no record. Farmers and wildlife managers get flustered because people say they should use more scientific management, but I frequently ask: which science? Some experts contend fires occur every three years, some say every century, and others say everything in between. The truth is they may all be right—just in different places.

Today the Great Basin is like an ocean of aridity. When winds that are laden with moisture lift up over the Sierras and the Cascades, they move across each of our mountain ranges and leave some moisture there in the

winter, but the valleys below remain dry. As you head up the mountains you find a much more favorable environment. It's an ocean of desert with islands of greater potential: the mountains.

This breaks up our animal populations, producing hybrid vigor when they do interbreed that is environmentally influenced but with genetically inherited traits. If you suddenly have a mountainous area where there are a lot more shrubs available, the deer increase. When they reach a population peak on that mountain the males will leave for another mountain where they will hybridize with the population there. You get a big expansion, and there's this tremendous growth of deer. The same thing happens with wild horses.

Right now there is an increase of mountain lions, which has become very controversial. The number of deer controls the number of lions. When these animals are out-breeding, predators are inconsequential, but when they are in-breeding, predators accelerate the crash. People get so overwrought about these things, but it's another situation where they are both right: they just come from different places in one continuum. The out-breeding and in-breeding of any animal population lasts for roughly fifty years, but most wildlife managers work in a particular area or field of study for only *thirty* years; in other words, their career spans one cycle only. Right now we're seeing an acceleration of a crash on deer populations. We need to remember that before World War I, Nevada launched a huge program to control predators after four hundred people were treated for rabies. That continued until 1932 and practically eliminated all the coyotes, mountain lions, and bobcats. Now we ask, "Why are the mule deer populations crashing?" Well, it's because there are more lions, more coyotes, more bobcats—more of everything again.

This is so important to understand. Everyone is lamenting "the sagebrush is disappearing" or "we're going to endanger the sage grouse" or some such stuff. But the shrubs have actually increased. The first reaction to grazing was an increase in shrubs, because there wasn't any grass to ignite and carry fire. Also, before we got all these invasive weeds such as

cheatgrass and halogeton, native grasses were dry enough to burn in late August and September. That's an entirely different fire from one that burns in June or July, when days are shorter and nighttime humidity is higher; there are far fewer consequences then. When cheatgrass arrived here as a contaminant of wheat, it changed the chance of ignition, the rate of spread, and the season of fire. That is a *major* difference.

All our moisture here comes during winter. A shrub has growing points which are permanent, and it keeps extending out. But grasses start from the base each time, so grass has to renew its stems and flowers every year. Grass flowers and produces seed, and then it builds up carbohydrate reserves before summer drought. If you graze too heavily year after year, grass will disappear during spring. Now, when is forage the most valuable? Mid-March to mid-April! Historically, that was when folks were hard up. People ask, "Why would ranchers be stupid enough to put their cows out then?" Well, for one reason, they probably ran out of hay. For another, they might have gotten tired of feeding their cows all winter long. Third, they had to take their livestock off the meadows so those meadows would grow back and they could cut hay for the following winter.

A typical grazing cycle on the range usually works this way. There are shrubs from the rose family which are valuable browse—bitterbrush, mountain mahogany, and such. Livestock follow those shrubs up the foothills and into the high mountains. Those are the mountains that once had ponderosa pine, Jeffrey pine, and Doug-fir, but all that's there now are more shrubs. It's the top of the island in the sagebrush ocean. There are alpine meadows up there now, with aspen patches and so forth. In the fall, livestock come back down and hit the foothills a second time that year. That's how you get the term "spring-fall range": they hit the desert once, the mountains once, and the foothills twice.

In the Great Basin we don't have evergreen shrubs, we have ever*gray* shrubs. Shrubs are gray because the hair on the leaves reflects incoming light, so there is some chance to get moisture balance. Otherwise there is *too much* light. Those hairs break up the wind, and the plants don't use as

much moisture. Anywhere you notice green, such as greasewood, it means that plant uses salty water. Greasewood takes in saltwater and then gets rid of it by dropping it around itself. In the desert, where you find greasewood, the soil is actually saltier underneath the plants than it is between them!

There are numerous accounts that when settlers arrived here their livestock refused to eat shrubs. Then they found winterfat, or white sage. Winterfat is largely a monospecific semishrub community where plants of one species grow very close together, like wheat, so that insects or disease can't get to it. After winterfat freezes in the fall, horses, cattle, and sheep love to graze on it. Some of the stories that have come down through old pioneer families say that once there were grasses mixed in with winterfat. Well, that means it wasn't always monospecific. There is a real problem in eastern Nevada now because winterfat is dying off. You'll hear some ranchers say it's because there are too many horses, and you'll hear wild horse folks say it's because there's too much livestock, but it's more likely that the winterfat community is unstable because it was too pure! If you look at stands of winterfat where they took off the cattle or where horse numbers were reduced, you'll see grass coming back. It probably was a much more balanced community in the past.

The term "stand renewal process" basically means no vegetation lives forever: it has to turn over its generations. If you're in a rain forest on the equator, all the leaves and pieces of bark that fall will be completely mineralized by the end of the next day. As you move away from the equator and travel up in latitude and elevation, the vegetative litter lasts longer. All the nutrients are trapped in undecayed litter. Big sagebrush apparently was always what we call catastrophic—in other words, it burns. When you look underneath any sagebrush plant you'll see a big accumulation of litter. Oftentimes nothing grows there because that litter gets so deep. When those nutrients, especially nitrogen, release catastrophically during a wildfire, that is a stand renewal process. So all competition in the Great Basin environment is for moisture, but the catalyst that governs that competition is nitrogen (which acts in tiny amounts), and fires were always part of this

environment. For a short time, depending on the elevation and the soil of a particular site, grasses did dominate and some shrubs did sprout. Many of those didn't come from the Arctic (they came from the tropics), so temporarily there was grass, a few sprouted shrubs, and sagebrush.

Sagebrush is such an interesting plant. During spring it produces a great big wide leaf, which is very efficient photosynthetically but not very efficient for water. As soon as the leaf dries, it drops to the ground. The smaller leaves aren't at all efficient photosynthetically but are extremely water efficient. They last from five to ten years. In late summer, sagebrush produces a zillion tiny seeds that mature in late fall–early winter. It does this whether it's a two-year-old or a two-century-old plant. In a wholly stocked stand you'll notice that about every square yard each sagebrush plant produces almost enough seed to cover all the ground beneath it. What chance do those seeds have for establishment? Virtually none! Essentially sagebrush produces seedlings that act as annuals.

The Great Basin grasses are bunch grasses. We don't have any rhizomatous grasses like the Great Plains. People say, "Look at the Great Plains; all those herbivores were there." Well, the plains have rhizomatous grasses that have an alternative form of photosynthesis that works in late summer. It rains in the summer in the Great Plains. Our successional bunch grasses are all short-lived; there's almost no summer rainfall here.

With all our natural resources in the West, I think we have to give up our ivory tower theories and get to site-specific situations. If not, the exceptions will kill you every time. By "site specific" I mean the soil and vegetation of any given community. I call this "thinking small."

If we know anything from the last couple of decades, it's that the climate is always changing. It's not necessarily from human-induced gases or things like that. Climates just change—that's their nature. They change on a short scale, on an intermediate scale, and on a long scale. Five to eight hundred years ago the Truckee River got this far north, yet it was clear down near Tonopah one thousand to fifteen hundred years ago. *Every day* the composition of animals and plants changes, even with microorganisms.

There may be miniscule or gross differences between them, but every day those differences do change.

Things are changing in the Great Basin, and the public needs to be more knowledgeable about the range. The pressure of our growing population is great. Vast stretches of new development are everywhere. With the next big fire on salt desert vegetation, firemen will have to protect public health first, since there are more people living further out on the flats. People should at least have a general background so they can make an informed choice.

As to wild horses, the public must realize that we have to increase the level of management to keep things sustainable or it's going to damage the habitat too much. If our society is willing to pay for it, and as long as the herds don't damage the range, then so be it.

Bob Abbey: Nevada State Director, Bureau of Land Management, Reno, Nevada

I'm a firm believer that wild horses are a part of our heritage and they belong on public lands. It's just a matter of what the resource can sustain as far as numbers. One difference we have in Nevada is the amount of land BLM manages. There are forty-eight million acres—that's 68 percent of the state's entire land base! The estimated horse numbers this year are around twenty-five thousand. We also estimate a reproduction rate of about 22 percent per year, depending on available forage and water.

We have a need to establish appropriate management levels in all our herd management areas, and we're diligently pursuing setting those numbers. We're also monitoring each herd to determine when there is a problem relative to forage or availability of water. We're performing inventories to determine the number of horses within each of the areas. We don't have sufficient funds to do the number of inventories we'd like or as routinely as we'd like, so we're not always as current as to what the exact number of horses is in any particular area, but we do it routinely enough to have a pretty good estimate. From that point on, it's a challenge. There is a limited amount of money available for BLM to manage wild horses and burros under the law. Certain priorities are set at the national level, and what I deem im-

portant doesn't always get chosen. We rarely receive sufficient funds here in any given year to do what's necessary. At best, we stay at the status quo.

Where some frustrations take hold is we're not seeing progress being made. If anything, we lose ground relative to ensuring a healthy rangeland. I think for too long we've let emotions drive the Wild Horse and Burro Program. I'm not being critical of those who bring emotions to the discussion, and I think it's important that we understand how people feel about maintaining a healthy, viable herd of horses and burros on public lands; that's something I definitely support. But during the debate we've lost sight of the real issue, which is the health of these rangelands and the ability of the range to support the numbers of wildlife, wild horses, and livestock that use the same lands. To the best that we can, we need to take emotions out of the discussion and start focusing on science and the reality of what these lands can sustain, and then take actions necessary to bring numbers to where they're consistent with the sustainability of the land.

The biggest challenge is trust. There are many people who believe that we in BLM have a hidden agenda, and that this agenda is more in line with trying to support livestock interests than expending energy to provide range for healthy herds of horses and burros. For some reason we haven't been able to get past the errors and deficiencies of the program from so many years ago, and there is still a lingering lack of public trust in our ability to perform the job appropriately. Anytime I talk with people about the wild horse program, the response is either that we're sacrificing the livestock industry for the sake of the wild horses or that we're sacrificing wild horses to support the livestock industry. There are a lot of allegations and accusations made about our incompetence and our inability to manage the program, and I think some of the criticisms are right on the mark. We have not always done a good job. But I really believe that over the past couple of years we've gotten our act together. We know what's important now. We know the science required for monitoring. We know what's needed to form an appropriate analysis. We know how to come up with the best numbers to determine what is sufficient relative to the ability of the resource to sustain

that use, so as to have a balance between the number of wild horses and burros, the number of livestock allowed to graze under permits (and the conditions for their grazing), and the number of wildlife, which are so important to the habitat. We've become more professional so as to provide better information about what we're doing, as well as the ability to defend our actions against the critics who are always there.

One thing we don't do a very good job at, however, is telling the public why it's important to gather these horses in the first place. Back in the 1970s when we were doing a lot of roundups, the entire emphasis was about finding places to put these horses. Over the past ten years the emphasis changed from just finding any place to put them to locating quality homes for them. I think the success rate has improved significantly compared to that time, because the record was kind of dismal then. There are more compliance checks now. There's certainly more work done to review qualifications of potential adopters, since many times people have their hearts in the right place but no idea what they're getting into. A $125 fee is the cheapest thing an adopter will pay for a horse, and sometimes people really don't have the financial ability to maintain a horse over a long period. When that happens we find ourselves having to put the horses through the adoption program all over again, and that's not good.

Adopting a wild horse can be like a crapshoot—you never know what you'll get! Every horse has its own personality, and some require more training than others. One thing we're doing is arranging for proper training. We provide demonstrations for potential adopters, we invite veterinarians to speak with people about types of feed and supplies that are required, all so people will have knowledge prior to making a decision.

In my view, there is a place for an inexperienced adopter. Many people who have successfully adopted these horses are often willing to share their experience and knowledge with novices. We try to share the names of these people so if novices aren't comfortable calling BLM (because they think we'll confiscate their horse) they can get counsel from a support group.

Prior to coming to Nevada I thought the adoption program could take

care of all the excess horses. I've since come to realize it can't. The adoption program is an important tool and we need to use it to the best of our ability, but we have to look at other options. Once we get wild horses to appropriate management levels, it will be easier to maintain their numbers and the adoption program can serve the program well.

BLM was optimistic about the immunocontraceptive program implemented on the mares, but it had minimal success. Until we see a vaccination that can last three years, we're not going to be able to address the breeding population. There are also a couple of issues with gelding stallions. First is the cost and the care required. If we gathered the horses and gelded the studs on-site, we'd need to maintain them a week or so to make sure they'd be healthy enough to be released. Some folks may not agree with that, but our veterinarians have advised us we would need to hold the horses or there could be injury. All that adds to the overall cost of the gathers. Another criticism is that gelding would alter the dynamics of the herd simply by picking and choosing which stallions to geld and which to remain as studs. In reality, though, anytime a herd is gathered their dynamics are affected, and so we're already doing that. People must understand that if a dominant horse is removed from the herd for adoption, this in itself affects herd dynamics. We're not trying to hide that. Over the past five years it has also been our policy to remove only horses five years or younger. That affects the dynamics as well.

In my view, we must focus energy on the sustainability of the resource itself instead of talking only about the horses. And I'm not sure that many advocacy groups look at the long-term effects of the actions they propose. The truth is we're always going to have some conflicts between livestock, wild horses, and wildlife on the range. The point is: how can we work together for the common goal of maintaining healthy and viable herds of horses? The wild horse habitat has been affected over many years; the concept of not managing these herds is extremely unrealistic. We need to agree that management must happen, determine the appropriate numbers, and then manage accordingly by using all the available tools to do that.

We need to do more than just gathering and adopting horses. We should be implementing range improvement projects to enhance the viability of a healthy herd. We need to ensure access to reliable water sources. We should install fences in some cases, or eliminate fences in others. Wild horses need sufficient forage, particularly during periods of drought like we experience routinely here. We sometimes talk about years that are "above average" or "below average," but when you live in the high desert, drought is always part of the ecosystem.

Our program has had many false starts, many ups and downs relative to funding. We've gone through several strategic planning exercises, and we've made commitments we've not been able to keep for various reasons, but we've never spent the time necessary to implement any of the recommendations or plans that have come down from the National Wild Horse Advisory Board. It seems like our actions are always being impacted by the emotions of the day. Or that we start something and then quit a year later for whatever reason.

One of the values I hold very dear is credibility, especially my own. When I see that we've reduced the number of livestock within a given allotment because forage isn't available, but that we're still way above appropriate management numbers for wild horses in the same area, and then observe that we don't gather horses to bring them down to appropriate levels because of lack of funding, I feel like a hypocrite. That's a credibility issue, and that's where my frustration lies. I'd like everyone to be treated fairly. Maybe that isn't always equal, but it should be fair.

The amount of money that comes to Nevada is fairly consistent year to year. The Palomino Valley facility is under the jurisdiction of the national program office, not the state. Nevada horses are processed at Palomino Valley with wild horses from adjoining states and then shipped elsewhere for adoptions. When you look at the adoption program back East, most of the horses are from Wyoming, Utah, and Nevada. What I find frustrating is that there may be areas where I could improve on our efficiency here or do a better job to benefit the state, but have absolutely no control as to how

those facilities or programs are operated. The monies we receive are sufficient to gather around four thousand horses a year, but simply to maintain the status quo we need to remove about six thousand horses a year! So, if there is any chance at all of achieving appropriate management levels over the next five years, we must remove upward of even more. And that's just Nevada's rangelands! Right now we're not doing that, and I don't see anything that leads me to believe we're prepared to do it in the near future, even though we've accepted this as part of our strategic plan.

There are overpopulations of horses in Wyoming, Utah, and Colorado, and in Arizona and California with burros, but nowhere is there the extent of the problem that's in Nevada. We need to be accountable for implementing the actions advocated in our strategic plan. We need to do the things we say we're going to do, and we need to plan for surprises along the way, like droughts and fires. Some years we'll need to conduct emergency roundups, and these will impact the number of horses we would normally gather because there will be extra emergency horses coming in and filling up the current facilities. We've got to be prepared to deal with the unexpected!

The existing law does not necessarily encourage a cost-efficient program. The way I look at it is that wild horses are important to the American public. If the public wants us to manage more efficiently within an existing budget, then we need more tools available to deal with the population issue. Many of these horses are just not adoptable at all, so that means we are going to need more sanctuaries or more holding facilities for the long term. It means we're going to have to feed a lot more horses for a long time.

Steve Pellegrini: Wildlife Biologist, Yerington, Nevada

One day during my junior year of high school I went to the hills with my uncle, my cousin, and my father and we saw wild horses. My uncle was a horseman par excellence and my dad had invented a wild horse box trap, so we went out to the Wassuk Range to set it up. On Easter Sunday we went back and here stood this little yearling. We named him Chico. It was like a window opened for me that day. It was one of those junctures in life that you

know is a transforming moment, and it came from riding horseback with an uncle and cousin I deeply admired.

There were so many mysteries! The wild horse was really interesting to me, and I wanted to know all about them. I remember finding pine pitch in Chico's mane, so I knew he had been up among the trees. I clipped it and took it home, and I would sit and look at it and wonder. Where did he pick that up? What did he do with his day?

As time passed, I spent all my spare time on horseback out in the Wassuks with my uncle and cousin. You might say I was drawn back to the wild horses because of them; there was a certain mystical connection to the entire experience. Then, during my undergraduate years at college, my uncle and cousin each died from a heart attack within four days of one another, and one month later my major professor passed on. I began to seriously question what I wanted to do with my life. Soon afterward the university hired a new professor of wildlife management, Mike Pontrelli, who had an interest in wild horses. Mike became my major professor. When I told him I had spent every weekend since high school looking at mustangs, there was no discussion about where my graduate studies would be headed!

I started my field study with the same herd of horses I first saw with my uncle and cousin. I worked part time as a teaching assistant and I would go to the hills every Friday through Monday. I was on the ground with the horses all the time, either on foot or horseback. A lot of times I'd go out after dark and follow them at night. My family just didn't understand what I was doing! I was a small-town kid, my grandparents had a ranch, and I came from a background of practical, hard-working German Italians. Following wild horses around week after week didn't hold much value to them. A lot of my friends also questioned it. But mine was the first documented study of feral horses. Przewalski's Horse had been studied, but he is truly a wild animal and not a feral horse. As far as I know, no one else had taken any scientific interest in wild horses before I began. My studies have lasted twenty years.

I have very strong feelings about my research. In 1987 I wrote a paper

proposing that high-density wild horse herds will disassemble the normal band structure of a low-density herd. I'm still convinced those conclusions are correct. Every herd has territories. These territories are situated in such a way that a normal band can get to water without overlapping another band or causing territorial abuse to any appreciable extent. When too many horses get together for one reason or another, some of their territories will expand farther away from the water source, and that means they must cross through somebody else's territory to get to it. This essentially sets up a situation like rotation. One band moves into the area and another moves out, and pretty soon what you have is a melee with no more home ranges. Instead there is an area of immediate occupancy that must be defended, such as the water hole.

Whenever you see a large group of wild horses—say, a hundred head—you're not looking at one band. Rather you'll be looking at several bands. A "super band" is what I call them. A boy in my class recently brought in a picture from the newspaper showing about thirty horses in a bunch. I picked out five individual bands and a couple of lone studs just by the way they were situated.

When I started my research, horses were all snowed in over in the Pinenut Range. I rode out in the plane when BLM dropped hay to them, and I went back later when they performed an autopsy on them. I had the idea then that what I was seeing was a fairly low density herd. There were little bands of about five horses in one spot that were fairly well isolated, then you'd travel and see another band of perhaps seven in another spot, and then maybe a lone stud here and there out to the side—that sort of thing. A few years later I returned to the same area. There were about fifteen hundred horses in one bunch by then, but I could see these little groups were still there in that larger group, and that's how the concept of a super band took shape. This is the same type of activity you see with wild horses today because of increased population numbers.

₊₊*

WHEN HORSES are few in number, they are able to establish a home range adjoining a water source and don't have to displace another band to get to it. When they do displace, everything gets scrambled. Then nobody has a home range, and instead they focus on defending one little area wherever they happen to be standing. You can identify a high-density area because horses don't mind being a hundred yards from another band; they grow accustomed to seeing them travel through their territory to go to water. When things are normal horses keep to their band, everything seems to hold within their band, and the stallions still defend their mares. In a high-density area it all looks the same, except that instead of one band being in an area of maybe fourteen or twenty square miles, it might be thirty yards from one band to another. I can tell if an area is high density from what kind of home range the horses establish, and I can tell by their band structure if they are a super band or not.

I've always considered myself an environmentalist. Anyone who has lived in Nevada day in and day out, who loves animals and has any brains at all, can see what has happened with wild horses since the 1971 act. Something isn't right! Everything has to fit on the range in a healthy way or something's got to give, and usually, if something does give, the whole puzzle falls apart. That's what I worry about. The animal rights movement seems completely out of touch with the reality of our ecosystem. They're not present to see the suffering these animals go through when they are overpopulated.

There is a pending disaster outside right now because of the drought. Here in Yerington we got only 1.7 inches of rainfall last year. Every spring I teach a wildflower class at Western Nevada Community College, and this year we all went to the field. It was mid-May, and over on the East Walker River the range looked exactly as it does in mid-January! There was nothing there—no greenery, no wildflowers, no growth at all. If it shakes out that we have a decent winter and get enough snowfall, there could be mass starvation of horses. Because what are they going to eat? When there's no forage, cattlemen can hold their animals off the range. But wild horses re-

main. I saw the same thing happen in 1968. There was heavy snowfall and the horses moved up to the ridges. Now, I'm sure their metabolism must change in winter, and they do adjust to climate changes to a certain extent, but they still need forage to keep warm. They've got to have fiber, and without it they go down to bare bones. So there are lots of levels to consider about this kind of situation. The sort of trauma that occurs with fifteen hundred wild horses is much, much different than with six thousand; the entire magnitude of the suffering changes.

I think the public too often confuses animal rights and environmental protection. Perhaps the best example I can give is with Wild Horse Annie. I had a high regard for Annie. I worked alongside her for several years and we became close friends. She grew up on a ranch and was a very intelligent woman. Annie became an animal activist because of the abuses she saw happen with mustangs. The barbarism of some of those early mustanging practices got to her. It does to me too whenever I think about it, and I'm grateful she put a stop to them. But when she first entered politics, "Save Wild Horses" was her one and only motto, and it was a narrow focus. After she became associated with the university Annie began to understand that scientific research had something to offer and she became informed about where wild horses fit in the bigger picture of the habitat. I think it's a fair statement to make that Annie grew so convinced about the importance of that whole picture that the wild horse became only one piece of it. I also think that by the end of her life, Annie realized she had the tiger by the tail! She had an immense public image, and she thought she'd sell too many people down the river if she drifted too far away from that original motto. Her voice carried so much weight, and many animal rights people hung on her every word. But on several occasions Annie indicated to me that her concern was for the well-being of everything in the ecosystem. So through the years I watched her move from a narrowly focused animal activist stance toward a position as an emerging ecologist. She transformed greatly. She became extremely knowledgeable and she enjoyed speaking with trained scientists in their language. However, Annie never had a great compunc-

tion about putting a horse down. Any farm girl understands those things must happen, especially with old, sick, or lame horses.

* ⋆ *

WHEN I STARTED my study there were thirty-five horses in the Wassuk Range. It's fairly big-sized country, and that first summer I couldn't find them. I wandered all around, hiking and on horseback. I tried camping out. I sat in blinds for hours. Finally, one day I was out on my horse and it was late afternoon. I had been riding all day and was heading back to camp. I stopped at the spring to give my horse a drink, and as I was sitting there I looked down at the tracks of the horses that had come to water. Those tracks were like a signature: the horses had been standing right there, and if I could have stepped back a few seconds in time I would have seen them. I thought about how detectives work from circumstantial evidence and wondered what I could do with those tracks. Now, every horseman I know can tell the back from the front foot of a horse by its marks, and I was familiar with that too, so I began to look more closely at the tracks. I realized that the shape of the hoof, the size of the hoof, and the frog print were unique for each one. I could identify an individual horse. Well, if I could find him here, it meant I could go a mile from the spring and by looking long enough I could find that same horse again by the way it stepped. So I started drawing and measuring tracks. I followed their trails with a compass and plotted where the horse had gone.

One day I came upon a spot where one horse had stretched out its feet and urinated. I knew that horse was a male, and now I could sex them. Then I discovered where they stayed under the trees. They would lose their mane and tail hair there. I found where they rolled, and that was even better yet. Pretty soon I arrived at a scenario of what they looked like, their sexes, and the size of the band. I could see the stud wasn't following the trail. A lot of the time he stayed off to the side as the family moved along, and every so often he'd move to the back so he was following them, because I could see where his tracks had moved on top of everyone else's. Well, when I finally

made contact with the horses after a few months I witnessed everything I had surmised! It was a big achievement. But then, just as I thought I finally had their home range patterns and everything all figured out, everything changed. I was concerned my conclusions were wrong until I discovered the changes were related to the season; their home range altered according to the time of year.

There were some surprises. Stud piles, for instance. There's a lot of folklore about stud piles, and there are some who might still argue about it, but those piles aren't used exclusively by stallions. Manure piles are made by the whole band, and the stud usually deposits off to the side. He's not always a welcome animal in the band anyway, and he's not always well behaved, so it was my observation that mares primarily used those piles. I've watched them stop and make a drop as they go down a trail, and just as often as not the stud will make his deposit off to the side somewhere. Nor could I see any evidence of stud piles being any kind of territorial marker. Wild horses stand for a long time in one place, such as around shade trees or by a ridge, so for years I played with the idea that stud piles must be a way of marking territory. However, I don't think they mark territory in that sense at all. If they did, they wouldn't be able to give up their territory in a high-density situation, which they definitely do.

I do believe wild horses defend their territory when they start out. I saw a lot of disputes at water holes, and a lot of times it had nothing to do with mares. For example, one stud from one band would attack another who came in to drink. The mares were a safe distance away, and it seemed to me on many of these occasions that the dispute was more about water than about the mares. Attacks are definitely testosterone driven, and some of that is normal, because male horses like to spar with each other. Joel Berger did a later study of wild horses in the Granite Range near Black Rock Desert. His was a situation where Band A and Band B were twenty yards apart from each other, so that kind of tension level is going to be pretty high. In super bands you see a lot of ears going back, a lot of nervous movement, a lot of posturing, putting haunches back even when it's not needed.

I think these are all horse whisperings, subtle signs of one horse saying to another, "That's close enough!" Of course, in an emergency situation such as a drought or fire, horse behavior becomes resource driven. When that happens, aggression isn't about defending mares, and although bands stay together it's because they're used to doing that. It's a matter of survival, and the natural resource becomes the most important thing.

The stud horse isn't the ruler he's made out to be, either. Sometimes a stallion may wait to get a drink at a water hole, but that's not because he wants to be polite to a mare; he just waits because he has to! I've also seen mares knock the hell out of a stallion if they try to get ahead. One of my early observations occurred at Butler Springs when a band came in to water. I had stopped to watch them from up on the hill. They were thirsty, it was summer, and they had been grazing all day, and this one particular stud kept trying to come in to the water. He'd come around the bend, head down the hill to the spring, and that lead mare would lay her ears back and he'd back right off. Then he'd sneak around again, and still she'd lay her ears back. Then he tried a lower trail, and she saw that too and came down after him again. There was no question she sent him back. I've seen that behavior often.

I love horses and I have my own, but the bands I studied gave me a hard time. It was almost like an adversarial situation. For my part, faced with the reality of doing serious research, it was difficult to maintain objectivity and put order into the natural environment. I'd whisper under my breath to them, "Now if you guys would just travel down that gully and give me a little glimpse, that's all you need to do." One day I fell asleep in my blind, and when I woke up it was nighttime. Well, here were all the horses! They came down the trail behind me and were just standing around me, staring. It was straight out of a Gary Larson cartoon.

One fascinating thing I learned is that there is nothing in the historical record to indicate that anyone ever manipulated the Wassuk Range horses. There's no record of their being released. So I have a lot of questions about that, especially how Wassuk mustangs may differ from horses in other

areas where we know there were a lot of estrays or where someone bred up
the horses for one reason or another. Why not compare these horses who
haven't been manipulated with other herds that have? Nowadays there are
a lot of bay horses in the Wassuks, whereas there were once more roans and
whites. The bay is a sign of the primitive horse coloration, agouti, a brown-
ish-colored hair with a black tip that horsemen traditionally called clay-
bank or dark buckskin. Related to it is the incidence of leg striping or dor-
sal striping in some of those same primitive colorations. If a study were
done, I suspect one might find more of those primitive markings in the
Wassuk horse. Other questions follow with respect to DNA analysis and herd
origins. To my way of thinking, these little Wassuk horses are a true genetic
reflection of the desert. Let them remain so.

I still go out regularly and visit the horses. One recent Sunday there was
a little band heading down the hill. The sun was going down, and they were
all bathed in the golden afternoon light. They weren't doing anything dif-
ferent out there, they were only feeding, but I wished I could have stayed
with them longer. I just said, "Hi," and went on my way.

John L. "Jack" Artz: Natural Resource Manager, Cool, California

I've observed a lot of wild horses over the years. When I first came to
Nevada almost everything from Interstate 80 south—through Eureka and
Lander counties and most of Nye County—was no-man's-land. It was com-
mon in those days to see wild horses close to a town because people had
free-use permits, which went back to the time when locals could keep a cow
or saddle horse on the range. An interesting difference was around Austin,
which is adjacent to the Toiyabe National Forest, since it's generally true
that the Forest Service eliminated most of the horses in the national for-
ests. Going west from there, there were always horses on the range. One
herd near New Pass was called Gondolfo's bucking string. He was a rodeo
contractor and those horses were his.

The winter of 1956, I drove from Eureka to Tonopah, through Little Fish
Lake Valley, Stone Cabin Valley, and Reveille Valley, about every other week.

My job was to track winter sheep use for BLM and so I'd spend a couple of days going to all the camps. That territory is now a major wild horse area. I remember taking out my binoculars and seeing just small bands of horses, and it was exciting. Later on I worked in the Carson City District. There were horses in the Clan Alpines and up through East Gate; and around Basalt Junction, south of Mina, there were lots of burros. There was a little stone cabin, and an old hermit miner lived there, and those burros were his. My assumption is the little Basalt Junction band moved and grew to become the current herd of Marietta burros.

Wild Horse Annie became a public figure in those days. The *Weekly Reader* magazine was sent to all the schools, and it was Annie's main outlet to get children interested in wild horses. I don't believe Annie ever thought wild horses were going to disappear from the state. There were always areas where the horses were considered a nuisance, and whether those bands had a history of being there for ten years or one hundred years, if their population started to build up, someone would make an attempt to gather them.

I went to work for the University of Nevada after 1959. I still traveled a lot because I was involved in drafting environmental impact statements on public lands. The area around Tonopah was one of the first to be looked at, and I spent a lot of time there. It was a totally different picture in terms of wild horses by then. During the 1970s you could drive into Stone Cabin and Reveille valleys and the whole flat would be covered with horses of every color. You could easily see one hundred or more horses together; there were stud piles everywhere and lots of evidence of heavy overgrazing.

During this time I was invited out to the Haystack Ranch, west of Eureka in Antelope Valley. The ranch wasn't stocked with cattle when the owner bought it. In fact, that range was so overstocked with wild horses that he didn't even want to put cows out, so that's why I went out to take a look. There were big white sage flats south of the Haystack, going down through the valley. I recall very clearly that on these great big flats the white sage was almost invisible. I still have pictures of it. It was all nipped right down to

the ground. There were horse manure piles all over, around twelve inches high. It all looked pretty terrible, and there hadn't been a cow or a sheep out there for several years. It was a memorable experience.

Last summer, when I served on the National Wild Horse and Burro Advisory Board, there was a meeting in Ely. I mentioned to the group that I wanted to go look at some of that range again, and so several board members drove over with me. Well, there is no more white sage there now. It's all solid weeds, just solid. So whenever people say there is no damage by overuse of horses, it's simply not true. That particular problem I witnessed may be an isolated example, but I can say without question that I observed it happen over this particular time. It was very clear to me that the damage was definitely done by horses, and that it could even be irreparable.

I don't think the public understands any of this. Last year, when there were so many wildfires in Nevada and millions of acres burned, BLM had to remove horses and livestock from the most heavily damaged areas. I attended a Wild Horse and Burro Advisory Board meeting where some activists were protesting the removal of horses from those areas. One of them claimed she visited a specific herd area targeted for removal, and she objected because she saw grass growing there. She made a comment, for the record, that there was lots of wild rye sprouting up and the horses were already eating it. Well, that is *exactly* the reason why those horses had to be removed. Great Basin wild rye needs protection from grazing during the growing season. New grass must be left alone so it has time to grow and reestablish itself.

I worked with Wild Horse Annie on a few projects in the 1970s. At that time, a lot of groups were getting organized and there was a lot of controversy, either about the inhumane treatment of wild horses or that they were an endangered species or that they were all remnants of Spanish colonial horses—all things that we now know are mostly untrue. One of our United States senators approached the administration at the university and said something needed to be done. From that evolved the Wild Horse Forum of 1977. The idea was to get people talking to each other and see where com-

mon interests or solutions might be found. Over 150 people attended from all around the country—wildlife biologists and animal protectionists, the state BLM director and other Forest Service representatives, livestock men, environmentalists, academics. It was a working group, and all the participants spoke from their hearts. Annie was very involved in planning the forum but didn't attend because she was ill. She died two months later.

During the forum people worked in committees and prepared a formal statement which was then endorsed by all the chairpersons. It's very interesting to compare that statement with how things are perceived today. At the time BLM didn't have authority to transfer title to adopted horses; that has since been granted. Yet there are still extremist groups nowadays who insist that a once-wild horse should never go to slaughter even after they have been adopted out and the owners have title. BLM has adopted something close to 150,000 horses through the years, and certainly many of those will die of natural causes or because they're old. People need to have the right to dispose of their horses just as they would dispose of a pet cat or dog that gets sick or dies. Unfortunately, I think some groups would rather keep these issues unresolved.

In the early 1980s I was appointed to serve on a National Research Council committee for the National Academy of Sciences to make recommendations for research needs on wild horses. The committee was made up of scientists, equine specialists, and geneticists, but most of the research that we reviewed was on African equids, not western horses. This was a very professional group who wanted to stay focused on pure science, but there was little in the way of utilization studies being done or written about range conditions or deterioration with respect to wild horses. The same problem exists today. There are many people knowledgeable about range ecology who know that actual damage is going on. But if you go into any meeting and ask for data, it can be damned hard to find. BLM hasn't kept good records, and in a lot of cases they still don't. It's frustrating to people both in and out of the bureau.

With all the environmental studies and land use planning requirements

being done now by government agencies (I'm not saying these are without merit), a great deal of time is spent collecting data and making reports to convince others about something a manager on the ground already knows. Just as often, that person is required to spend time in an office or a meeting rather than being out in the field observing, communicating, and making assessments. There's a whole new bureaucracy now within and beyond the bureau—at the district, state, and federal levels—and the field person can't do anything without paperwork. Not only that, but if a particular supervisor doesn't like one field person or thinks he or she may be doing something wrong, well, that's great, because paperwork keeps them off the range.

A lot of effort to collect data is also done merely to justify proposed actions, either to special interest groups or to higher administrative levels at the bureau. Much of it isn't the kind of precise information a person on the ground needs to make sound decisions, and in fact, much of what a field person needs are professional observations, samplings, or records that won't hold up in court just because they may not meet the "statistically significant standards" or other criteria of a scientist, bureaucrat, or lawyer. In the field one certainly doesn't have the time, or the help, to collect information with the kind of precision necessary to support a position in court, and that includes the court of special interest opinion. So what happens very often is that a detailed study is useful only in a legal proceeding, while the broad approach is what provides better information for practical assessment and management decisions. This is all unfortunate.

There is a trend toward managing the wild horse program from Washington. There were good reasons for it; however, at one time the entire program was operated out of Reno. The National Wild Horse and Burro Advisory Board recommended there should be one specific person designated to be responsible for wild horses at the national level, and this has been done. However, there is still a problem of how that person fits in with every BLM state director. Generally, I think the Wild Horse Advisory Board is effective only where the bureau wants them to be. The board does make a

lot of recommendations, but most of them deal with the humane treatment of horses after they're removed from the range, not when they are still on the public lands.

One major problem is that over half of all the wild horses in the West are in Nevada. Those other states have fewer wild horses and they have their programs under reasonable control, so their excess horses can be absorbed within their own region. Most of the special interest groups also recognize that the major problem is in Nevada, so they tend to blame the state, which is a misperception. I hear comments that other states have solved their problems and Nevada hasn't, and then they'll cite reasons—such as blaming the ranchers because of their livestock, or the local citizens because you can't believe them, or the state office because it wastes federal money, or whatever else fits as a scapegoat. So, if you want to talk about really resolving this problem, it would be helpful to operate a separate program for the other states, one that is different from Nevada's. Most of their issues could be simply and effectively handled by them. We must recognize that the most serious wild horse problems are unique to Nevada and find unique solutions to match the situation.

There are many more horses and burros on the range now, if you want to use that as a measure of the act's success. But a lot of short-term and permanent range deterioration, including horse habitat destruction, has occurred and will continue to occur as a result of excess numbers. Most of the horse health problems and damaged conditions are site specific. They're obviously larger in Nevada because there are more animals here. The limiting factor remains the availability of acceptable options for disposing of animals excessive to the capacity of home range areas. This will forever be a factor because there will always need to be horse removals in every herd management area every few years, regardless of what numbers are agreed upon. The greater the appropriate management numbers in any area, state, or nation, the greater will be the annual problem of disposing of surplus numbers of horses.

There aren't any easy solutions. It's frustrating and disappointing that we haven't come further in all these years, and that we are still wrestling with some of these very same problems that the Wild Horse Forum wrestled with in 1977.

Bob Brown: Wild Horse Specialist (Retired), Ely, Nevada

The wild horse program has a lot of politics behind it. The issues are always changing, and we're under attack either by the wild horse advocates or by our own Washington office. Generally, I think people are afraid to take on the real issues.

I'm a biologist and I grew up loving animals. I've always had critters, and I certainly don't ever want to see any animal abused, but too many people revere the wild horse. The whole definition of animal abuse has changed in this country, but some things the animal protection groups come up with are plain silly. BLM was recently sued by one group, so we had to change our contracts with adopters as a result. Now whenever anyone signs an adoption agreement, they must agree never to take their adopted wild horse to a slaughterhouse. Well, what do domestic horse owners do with their animals when they are old or decrepit?

Before I came to BLM I worked at the Arizona-Sonora Desert Museum in Tucson. One of my jobs was feeding vampire bats, and I had to go to the slaughterhouse to get blood to feed the bats. I saw lots of cattle, sheep, and other animals slaughtered there. Let me tell you—it's *quick*! There's no sound, the animals go down instantly, there's no chance for them to feel anything. If a wild horse owner has title and a reason to take a horse to slaughter, their animal is private property and they should be able to do so. Naturally, if they don't have title it's a different story. Then the animal is government property and we should go after them.

Anybody with a letterhead and a stamp can appeal any action in the wild horse program; they don't have to be a powerful group. They can just pick on any cause and go after it. Unfortunately, there are some folks who jump

on an issue without understanding what's really going on, and they go on the attack, and they take it to the extreme. In my view, they need to get a life instead of a cause!

BLM manages all the wild horses in Nevada because we have the greater percentage of land. The Forest Service doesn't have the funding, for one thing, and for another they don't have the expertise, so there's no reason to duplicate efforts. In the northern part of the state, wild horses have a winter range and a summer range, and a lot of times the high country belongs to the Forest Service while the low country is handled by BLM. Down in the southern half of the state it's different. In this area we manage two herds for the Forest Service: the Monte Cristo herd and the Cherry Springs herd.

Fencing is another issue. When I first came to Ely nobody wanted to put in fences. They found out later that if you fence across the valleys and leave the ends open, it will prevent livestock from moving but allows the horses a means to find their way around. You need to make sure the opening is highly visible, because when horses are used to migrating, if they have to cross a fence that wasn't there yesterday, they'll get tangled in the wire and there will be one hell of a mess. In this area we found we can put in fences in several valleys and it hasn't stopped horses from normal migrations. They may wander farther to get where they're going, but they don't seem to mind.

When the average person sees all this space and vegetation it may look like there's a lot for an animal to eat, but 90 percent is not what a horse will eat unless they're starving. During the winter of 1992 we found a lot of dead horses out in the deep snows. They were stuck and couldn't move, so all they had to eat was sagebrush. Well, sagebrush is like eating wood. It gets compacted in their stomachs, so even though they have a full stomach they can't digest it. They'll start eating the leaves first, then the small twigs, and finally the bigger ones. By the time they died they were eating sagebrush as big as my fist! So just because it looks like there's a lot of foliage out there doesn't mean it's edible at all.

When wild horses eat, they crop the plants right down; they tear it. When plants are small, the horses get right to the base and pull it all up by the roots, whereas other animals don't necessarily do that. This means that if horses were left unchecked, they would be the last to survive out there because they're probably more efficient about how much they can eat. But if you let these herds populate naturally, eventually they would overstock the range and denude it completely. We had serious drought problems here in 1996; we did a lot of removals because of lack of water. In areas where horses were concentrating around water, there was nothing growing anymore. A lot was due to trampling, but the horses were also eating those plants all the while.

When I first came here I had a very negative attitude about ranchers. I'd heard all the rumors that they hated wild horses and wanted them gone so they could have more cows. Over time I did run into a few with that attitude, but most ranchers just want the land in good condition so there will be enough feed next year for their cows, too. Naturally, when they see herd numbers escalate they're upset, because they're trying to make a living. But the ranchers here also know the horses' habits better than anybody. They're accustomed to living with them. Wild horses are in their blood. A few times, just for the sake of argument, I asked, "What if BLM removed all the mustangs?" They always answer, "You better not, I've been watching them out there since I was a kid." They like to see these horses running free; they think it's as majestic as anyone else. I'll fight anyone who says ranchers want to see these horses gone. It just isn't so.

Out on the range, a mustang isn't any different than a coyote or a grizzly bear in that they have wildness in them. There are rogue horses too, just as with any population. Face it, there are people who are rogues! So there are some horses that are inherently bad, and there are others that are inherently good. I've seen some wild horses that within a couple of hours after gathering, you can walk right up to them. They may be a little skittish, but if you just stand by them for a while, pretty soon they get curious and they'll come up to you, and when they realize they don't have to be afraid you can

scratch them. I've also been with others that if you even try getting near them you better watch out!

One year we gathered a bunch of horses from the White River herd, and they were fighting every step of way. They were a really nasty bunch, and we held back shipping some of them. Well, next year at our national meeting one of the folks from Idaho came up to me and said, "So you're the guy who sent the Swarm!" They named that bunch the Swarm because the horses tore their feed bunks apart and stomped all through all the water troughs and tipped them over. They couldn't keep those horses from trying to destroy everything. I heard they held an adoption event at a community shopping center in Boise or somewhere, and they set up those heavy steel portable livestock corrals, and the Swarm just kicked those gates open and escaped right out into the parking lot, with all kinds of cars and people all around. They ran all over that shopping center! Some wranglers went after them horseback, and the Swarm finally made a loop and went back into the pen. That could have been a real disaster because those horses were absolutely crazy!

When I heard this I wondered why the situation happened. We pulled two hundred horses off one particular mudhole on the first run with that herd. The water situation was critical that year and there was nothing grow-ing there, so I speculated perhaps they could have eaten a poisonous plant. We'll never know unless we catch some horses again from the same area with the same behavior.

A fellow named Beverly Hooper created a lot of colorful horse herds out this way. He believed in raising white horses because white horses mixed with dark horses produce every color of the rainbow. That's why there are so many palominos in the Buck and Bald herd. We've also got buckskins, roans, pintos, and grays. Down around the Monte Cristo and Sand Springs areas there are a few Curly horses, and we've also caught some up of them in the Diamond Mountains. There are more Curlies over by Austin and Eureka.

Our district covers about twelve million acres. Roughly 40 percent are

herd management areas, and there are twenty-five different wild horse herds. There are thousands of horses out there! Most of the water sources are from springs, wells, and reservoirs. Back in 1996, when we had a really dry year, the horses up here seemed to handle it pretty well, but a little farther south the springs all dried up and there were horses choking from lack of water. Luckily, we saved a lot of horses before it became a disaster. We have a very savvy district manager, and the minute he saw potential problems he got on it immediately. He closed the range to livestock grazing, and we removed about eighteen hundred head of horses in one summer.

Book learning can teach you a lot about range science, but range management is as much an art as it is a scientific discipline. The art part is what you pick up from being out in the field year after year after year. You learn to understand the creatures' habits, whether they're horses, livestock, or wildlife. It's all about how they graze, where they're going to be seasonally, their feeding habits, how far they'll range for water. I used to think that one band might have a ten-mile radius to get water, but they have a lot wider range than that. We collared horses one year from one area and found some of them fifty miles away the year after. They really move around! That's why we started to manage some of these herds as complexes instead of holding tight to a boundary line. Why, any horse from here could end up in Elko if there weren't any fences. Like, one herd on this side of the Diamond Mountains is in our district, but on the other side is the Battle Mountain District, and there is a much bigger herd over there. And where all those hills lie to the north is the line for Elko County, and there's some other herds there. We could never get a good handle on all these numbers because we'd do a gather on our side and then two months later there would be two or three times that many horses all over again. So in 1997 we gathered all these areas together. We left just the right amount through that whole Diamond Mountain Range, and when we went back next spring and counted, those numbers held. Everything flows together better when we manage for large complexes, especially when you realize that the migrations are so much wider. This is just one example of what happens when

people have been around one area over a long period of time. It's how history comes at you, how you learn from past experience.

When I first started in this program nobody trusted anyone. The horse groups didn't trust BLM, BLM didn't trust the horse groups, horse groups didn't trust the ranchers, and vice versa, the ranchers didn't trust BLM. I think we've made a lot of headway since. We've adjusted some of the livestock numbers and we've adjusted some of the horse numbers. The range has improved in places, and the trust is starting to show. Everyone realizes now that we're all striving for a common goal, a healthy rangeland and healthy riparian areas. After people stopped fighting they began to wonder, "Why have we ever been at war?"

We've done census counts of horses where we've seen 28 percent reproduction rates year after year. That's *survivable* colts, not just the ones that are born, because a lot of colts die from hard winters or poor nutrition, or every so often a lion or a coyote takes one down. The budget has never been enough to resolve all the problems, and Congress runs hot and cold. I don't think Congress has any real feel for renewable resources. They don't seem to get it that things on the public lands aren't static—that conditions change over time and horse herds grow. If riparian problems aren't handled they get worse, and then it takes even more money to solve those problems. You can't just spend money one time out here and then be done with it.

In Nevada, we've never been able to get wild horse herds in line with the grazing capacity of the land. Historically, the old wisdom was to keep control of the numbers for just this reason. The locals were out on the range working their own stock, so they just rounded up these horses as they rounded up their cows. After the act was passed, the numbers went out of control and the federal budget wouldn't allow for what private individuals once did on their own. That's why it's so important to gather them down every three or four years, like clockwork. Once you wait, it only causes problems again.

The most important thing to remember about wild horses is to maintain the habitat. A healthy habitat will produce a healthy, well-fed animal from

any population, whether it's a horse or a deer or an elk or what have you. A healthy animal also has the best chance of surviving a harsh winter or a drought. We ought to be maintaining these herds to produce strong, healthy, sound horses with good conformation. As to the old, sick, scarred, or mangy horses that nobody wants, well, I wish the bureau had sale authority. Not as a first option, mind you, but in the case of those animals who are proven unadoptable. But it always comes back to the habitat. No matter how you look at it, it's always the most important. The range continues over all.

Jim Gianola: Wild Horse Specialist, Carson City, Nevada

When this program started we had a lot of support from the public and the press. Everything was new and glamorous, but it was a huge learning curve for us. We learned by experience, and if there was a problem we changed it. The program has gotten much more political since then. Nowadays we focus way too much on politics instead of what is best for the range and the horses.

Our first monitoring flights to count the herds took place from 1973 through 1977. We completed the best census we could and we mapped the areas were the horses were located, and we estimated the Nevada population to be between seventeen and nineteen thousand horses. That number was never officially adopted, so the first time we set management levels was during the 1980s, and we used those until 1991. Then we had a lawsuit from the Animal Protection Institute. They claimed our management levels were only for political purposes, so they took us to court and they won. We had to go all the way back through the whole process and start all over again to monitor the herds and the vegetation. We've been doing that ever since. Nevada has never gotten close to achieving its appropriate levels.

Right now our biggest problem is that there are about twenty-seven thousand horses in Nevada. The BLM national program office has run several different scenarios based on population models. If we continue with what we're doing with selective removal—removing horses only age five

and younger for the adoption program—the estimate is that by 2010 there will be seventy-five thousand wild horses in the West. Think of it! There are fifty thousand horses right now, and we spend about $22 million a year to manage these animals. If the number of horses is doubled, that means we will be spending 60 to 70 percent more. It also means we're violating numerous laws that say we can't allocate above what the resource will bear. In our district, we made a majority of reductions with grazing livestock. Pretty much every permittee in our district is on some kind of grazing system, which means they can't just turn their cows out in the spring and gather them in the fall; they have to move them around to manage them. Unfortunately, every inch of ground regained by reducing livestock numbers has been lost because we can't maintain the wild horse numbers.

Politics, pure and simple, is what gets in the way. Everybody in BLM knows what has to be done, but it isn't happening. We rely 100 percent on the adoption program to distribute the excess horses, but it can't keep up with the numbers of horses that have to be taken off the range. The act says BLM will manage wild horses at the "minimum feasible level." That means not just the population level, but handling the horses in a way that has the least impact on them. Well, just take a look at it now. People come from all over the country to do special studies on them. They observe them, they do immunocontraceptive research on them, they do this, or they do that. It all means we have to gather them, sort them, tag them, collar them, each and every time. We ship certain age groups, then we let the rest go, then we wait two years and do the whole damned thing all over again. And these horses get savvy. They get harder to catch each and every time, and a lot of horses end up either in sanctuaries or feedlots. All these things have gone way beyond the scope of what the act says or intended.

I haven't been on any government sanctuaries. I definitely think they are the best alternative during an emergency, like after a fire when horses would starve if they were to be left out on the range. Still, the law says to manage them at a minimum feasible level. The adoption program is only an outlet, and for those horses that are old or not adoptable it also allows for

humane destruction. But there's never any money appropriated for that because it's a political hot potato.

Some people have suggested we should leave the excess horses on the range and let them die a natural death, even en masse. Well, for one thing, BLM is a multiple use agency, which means we must manage natural resources for everybody. For another, these horses are hardy. They not only can live where cattle can't, they would eventually outstrip all the vegetation for themselves, and for the cattle and the wildlife, if they were left alone.

The Nellis Wild Horse Range is a good example. Nellis has had virtually no livestock grazing on it for fifty years. They had a wild horse herd there, and everybody said, "Leave them alone and get rid of all those cows. It's not the horses, it's the cows that are the culprit; there's just millions of cows and only a few horses." Well, we did that. We left them alone, and what actually happened is that they ate themselves out of house and home. I worked on that sonofabitch, and I don't know how many horses we took off exactly, but it must have been over ten thousand horses over about five or six years. They were all dying of starvation and dehydration. You'd see horses come up for a drink of water, and they would walk around in a figure eight for about an hour, and then they would just pitch over and die. Or some would sit down on their ass end like a dog, with their legs straight out, and just roll their heads and die. I'm talking about thousands and thousands of horses where there should have been hundreds! It was the saddest thing I've ever seen. We had a trap set, and there was a spring outside, and we were pumping the water so they'd come in to it. There would be four or five hundred head of horses around this trap, and we had a hose, and all we had to do was just water down the front and those horses would just walk right in to get water. That's how bad off they were. We held the hose up in the air and sprayed it, and if all the horses had their asses toward us, as soon as the spray went up they'd all turn around. We actually had horses come up and drink right out of the hose, that's how thirsty they were. These were wild horses, and we hadn't done anything to manage them. It was just terrible.

Nellis was an ugly reminder. It opened eyes for some of the horse advocates too, but I think for others it was a blip on the screen. The more extremist groups are still repeating this mantra to let nature take its course. I couldn't stand leaving wild horses alone ever again, that's for sure. Because what I'm saying is that by the time these horses would be all gone according to "nature's way," there'd definitely be no livestock and no wildlife and no vegetation either. I'm not talking about dietary overlap or water holes, but the whole damned thing. Horses eat all day; that's their job, to eat and run. They would strip it all.

Everybody dreams about a naturally pure resource these days, where there's no human influence on animals. It's just not that way. Domestic livestock are part of this resource, wildlife are part of it, and horses are part of it, and every single one of them has to be managed. Livestock are managed intensively and harvested through the market. Wildlife are managed intensively and harvested through hunting. Wild horses are managed semi-intensively through gathers. Unfortunately, it's not working with them.

Even if birth control worked for a longer period of time on mares, I think the best thing is to do what the law says—gather these horses, put them through the adoption program, put the difficult ones through several adoption sites. For those horses that can't be adopted, then I say let's *give* them to the humane groups. Why not? And if the wild horse groups can't or won't take them, then I think the proper answer is to implement the law. Personally, I think sale authority would be a good alternative to humane destruction because it would allow us to sell the horses as a last resort. Yes, it would allow those people who buy them to do whatever they want with them, but at least something purposeful happens with the animal. I don't think anybody enjoys the thought of wild horses being euthanized, but it's a fact of life. Hundreds of thousands of domestic horses are put down every year for one reason or another, and so are dogs and cats. Yes, people love horses, and wild horses are special. But they are an animal that must be managed, and if we don't manage them they have problems. We have to think about these things. Something has to give.

There are several proposals to put all the excess horses in sanctuaries. Initially, this sounds like a viable idea if we follow through with funding. Unfortunately, BLM has a poor record of following through on anything to do with wild horses. A lot of times the agency tried to make a good run at getting a handle on the problem, but then after a few years, when the money is gone or when there's no longer as much interest, everything falls apart. Right now, plans call for no more selective removal. This means that, say there is one area where there are one thousand head of horses but we're only supposed to have six hundred; well, we would catch them all. We would take off the first four hundred we catch and put those in the adoption program. Any of those horses that aren't adopted will go to a sanctuary. Obviously, for the first several years the costs will skyrocket, but then capture costs should eventually go down because we wouldn't have to gather as many, and once we're at AML we should be able to capture just enough to keep it that way. According to the model, we'd be at AML after ten to fifteen years and we'd only be spending roughly the same as what we do now, maybe less.

The Wild Horse and Burro Act is a simple little law, and this would be a simple program if we did what it says. If there's a problem with quality in some of these herd areas, all you have to do is put in four or five new studs to mix or breed up those genes. That is a simple thing. We do all this other research, but I think that's just making a lot of other people rich. I really don't think we're getting anywhere. It is all pretty pathetic when you realize that ultimately it's always the horses that suffer.

I've been doing this work since 1977. Whenever numbers get too high and we do a gather, a certain percentage of horses always look terrible. It makes me feel horrible to see horses look that way. For years, every gather I saw had some horses that looked really bad, some that didn't look too good, and some others that were standard, and finally some that looked really healthy. I originally thought that was just the way things were, but it was actually because we'd never even gotten close to AML. As we've gotten close to appropriate numbers in some of these herd management areas, I

didn't see that anymore. Sure, there are still some poor-looking horses, because there are still some old horses left. But when you get horse numbers close to being in balance with the forage even the older horses do much better.

A lot of people get confused because they equate numbers with success. But success is really when the horses are doing well and are in balance with the land. It's a lot better to have fifty horses, if they're fat and doing good and having colts every year, as opposed to having five hundred where even if each mare has a colt, half the offspring don't survive or the ones that do are scraggly and the mares are all beat up because they're so malnourished. The Flanagan HMA is a good example. There were eight hundred horses there once, and AML was supposed to be one hundred. Whenever we gathered, the horses looked horrible. After we took the herd down to one hundred, they were all nice and big and fat. Now, you tell me it isn't better for a horse to have plenty of forage and plenty of space. When you get too many, it's just not good for the horse.

These horses need space. Some people have criticized herd areas for not being big enough, but the only reason horses move outside an area is if their numbers outgrow it. Otherwise they may drift out now and then, but they don't make any large impact and they sure don't make a home range outside it. But when you have one area that should have one hundred head of horses and it grows to eight hundred, obviously they're going to move everywhere. They've *got* to move out to get forage, space, and water. So numbers aren't the issue, and neither is space. It's the quality of life of the animals that are there.

Everybody seems to throw the health of these horses by the wayside; that's what bothers me. Even the national advisory board concentrates mainly on the adoption program. Yes, we have a problem with adoptions because it's hard to move these wild horses through the pipeline. For instance, if the Washington office sets the adoption market at, say, two thousand horses one year because that's all the budget will handle, well, that's what we gather even if we should be removing ten thousand. That's like the

tail wagging the dog! It's the resource that matters, and without that, nothing matters. We have to manage on the ground first, and then worry about the adoption program. But we've narrowed ourselves to such an extent that if they can't adopt these horses, then we don't gather them. Well, if we don't gather them they beat the hell out of the country and hurt themselves.

I've been saying the same thing for twenty-five years. If you live by the law, this is a very simple program. All people ought to read the law.

Gary McFadden: Wild Horse Specialist, Burns, Oregon

Balancing the uses means making sure the habitat has an opportunity to reach its potential for each year's climatic influences. Since wildlife and wild horses are on the range year-round, we have to make sure enough forage is available even in drought years.

On any piece of ground wild horses and burros, wild game, and domestic livestock all utilize the same area during the growing season. Say it has been a bad winter or it looks like there's going to be a drought, we'll ask a rancher to reduce the numbers of livestock during the grazing season or maybe even wait to put cattle or sheep out altogether. If we happen to be overcrowded with wild horses, maybe we'll negotiate further. We might say, "We're over our horse numbers right now, so could you not turn out your cattle at all, or could you turn them out only in the fall?" It all depends on the resources that are there, and we do what we can do. Domestic livestock and horses are always in the mix because they have a dietary overlap. Horses are a lot better grazer, they travel farther from water, and they travel steeper slopes. Livestock may already have consumed forage on the flat or close to water simply because cows can't go where horses go.

BLM originated in 1934 with the Taylor Grazing Act, and its purpose was to settle issues on the range. There weren't horse issues then, but there were livestock problems. Up to that time there had been no regulation on the public lands, and there were immense nomadic sheep operations moving tens of thousands of sheep through the West. They'd start out in Canada, for instance, and end up in Mexico and then just make a big loop back.

Those itinerant operations hurt the rancher who lived here year-round because whether he was or wasn't doing things right by the land, when huge bands of fifty thousand sheep came through, they wiped everything out.

Whenever the bureau performs adjudications they work with ranchers who have existing permits. Often what's written on paper for these permits didn't match the carrying capacity of any given piece of land. Starting in the 1980s BLM began to correct carrying capacity on the public lands and apply more science to grazing allocations. That process continues to evolve.

It's hard for a lot of people to accept that the West is a desert and must be treated like a desert. In the Great Basin, it's critical that we give the range every opportunity to produce whatever it will be capable of producing that year. You can't compare native range with pasture. People who move here from the East or the Midwest always fall into this trap. You'll hear, "I did this and such before in my meadow." Well, yes, you could do that in a hay meadow back there, because back there you just open an irrigation gate and you can pour water whenever you want. Or maybe you can graze an area differently because you're in a thirty-inch or forty-inch rainfall belt. Water pretty much heals all problems that way. But on any of our rangelands here that are fourteen inches of rainfall and under, well, it's not the same. Let's say you're intensively grazing on a four-pasture system, and you're on three pastures one year, but next year you might not get any rain at all. You've built your whole operation by getting locked into one system of doing *a*, *b*, *c* one year, and then *b*, *c*, *d* the next. If it doesn't rain for two years, what will you do?

Since the 1990s, partly due to the Endangered Species Act, BLM has been forced to acknowledge all the multiple interests on the habitat—ranching, watershed protection, indigenous trout, wild horses, recreation, and so on. Wild horses always seem to be a major pawn in this movement. Some protection groups feel we should allow their population to peak and let the horses all die. But we're responsible for the management of the whole habitat, so we can't do that. Allowing wild horses to increase that way would

mean a horrible death for them, and they would just eliminate the habitat in the process. They would pulverize it!

When Congress passed the 1971 act, I don't think anyone anticipated what the results would be, including BLM. Up until the 1980s the bureau had no precedents and no guidelines. We gathered some horses by horseback, and we gave them away or did whatever we could with them, but there was no adoption program like today. All the while those wild horse numbers kept snowballing. Before that, Wild Horse Annie's 1959 law prohibited the use of aircraft to capture them, so that tied our hands, too. Finally, that aspect of it was amended and we began gathering with helicopters. However, we still didn't have a plan, and everything just unfolded as time went along. By the middle of the 1980s there was a huge problem, and everything just slid all over the top of BLM. Nobody knew what to do with all the animals. The adoption program was just starting, and we were trying to adopt out these wild fifteen-year-old stud horses. Anyone could see why that didn't work, because a new horse owner doesn't have the capabilities to handle a horse like that. Today we try to adopt horses only five years old and younger. That makes for successful individual adoptions, but the adoption program still doesn't service the excess animals. Those numbers are still snowballing out there on the range.

In the late 1980s the Animal Protection Institute filed a lawsuit that effectively shut everything down for three years. At that time there were about forty thousand head of horses in the West, and a 25–30 percent colt crop continued pretty much everywhere. Looking back, you can see how the bureau was behind the power curve, so once that suit was filed, it all added up to a bad deal. The numbers just got out of control. Today our decision-making processes are more streamlined and the program works much better than ever, but we still have the same problem. *What* are we going to do with all these horses?

The Nellis Wild Horse Range was set aside in 1962 as a cooperative arrangement between BLM and the U.S. Air Force. They drew a line on the

map for approximately 400,000 acres with no regard for topographical features. There were other horses in the area then, but they designated an HMA for that particular territory. This was a very proactive movement for the time, but no one was prepared to understand the pending issues that were involved. So, after a while those horse numbers started to increase, and by 1971 when the act passed, the earlier 1962 agreement on Nellis became null and void. The act stated a herd area is only where the horses existed at the time the law was passed. Well, by that time that entire area was inhabited by wild horses. A few years afterward the air force began to develop some new programs on Nellis, and as a consequence, they fenced one boundary line of the wild horse range. One development also included drilling new wells, so the presence of that water enticed horses from other adjacent herd areas onto the Nellis range. That compounded the problem further.

Wild horses reached a peak on Nellis in the early 1990s. There were over ten thousand head of horses there then. Whenever we flew over to try and count them, there were so many there was just no physical way to do it. It was like trying to count wildebeests on the Serengeti! There are three valleys in that one area. If you picture how open these valleys are in Nevada and how typically one might be twenty miles across so you can see all the way from one end of the valley to the other, well, when those horse numbers were high, if one group of animals began moving on one side of the valley, within minutes every horse in the whole valley would move. It was unbelievable.

A decision was made to do a gather in 1990, but a legal action filed by an animal protection group prevented it. When we finally got started we rounded up horses probably three times each year up through 1993. We'd gather horses in one valley, but then we'd run out of space to put them; or we'd run out of money. And then after a few months we'd get some more funding, and then we'd move over to the next valley. The logistics of those gathers were astronomical. We took those horses down from about ten thousand head to six hundred.

Wherever there is a spring on Nellis, it's piped down to a trough or a little reservoir for the horses. When those numbers were at their peak, you could go to any one of those waters and there'd be at least a hundred horses standing in line waiting to drink. One band, say, consisting of a stud and two mares and their colts, would have to fight their way in. The stud would get a drink, but the mares and colts were always apprehensive. There was fighting going on everywhere around them. If he didn't have to fight, as soon as the stallion got a drink he'd just gather up his group and they'd be gone. Sometimes the mares and colts never had a chance to drink their fill.

A lot of horses died on Nellis. Old horses get weak when their teeth are exhausted, and they starved to death. When the old ones came to the water they were already in poor condition, so they couldn't fight, and since they could hardly move, they just perished. But I couldn't believe how some of those old mares made it through that situation. Their body functions were in such weakened condition, but they were still producing foals at thirty years. It was survival of the fittest in the extreme.

Death is a slow process when a horse's teeth go. If their front teeth are gone or their molars aren't functioning properly, they can't bite the grass and they will start eating twigs and those kinds of things. It's not like their teeth all fall out in one day. It's a gradual process that lasts perhaps several months. Finally their physiological processes, like the liver, start to shut down, and keep shutting down until it's over. It's not a pleasant process.

I had to put down a lot of horses on Nellis. It was a horrifying experience but the options were even worse. If I had a horse in the corrals and got him in the chute so I could open his mouth and inspect his teeth, and if I saw the teeth were gone or that he had other physiological problems, and I *knew* that if I turned him out within the next month or two he wouldn't make it and would die a really horrible death, then I felt I owed it to him to solve the situation while he was there in front of me. You know, it's the wild horse specialists who are on the ground and right there with these horses. We have to make a fair, biological decision, and that's difficult enough. But afterward we are sometimes forced to defend our decisions to people who

weren't even there at all to begin with, or who aren't required to be either fair or scientific either. None of these decisions are easy, but when you've got your hands on a wild horse who's traumatized like that, I think it's cruel to turn him back out when you know there is no hope.

I think BLM has gotten better over the years. We have to make our range-lands more viable, and that means we have to reduce the use of the resource so that everything—horses, wildlife, watersheds, livestock—can exist in balance. These public lands belong to everyone in the United States, and everybody wants them to be in good shape. The public may never even see these lands or the wild horses, but they want to know that they are out there and that they are being managed correctly.

Dave Tattam: Wild Horse Advocate, Las Vegas, Nevada

I've been involved with the National Wild Horse Association since 1984. We work to make sure that wild horses have water and feed on the range. We have a cooperative agreement with the National Park Service, the Forest Service, and BLM. If there's a problem or something needs to be done, we try to help out. Sure, we fight and piss and moan with the government because we're not always 100 percent supportive of everything they do. But the bottom line is that when we have issues they get resolved, and then it's back to work. We're very involved in the adoption program; we do anything to help adopters have success. We do a lot of spring cleanup and improvements on the range. We volunteer on gathers. We've raised a lot of orphan foals. We worked on the Nellis Wild Horse Range. Basically, we do anything hands-on.

The last few years we've gotten a lot more high profile and politically motivated. We're trying to show there are some groups that have a realistic understanding of management and what it means. I see a lot of things done by other groups that in reality hurt the wild horses. Those groups don't seem to realize what a cruel taskmaster nature can be, and they don't seem to realize that if this habitat is destroyed, there won't be any more mustangs because they won't come back overnight. We want to let people

know these things so they understand that wild horses do need to be controlled.

I would dare any person who ever went to a gather—after seeing that many wild horses loaded up, hauled around, sorted out, and everything else that happens—to try it themselves and come out with the minor amount of injuries to the horses that actually occurs. You could never load one thousand domestic horses in a trailer, haul them a hundred miles, and unload them, and not have any more injuries than you get in a gather of wild ones. People also need to understand there is some social trauma that the horses go through, but that's life. Because it's either that or let them eat themselves out of house and home. Some people also get upset when horses are culled from the herd. Yes, family units are broken up, but that's the only way to handle these animals. Perhaps in the long run there may be some science involved that can effectively address the reproductive issues through long-term birth control, but as long as we have to go back to these same herds and re-sort them, there will be some imbalances that occur.

After being in the horse business for twenty years, going out on gathers made me stop and think. I've bought and sold lots of horses, but when I saw what these guys actually do on these gathers, how they work with wild horses and what they are actually working with—well, holy shit!—one six-hundred-pound mustang can drag you all over creation. I'm a big man, but I've been drug all over by these little wild horses. It's a matter of life and death to them, and they act accordingly.

Sale authority is beyond the realm of what most people can understand, although in terms of getting the horse numbers down to AML, I think we may need it. Once we've got AML, we won't need it after that. If BLM can gather up all the excess numbers and then use the adoption program to maintain it, that could work. Perhaps there will need to be some long-term sanctuaries, and perhaps we'll need to spend millions of dollars to hold horses off the range. In my opinion, what should happen is a four- or five-year window where BLM gets sale authority. We could take the money and put it back into range improvements, and thereby everything would be

recycled. I realize the whole concept of horses and slaughter is sensitive in America, but when you get right down to the bottom line, *what* are we going to do with all these horses?

I think this country is going to have to spend some money. If our society can't handle sale authority, then we need to have a big sanctuary program for the surplus animals and use it for nothing else. We need to put in some durable chutes and corrals. We need to try to keep these horses from reproducing, and then we need to let them all age out. If it takes twenty years for them to die off, then so be it. The best you can hope for is to take all the unadoptable old horses and put them off in a sanctuary until they die. The worst that can possibly happen is nothing.

I have no idea of what this would cost. What would it take to get some land and employ a half dozen wranglers to keep fiddling with the same group of horses all year, every year? Say, maybe eight guys for ten thousand horses? I don't know what the feeding costs will be, but the government is going to have to tell the public that a long-term sanctuary is a reasonable option. Maybe we should have that sanctuary right here in Nevada, like take the whole Owyhee Desert or someplace, and maybe we should make sure that these horses get hay from Nevada ranchers, and maybe we should make sure that the sanctuary is accessible and designed so tourists can see them. These are all just thoughts. It seems to me that if we can put someone on the moon, we can figure out how to keep some healthy horses on the range and not destroy the rest of the habitat, and also make things work.

Wild horses are good horses. I've seen a lot of people do wonderful things with adopted horses. And I've seen as many success stories with folks that don't know which end of a horse is up as I've seen terrible failures. As to the adoption program, it's a matter of education. There's no reason why there isn't a national volunteer mentoring program for new horse owners. That's what we started here. We've got thirty people to call on to help somebody with a new horse. Some of those people don't own a horse, and they never have or never will, but they're involved. They go to clinics, they learn how to approach the animals, they learn what these horses need. There are prob-

ably one thousand adopted horses right in this valley that we've worked with like this.

Personally, I can't think of any volunteer work I'd rather do than to be with these horses. There isn't one salaried position in our organization, and that's the best thing about it. In fact, our bylaws state specifically that nobody gets paid. We get reimbursed for gas or a hotel room, but that's about it. It's all volunteer. I think that's very important, especially when I see all the different lobbyists from these other animal rights groups. The minute you take money out of the equation, it shows whether someone believes in what they're doing or not.

The tragedy at Nellis happened because of military security issues. Nellis was on the back burner as far as BLM was concerned, and it was on the extreme back burner as far as the air force was concerned. Some of the animal rights groups also opposed the roundups. Many times these groups oppose gathers based on the way some document is written, instead of realizing it may be a poorly stated document but there are still way too many horses and we need to do what's right. It's important for people to work together instead of chucking rocks at one another and calling each other names.

National Geographic did a feature story on the Great Basin about five or six years ago. On the cover was a photograph of a pinto horse that supposedly is running free through Stone Cabin Valley. The horse was in great physical condition. Well, I don't know where in hell they got that photograph, but I've never seen a horse with that much weight on it in that part of the country. So this is how the myth of the wild horse is carried on. Someone sees it and thinks, "Well, I saw a mustang in *National Geographic* and it looked great!" It builds up a misperception.

When people visit here, I say, "We don't have winter in southern Nevada, we have summer." By the end of summer is when the horses here look the worst. People need to relate to this and start plugging that stuff in. Whenever tourists go to Red Rock and see a horse that looks really rough, it's time to remember what month it is.

Through the years, I've seen a lot of changes in the BLM. I think there are still some fundamental changes they could do for the good of the range, but when I hear folks criticize the gathers, well, if you took Monty Roberts himself to a roundup I'm sure he'd be the first to acknowledge that some animals will get hurt. If it wasn't for Dave Cattoor, BLM would never have started hand-raising leppy foals at trap sites in the first place.

A lot of this is pretty simple. When you're out on the range and you see horses in dire shape, it doesn't take a rocket scientist to figure they need more food or water. When I read newspaper articles about how BLM is ruining wild horses by rounding them up, I know that doesn't happen because I've been to those gathers. It's the same thing when articles report on some rancher flogging the public land. We all know darn well some ranchers do, but most of them don't.

If we don't start gathering up these horses pretty soon, one big winter is going to come along and knock the hell out of all of them. But it's all a bunch of catch-22s. Like, we shouldn't take all the young horses off the range, but they're the only ones that will work in the adoption program. Or, we shouldn't put back out the old horses after the government has paid to catch them, but we do anyway because they're not adoptable. There are a lot of things that don't jive. It's always a question of how many horses can go through the adoption program, and there's no place for them anywhere else. Down at Nellis, Gary McFadden and I sent a lot of horses to corrals that probably should have been put down, but because BLM didn't want them put down there they went to a sanctuary where they died anyway. Well, why didn't we make the hard call right then? Why put those poor old horses through so much more stress, on top of all the other crap they'd been through, and then send them off to a holding facility when you know they're going to die anyway? We could see they wouldn't make it through winter. We were into fall, their teeth were gone, there was just no physical way they were going to make it.

When I first went up on Nellis I was appalled by the conditions there, and things stayed that way for maybe fifteen years. From 1982 through 1993

there was no improvement, nothing but more deterioration. I'd never seen anything like it. Basically, the situation was left on the back burner because nobody had to look at what was going on. There were several different state directors and district managers involved, and I think some things also happened because of the good old boy network. If the government had sale authority, they could have taken care of the whole situation for a fraction of the cost and prevented a hell of lot of horse suffering in the process.

If I had a choice between going to a sanctuary and taking a bullet in the head, I'd rather take the bullet. Over in Utah awhile back, BLM had about a dozen horses threatened by disease. Because of publicity they were forced to keep them alive. I don't know how much money they spent, but I bet it was close to $100,000 just to save twelve wild colts. They paid one guy to live out there for three months to watch over those colts, they paid for a special trailer to be built to ship them to Oklahoma, they paid all the expenses after they got there, and then all they got was $125 for each one when they were adopted. I don't mean to sound blunt, but money is tough to come by, and there are a whole lot of other horses we could help with a hundred grand.

We've got some serious issues here. If you don't give BLM authority for removing these horses—for selling them or building a sanctuary to put them in—then you can't expect anything more than what we currently have happening out there now. You increase adoption, give sale authority, open up sanctuaries, or all of the above. That's the bottom line. We all know the answers. Everybody knows.

Richard Sewing: Wild Horse Advocate, Cedar City, Utah

The primary purpose of the National Mustang Association is to help preserve and perpetuate the survival of the mustang in a natural environment. One thing we do is develop water sources. Another emphasis is to demonstrate what can be done with these horses.

We have a ranch in Barclay where we keep seventy head of unadoptable wild horses. They can be young or old, but for some reason, due to their

looks or whatever, they're unadoptable. We have 614 acres of private land and approximately an 8,000-acre grazing allotment. The horses are in a corral only one day a year; that's when the vet gives them their shots and worm medicine. Then they're turned right back out on the range again. They are living a perfectly natural life, and they will live out their lifetime here.

We've concentrated our work in Nevada for years because the state has so many horses, but now we're doing more in Colorado and Utah. In our newsletter we show what we are actually accomplishing and how much each project costs. One little program was called Adopt-A-Horse. If a member wants to support a mustang on the ranch, they contribute a small stipend to help cover the vet bill and hay. One year we sponsored a graduate student from the University of California to monitor a BLM roundup. We've also financed research on the Montgomery Pass herd on the Nevada-California border. And we assisted some other research projects out of Oregon State University and Utah State University.

We own our water here at the ranch. We've got some springs that have never dried up, and we've put in wells and pipelines. The only time the horses come in to headquarters is when the snow starts to fall. They know the way, and we feed them all winter long. Once they're on the pastures and the snow gets at all deep to where they can't graze, then we feed them. We have a full-time wrangler and his wife who live there. We provide their housing. There's no electricity, so everything is propane-generated. It doesn't sound like much, but all they need to do is buy groceries and clothes. There's a big shop building and a hay barn where we can get two hundred tons of hay under one roof. We also bought a backhoe. It's a lot of work to manage a ranch and it can be a pain sometimes, but we've got the place in pretty good shape now.

Horses love water. My main philosophy is the best thing we can do for wild horses is help provide water for them. We do that in conjunction with whoever owns the water, whether it's a cattleman or anybody else. We did one job south of Eureka on the Sand Springs Herd Management Area. I

looked on the map one day and noticed there was a spring there. We went up and took a look, and there was nothing but a wet spot at the end of a pipe. The first thing we did was find out who owned it. I asked BLM but they weren't sure. I asked the Indians and they didn't know, but the tribe called the state water engineer and found out that in fact they did own it. We made a little deal. They provided the backhoe and we did all the work to develop that spring. Now there's a brand-new ten-foot trough that's got water running in and out of it. The tribe got enough water to take the overflow and run to their livestock, and the wild horses are using it, too. As soon as we got that water running, the birds just flocked in there. Before, that spring was nothing but a spot of mud where a horse might have to stand thirty minutes to get a decent drink. Now everybody is benefiting.

Another project happened when a range rider found a two-inch piece of galvanized pipe sticking out of the ground over at Domino Spring. There was one tiny spot that got about one drip of water every two minutes, and on that spot was a little grass. Nobody had ever messed with this spring. We made a deal with BLM to develop it. They got a big front loader and dropped the bucket on that pipe, and we just started shoveling to follow that pipe back to its source. Finally we located where it began. We dug a deep trench and laid down a lot of black plastic, and we put up a big new spring box. Well, before they got it all covered back up and we had time to set up the trough, water just came running out. That was the most successful operation we've done.

We try to develop about three springs a year. But water developments are costly, so I've always set a limit on anything we do. It takes cooperation, and we have to work together to get things done. All the water permits in Nevada have forty acres that go with them, so any development is always up to the individual owner. If a stockman has enough water somewhere else, he may not be interested in investing any more money. That's where we come in. Sometimes BLM may agree to bring their equipment out, or like with the Indians, the tribe loaned us their backhoe. At other times a project will cost more because of the type of job it is.

Wild horses will travel twenty miles a day for water, and in most cases we look for springs on higher ground. Ranchers usually don't want their cattle to head up high, because they can't find them. They'd also rather keep the horses and cattle separated, because in places where there is only one water source you'll get a sacrifice area where everything gets eaten off, and that usually just keeps getting bigger. So instead of the horses coming down low, we develop a spring for them higher up. The feed is there. Those horses start out in the spring and they follow the green right up the mountain. They're out of the heat and the flies and such. When we develop a spring, we'll also run a pipeline a mile and a half in either direction so that cattle and everything will stay off that area for the time being. It's my opinion that the more water sources there are the better.

There will always be wild horses that can't be adopted. Right now BLM is looking all over for big long-term holding facilities to hold surplus horses. But for twenty years now we've been trying to show them that small-scale sanctuaries like ours can work even better. You just have to have the right location.

Some big sanctuaries are ideal. Like out in Oklahoma, it rains every day and the grass is high, and the horses move from pasture to pasture. I bet those mustangs think they've died and gone to heaven there, because here in the Great Basin they're eating nothing but rocks and sticks and whatever else they find in between. Sanctuaries can be good for the operators, too. We're trying to promote projects where stockmen can manage wild horses by exchanging livestock permits for horse permits. This is an example of what can be done.

Reproduction on these horses is a big concern. We offered to finance a research project on vasectomy. We know a veterinarian who thought he could do a vasectomy on wild stallions that would prevent them from re-producing but wouldn't change their social behavior. They would still breed but wouldn't be capable of siring colts. We found a herd management area that we thought would be a perfect place to perform wild horse vasec-

tomies, and we offered to pay to have those done on half of the stallions there and to leave the other half alone. That would be a controlled situation and BLM could monitor those horses from year to year, and it wouldn't upset their social structure at all. Nobody bought the idea; BLM refuses to operate on wild horses.

Not only do we develop water, we pay for reseeding. We donated $10,000 to the Sulfur Herd Management Area in Utah, along with the Rocky Mountain Elk Foundation and the Utah Fish and Game Commission, for reseeding after the pinyon and juniper stands burned off. A lot of people don't know that one stand of pinyon and juniper will suck every bit of water right out of the ground. When they burned pinyon-juniper off that ground they found a spring there no one knew about. They named it after the National Mustang Association.

Wild horses always know where the water is. On our ranch, we like to give them a good place to live. Our horses will never lack for water.

William A. Molini: Wildlife Manager, Reno, Nevada

Wildlife is my passion. Over the course of thirty years I've observed wild horses and wildlife interact, and I've seen their varying impacts on the landscape. I've also had quite a bit of interaction with some wild horse groups. Many horse advocates have tried to draw a comparison between mustangs and wildlife but against livestock. Frankly, we always objected whenever wild horses are considered on the same plane as indigenous wildlife.

Those of us in the wildlife field believe it is more appropriate for these horses to be called feral horses. There's no question that they exhibit wild characteristics, or that they have their own population and social dynamics. They're interesting animals. But they did not evolve over the past ten thousand years as part of the ecosystem in the same way that true wildlife did: deer, antelope, bighorn sheep, sage grouse, and so on. There is a vast array of wildlife that occupy the Great Basin who form a part of the evolu-

tionary history that evolved within the system itself and are truly wild, free-ranging animals. We think there is a definite distinction between "wild" horses and actual wildlife.

There is a glorified history of the role of wild horses in the settlement of the West. It's an attachment that appeals to more people than, say, an antelope would, although historically the antelope was probably the dominant ungulate animal in the Great Basin before white settlement. That's an interesting point because it speaks to the fragility of the land, the basic vegetative resource of the region. There is evidence that there were bison in northeastern Nevada, but in the central and north-central portions of the Great Basin there were neither elk nor bison. The dominant animal there was probably the pronghorn antelope, a very diminutive animal that is light on the land and makes very little impact. The antelope have a pretty wide forage base. They may eat a little grass, but they eat more forbs and browse. Bighorn sheep were extant across most of our mountain ranges, and at one time Nevada was probably the only state that had all three subspecies: rocky mountain bighorns, desert bighorns, and California bighorns. With the advent of settlement, wild sheep were pretty much eliminated in the northern areas due to disease transmission from domestic sheep. Those bighorns that remained pulled back into enclaves that are very rugged and poorly watered. Over the past twenty-five years the Division of Wildlife has had a very aggressive program to reintroduce those sheep to their original habitat.

What's important about this picture is that antelope are a small animal. Their live weight is maybe 120 pounds, compared with domestic livestock or wild horses, who are much larger and therefore have a far greater impact on the resource because of the amount of forage they consume. In the case of horses, their traveling instincts to water sources and the fact that they are large and heavy with big hooves make for big, deep trails on the desert; whereas a herd of antelope are so light on the land you can hardly tell they're there. It's an important consideration when you look at overall range health.

We had an eight-year drought starting around 1986. In my entire tenure I had never seen the range in such bad shape. Bitterbrush stands were dying because they had been stressed for such a continually long time. Most of those recovered pretty well, but by the end of this eight-year period the range conditions were horrible and the animal conditions reflected the availability of the forage. All the animals were in really poor shape. We had a very heavy winter that year, with cold temperatures and deep snow, and an Arctic cold front moved in. That winter just knocked the socks off of the antelope, the deer, and the wild horses. They all died in substantial numbers across the range. It was a unique set of circumstances, and winterkill really knocked the mule deer badly. As a management agency with a harvest program, had we a crystal ball that told us there would be a devastating winter we would have upped our quota so that we could have hunted those deer rather than have them die that way. This is transferable to the wild horse situation, because if mechanics had been in place to remove horses quickly and efficiently, that too would have been an appropriate thing to do. There were horses dying en masse on the range because they were in such poor shape. My point is that due to the drought, the forage base was so depleted that even as strong and big and mobile as those horses are, they couldn't find adequate food. This is the essence of the problem throughout the whole state. There are far too many horses for the ultimate carrying capacity of the land.

Probably the epicenter of the whole conflict between wildlife and horses is because water is limited here. The greatest impact is always around water sources, because animals tend to linger there longer and so they tend to deplete the forage resource there first. When it involves grasses and forbs, those plants can die, and then you get accelerated erosion and a lowered water table. You can change the whole vegetative aspect of one single area because of erosion and lowering of the water table.

In many locales there are just too many horses for the long-term sustainability of the land and the long-term carrying capacity of the resource. It's particularly a problem in the harsher parts of the high desert. If you

look at the Basin and Range provinces of the Great Basin, you get low points like Lahontan Valley, Humboldt Sink, Carson Sink, Walker Lake, Pyramid Lake, and, over in Utah, Great Salt Lake. These were the terminuses of the internal-draining rivers, so they tend to be the lowest points. Because of the elevation and the rain shadow effect, some places, such as Pershing County, even in a good year are not very productive. Yet there are lots and lots of horses in Pershing County. On just about any day of the year I can see pretty substantial impacts of those horses. Water sources are very limited there, and even though the horses range a good distance, they're tied to that source. They beat the heck out of those springs and seeps.

There are really two parts to the equation of how horses and wildlife interact. One is the physical depletion of the availability of water and the condition of the forage in and around the water source. The other is the social interaction between the animals. I'd say wild horses have more interaction with antelope, largely because the antelope habitat and the wild horse habitat are similar; they occupy similar types of country. They both like wide open spaces, they like to see a long ways, they move a lot and quite freely. During periods of drought, where you have very limited water availability over large areas—square miles of habitat where both horses and antelope range—those horses can actually deplete the water source to where all you end up with is a little pool of mud. It's hard to physically even drink that water.

In dry periods horses tend to come to water at the same time, and they are more dominant. They'll stand guard on that water until they've all had their drink. That's what I mean by social interaction. I don't think there is a great problem with space conflicts, because I've seen many areas where antelope and horses go about their daily routine within the same terrain and there doesn't seem to be any strong avoidance behavior between the two. But when there is a conflict over water, the horse prevails. They are bigger, stronger, and more aggressive, and they will physically keep the antelope away from that water. That's not to say that eventually the horses

won't leave and the antelope will finally get a drink (provided what water is left is sufficient), just that there is this type of social interaction involved.

These are all harsh realities, and the only people who usually see them are the folks out on the land all the time: the field biologists, the ranchers, the range and wild horse specialists. There's no question that these kinds of ecological situations, where you have high densities of animals and the most limited resources, can cause aberrant behavior in critters.

There was a classic wildlife study about deer that was done in the 1950s on the Kaibab Plateau of Arizona. The major predators had all been killed off because there had been a specific program to reduce the lions. So the deer population built up, up, and up, and they ate themselves out of house and home. Well, it took years for those deer to recover because this had such a devastating impact on the habitat. When you take vegetation to a plane where it becomes that depleted (and horses can deplete it the most since they can eat plants right into the bare ground), you may not get complete recovery again at all. You can get invasion from exotic weeds and never get desirable forage plants back, so everything would suffer. In that scenario, over 640 species of wildlife in the state, plus all the livestock, would be disastrously impacted. You're talking all the reptiles and all the amphibians and an entire array of songbirds and other birds. So the whole concept to leave horses alone to self-regulate is not only unrealistic, it's irresponsible. Any of us who are involved with managing natural resources would never agree to let something like that happen. It's just crazy!

One thing that has been really eye-opening is having watched horses, livestock, and wildlife interact across the habitats of northern Nevada. I can say with certainty that these interactions are much more complex than even I can begin to understand. When I was a young biologist I used to think I knew a lot, but the only thing I know now is that I didn't even begin to understand anything. As an example, I've seen antelope populations in northwest Nevada increase fourfold at the exact same time that sage grouse populations were going downhill. Now, it always appeared to me that they

had similar habitat requirements—they both live in the same country, they both like to eat forbs, they both in some way are dependent on sagebrush— yet at the same time things were improving for the antelope the sage grouse were just going down the tube. I don't know how to explain it. Certainly, there may be habitat relationships that aren't evident to me or any of the scientists who work with this stuff, but what I mean is that these things are far more complex than meets the eye.

At one point in my career I worked on the Sheldon National Wildlife Refuge. It's one-half million acres in northern Washoe and Humboldt counties that is a wonderful example of classic high desert country. Histor- ically there had always been livestock grazing on the Sheldon. When I worked there I was concerned about the abuses of heavy grazing, because it is great habitat for sage grouse, antelope, and mule deer. It's been about six or seven years since they eliminated livestock grazing altogether up on the Sheldon, and I happened to spend a week up there last year. I hadn't seen the area in any detail since grazing was removed. The question had always been in the back of my mind as to what really has more impact—domestic livestock or wild horses? It's obvious there are impacts from both, but horses are more mobile. If you put cows out in dry country and there is a riparian system, a stream, where they can have succulent vegetation plus water, they will stay there until the vegetation is gone. Nevada is replete with examples of riparian systems like this, where the cows stay on the bot- tom lands until the forage is gone and then move up the mountain. Who blames them? It's shady and cool and there's food and water there. In my experience the horses hadn't tended to do that. They'd come to water and they'd linger a little while, but then they'd move on. But I still wondered if there were only horses now and no more cows, how much impact that would have.

What I saw absolutely fascinated me. In those places where the horses have been removed there were no problems. But up around Catnip Moun- tain I saw large bands of horses every day, and I saw meadow depletion there. I saw vegetation eaten all the way down to the dirt, the same kind of

thing I'd seen over the years, only now without any cows; all the damage was coming entirely from horses. It's simply numbers. If there were fewer horses you wouldn't see such a severe impact. South of Catnip Mountain is a basin that has a lot of antelope and sage grouse and a big deer population. There are too many horses there. I saw horse signs down near Badger Mountain, although obviously of a lower density because I found little horse trails, not big, deep, dusty trails. Again, this is my bias: here's a piece of country set aside for wildlife as the primary objective, and I would just as soon that there not be any horses up there at all. But the Sheldon is managed by a public agency, so if they can maintain a few herds of reasonable size that won't impact the landscape, then that should be done.

Wild horses do not have any predator base. Lions will kill horses, and I've seen evidence of it—not only colts but even yearling horses. But the major difference is their habitats usually don't overlap. Horses like wide open spaces, and lions don't. It's also been documented that a lion will try to get an adult horse, but I don't think they're very successful at it. What keeps them apart is that horses are fast and like to be out in the open. Lions are opportunists and damned efficient killers, but they just don't like that kind of country. I doubt there will ever be a state of equilibrium where lions keep horse numbers under control.

I love this land and I love wildlife. One of the basic premises of this whole business is that you can have only X number of animals on the resource, whether that's fish, reptiles, big game, or what have you. We count deer every fall to determine the ratio of bucks to does, to see how their population is growing. We go back in spring to count again, mainly to determine the survival of fawns over winter and assess how many young have been recruited to the population. Based on that and how many bucks we want to keep in the population, we set a quota of how many to hunt. If the population goes down and we want it to increase, we won't harvest does that year. If it starts growing, and if the density gets really high, then you know it's time to harvest more does. This has always been so simple for us in the wildlife business; we wonder why it can't be done with horses.

I understand the depth of emotion people have about protecting horses. Whenever a wild horse is illegally shot there is always a huge outcry. Yet if someone poaches a deer or an elk, the public never seems to give a damn. Not that I advocate wanton or random killing of horses at all. I don't advocate it any more than wanton killing of wildlife. People are also fond of saying that a good clean shot with a bullet is better than starvation. There's no question about that, although even in hunting you may not always get a clean kill, and that's unpleasant.

If you look back in history, you can see that Native Americans killed large numbers of animals, yet some folks nowadays are fond of saying Indians did it only for survival. There is currently a whole contingent of anti-hunting groups who think hunting is blasphemous, and they're naturally entitled to their opinion. However, if we're not going to shoot horses to control them, the public must pay a price to gather them. If we are vigilant, it can be done. The real problem is what to do with them once they've been gathered, as they are not all adoptable. I happen to be one who hates to see waste, and while it may sound offensive, there is a huge amount of biomass there that could feed a lot of hungry people anywhere in the world. If some animals could be put down by euthanizing after they were gathered, that might offer a compassionate and worthwhile solution.

There's an interesting analogy here with the Canada goose problem. At one time we counted as many as thirteen thousand geese in the Truckee Meadows. Do you know what that means? The geese eat the golf courses, they poop all over the parks, it's a big mess. Peak winter populations of wild geese are a mess everywhere. Some years ago the Minnesota Division of Wildlife contracted people to kill the excess geese, clean them, and take them to a soup kitchen. Obviously, the damage geese do to a public park is not the same as damage to the range, because that park grass was planted. However, the population of snow geese in Hudson Bay in Canada has grown to such numbers they are actually denuding the tundra. I don't know that you could even shoot enough of those geese to get on top of that whole problem. It's another example of what can happen when population num-

bers get so high they destroy their own habitat. I don't know how our society is going to get a handle on any of this, but the way it is now, the cost is immense.

Larry Johnson: Wildlife Advocate, Reno, Nevada

My father was Konkow Maidu, so I am half Indian. I was raised on a little ranch on the west flank of the Sierras in the Feather River country and I've been a horseman as long as I can remember. My father would put me on unbroken colts when he led them in from the range. They weren't intimidated by the weight of a small child, and they got used to having something on their back, so I never got thrown. My father had an extremely gentle hand with animals. He was a superb horseman. Although we were probably considered poor by today's standards, we were very rich living with the country. My parents both had an ethic of hard work, and they encouraged me to better myself. Quite frankly, they are the reason for my success.

Today, my horses are all grandsons of Bezetal, my father's Arabian stallion. They were all foaled on my sister's ranch, and I trained them when they were small. The best thing you can ever do is become a best friend to your horse. My horses are all excellent mountain horses, and my finest times are on horseback in the high country. People marvel at what I do with them. With animals as spirited as Arabs, you can't make their first experience at anything unpleasant. But if you work with them correctly and make sure that when you introduce something new it is a pleasant experience, you will find they have a need to please. In our family, our animals always come first.

Most people misunderstand the hunt of the Native American. Yes, it was necessary to put food on the table and have clothing. But it was also intertwined with our culture and religion. The hunt was practically the whole life of the male portion of our society. It's how I was raised. Our family were subsistence hunters, and I was taught (although I had to reach my own conclusions half a generation later) that the wild game was ours. It wasn't necessarily because of tribal rights, but because we perceived that we were

here first, that this had always been our land, and that the animals gave themselves to us for sustenance. At the same time, animals were a part of our lore and our culture, so there is an incredible reverence for the animal. Most people misunderstand this relationship. How can we revere an animal and then kill that animal? I turn that around by saying that the white man has an incredibly unhealthy view of dying: that death is something to be feared and avoided, an ultimate sadness. I was taught that death is a part of the life cycle, and that you're not ever going to escape it. I have a tough time putting this into words, but it is a natural thing for me to hunt and kill. We are taught that this is a thing of beauty, not a thing of sadness.

When I came to Nevada I fell in love with the fact that I could run across every mountain range without hitting a No Trespassing sign. I thought it was the most magnificent place I'd ever seen. I came from a country of big timber, rivers and waterfalls, and postcard-type splendor. Nevada has a different beauty. The high country carries that same alpine scenery, but the sagebrush and the lowlands have an absolute, stark beauty all their own.

Within about ten years of being here, what struck me was that the wild horse population was beginning to adversely impact the range. In a lot of areas the horse populations were much greater than wildlife populations. This was disturbing for several reasons. Number one, this country did not evolve with large-hoofed ungulates, at least not for the past ten or twelve thousand years. Our vegetation types are pretty fragile, and they can't take pressure from overgrazing from any source. Whereas domestic livestock grazing is strictly regulated, and in dry years the particular season of use and turnout times are very closely regulated, wild horse herds are increasing and are on the range the whole twelve months out of the year.

Because my family and I are outdoors so much, over the years we've witnessed extremely sad episodes of wild horse overpopulation and die-off. Wild horses are big, strong animals, so by the time you start losing numbers it means they have adversely impacted range conditions and monopolized water sources to the point where wildlife populations have been drastically impacted. Most problems occur during drought years. In

extremely wet years range conditions are great, and so the animals aren't crowded, stressed, or concentrated nearly as much. In drought years it is so sad. We've seen two hundred wild horses camped on a small spring. In the worst case, the water is just a seep to where one horse will drink it completely dry, and then it takes minutes to fill up again. Stallions will be fighting, stallions will be maiming colts, they're all together, they're all stressed. It's not a pretty sight. We've also watched antelope herds circle the horses and finally give up and walk away. Division of Wildlife surveys of resulting fawn recruitment rate during a drought plunge down to almost nothing. Normally by midsummer, when a drought is at its worst, fawns should be big and strong enough to survive without mother's milk. But without water they die. I wish the horse advocates who claim to love all animals would accept this truth.

Wild horses are tied to a particular radius around a given water source. I just returned from an antelope hunt, and we saw more wild horses than antelope. BLM initiated a gather in that area and removed two thousand wild horses this year. Still, it is a steady stream of wild horses to this lone, isolated spring. All the trails are three and four inches deep of alkali, and you don't find a blade of grass within a long way from the water source. It's just extremely sad to see the land reduced to a complete dust bowl.

The outdoors is my life. Before the white man, bighorn sheep were the most numerous big game animal here. Up to that point all the animals had been browsers. We had antelope, bighorn sheep, and scattered elk in some of the higher mountains. The most conspicuously absent animal when the settlers arrived was the deer. Mule deer didn't really come into Nevada in any great numbers until ranching and farming interests changed our vegetation from the natural grassland to sagebrush. Much of that was due to overgrazing. Deer are browsers, not grazers, so they came in response to sagebrush communities, and they probably came from a good way away. There was a good deer population in Idaho back then, and some of the northern Bannocks were very skilled deer hunters.

Nevada pioneers cut every pinyon and juniper tree off many of the high

mountain ranges to make charcoal for fuel. They used timber for the mines. Between that and grazing (quite frankly, we grazed things to the bare earth in the 1920s and 1930s) the sagebrush came back. There were also huge transient sheep herds sweeping through here then. There have been wild-life fluctuations as tremendous as vegetation fluctuations ever since the state was settled.

It could be interpreted that I'm being derogatory about ranching. I'm not! The mule deer are here in direct response to manipulation of the landscape by ranching. Another thing you find in early pioneer journals is that none of them referenced the presence of sage hen, and that's because the sage grouse also came in huge flocks as a response to ranching. There are people today who want to list the sage grouse as threatened and at the same time remove all the cows from the range. Those two don't go hand in hand. There is an agenda by some to get cows off the range, and the sage grouse is often used as a tool for that. The wild horse is unfortunately bat-ted around as a tool as well.

The mustang is a symbol of the West, and I think they belong here and deserve protection. However, I honestly don't think we ever will push the wild horse to the brink of extinction. Yes, there were once cruel, inhumane roundups that were incorrect and improper and should never have been done in that manner at all; but that was a minority. Unfortunately, those occasions still project a bad image among the public and with the press.

My wife and I have a favorite area in northern Washoe County where a rancher once turned out draft animals. You can still see twelve- and thirteen-hundred-pound wild horses there, and they are every color of the rainbow, colors you never see on a domestic horse. Those horses are beau-tiful. Some herds, though, are so inbred it makes me scratch my head and ask whether we should even perpetuate them. Over the years, I've watched in dismay that while we may have a national wild horse protection act, what we lack is sound wild horse management.

Several years ago I was nominated to serve on the National Wild Horse and Burro Advisory Board. My position is to emphasize that we have spent

nearly thirty years on wild horse protection and that protection is in place now. So it's time (in fact, the time is way past due) to really engage wild horse management. Through the years, BLM efforts have been hampered by animal protection groups who don't understand the ecosystem and allege, among other things, that management is a grand conspiracy to eradicate horse herds all across the West. They dispute census numbers and the need for gathers, and they file court actions left and right. I want the best treatment and management for the horse. However, many of these people are either misguided and don't understand the situation in the high desert, or they do understand it all very well and simply don't care.

BLM finally has a strategic plan to reduce wild horse herds across the West. We have close to thirty thousand animals in Nevada now, and when there is a recruitment rate of 20–22 percent a year, things can get out of control fast. It will be necessary to pull horses off the range at about that same rate for the next four years. After four years of removing that many horses, someone is bound to say the number adds up to the total population. Remember, these horses keep breeding each year, so we need to remove that many just to get the numbers down to the appropriate level statewide. At this point fourteen to seventeen thousand horses is an approximate figure, but regardless of what the number is, this effort is contingent on funding, contingent on good management, and contingent on eliminating extremist lawsuits.

I believe wild horses probably affect antelope and mule deer more than any other animal species. Probably they also affect animals like sage grouse, and possibly more than we know, but again, those studies have not been done, so it is difficult to reach true scientific conclusions about that. But let's take mule deer, for instance. A mule deer has a summer range in the high country and migrates oftentimes into low country or lower mountain ranges to spend the winter. The effects of wild horses on mule deer are normally the greatest in two areas. One is during drought years on the summer range, where their overpopulation just denudes the land. The other is when we do not have healthy does, and that's whether we are speaking

about mule deer or antelope. They can't produce sufficient milk, as well as sufficient nourishment in their milk, to keep their offspring healthy and alive. It may be that a fawn is not as strong or not as fast, and so it is easier for a coyote to catch and kill them. But did the coyote get that fawn because he's malnourished and isn't strong enough or because range conditions are not good enough for the fawn to gain strength? That's the question.

* ⋆ *

SINCE THE 1960S there are half the cows on the range that there once were. But in other areas, where wild horse populations are 400 percent and 600 percent over appropriate management levels, a rancher is told they can't put their cattle out because the horses have already eaten all the forage. Well, if land managers have concluded that there's not enough forage left for domestic stock, imagine what has happened to our wildlife populations. When that kind of damage is done, the effects are potentially devastating.

It has been established that an elk usually consumes less than a cow or a horse. That's one difference between a native species that evolved along with the plant life versus a European species that was introduced. Elk are also mobile. As they graze they travel for miles, but they are not as mobile or as fast as the horse. Cows usually remain in one spot and nibble there. And it takes several deer to make up what one cow or one horse will eat. A lot of times, what saves the situation is that wildlife populations are forced into the most rugged portions of the mountain range, and these areas are normally inhospitable for livestock grazing. But I've seen wild horse droppings high up in the cliffs and on the tops of mountain ranges. It's incredible where they go, almost like they get airlifted into some of these spots. You just wonder how and why they get there.

The wild horse has value intrinsically and aesthetically. As a wildlife activist the best I can hope for is that we somehow reduce wild horse populations down to appropriate numbers and maintain them there. But until we are able to encourage a realistic view of the West, I worry about the future. Many animal rights groups are involved in an out-and-out effort to

do away with hunting. The emphasis seems to be that if hunters kill animals, we must obviously all be bad. I hope it's nothing but a fad; however, all sorts of things become fashionable that are nonsensical. I want to see bighorn sheep in certain mountain ranges of Nevada, and I want to see wild horses down to appropriate numbers. This is what I want to accomplish before I bow out of public service.

Deloyd Satterthwaite: Stockman, Elko, Nevada

I've been a rancher all my life. I've done everything from the ground up, and all I know is this business. At our ranch we try to complement both sheep and cows. It's definitely a full-time job, and I've often said that if I ever had to go back to school to get an education, I'd be a psychiatrist. You can learn to handle cows, but sometimes people can drive you nuts!

I was the second livestock representative appointed by the governor to serve on the Nevada Commission for the Preservation of Wild Horses. It's such an emotional issue that I don't feel we ever accomplished much, but we worked at it. The problem was the commission is charged with promoting the preservation of wild horses. They're not able to work out a suitable program so there can be a healthy, thriving herd. So there's the rub. The commission never stopped a wild horse gather, but they have managed to make it frustrating for BLM to do the work they need to do.

We always had wild horses on our grazing allotments. There were horse permits in those days, and we turned our saddle horses out on the range. Our horses would mix with the mustangs, and we managed them ourselves. We culled them and sold them like our own horses. We'd break them to ride or we'd sell them, and that kept the population pretty well in check. I remember a little gray mustang named Butterfly. We had her for years.

I knew Wild Horse Annie, and I think she would turn over in her grave if she saw how the wild horse program is being run today. I mean it. There is a wild horse resource just running berserk out there. I'll give you an example. When legislation went through on our Spanish Ranch allotment, it called for 119 horses. There are well over 1,000 there now, and the only time they

are ever gathered is during an emergency. The last time was when the fires burned—the Winters Creek fire they called it—BLM wanted to remove a certain number of our cattle, and so I insisted they remove a certain number of horses as well, which they did. Since that fire, horse numbers have never been kept in check. It took an emergency, when the horses were starving or choking to death, for a gather. Regular gathers don't happen.

There's two sides to an allotment management plan. When you enter into an agreement with the government, the system is supposed to kick in and include a regular schedule of wild horse gathers. You set an appropriate management level for horses as well as cattle. Let's say we agreed on 170 horses. Well, we'd be glad to have them! We would have our cattle out there, too. In that plan, if you added a 20 percent colt crop each year, the government would come back in and take the numbers back down. However, this hasn't worked out, because if you read the small print it says only *if* there is manpower or money to do those gathers.

This isn't just what I want; it's what the range can handle. I don't have a problem with wild horses if their numbers are held in check. I'd be dropping on my knees every night if they would keep the number at 170, but I can't handle 1,006, which is what's there now.

Everyone agrees the first thing to do is set the numbers for AML. There's been talk about setting a statewide appropriate management level for years, but there probably aren't two people in this whole state that will agree about how many horses are actually here. Let's say that, in Nevada, people agree the number is seventeen thousand. Everyone knows that a thriving herd of seventeen thousand horses is a lot better than a dying bunch of twenty-five thousand.

The government doesn't gather because there isn't enough money or manpower, plus every time they try, some special interest group will throw up an injunction or try to sue them. Last year the corrals were full at Palomino Valley, which meant the adoption pipeline was plugged. If there's no place to go with the horses, then BLM just won't gather them at all anyway.

AML is meant to get things in balance so everybody can use the range.

The land is set up as a multiple use concept, and that includes horses and deer and elk and rock hounds and fish and snowmobiles. It includes every-body. When you have an allotment management plan, it addresses all of those things. Horses are only one part. We've got to find a way to manage these horses that everyone can be comfortable with.

One problem is the fact that when they gather these horses, those that are unadoptable plug up the pipeline. Many of those horses live their entire life in Palomino Valley or some such facility until they die. They can live to be thirty years old, and they'll eat better hay while they do. The past few years BLM tried to take off only horses that are five years and younger be-cause they are more appealing to adopters. Well, if it costs a certain num-ber of dollars for a helicopter to run those horses into a chute, and then half of them are turned back out because they are over five years old, you can see the whole price of the operation doubles.

The traditional way that horse numbers were once controlled in the Great Basin is that excess wild horses would be brought in and sold. Now, I guess we may as well call a spade a spade, because many of them were sold for chicken feed. And they were probably put down in some way, shape, or form. But they were made useful. That may not be what people want to hear, but that's probably an answer we need to hear. Because if you name any other animal—a fish or a dove or a cat or a cow—everything is harvested to keep things in control. That doesn't mean it can't be done in a humane way. Nobody likes to see an animal die. But there is nothing worse than to see horses choke or starve to death. Folks want to think of these horses as wild and free roaming, yet the way things are now they die suffering.

One thing I've learned over the years is that there are always two sides to every story, two sides that should be heard. People need to hear these facts and make up their own minds as to what's best, but what happens is that facts get twisted and numbers are bent out of shape. You'll hear things said like, "Oh, Deloyd just wants more grass for his cows. There would be plenty of feed for those horses if he didn't run sheep and cattle out there." Well, even if I did take all my animals off, we would still have this same conver-

sation somewhere down the road, because these horses would eventually eat themselves out of house and home. Yet because I'm a rancher, people would rather perceive me as a bad guy.

Throughout my whole career I've always tried to understand people's feelings. I know how sensitive this matter is for some people. I know how people feel about animals, and I try to respect people for what they believe. On the other hand, I hope they will respect what I have to say. Somewhere in the middle there should be a meeting ground; we should be able to find a common goal on how to manage these horses.

Remember not too long ago when those three people shot all those horses near Virginia City? Right about the same time there was a guy who worked for me as a caretaker on our ranch. Well, another fellow came out to visit one day, and these two fellows got to drinking, and after a while an argument started, and so this one fellow took a gun and shot my employee. So the sheriff came out, and to make a long story short, they only gave him a fine. He's out walking the street now. But when those fellows shot those wild horses, money came rolling in from all over the country. They posted a $30,000 reward, immediately, for shooting a wild horse. Yet the fellow who shot my employee is out walking the street. That gives me a sense of where our values have gone about this whole thing. The life of a wild horse has become more valuable than that of a human being.

I want to make it very clear that I'm not in favor of the elimination of wild horses, and I'm sure most of the ranchers in this state feel the same way. But there has to be a way to dispose of the excess horses, especially the old, undesirable, unadoptable ones. I don't agree with the suggestion they should all be left out to go back to nature. Because if they do die from starvation or thirst, that's very, very cruel. If there was a way to sedate them or shoot them with a dart gun so they could just go to sleep one night but not wake up tomorrow, that could help. The way things are, a lot of wild horses are out there beating their heads on the ground for at least a week before they die.

I serve on a federal resource council, and we've wrestled with this prob-

lem a lot. I'd much rather see these old, undesirable animals be used for some beneficial purpose, whether that's to feed the poor or some other such thing. Maybe some ideas aren't worth any more than the paper they're written on, but one we came up with was to produce a quality herd in this state. If there was one herd of really good paint horses, say—no jugheads or cripples, and no inbred brothers and sisters, but a quality group of healthy and beautiful wild horses—well, that might create more desire in the public to adopt them. So far, we haven't found anything that is acceptable to everybody, and particularly everybody east of Denver.

A couple of years ago some of my cowboys were out branding. Some mustangs came by, and one of our horses just took off and got in with the mustangs, and he still had a saddle and bridle on. Now, that was a $3,000 saddle. We couldn't go get our horse because the law says we couldn't go after a mustang even if it's legitimate. I finally went to the local BLM office and said, "I don't care what you do, but I'm going to find our horse and get our saddle back." Believe it or not, the next morning that horse wandered back into camp with his saddle still on, so we were lucky. That wild bunch is still there. As long as it's there, I can't use the field for my horses even though we have a legitimate horse permit for the same area. If one of our horses mixes in with them, we could never get ours back.

I don't know how far up the political ladder things will go before the situation improves with wild horses. I do feel for the people in BLM. They know what's at stake. I've worked on this for the past twenty-five years and I'm sure I'll probably keep on at it until I die. Nevada is very fragile, and the range has to be managed right.

Marty Vavra, Ph.D.: Range Scientist, Burns, Oregon

The ecology of the Great Basin isn't limited to state lines. Vegetation doesn't care which way the water flows; it cares more about what comes out of the sky, so it's all the same kind of country. Here in southeastern Oregon we're in a little better ecological shape than Nevada. We've got a little more moisture, and we're also a little cooler. Our sagebrush country is in pretty

good shape compared to Nevada or southern Idaho, too. I don't know why, really, because it's also been settled and worked. Maybe it's just an Oregon attitude!

I was one of the first people to do research on the effects of wild horses on the range. I looked at food habits and what competition, if any, occurred between cattle, horses, mule deer, and pronghorn on the range. Those early studies blossomed into a few more comprehensive projects. There certainly wasn't any glaring problem that we found. Cattle and horses generally are pretty compatible. They each use a portion of the range, but it's a matter of balancing their numbers to make it work. Pronghorn, mule deer, and bighorn sheep don't overlap nearly as much. Some people were concerned then that wild horses could dominate water holes, but typically, in a healthy situation, the horses usually come in to drink and then go out.

Elk are really kind of new to the northern Great Basin. Twenty years ago there weren't any here, but now they're on the Steens and Hart Mountain, and we're starting to see them again in places like Nevada's Ruby Mountains. Both elk and horses by nature are pretty tough and aggressive critters, but I think if there were any problem socially, one or the other would just move on to another area. As long as the numbers of either one don't get out of bounds or the forage base declines, I don't see any problem there. There's a little wild horse herd just out of Burns that I keep in touch with, and the elk winter in with them all the time. In fact, right near the wild horse area is a center pivot of alfalfa. Some of the elk spend all summer near the mustangs. They take cover in the junipers and then scoot over into the alfalfa field for food.

I always thought we should study horses on the scale of the landscape. Twenty years later it's interesting to see how so much more research is headed that way, because nowadays the big questions are all landscape oriented. Recently I completed another little study on mustangs. Some folks at uc Berkeley were interested in what mammoths and horses were eating millions of years ago from the Miocene to the Pleistocene eras. They were picking up fossils and looking at teeth, because they can tell if an animal

was eating either a warm- or a cool-season grass by the isotopic composition of the teeth of those fossils. They wanted some food habit work done with wild horses up here, and I was able to find some skulls from dead horses where they could look at their teeth to make comparisons. It has absolutely no practical application to the world of wild horse management today, but it was really fun.

Overall, there are a pretty progressive bunch of folks in southeast Oregon. The livestock community has been very cooperative in addressing environmental issues here. In the early 1990s a group of ranchers from Trout Creek Mountains formed a coalition and removed their livestock from that area just to reestablish riparian zone quality and help to maintain the native trout population there. They all took their cattle off for five years, which was a very substantial change in their traditional pattern of use. I think some wild horses were redirected at that time also, so it was all very successful. The current changes on Steens Mountain are another example. The BLM districts in eastern Oregon are also developing some very environmentally compatible grazing systems. They do a pretty darn good job of looking out for not only riparian conditions but specific habitat needs of other species these days. Throughout southeast Oregon we have a background of cooperation.

It really doesn't matter what animals you're talking about, whether it's cattle, wild horses, or elk. Certainly, if deer and pronghorn numbers were high enough they could impact shrub components, but not grasses. When it comes to native grasses, herbivores have the ability to alter ecosystems. We know that; it's a given. So whenever you try to establish population numbers for any of these animals, it has to be conservative. The range is a finite resource limited by climate, and the weather changes drastically from one year to the next. Because we deal with such fluctuations in annual precipitation, we really have to make sure nothing is hurt during the dry years. When there's a wet year there's going to be some leftover forage, but that's a kind of gravy because it helps the plants take advantage of those years and perhaps build some reserves. With cattle, we have the opportunity to move

and defer grazing during critical periods of growth of the native bunch grasses. But horses and elk use those grazing areas continuously, so those plants are grazed during the critical growth stage every year. That may kill some of those plants or make them somewhat unhealthy.

I believe our bunch grasses are a lot tougher than we sometimes give them credit for. Mainly because they're still here! If you look at photographs and other historical records from the late 1800s and early 1900s, you can see how we beat the country into the ground. How did those plants ever survive? We shouldn't have anything left anywhere, the way we abused the land back then, but we do. So this country is pretty tough; it can come back.

Cheatgrass has thrown a big monkey wrench into the whole works because it invades so well and native plants can't return after any disturbance. Cheatgrass seed was a wheat contaminant that was inadvertently imported during the nineteenth century. If you've got a very good stand of healthy bunch grasses, they'll allow a little cheatgrass to grow here and there, but it won't replace any of them. However, once there is any disturbance event like a fire, then cheatgrass is a very rapid invader, and restoration of that site is sometimes impossible. Plus, the initial growth of cheatgrass that comes in after fire comes up so quickly that the opportunities for another fire increase immediately. So you get an increased fire cycle that, over time, knocks down the bunch grasses and the sagebrush, and in that situation it's a cycle you can't break. We could end up with nothing but cheatgrass out there if we're not careful. We're still reaching for restoration activities that can handle it.

All of this gets really tough, because when it comes to natural resources, public knowledge is pretty pitiful. Certainly, in many instances today, cattle grazing is not yet environmentally compatible or ecologically sound, but we're moving in that direction more and more, and getting better with it all the time. I think we're progressing at a pretty darn good speed. This forest fire business we're going through in the West is also related to years of fire suppression policies. We're going to have a holocaust on our hands if we

don't do something soon, yet there is still all this political pressure that originates from the public, even if it is a minority view, *not* to do anything. There's a lot more that could be done if folks were ecologically aware and could address their politicians better. Perhaps this is rather critical, but I think a lot of problems have roots in our schools. There are a lot of high school science teachers who got their training in liberal arts colleges, and in my opinion they are packing baggage that they really are not well versed in. Many of them don't see natural resources as viable entities that can be harvested on a sustainable basis and still be ecologically maintained, and so they pass that on in the school system. This encourages the "hands off" idea—to let nature alone. Well, we can't. We're all here; and what's more, we are the ones who screwed it up.

Ever since Europeans arrived in great numbers they have really done some weird things to this land—from water diversion to fire suppression to overgrazing to improper logging to lousy farming methods to urbanization. Obviously, we need to work to remedy that, but we must understand that we can't fix it all because we don't even know *how* yet. As we learn more we can adapt how to do things, and, hopefully, by continuing to observe what we're doing and making adaptations over time, we will have a trajectory toward ecological improvement. But it's unrealistic to think there will be an end-point where we can say for certain, "By 2023 we'll have this all fixed." That's not ever going to happen. We have to understand that all of our ecosystems are screwed up. But even if we threw out all of the logging, grazing, farming, and left everything alone, we would still have juniper invasion and cheatgrass in the Great Basin, and we would never get back to a natural fire cycle. These landscapes have to get back in shape through management before they can ever become "naturalized" again. Unfortunately, the concept of management has a bad image because many of our past efforts were misdirected or even poor. Now, it's true that in the past, efforts were often directed more toward commodity extraction than sustainable use. But at this point in time that mentality is gone. Today it's a matter of trust, because the resource needs to be managed now more than ever.

Many people don't want to look at the natural world as it exists. There is a finite resource out there. Even if we threw off all of the cows it would be only a matter of time until there were enough wild horses to make up for all those cows, and even if they had a whole lot larger landscape to deal with, pretty soon they'd be out of food and starving again. Wild horses have no consistent natural predators, and there are limitations on their movements, so the free passage of genes through an entire western landscape of wild horses just doesn't occur anymore.

I've spent a lot of time working with wild horses. Maybe I'm not being an unbiased scientist here, but I think mustangs really are a symbol of the Old West. Maybe they're not native, so what? They're a part of our heritage. To rid the West of wild horses is the same as saying that a historic log cabin isn't a part of the natural landscape either. They have a place on the range, and I like seeing them there.

Charlie D. Clements: Wildlife Biologist, Reno, Nevada

I've been working on the Sheldon Wildlife Range for fifteen years now. Restoration and rehabilitation of arid rangelands is my primary focus. What's unique about the Sheldon is that it is a true grassland. As you come south out of the area you're apt to see more shrubs dominant on the land than grass. Up on the Sheldon, because of the precipitation zone and the change in vegetation, there is more herbaceous vegetation.

In 1992, the Fish and Wildlife Service removed livestock grazing from the Sheldon. The idea was to get a flourishing habitat for indicator species— sage grouse, pygmy rabbits, and the pronghorn—because the Sheldon is primarily an antelope refuge. Since then, there has been a flourish of grass. Of course, there was always grass there, but now there is a lot more and it's become a fuel. Well, when you add fuel you get catastrophic wildfires. Although it's supposed to be a natural system, what happened is that fire took away critical habitat for the mule deer, pygmy rabbits, sage grouse, and pronghorn. They haven't responded to the change. So the question arises: how do we manage grass as fuel?

Sometimes management decisions are done with an angle. There's always a diverse group of people who play a role in what they want to see as an outcome for any particular habitat. A wildlife specialist might want bighorn sheep or more elk, more deer, more antelope. Wild horse advocates want more horses. But many wildlife people don't even understand that a particular habitat is good only for one certain species. For instance, you can't have a healthy mule deer population and a healthy elk population at the same time in the same place. It may appear that way during a time of transition, because whenever you have a healthy environment there will be healthy herds who follow into the habitat. There is a time continuum where there's an equilibrium between populations, but at the same time those communities are changing, so one habitat will eventually benefit one species but not another.

The definition of a pristine habitat is what things looked like at the time of European contact here. That all happened during a climatic change moving from the small Ice Age into today, when there was a rush of settlers and domestic animals entering the region. In the Sheldon during that period, white-tailed jackrabbits were dominant. This is because the land was dominated by herbaceous plant material, grass rather than shrubs. The sharp-tailed grouse there at the same time were more dominant than sage grouse due to this same characteristic. Sage grouse has been of concern recently because it is being considered as a threatened or endangered species. What has happened is that even though we've taken the Sheldon back to these so-called pre-European conditions, we still don't have the species that we're so concerned about actually benefiting from that change. This is where wild horse management comes into play. On the Sheldon now is an environment returning to a dominance of grass. Since wild horses are grazers, grass benefits them. The environment is better for a grazing animal, but less valuable for other wildlife species that benefit from shrubland dominance.

The wild horses on the Sheldon are some of the best-looking I've come across. I spend a lot of time sitting behind blinds at water holes, and it's

really interesting to watch their behavior. A mustang is the most aggressive animal I've ever seen. There aren't a lot of water sources on the Sheldon, and the Fish and Wildlife Service has dug some pits which collect water over the winter and spring so the animals can use it during summer. Those wild horses chase away any wildlife that tries to come down and get water. Pronghorn are very skittish, and all any mustang has to do is just take two steps toward an antelope and that antelope heads off running. The horses have taken over that territory and they intend to use it. Now, how much energy is that antelope using just in being scared? Stress has a role, especially during dry years.

The nature of the Great Basin is dry. If somebody tells you there is twelve inches average precipitation up on the Sheldon, that means one year there may be sixteen inches followed by a whole lot of dry years. It's not a true, consistent reality. It looks just gorgeous now up there; the habitat is flourishing, there's grass, the shrubs look really good, and there's a lot of edge effect, which is also good. But if you start counting, you'll see a decrease not just in one species but in the diversity of wildlife there. As soon as you leave the refuge and go down to what might be called "degraded" rangelands, you'll immediately notice an increase in wildlife again. So I think what we humans may perceive of as pristine habitat for animals and what those animals actually use are two different things entirely.

When the early explorers first came to the Great Basin they went through all this undisturbed land. The Sheldon was one of these areas, but those explorers still had to kill their own horses to have something to eat. What wildlife was there was in small pockets, and usually those were in valleys with wild meadows. The type of edge effect around Honey Lake Valley in eastern California is a perfect example. The early settlers noted that sage grouse were plentiful, and they noted bighorn sheep, mountain lion, mule deer, antelope, and waterfowl. Well, as you go north to Gerlach and across the edge of those deserts it's a whole different story. People were actually sticking their hands down ant holes to lick the ants off, just to have something to eat. Wildlife experts still argue about what kind of plant commu-

nity and what kind of wildlife were actually here then, and since there are no photos, all we have are journals. Some people use newspaper article accounts as accurate, but if I took any newspaper article today, would that give a fair picture? .

It is a wildlife agency's job to protect and enhance wildlife, and right now no one knows why there is a decline in antelope on the Sheldon. Most people who have lived in the area for a long time have seen a decline in mule deer herds. Locals see a lot that biologists don't, because many times biologists are stuck in an office doing paperwork. Trappers, hunters, ranchers, and others who are outdoors often see much more. They may not have the kind of education to be able to translate that knowledge properly, but you still can't take what they say as just another barbershop story or barroom talk. I think that sometimes in our field we don't give enough credit to local information. If we listened to it and tried to weed out what's being said, we could learn a lot. Our job is to learn something every day, and if we don't we're not doing our job well.

One topic definitely worth researching concerns competition from any new animal to a given habitat and how that affects other animals who are there, whether they are native or nonnative. I look at wild horses this way. Just what are we managing them for? Many times when I've been up in the Buffalo Hills area and out on the Granite Range I've seen wild horses that are just jarheads. They're inbred, they're not good-looking, and in some cases they're really suffering out there. I look at things this way: if you have good-looking horses, it adds beauty to the range. If there aren't good-looking horses, we're not helping that herd.

Wild horses have been pictured by many as a nondomestic animal because some folks believe one native species won't harm another native species. That's not true. There are also people who think there's no way a beaver can harm a riparian area because they're made to live there. That's not true either. So we must manage, just not overmanage. When a horse population can fit into a management scheme, you'll get an exceptionally healthy horse population, good-looking horses, and increased aesthetic

value. Everybody involved with these matters should go to the field more, observe more, and then base their comments on their observations rather than let emotions enter into the discussion.

The public wants to protect the land and animals because they think protection means things will remain pure. But "pure" was only one point in time. We are part of the equation here now, and we live in a continually changing environment. All we can do is try to manage how our environment is used. Sure we want to negate destruction, but disturbances do occur. The only assurance is that during the small Ice Age the Great Basin was getting seventeen inches of precipitation, and now we're a desert.

If how we presently manage is wrong, that doesn't mean no management is better. In my experience, no management is much worse. Management means you *know* the land. If a fire happens, you know what the habitat was, thus you're aware of the actions needed to ensure a healthy habitat.

At the Sheldon there are prescribed burns. Again, that is a habitat which has a certain type of community, and it ensures a certain result. When you go into a large part of the Great Basin—the sagebrush–bunch grass zone, for example—and start getting down to where cheatgrass has mined a site, any fire results in more cheatgrass. It replaces critical shrub habitat with an annual grass that causes havoc, so that's an example of where fire is not a tool. Right now we're losing millions of acres in Nevada in a very short period of time because of interval fire on these rangelands. Whenever fire is used, we must have research to make sure it won't come back and bite us.

The only way to manage wild horses is to keep a certain number of animals out there, see how healthy they are, and how they fare over different seasons. That will tell you if this is a habitat type and if the range is comfortable with that level. Then you know if you can increase or decrease that management level.

Whenever wildlife biologists work with elk or bighorn sheep, they have to show what the habitat is before they are there. One of the things I've never understood is how we can manage for every ungulate out on the range, but not for wild horses.

If you compare Nevada's range and wildlife to the turn of the century, the state has done a wonderful job in terms of wildlife enhancement and range improvement. There are enormous amounts of bunch grass communities in the Calicos and around Smoke Creek now. When you look at old photos, there was nothing left out on those ranges. In 1905 it was also front-page news if someone killed a mule deer outside Reno, yet now the deer are eating roses in their yards. Given what there is, I think Nevada has done a wonderful job.

Jim Andrae: Ranch Manager, Tuscarora, Nevada

When I started I broke a lot of horses, cranky and gentle. Everybody turned their horses out back then. There were lots of mustangs and we'd bring those in too. Today at the IL we raise all our own horses and we start them all here.

It used to be that the mustangs were a better class of horses because everybody turned their studs out and their mares. A lot of them were good horses. We started a lot of them, and we'd use them. Those mustangs didn't harm the country then, but you had to keep numbers down because if it got out of hand, well, you'd be in the same position we're in today. When ranchers harvested those colts they would wean some, and they took care of the herds. Now their numbers just keep snowballing.

I think there's close to two thousand horses on our range now. The local BLM rep will argue there isn't, but when they get down to gathering I'm sure there's going to be pretty near that. I don't have access to count them with a helicopter, but I count them at water holes, and I sure see them all the time. There's just a lot of horses out there. When you get a huge herd of horses like that, they break off the grass; they keep stirring up the dirt. They just don't do the country any good.

I don't think the adoption program is realistic. You take an individual from some town and let them adopt a five- or six-year-old mustang stud. Well, someone like that isn't even capable of getting that horse halter-broke properly. BLM has programs at some state prisons for starting horses, and

if they do that, why, that's all right. But I still think all the money involved in that whole deal is wasteful. Who do you know that even knows how to break a wild horse today? That's the first thing. And when that's done you still just have an ordinary horse. So for the most part, it's expensive.

After they fenced all these ranches, domestic horses were no longer run out on the range. There weren't any more horse permits, and studs and mares weren't being turned out anymore, and so you get mustangs that look the way they do now. These horses we see today just don't have it. When the big ranches were turning horses out—work horses, saddle horses, everything—wild horses were a much better quality horse.

Fencing individual areas is great. But if you've got horses inside, they're really not free-roaming anymore. Up on the Spanish Ranch the wild horses there used to winter on the desert. Now it's fenced so they winter in the mountains. The horses on our range used to summer on those mountains, and now because of the fence they can't go there either. Probably in some areas horses still can be free roaming. It depends how the fences are.

A lot of ranchers didn't want fences. They fought it pretty hard until they got used to handling cows with less people. On this ranch we have a little over five thousand mother cows, and we do it with six cowboys and a crew of seven for haying, irrigating, and fencing. Back then, you'd have twelve or fourteen cowboys doing the same. So that's the difference. Luckily, we get the work all done.

All these wild horses do get in the way. The government makes us take our cattle off so we leave a certain amount of feed every year. But if you've got 2,000 or so horses eating the same grass 365 days of the year, how many pounds of feed does that weigh? The appropriate management level designed for this one allotment calls for 57 head of horses. And we have three big allotments, so it should run about 165 altogether. Right now we're doing an evaluation to see if our AML is up to expectations. We have to allow for so many deer, so many antelope, and so many horses, but the number of horses is much more than it's supposed to be. Normally, there's water out in Dry Creek through June, but this year there's not. We can take our

cattle off, but the horses stay. If they aren't gathered before long they will probably die.

When we used to gather horses we'd sort out a bunch of young studs all at one time. We caught them and mouthed them, and the ones we wanted we kept and halter-broke and gelded. We'd run them with the saddle horses for one winter, turn them loose next spring, gather them in the fall, and then break them to ride. It was a good experience. Those mustangs weren't really ornery; they were just wild little buggers on the ground. If somebody would ride up, they'd jump all over and whistle and snort. When you gathered with an airplane, all the pilot did was supply the flying service. We would do all the ground work to get them through the fence and put them in the field. Over in the Dry Creek area there would be about six of us that would rope and hobble them. Then the pilot would bring the rest back and we'd rope them. You could rope forty or forty-five in the mornings and spend the rest of the day loading them up. We'd bring them to headquarters in a truck. It was hard work because it's not easy to load them. We didn't build any corrals because that was an extra expense, and cowboys were easy to come by back then. Today, they have all these portable panels, portable corrals, portable chutes, portable everything. They don't have to do it the hard way.

The old-time traps would be covered with cheesecloth, or anything a horse couldn't see through. They'd use two, three, four, or five gentle horses and take them away from the trap, and when the mustangs got near they'd turn them loose and then lead them into the corrals. We did the same thing to corral them here, except we would take all the saddle horses, and at that time, why, we probably had 120 head of saddle horses. Then we'd mix the mustangs in with the saddle horses so you could take them anyplace. Today they still use a Judas horse. But now you can build a working facility in three or four hours with those portable panels, and you can take it all down in the same length of time.

Leonard Sheperd was a pilot we used. He'd break them horses to drive from the air. He had a .410 pistol, and if a horse didn't stay in with the bunch, he'd shoot the pistol in the air and the horse would go right back

into the bunch and stay there. Leonard really knew horses. He'd put you on a road or a trail or something, and he would figure out where you were going to be, and he would bring the horses right to you. He'd fly right down in front of them and just hold them right in so there was nothing to roping them.

One time Leonard had a bunch of horses and we were trying to put them through a fence. We had let the fence down for probably a hundred yards; it was all rolled up and out of the way. But the horses were hooked on running the trail alongside the fence and they wouldn't go through. He turned them two or three times, just right there, but he still couldn't get them to go, so he brought them right down the fence line one more time. He was probably eyeball to eyeball in his plane with that lead horse, and he put him right through the hole in that fence! I wouldn't ever want to fly in a plane like that! But Leonard sure could handle horses.

You know, a full-grown horse can eat all the time except for when it's sleeping. If you fed a horse all the hay it wanted, it would eat it. A full-grown cow will eat fifteen or twenty pounds and then she has to lie down. She'll chew her cud, but there will be quite a period of time when she's just resting and not eating at all. Now, these wild horses don't eat all the time because they have to trail so far to get water, and that takes time. But they still can eat thirty-five to forty pounds of grass in a day.

I don't blame BLM. I work with them, and I work with the Forest Service, and I do my share. I just want them to do their share, too. But I do wonder why there are some districts or counties in this state that seem to have a much better handle on the situation. The government is allotted only so many dollars every year to gather horses. In my opinion they should be able to slaughter some of the old horses to feed hungry people. I understand some people have a hard time with that, but I would much rather sacrifice a horse to give some kid that was starving to death some meat to eat, and particularly if that horse was old or sick or never going to be of any use. If that could help some little kid have a decent life, why, I think it would be worth it.

This area has some super feed. We're required to leave so much of a percentage of it. I can show you places where the horses stay out all year and there's not much of anything. When we took cattle off the Dry Creek allotment last year there was 45 percent left in that area. By the time winter came, those horses had pretty much eaten up all the rest, and if it had been a hard winter they would have been in a heap of trouble right then. There was just nothing left. Now, where else can those horses go when they're fenced in? Last fall I called BLM and said, "Hey, your horses are going to run out of water over here." They were going to move them, but then it got stormy. So then all those horses were falling over each other in solid mud, just trying to get some water out of those holes. There was nothing but mud there.

The public has been brainwashed into thinking there are all these rich ranchers out here who are reaping a big harvest on public lands. They ought to come out and take a look. They'll see how big the harvest is. If the people could really see what is happening, I think they would quickly change their minds. It's no fun to see little colts getting abandoned when big bunches of horses run off and all those little guys can't keep up. This doesn't happen only when they are being gathered, either; it happens whenever those big bunches move. When those big bands take off, the mares never come back for those leppies. We were branding one time and saw a little bunch move out and a mom left a leppy behind. The next time we were over that way, well, those bones were there. Now, if it's an old mustang that's left behind it may be one thing, but when some little baby colt starves to death, to me that's another story. And it's sad. Sooner or later someone is going to have to bite the bullet about these horses.

Ira H. "Hammy" Kent (Deceased): Stockman and Outdoorsman, Fallon, Nevada

My father told me that in the early days, when the government bought horses for the cavalry, he had to meet their specifications. There were about three hundred wild horses in the Stillwater Mountains at that time, and he

replaced the mustang studs with old cavalry stallions the army couldn't use anymore. He turned those older stallions out with the wild herd, and that produced a really nice horse. Then they would catch the younger two- and three-year-old stallions they liked; they would bring them in and break them, and then they sold them right back to the cavalry. I don't know why he quit doing that. I recall him telling me that around 1907 he quit turning horses out and he didn't buy any more stallions.

The wild horses in the Stillwaters really got inbred after that. By the end of the 1920s their average size was down to about eight hundred pounds. They were all long-headed and pretty worthless looking. We fixed up some old corrals that my dad used a long time before, and we caught some of those horses there. We'd tail them to a big old work mare so they couldn't get away, but we had to bring them clear in to Fallon to be shipped out. It wasn't very economical. It was the Depression, so you could only get $5 a head for those horses then. So we tried something else. Horse hides were worth $3 apiece, so we shot some of the old horses to sell their hides. Horse hides made good commercial hides. A green hide weighed about fifty pounds apiece, so you could get only about three or four on a pack horse. In the summertime it got so hot we had to salt them. There were accidents on the trail and that sort of thing, so that didn't work out.

Pretty soon there were so many horses out there that they were eating up the country. They were just pawing the grass out, and there were no deer, not even any livestock out there. We had been running our cattle and sheep there, but there was just nothing left. In the wintertime it was so bad the horses were coming down to drink out of the Stillwater Slough, coming for water down in those sinks, and around what they called the nut grass north of there. There were just so many horses they were going in every direction. A lot of folks tried to catch them out on those big flats. They'd try and rope them, and a lot of it was for sport. There were just so many and if we had a bad winter they would all die, so we knew we had to do something. We finally decided we'd better humanely shoot them. We culled them only

once like that, but it was either that or the alternative—they would all starve to death. We never wanted to exterminate the horses; no way. We liked them. I still like them out on the range.

I don't know exactly how many mustangs are there now. The Stillwaters don't have any roads to speak of, so no one ever sees those horses unless they go in by foot or horseback. When the act was passed there was just a small herd, and that number had been the same for about ten years prior. We took off all the stallions except one, and mountain lions moved into the Stillwater Mountains about that same time, so very rarely did a colt survive. We'd see six or eight in the spring of each year, but by fall those colts would all be gone, so we knew the lions got them. They keep the horse numbers down to this day up there. My son was up there hunting chukars about ten years ago. He was coming around the side of the mountain, and he saw all this dust flying. He ran around to see what it was and there was a mountain lion that got a mare. She was about five years old. That lion had his mouth right there over her nose, and he had her nostrils closed off, and he was choking her down. He didn't let go until she was dead. My son watched the whole thing.

Normally one wild stallion has eight or ten mares. I've seen one stud with thirty mares before, but that's rare. When the mares have colts, as soon as any young stallion gets to be a certain age the old stallion runs him out and keeps the young fillies in his herd. The old mares die, but the fillies are still in the herd, and the stallion is breeding them. That goes on and on, and that's how you get these little seven-hundred-pound horses.

Before the act, all the ranchers used these horses. They took care of any problems, but there was never any rancher I knew who wanted to remove all the horses from the range. That just wasn't their way. But the northern part of this state is entirely different from the southern part. Down south, horses die from dehydration; that has always been a big problem there. Now, it's just not humane to sit by and watch a horse die from thirst. I think most of these animal organizations have no idea what's going on. They sit

at a desk far away, and they've never sat out here, year after year and observed what happens. Nowadays people know only that the food they eat comes from out of a box.

A lot of people ate horse meat in the Depression. They would eat anything! I've eaten gophers and muskrat and groundhogs. We'd bake the groundhogs in a Dutch oven; they tasted just like pork. One summer day we were herding cattle down near Carson Sink and we got hungry, so we decided to get some mud hen eggs and eat those. We were riding through the tules, and we found about a dozen eggs, and we got an old tin can and filled it with water. We built a fire and threw the eggs on, and after they boiled we started eating them. One of the guys broke one open that looked like it was about ready to hatch. He just ate it anyway. That's how it was in those days.

A while back they gathered a bunch of horses out of the Clan Alpines. I'm not sure how many young ones they took off, but they turned loose about as many as they kept. Now, if you turn those old horses loose and leave them out there like that, well, that's not a humane way for a horse to die.

I knew Wild Horse Annie real well. She lived in Fernley and her dad had been a wild horse runner. I worked with her when she was drafting the national legislation; we talked quite a bit. Her big concern was to stop all the cruelty. It was pretty cruel the way some people were handling the horses then.

I love wildlife. We have a lot of wild animals all over our allotment. Historically, there had always been bighorn sheep there, so when the first desert bighorns came back they were turned loose on the Stillwaters, and we were very excited about it. We get quite a nice herd of antelope out there too. They come and drink right along with our cows in the wintertime because that's where the open water is. About a month ago my son drove up early one morning to break the ice off the top of the tank. The cows and the antelope were standing right there waiting. There was an antelope fawn, probably about six months old, playing with an old cow. The fawn would

run out a little ways and stop, and that cow would run out after him a little bit more, and then he'd come back close, and they'd start all over again.

There were a lot of sage hen in the Stillwaters when I grew up. I recall going out with my dad; it seemed like there were hundreds of them! About twenty years ago a bunch of Indians shot every sage hen there, and that was the end of the sage hen in the Stillwaters. We also had a very good population of mountain quail, but the winter of 1948 we lost every one. The chukars originally came from India. I happen to be the person who imported them here in 1934. The chukar has probably adapted better than any other bird released in the West. They're beautiful to see. They're good to eat, too.

I know this state. It's fragile. I remember times when the land dried up and there was nothing growing on the range. We shipped all our cows off. For three years we never put a cow on it, just to let it heal itself. There were several dry periods when we left it alone like that. We wouldn't get hit as bad as some others, but we still reduced our numbers voluntarily. Nobody told us to do it.

Everything about the wild horse has just gotten way out of hand. If Wild Horse Annie had lived, I don't think the mustangs would have so many of the problems that are happening now. Down in my heart, I don't believe that was ever her intention or her interest. I don't know if Congress will ever do anything. I don't know if they have the guts.

John Winnepenninkx: Wild Horse Specialist, Battle Mountain, Nevada

A wild horse specialist basically makes sure that all matters dealing with wild horses are done according to Hoyle, so to speak. They make certain the laws and regulations are followed, that evaluations are done correctly, that any environmental work on public lands is done with a consideration for wild horses. They monitor to see if there are overpopulated herds. The law says these horses shall be considered comparatively with other resources, and the specialist makes sure of that.

The most important thing is the health of the land. The other is that wild

horses must be managed in areas where they were found when the law was passed. Those are defined herd management areas that are mapped. Wild horses must also share the resource with livestock and wildlife. Now, some people think that because there are more livestock out there, that must be part of the problem. But let's say, for the sake of argument, that the stock-men all decide they don't want to ranch anymore and they take all their cows off. Right now there are about 50,000 horses in the American West, and we are trying to find homes that will adopt 8,000 horses every year. What in hell are we going to do if we had 100,000 horses on those same public lands and were trying to find homes for 20,000 a year? So the health of the land is the first priority, but the second is keeping the populations down so that we are only putting 5,000 animals a year through the adoption program.

Anyone is eligible to adopt a wild horse, and we do check folks out pretty thoroughly before we ever give them one. They can board the horse at a stable, but they have to provide sturdy facilities made from pipes or board planks. The corral has to be six feet high if the horse is over eighteen months old; with a yearling, it can be lower. They have to be safe, with no protrusions that would hurt the animal. Wild horses will try to get away, so an adoptee is required to provide at least four hundred square feet of space, or a twenty-by-twenty-foot corral. A fifty-foot round pen is excellent because then you can work with the horse there. They should also have some type of shelter, although that depends where they live. A horse in Las Vegas obviously doesn't need the same shelter as in Minnesota, for instance. Other than that, an adoptee can't have any record of convictions of inhumane treatment to animals, and they must be a United States citizen.

If there were fewer animals to adopt, BLM could get a better price for these animals. And we would be in a better position to ensure that horses were receiving proper care once they were placed. We could be more careful about who gets these animals to begin with, because there are only a finite number of adopters. I don't think we've saturated the market by any means, but it would be so much more worthwhile if we only had to worry

about adopting five thousand horses per year. If we can get the supply down, we can make the whole program much more self-sufficient, and ensure that the horses receive better care as a result.

We could breed up these horses. The American Curly horse was first introduced in central Nevada. The area where Curly horses were originally found has since been designated the Fish Creek Herd Management Area. I think it makes all the sense in the world to manage that area for the historic characteristics of that herd.

Several years ago a fellow from Rutgers Law School called me from an animal rights law clinic based at the university. He called about a gather plan issued from our office and asked all kinds of questions. One of his comments was, "There are 4 million cattle out there and only 40,000 wild horses, so it's obvious what must be causing the damage." I said, "Okay, I won't argue with you. Let's say, instead, that I can do just what you want me to do. I'll chop off 2 million cows and there will only be 2 million cows from here on. Then I'll let the horses populate until they are the exact same number. So, now there are 2 million cows and 2 million horses; how does that sound?" He said, "Well, that's much better." So I said, "Do you realize, now, that we have a little matter called reproduction here? Cows have calves, and that's how ranchers make money, by harvesting calves." He replied, yes, he understood that. "But," I said, "in the national wild horse program, we don't sell wild horses. We have a law that says we can't sell them, we can't kill them, and we have to find homes for them. Now, do you realize that with 2 million horses on the public lands, that amounts to 400,000 wild horses that will be born every year, and that we must find a home for them? I've been in this program since 1979 and I personally am having one helluva time trying to find a home for 8,000 horses a year. So you tell me, just what in the hell am I going to do with 400,000 wild horses every year?" "Well," he said, "I see your point."

I love this program. I love animals. I love horses. Wild horses are good horses. They are sturdy and durable and smart. But we have to be realistic. We have to get down to some more realistic numbers because we can't con-

tinue to find homes for ten thousand animals each year. If there wasn't one cow or one deer left out on the range there would still be a finite demand for these horses. And a finite amount of the resource. This is a really big thing to me. What are we going to do with all these surplus animals?

Being a farm kid, there comes a time when you understand that your favorite horse or chicken or dog has to die. They either die naturally or you have to assume the responsibility to put them down. In this country we humanely destroy millions of cats and dogs every year, but if one person shoots one wild horse, just see what happens!

Every time we do an adoption there are a large number of folks who come and adopt again. There has been some criticism of folks who supposedly adopt these horses and then, once they get title to them, take them to the auction or the killer plants so they can make money off them. Well, just figure the math. If you adopt a horse for $125 and feed it for one year, even if you don't do any vet care whatsoever and just keep it in a pen, and then after one year get title and haul it to the local sale yard, you will not make a bunch of money. It doesn't pencil out. I figured it one time on paper. Let's say I got four one-thousand-pound horses and fed them for one year. Say I didn't give them any veterinary care, none whatsoever. Even without any hauling costs, if they were sold at market price and I got my check right away in the mail, I would still lose money.

My daughter adopted a wild horse; he's outside. He's only a year old, and she can't wait to ride him. She's started him out already, real slow; she's getting him gentled down, and it didn't take very long. The first day home she was picking up his feet and leading him around. We got him the end of July and this is December, and she's gotten a saddle and reins and a halter on him, and he's responding very well.

During adoption events I try to match the horses with the best adopter. A wild horse is like a man, you know? The older they are, the harder they are to train! Seriously, one time we had a seven-year-old paint horse up for adoption who was just a weird animal. A young boy came up, and he had his

eyes on that horse just because he was colorful. That little kid had owned
horses before, but they had always been trained before he got them. I told
him he couldn't take the paint because he was so crazy. Well, what finally
happened is that horse killed himself by ramming into a gate in a frenzy.
But when an adopter takes a young wild horse and puts them through a good
program, I've seen them get as gentle as house cats.

There is some competition between wild horses and the domestic horse
market. Most adopters want a wild horse for their emotional appeal; they're
not the type to buy a $30,000 cutting horse or a $10,000 Thoroughbred.
But even if BLM stopped the adoption program altogether, I don't think the
domestic horse industry would sell any more Quarter Horses or Arabian
horses than they do now. If the domestic horse industry is having trouble,
they don't need to look to the mustang as the cause.

The worst problem the adoption program faces is abuse to the horse.
We are a small district, and we do compliance checks on every horse that's
adopted out during the first year to make certain they are cared for prop-
erly. In my day I've repossessed a lot of horses, and I've seen many of them
die from lack of proper care. Once there was a fellow who adopted a wild
burro and starved it to death. That guy had been a 4H leader, so obviously
he knew how to take care of that animal, but he let its feet grow so long that
when we found it, the burro was almost tipping over. We brought in a vet
and tried to save it, but the burro died. Those kinds of incidents are rare,
but they do happen. Compliance takes a lot of time and money.

I think more people from the special interest groups should come here
to see things for themselves. One lady did come recently from Washington,
D.C. Her organization maintained that the fire up at New Pass Ravenswood,
which wiped out half the habitat in Antelope Valley, was only a superficial
burn. I could tell it was her first trip west because she came out to the field
wearing spike heels and tight pants! Well, we didn't hide anything. We were
gathering horses then, and I enjoyed trying to help her understand what it
is we deal with. Half of that country had burned up from that fire, and the

other half was just nuked. Those New Pass horses came off the trailer and were so weak from malnutrition they almost collapsed. So she was a Doubting Thomas who put her hands in the wound, so to speak.

I still think most people in New York or Washington or even San Francisco, for that matter, wouldn't know a sagebrush from a parking meter. They don't know and they don't care what goes on here. These groups make money from donations, and no controversy equals no cash.

When I started to work for BLM there were about fifty thousand wild horses on the public lands. Here we are, twenty years later, and there still are some fifty thousand wild horses out there. Most of my career has been dedicated to the wild horses, and yet I feel I haven't accomplished a damn thing. In my opinion Senate Bill 457 made a lot of sense. I was sorry it never passed. Basically, it said the government would take all the excess horses off the range and they would be available for adoption for a certain period of time. After that, whichever horses had not been adopted privately would be offered to animal interest groups or humane societies. They would then have a certain time period to find a home for them, but if they didn't the horses would be offered for sale to the highest bidder. Those horses could then go toward some purpose like feeding the hungry. Just take a look at what's going on in Afghanistan right now, for instance, while in our culture we eat beef and chicken and pork all the time. Now, I love horses. I like them far more than cows or chickens, for that matter, but we have to face reality.

The BLM has got to maintain appropriate management levels and not let horse numbers get out of hand ever again. I understand money needs to be put to other good uses, but we can't stop managing wild horses on the public lands. We haven't pulled it off yet, but we just can't let things go on like this. Not for the sake of the land, and certainly not for the sake of these horses. They both deserve our care.

Vern Schulze: National Wild Horse Program (Retired), Reno, Nevada

The wild horse program does feed the mythical ideal of the mustang. BLM portrays the wild horse as a symbol of the West, and that perpetuates the

whole image. But I think Americans perceive all horses as special animals, so BLM includes that perception as part of the picture.

If the bureau can find good adopters for these horses within a relatively short time, it's definitely a good way to go. But the problem comes up two ways. First, there aren't enough qualified adopters, so BLM can't gather horses fast enough to protect the resource. The second is actually more important, because if we can't protect the basic resource, *everybody* suffers. The question is: how can we manage mustangs on public lands so that we protect the soil, water, and plants without having any authority to sell or destroy excess animals? I sometimes think that humanely destroying old or excess horses would be more compassionate than what these animals go through if they remain on the range malnourished or unhealthy. It's distressing to see them rounded up, transported all over the country, placed in feedlots, or adopted by someone where they may not receive proper care. Not only this, but the average taxpayer is subsidizing the program to an immense degree. In 1995, for instance, by the time each animal was removed and placed, it cost about $2,000 per horse. That's $2 per day, 365 days a year, for each animal. There are still huge numbers of unadopted wild horses in government sanctuaries.

When I was in the Washington office there were several pivotal lawsuits against BLM. The biggest required current studies for all wild horse removals. Before that, BLM used what is called a resource management plan to decide the numbers of animals on each herd area. Because of that one decision we were required to collect more data prior to deciding if wild horse numbers were in excess in any area. We had already started comprehensive studies to adjust livestock management, so this required the same for wild horse management. Well, any study means you have to monitor vegetation in a given area for several years, so we couldn't conduct one single gather until we collected enough data to support needing it in the first place. That one lawsuit stopped all horse removals entirely in some western states, and Nevada was one of them.

The groups who filed the lawsuit maintained wild horses weren't treated

fairly in terms of the grazing resource. Since 1971 (the year the act passed) was one historical point in time, their point was that there had been both fewer and more wild horses before. Also, the prevailing attitude of the day was to leave livestock numbers as they were and only remove wild horses, so once *any* number was claimed the fight was on. The resistance didn't just originate back East. There were many folks from out West, including several BLM employees, who were involved. Several government employees were passing information to those groups because they were concerned.

I always come back to the same question: why is BLM managing the land to begin with? The answer is we're trying to manage the basic resource: the vegetation. Today, livestock numbers have been reduced a considerable degree, so problems persist because horse numbers have continued to increase. In my view *none* of the numbers for horses or cattle come near to what the land can support, and the fact that there is no summer rainfall in the Great Basin should be the key factor in determining which animals are allowed to graze. Our native bunch grasses evolved with very little grazing. For the most part, the growing point of these grasses is above ground. Well, if you remove the growing point at the wrong time of year (such as early summer) there's no seed production, and if you graze too heavily those plants can be damaged. Both wild horses and livestock have areas that they return to year after year. No matter how many animals there are, if they're not moving from one area to another during the critical growing season, those plants will be harmed.

Water is the primary factor in determining where animals graze, and water developments in the high desert are few and far between. Cattle typically graze within a mile or two of water. Obviously, if they do that year after year, pretty soon there won't be anything left and native plants will be replaced by less desirable vegetation, even weeds. Horses move farther from water, but they also create damage at watering areas, particularly if the herds become too large. Because horses always travel the same trails, this also causes significant soil disturbance. Optimally, if a wild horse population is balanced with the available resources, the damage will be minimal.

When I was with BLM we considered the adoption program part of a pipeline that starts with gathering horses on the range and ends when they are adopted. Between the beginning and the end are a number of points where the flow can be delayed or stopped. Adoption is the only outlet for wild horses at present, so if they aren't or can't be adopted, the whole pipeline comes to a halt. You can't bring more horses off the range because the existing facilities are already filled. You can't afford to feed any more, and since there is no other place for them, they remain where they are.

It's also more expensive to feed wild horses in a holding facility than to leave them on the range, even though everybody knows that excessive numbers destroy the land. Yes, leaving them out there has a cost, but it's an indirect cost in the short term. It doesn't show on the balance sheet, for one thing, and very few people ever see it, for another. Strictly from a financial standpoint, everything else comes directly out of BLM's pocket—gathering and adopting horses, shipping them, putting them in a sanctuary, and feeding them; that all comes out of the agency budget. BLM gets only a fixed amount of money to manage wild horses every year, and that number becomes all they can handle. They can do only a certain amount of research, they can gather only a certain number, they can feed only a certain number, and they can adopt only a certain number. As long as Congress appropriates only so much money every year, excess horses will remain on the range. This means that all of the animals that are out there, plus the range itself, will pay the price even if the damage remains hidden for years. Or at least not unless something unforeseen happens, like hundreds of horses dying of thirst from drought, or the need to remove even more livestock because there's no forage, or another devastating fire. Then all you'll hear is: "Oh, shit! Let's do something to save the horses!"

It's not always the resource that dictates how BLM manages these horses, either. There's a lot of pressure applied by animal protection groups. Now, special interest groups have their own view of the world, and there is a very broad spectrum of beliefs among them. Many agency decisions are made because of their influence, or even because one BLM manager has his or her

own personal bias about certain issues. By and large, wild horse groups have little clout in how funding is allocated; that is, unless it's a problem with population growth. Another reason for the lack of success of some groups is a failure to reach agreement amongst themselves. Then again, animal protection groups are still just one out of lots of stakeholders who affect public land management. There are other programs that BLM or the Forest Service manage, and each one of those has constituent groups, too. I think the best system for providing input is through the local resource advisory councils, since people involved in them are knowledgeable about their region. However, even advisory councils are just one part of the mix. Not only this, but any close friend of any congressman can have as much effect on how public lands are managed as all of the other hard-working people combined.

I was in the wild horse program for twenty years, and I can best describe it as a yo-yo: lots of movement and little progress. When I first came to Nevada there were an estimated thirty thousand animals in the West. By the time I arrived in Washington the numbers were around sixty thousand. The lowest was in 1989; then we had a change of administration and—*whoosh*— the population jumped right back up. Then more money was allocated, then it was brought down, and now it's right back up again. It's really sad. We are destroying our natural resources in this process.

I think of our public land resources as a pie. Everybody wants a piece, but the pie isn't big enough for the size everyone wants, and even the size of the pie becomes an argument. By law BLM is required to make a decision, whether good, bad, or indifferent. Folks who live in the Great Basin are more willing to work together now, but that doesn't change the fact that people elsewhere in this country may want input into how the pie is divided. We're at a stalemate. Everybody is pulling, everybody wants a piece, but we simply don't have enough for all these stakeholders; and nobody wants to give up anything. Folks who live here understand it's necessary to share, but their cooperation won't stop lawsuits from outside groups, and it won't change congressional input.

Wild horses, ranching, and native wildlife are part of our heritage and a valuable part of our culture. Until a compromise is reached in this tug-of-war, I'm afraid the political stalemate and the resource damage will continue. In my view livestock on public lands should be limited to a number that can be managed in an environmentally and economically sound manner, and those numbers should be smaller than what is now permitted. I also believe wild horses should be limited to a number that can be managed with minimal resource damage and whose annual reproduction rate can be adopted out every year. Frankly, I think the resource would stand an even better chance if large grazing animals were limited entirely to pronghorn antelope and deer, with maybe a few elk. Considering the public's emotional attachment to the concept of wild horses, a reduced population may be a long time off.

Rex Cleary: BLM District Manager (Retired), Genoa, Nevada

Throughout the West there have been pockets where ranchers used wild horses for breeding herds. They turned out good studs and some good mares to upgrade the bloodlines. The Mahr brothers were still alive when I first arrived in Susanville. They had extensive wild horse operations in Lassen County, California, and Washoe County, Nevada, dating back before the Taylor Grazing Act. Their operation continued up into the 1950s. They had contracts with the government to furnish cavalry horses, so they turned out remount studs into the herds, and there is still evidence of those bloodlines there as a result. They kept upgrading the population so they would get marketable colts every year, and every year they'd gather the horses and colts, brand a few, and then turn the base herd back out. They always kept a pretty good selection to market, whether it was to the U.S. Cavalry or somewhere else. Another similar venture existed on and around the Sheldon Antelope Range prior to its becoming a game range. These kinds of operations occurred all through the Great Basin. The more desirable wild horses are still around today because of that.

Horsemen develop standards that they like to see in horses—tempera-

ment, size, athletic ability, the size of bone—various conformation charac-
teristics. Those characteristics were brought into the herds here, and they
resulted in offspring that were a lot more desirable for quality and usabil-
ity. I'm not a geneticist, but my observation is that those characteristics
will prevail for a while, but they will eventually become more and more
subdued. The reason is natural selection. For instance, one of the charac-
teristics you always see in all herds that are just breeding naturally and
without interference is that they will have perfect feet. Good feet are nec-
essary for survival, and any animal with anything less will die. Another at-
tribute is size, so you will also find a less muscular animal, one that is
smaller in stature. In my years of observing wild horses I've noticed that
after several generations, any given herd will revert back to smaller-stature
animals with strong feet. This is a harsh environment, and a smaller,
hardier animal tends to survive best.

When I first came to work for the bureau in 1957, I naturally became
cognizant of wild horse populations on public lands. That was two years
before Wild Horse Annie got her first legislation passed. The airplane law
put a big brake on commercial operations that mostly used fixed-wing air-
craft to gather the horses. After having observed that situation for a couple
of years, my perspective was that commercial efforts did in fact contribute
to the decline of wild horse populations. There were just some very large
and effective operations going on then. After the aircraft law I continued to
observe what occurred up until passage of the act in 1971. There was still
some commercial gathering going on; however, it was much more casual
and not well organized. It was done mainly by cowboys on horseback. Like,
some might come over to Nevada from California on four-day weekends,
gather a few animals, catch a few colts, and then take them back home,
either to keep for themselves and break them out or to sell them. There
were also some ranchers gathering them, either for use as working horses
or marketing them for loose pocket change. In my observation those low-
level efforts kept the wild horse numbers stable for that period. So in the
curve of things, prior to the 1959 law there was quite a declining slope of

wild horses, and then a stable population followed for the next twelve years. Unfortunately, there were still some abuses occurring, which Wild Horse Annie stumbled onto and effectively used to get legislation passed for full protection. When the 1971 act passed, it prohibited all gathering except by BLM. Immediately, horse numbers began to explode right back up, and with a very steep curve.

During the time I was in Montana, the Pryor Mountain Wild Horse Range was established and I worked closely with the national advisory board. Later, I came to Billings as district manager and we had a gather. Annie and Dawn Lappin came up at my invitation and they helped with that roundup. That was before 1971, and we gathered about twenty-three or twenty-four colts, as I recall. We weaned those colts and Annie took charge of getting all of them adopted. We also had a cooperative agreement with the Crow Indian tribe to take the balance of those animals, which were mainly stud horses. That event created the model for wild horse adoptions, and it was all done with Annie's personal help.

When I moved to Susanville BLM was trying to assert population controls in certain places where wild horse numbers had grown excessive. In 1976, I put together a gathering crew. They worked in Susanville spring, summer, and fall, and during the winter the same crew gathered for the BLM Desert District and the U.S. Navy. They also went on the road with mobile adoptions. So we had this firsthand experience with the whole wild horse program, including adoptions. Well, through the years, the bureau was getting itself into more trouble with a backlog of excess animals, and we began to work with the Experimental Stewardship Program in the northern part of the Susanville District to see how to streamline the program. We came up with some procedures that we eventually applied to all the herd areas in our district. It included gathering excess animals only out of the five-year-old and younger age group, and making them available for adoptions. For the last few years I was there, all of the animals gathered were desirable animals who were either adopted there directly or were put into the national adoption pipeline. Now, the flip side to this is: what happened to all the

older horses? Those animals were left on the range to die a natural death. Our approach was effective because we were able to gather the excess, we still left ample seed stock for a viable herd, there was an even-age distribution of the animals on the range, and we were able to keep costs down.

Because we had population levels established for California's land use plans in the Susanville District, and because we gave our plan a good test, a lot of people thought our concept could work nationwide. In the early 1990s, BLM put together a second National Wild Horse and Burro Advisory Board to try to address these problems, and the outcome was they did adopt the Susanville procedures. However, there was one major flaw: they attempted to apply the procedures to all horse populations, including the most heavily overstocked areas, and it wouldn't work on herds with double or more the appropriate number. It works only when you start with populations about 150 percent of AML or lower. So they did gather the horses, but they had to turn so many back out that it didn't work.

It's my feeling that with a really excessive wild horse population, BLM needs a one-shot effort to remove all the older, unadoptable animals. If Congress could give a limited-time sale authority to be able to move the animals through, for just that one period, to get that big bubble of horses out of there, they could then revert back to maintaining a sustainable herd population. I recognize that the idea of limited sale authority is terribly unpopular. However, a five-year window would enable the bureau to get to that point, and from then on it could sustain itself at a much lower expense. They wouldn't have to be warehousing unadoptable animals in feedlots, it would be a manageable program, and it would be in the best interest of the rangeland and the horses themselves.

Unfortunately, the concept of sale authority is so emotional that the topic has never been discussed in realistic terms. BLM has never been able to overcome the political chaos that would accompany an initiative like that. However, the U.S. Fish and Wildlife Service, in managing the Sheldon Antelope Range, had a population of wild horses that was well in excess of a thousand animals for years. USFWS doesn't fall under the prohibitions of

the 1971 act, so they routinely gather their wild horses and sell them, and they use the proceeds for their operation. It's a self-sustaining program that does not use any appropriated funds. So the precedent is there, and it has worked effectively. Fish and Wildlife has also never been chastised or taken to task by the public for any of this. So as distasteful as the idea may be to some, I think our society should consider using this means for controlling excess animals. The alternative is that BLM will keep muddling around with thousands of warehoused unadoptable horses.

Certainly, if Congress is willing to spend unlimited amounts of money, this entire problem can be kept at bay by providing unlimited expanses of land where excess and unadoptable animals are warehoused for the rest of their lives. That would take exorbitant amounts of money—a lot more money than has even been thought of so far. Because if you maintain a population base of fifty thousand wild horses nationwide, then an annual increase of 20 percent a year will require you to remove ten thousand animals each and every year. Maybe you can adopt out a few thousand every year, but that's still going to leave many thousands of horses that people won't adopt. And that situation will keep going and expanding and requiring more and more acres and more and more holding facilities where these horses have to be kept. So far, Congress hasn't shown any willingness to allow an unlimited bank account for wild horses. It becomes difficult to keep wild horse populations in check at the fifty thousand level throughout the West so that you have a reasonable number to be gathered and handled and put into the adoption stream nationwide. All of this has never been put in full and understandable context for the general public to absorb.

Actually, it comes down to much more than money. Using increasing amounts of funding to continue to warehouse wild horses is not necessarily in the best interest of the natural resources themselves, and hence of this nation over time. A complete policy change is needed, one that establishes a national population level that is manageable, plus a road map showing how to get to that level and keep it there, plus a congressional commitment to maintain it. Many people are unaware that the current law

doesn't prohibit selling or disposing of wild horses by other means. But because changing presidential administrations affect continuity, even the National Wild Horse Advisory Board has tended to address peripheral issues but never the heart of the matter. Congress must be the one to authorize such a program in order for BLM to maintain it effectively.

The idea of horses as a commercial commodity is very distasteful to a lot of people, especially if it's presented as unlimited or indefinite. I think that resistance is understandable. How do you develop assurances that the federal government wouldn't abuse sale authority? But if it was specifically limited to only a few years, there might be a better chance.

The passage of the 1971 act was the first time responsibility for any animal management effort was placed on BLM. Prior to that, the agency's responsibility had been land or vegetation, so the entire aspect of wild horse management was thrust upon them with no indoctrination or training whatsoever. I think BLM was plain ill-equipped to absorb it. From the top down, not one manager had any experience in animal husbandry. They didn't even know what kind of people to hire! The bureau is still struggling with this. I don't think they have ever risen to defining and setting standards about what a good wild horse management program is, or even of what kind of people should be hired and trained and brought into the program for it to succeed. There have been isolated pockets of success, but not overall. Public education has also been one of the most deficient elements of the program. The public should be informed so that all these things can be put in their proper context.

I have very fond memories of Wild Horse Annie. I worked with her until she passed away, and through the years we had a lot of conversations about her philosophy and objectives. During the heat of her campaign to pass the law, most of our discussions occurred on a personal basis; she was very careful about what she said publicly. Even though Annie had accomplished passage of national legislation to protect wild horses, she still had what I considered a balanced, reasonable view of how the law should be managed. It was with a great deal of frustration that she observed what some of the

more radical groups were attempting to do and in fact did do with the entire situation. A lot of it disturbed her. She was driven by a desire to make sure wild horses were not exposed to inhumane treatment, but at the same time she recognized that they needed to be managed and their populations controlled. It's my perception that Annie has probably turned over in her grave several times what with all the problems and power struggles that have evolved since.

John Falen: Stockman, Orovada, Nevada

People who raise livestock on public lands are often described as giant corporate entities. Well, that's absolutely not true. The strong majority of livestock permits are owned by family ranchers whose children are still involved in their daily management of the ranch, and the ranches may be in their second or third generation of operation. Most are in the three- to six-hundred-head size, particularly in Oregon and Idaho. These people all depend on those grazing permits; it's part of their livelihood.

In Nevada, the base property for a ranch is fairly small, which goes back to the Homestead Act in the nineteenth century. In those days, people in the Midwest could make a living on 160 acres. Very early on in the American West, it became clear you couldn't make a living on 160 acres because of the arid situation here. So the government gave permits to run livestock on public land adjacent to private property, and ranchers were able to use public lands to offset the difference. We've come by these permits for that reason.

A lot of people consider Nevada an absolute wasteland. They drive through on the freeway and that's all they see. But if you get off the highway and into the mountain areas, even out into the desert, there is a great deal of good land. Ranchers feel the reason much of this country is still productive is because we have maintained it and kept it that way.

Historically, the early settlers introduced horses here. After tractors and machinery replaced the need for work horses some ranchers left their animals out on the range and they went wild. It wasn't any big deal then.

When the U.S. Army used cavalry horses, some ranchers also turned out premium stallions with the wild ones. They would then gather those horses every fall, and a lot of them were sold. After the army quit buying horses the situation changed some, but ranchers still maintained those herds and kept their numbers under control. They kept some colts for themselves, they started some and sold some, but they never had an interest in getting rid of them. Contrary to some beliefs, they also did not abuse those horses. Now, I'm sure there were people who did capture mustangs simply for re-sale to the canners, but I don't think that was done as any large-scale deal. Most people who took care of the herds here were livestock people who cared about animals; it was done locally in their own area, and it didn't cost the taxpayers anything. Today there are very few ranchers in favor of eliminating wild horses. They get upset only because lack of management has allowed the herds to increase way beyond their intended numbers.

Right now in Nevada the AML should be about seventeen thousand horses, yet there is an amount of almost thirty thousand. We have a real problem here, but when it comes to scattering federal money around, the state doesn't receive even half of what's needed to maintain their numbers. A lot of people maintain that the most expensive part of managing these horses is the damage they can do to the range. It's more expensive than keeping them in a feedlot. Yes, monetarily, if you buy all that hay it's going to cost a lot. But when you factor in the damage that takes place around the watering holes and the range itself, it is much more expensive. The range is more time-consuming to repair. It takes years to heal.

Sure, horses compete for the same forage cattle use. In the spring, if horses and cattle are on the range at the same time, it can be difficult to get cattle to cycle so they breed correctly. So there are a multitude of problems. But we can work with wild horses being out there if they are managed correctly.

The perfect example to show that there are too many mustangs is that we are in a drought situation now. There isn't anything more destructive—to fences or water tanks or water holes—than when livestock run out of water.

Cattle will abandon their calves and create all kinds of problems instantly when they run out of water. With horses, it's just as severe or even more so. Anytime there is an emergency situation they should be gathered. One reason is to save the condition of the horses, but the second is to prevent so much severe destruction to the range. I want to emphasize that. It's the range that matters.

I'm convinced that those particular people who think wild horses should be left out there all on their own do not, in any way, shape, or form, see the whole picture. These horses multiply so fast, and they can cause so much damage. Right at this minute, if their numbers were to continue unchecked, in ten years there would be over 100,000 horses in Nevada. What a lot of people also don't understand is that livestock are controlled. We move our cattle from a spring area to a summer area to a winter area. We bring them in to the ranch the first of the year and take off the calves. But wild horses stay out there twelve months a year, 365 days at a time. They move from water hole to water hole. Yes, they will migrate because of the season, and if the upper country is filled with snow they'll come down to the desert during winter. There is natural migration that way, but there is presently no management as there is with wildlife or livestock.

All things being equal, the most expensive thing that has been allowed to happen is for bureaucrats to manage these animals. They haven't been managed well. They've been allowed to multiply and go on denuding the range. Folks used to talk a lot about horses versus cattle, but I think the true problem is horses versus the natural resource. Like down in Nellis, when their numbers grew, those horses were starving to death and totally emaciated. The range matched what the horses looked like. So the range gets hit first; it gets poor and denuded before animals do. Anytime you wait until the animals get thin, it means you've waited way too long.

Understanding what happens in any particular area comes from years of experience. Today this country is all fenced up and we're all on allotments. Through the permittee system we are allowed to have so many cattle for each allotment. We do utilization studies for the forage. Every year we check

different sites on the fields with BLM. Maybe one year we've got 30 percent utilization, or maybe it's 40 percent or 50 percent on the uplands, but we always stay within our authorization. Many permits do allow for 70 percent utilization, but the amount is always lower in riparian areas and so forth. My point is that, over time, you learn how many cattle can use a particular area. We might vary that some, on dry years versus really good years, either by lowering their numbers or by shortening the season, so there's some flexibility. But when horses are left entirely on their own out there, then the benefit of all of our efforts is lost.

Whenever there is damage to the range, the first thing to do is lighten the use. This country will revegetate, and it will repair itself, but you have to give it time. When you allow horses to multiply to such a point where it affects the land, you not only create a situation that's bad for the horses, but the livestock operator has to take his cattle off to compensate. Many times the only thing the federal government *can* control is the cattle. The permittee will reduce their numbers, but so many times the horses are still left to increase.

Many horse enthusiasts maintain that if the government takes off a certain number of horses, we should take off an equal number of livestock. But right now these horses are way over the appropriate numbers to begin with. Once you get to AML with these horses, whatever the number is, and we still see a degraded range, then at that point it is certainly feasible to say we should reduce cattle and horses in equal numbers. But until that AML is reached, it's not the ranchers' fault that the government hasn't done its job. Those people who feel wild horses should be left entirely on their own are small in number; however, they seem to have a great deal of influence.

Most people in this country do not understand the cycle of events on our public lands. If they knew what all of this was really doing to the range, I'm sure they would rethink their position. I just cannot believe anyone would want to see these lands denuded because of one particular train of thought. Although there may be many people that are uninformed, let's not allow the uninformed to be in charge of managing the range.

The word "renewable" means something. On our ranch we harvest our hay meadows each year. We don't harvest with a swather or a lawn mower, we harvest with livestock. It's the same on public lands. If you look at our meadows, they look good. We've taken the hay off and it's in the stack yard now. However, it often happens that if someone sees short grass on the public land, the perception is that land must be abused. It's not. All that's being done is that the grass is being harvested. Plants need to be harvested to keep them thriving, just like your lawn or flower garden. Outside of certain areas in this country, such as our national parks, we need to harvest.

There is no rancher I know who has any problem with the multiple use concept on our public lands. The problem is that if any species, whether it is elk or deer or wild horses or what have you, is allowed to become too numerous, then it's often livestock people who take the blame. But it is ranchers who maintain the water facilities that both wildlife and wild horses use. We maintain the fences. We rotate our cattle to maintain the usefulness and viability of the range. Now, I am the first to admit that some people in the ranching business, for whatever reason, are not astute in managing their lands well, and I think it is up to us to ride herd on them. But for the most part, I maintain that livestock people are the best managers of the range simply because we depend on it to make our living.

We are all here for such a short period of time. It really doesn't make any difference whether you're an average citizen or government employee or public land manager or a tenant who leases a certain property or a private landowner. Any way you stack it, we're all here for only a relatively short period of time. We are all stewards of the land for the time we are here.

Gracian Uhalde: Stockman and Wild Horse Commissioner, Ely, Nevada

My grandfather left France in 1881 and came to Idaho to herd sheep. He got a chance to trail about twenty-five hundred head from Shoshone to Carson City, and in return he got three hundred sheep as a grubstake. They gave him a tent and a burro, but about three days out a bear killed his burro, so he left everything behind anyway. It took him about six months to trail

those herds to Carson. He didn't have any map. Somebody would point and say, "See that mountain range down there, that funny peak? Well, go on the other side of it and you'll see another valley and go across that." That's how he went.

That's how our ranch got started, and it has always been a family operation. It ties into horses. My grandfather John had a brother also named Gracian, and they married twin sisters from the old country. Their family was in the north end of Butte Valley and our family was in the south end. Over in the Steptoe Valley there was also an Italian family by the name of Salvis, and another family by the name of Cordano. All their kids went to school together. Before the 1920s the Salvises, Cordanos, Parises, and the Uhaldes ran their horses together. They relayed them from one end of Butte Valley to the other.

There were always lots of horses in the valleys north and west of Ely. During the 1930s there were also a lot of little homesteads on the outskirts of town. The folks who lived there had a few horses, and they made moonshine, that kind of thing. As time passed, my grandfather bought up most of those little homesteads, and all of those horses ended up out on the flats. Some of them came from Oregon. Eddy Dragasavitch brought some roans down from Burns. They were big horses that he used as a work team, and you can see a lot of those bloodlines still there in Butte Valley. There's also some big palominos over in Long Valley. The mustangs down near our winter range are all hammer-headed and tiny. They've been in a closed gene pool for so long they got pretty well inbred. That's when you start seeing horses with crooked legs and things. The country is also much drier down there.

My dad and uncle grew up chasing mustangs. That's how I grew up, too. Whenever we were pushing cows or just anytime Dad had a chance to go after horses, we just dropped everything and took off. We'd keep some that we caught, and we'd sell some. All I ever knew was that it was ranchers who kept the herds in check. I'm not saying there weren't some atrocities going on, but I don't think it was as much as what some people thought. Then the

act passed in 1971. In a lot of ways that has been good. It guarantees there will be wild horses around forever.

The first time I caught a mustang was when I was eleven years old. It's a favorite memory of mine. We were up on Butte Mountain moving yearling cattle and we saw this bunch of horses. One of our sheepherders was with us. We snuck up on them there, on a ridge, and we bailed right down into the middle of them. My dad got the one he wanted; it was a yearling filly. She was a red roan, and he called her Beauty because she came from Butte Valley. He rode her his whole life. We still use wild horses on our ranch today. I used to break and train them, but my sons do most of it now.

Later on, the Salvis, Uhalde, Paris, and Cordano families went together on a horse-breeding deal. Everybody had horse permits then, and all of our horses ran together. We put good studs out with them. Our family also had a smaller permit for about thirty head of horses out behind 30 Mile, and we put our best stud there. My dad and uncle were also in the racehorse business for a while. They had a horse named Lindsey A who was a Triple A racehorse. He was at Santa Anita, and he held the track record at Phoenix. They almost got themselves run off the ranch because of that. My granddad got so mad he said, "You either do that or you do this, but you can't do both." That's what I mean. They grew up with horses, and they loved them.

In my day we used to skip school and chase horses. We knew where they hung out, so we went right to where they were. We never caught that many, it was just fun. One day my cousin Pete Paris and I caught a horse in Butte Valley. We loaded him up and brought him back, all in one day. Another time my uncle Pete brought a horse to town and my cousin Mickey was going to break it, so we took it to the schoolyard at the Ely Grade School. There was a big playground there, and the train tracks ran right along parallel to it. One day after we'd been sacking it out in the corral, Micky got on him. Just then, here comes that train, and it blows the whistle, and that horse takes off and gets down to the other end of the chain link fence and stops, and old Mickey went flying! He busted his arm pretty bad that day.

The other thing about old-time mustanging was that if you lived forty

miles out of town like we did, well, there wasn't too much to do if you wanted to have fun and stay out of trouble. A lot of times folks would come out to visit or work on the ranch, and we'd show them how to chase horses, too. If we caught a bunch of fifteen or so, maybe that would get enough money for everyone to buy a new pair of cowboy boots or something. But as far as making a lot of money? Hell, it was never a money-making proposition! We tore up way too many vehicles and too many of our own horses for that.

When the government closed down the horse permits we had to get our own horses off the range. The Parises and Uhaldes got together and built a horse trap out of trees out in Butte Valley. We got about three hundred head of our horses then, but we never got them all. That was all right with us, because by that time some of our horses were getting harder to manage and corral. A few years before, Dad tried to trail some of them and things got out of hand. We took off one stud because he was getting too wild. I remember when they brought him in. They had to put about an eighteen-inch hobble on him just so he'd have to slow down. He was a better-caliber horse, but he'd been out there a few years too many and he was really out of control. So that was the end of his stud days.

Everyone who lives here has feelings for horses. If you can get a good mustang off the range, and if they're not hammer-headed or inbred, they're definitely more durable. They're not the kind of horse that loses heart if you ride them every day. They're used to watching out for themselves, and they're a pretty dependable horse.

I think the mythical allure that surrounded the mustang caused a lot of hard feelings between people. For thirty-five years there was a lot of polarization. Now I see that changing. The people who are close to the ground, and who really care about these horses, are finally putting their differences aside to do what's best for the land and the mustangs. They're starting to work together. Shucks, I don't think there has ever been a rancher in Nevada that wants to see every horse gone. I know I sure don't.

Having too many wild horses really does have an effect. My uncle Bert Paris is dead now, but he used to lamb across the valley from our place. I

don't know for certain, but I think Butte Valley was originally supposed to have about a hundred head of horses, and those herds there grew to be at least three or four times that much. One year my uncle Bert was trying to lamb there, and it had been about a half-dry year. There was nothing for his sheep to eat, and all you could see was dust all day long from hundreds of horses going back and forth to get to his waters. We were luckier. I don't know why, but we didn't have as much horse use on our side of the valley. I remember thinking to myself, "How in the hell can that guy sit there and watch all of that happening, and still keep on trying to make a living and not get mad enough to go shoot some of those horses?" But he never did.

We don't run as many sheep nowadays. We run more cattle and we're trying to diversify. I don't think all people can be knowledgeable about all things, and I also don't think you can do many different things and still be good at very many of them, but that's what a lot of family ranchers are doing. There are certain places where sheep fit better on the range than cattle, and certain places where cattle fit better. Basically, they complement each other pretty well. We move them up north in the summer and south to warmer country in the winter. The wild horses have always been around, and they're not any competition when it's a balanced situation.

Right now wild horse numbers are definitely out of proportion in Nevada. In some of the really dry areas, like down in Lincoln County, there is very little for them to eat. There are a few horse groups who are sensible, but I think some of the others don't care what happens here. They never take the time to come out and have a look for themselves. That's what upsets me. It's not the horses, it's the attitude of some people.

The wild horse definitely has an aura about it. It's about the myth of the American West, and people really get swept up in it. When people first saw those atrocities happen thirty years ago, I think they got on a bandwagon and the pendulum swung one way, and we've had to wait all this time for it to swing back. If the government gets these herd numbers where they should be and keeps them there, then the mustang has a good chance to be something special again in our country. They would be rare, and they would

be a true, unique western horse. They should be seen like that. I hope so, anyway.

Dave Mathis: Wildlife Historian, Reno, Nevada

When I was a kid we did everything with horses. We plowed, we cultivated, we mowed, we raked—all with horses. The tendency in those little farm communities was to treasure draft horses. In Lund there was a group of Mormons who always chipped in to buy a fine stud together (maybe it was a Belgian, a Percheron, a Clydesdale, or what have you) and he would breed all their mares. They had a great bond with their animals, and mustangs were included in it. My cousin had a real good-looking colt whose sire had been a purebred Quarter Horse and the dam was a remount Thoroughbred. He never gelded that horse until it was four years old because he wanted it to breed up. He let all his domestic horses run free on the range near Douglas.

Rural kids of my generation had a different concept about the cycles of life and death. You'd see animals die of natural causes, and since most people butchered their own meat you'd see cattle and hogs killed all the time, too. When I was growing up my mother would say, "Go catch a chicken and kill it," and away I'd go and put that chicken's head on the block. *Pop!* The head would come off and that chicken went flapping! My sympathies were always with that chicken, and I'd cry a lot of times. But I knew it was the only way we got fried chicken and country gravy for dinner.

To see wildlife carcasses on the range always bothered me. Take deer. One of the biggest killers of wildlife is winter, and the toughest time is late winter. All summer and fall deer store up reserves to get through the winter season. The bucks get fat and heavy, but they get into rut and some of them come out pretty poor by winter's end. Deer also carry external and internal parasites, so there's any number of hazards waiting to happen if their nourishment gets below a certain level. If it's a pretty good year and a mild winter, a lot of deer survive. If it's a poor year and a tough winter, you lose wildlife to starvation. These are hard realities in the Great Basin.

Today in the West, humans are interfering with the life cycle everywhere. We impact it with agriculture, with housing and developments, with roads. One major impact has been the popularity of four-wheel-drive utility vehicles. The public has more access to the backcountry now than ever before, and that also opens up more opportunities for poaching. Some people like to shoot anything and don't care what kind of animal it is. Driving the back roads also impacts certain kinds of wildlife, especially during spring.

Wild horse numbers are certainly subject to natural forces. The more we reduce domestic sheep and cattle, the more we open up those ranges for horses and elk to increase. From what I've seen, horses are also tougher on the range than cattle. I believe that's true because cattle are ruminants. They have four stomachs and they chew their cud. If you observe cattle over a twenty-four-hour period, you'll find they graze pretty hard for a while, and then in the heat of the day they'll go shade up and chew their cud. Horses have a straight gut. A horse may take time to rest in the shade, but he's got his head down eating most of the time.

Our problem in Nevada is not only lack of water but the lack of a growing season. We may get only three months out of the year; say, from the last frost of spring to the first hard frost in fall. In the interplay of wild horses with wildlife, I believe that in those places where horses chew heavily the damage would affect all the wildlife, including sage grouse. I don't believe mustangs impact deer that much, because they feed differently, although throughout the West there seems to be a downward trend of mule deer.

If you ride the high country you'll see grass coming back. I just rode up Table Mountain in the Monitor Range, and I've never seen that country look so beautiful. There was Indian paintbrush and lupine and grass all over. That mountain slopes fairly precipitously up to about nine thousand feet, levels off, and then slowly goes up to about eleven thousand feet in all. It's beautiful horseback country, with big aspen patches and some pine and mountain meadows. There haven't been cattle of any consequence there since about 1990, and now it's a wilderness area. I've been riding there since 1975, so I know it well.

The only reliable report of elk in Nevada was in 1859 in White Pine County. It's curious why, if there was more grass back then, there also weren't more elk. One of the reasons may be that at the top of these mountains you get an annual rainfall of twenty to thirty inches, but down in the valleys you may get only about six inches. With wildlife, you must consider the intermediate and lower ranges. You might have feed in summer, but if it's not there in winter they can't survive.

In 1932 the Forest Service shipped thirty elk from Yellowstone National Park to begin an elk herd in Shell Creek. Two years later they planted them in the Spring Creek Mountains out of Las Vegas. After that, no introductions of any consequence were made until 1979. Now elk herds are building up again. On Table Mountain there are an estimated six hundred head of elk. It's good, high summer range. There aren't wild horses there, but there are some in the Monitor Range at Butler Basin. I anticipate competition emerging between elk and horses at some point because they eat pretty much the same feed. An elk's feeding habits are not too different than livestock, but an elk is more a grazer of grass. An elk also requires about the same amount of feed as a horse—about twenty pounds a day. I don't necessarily see any problems with summer ranges, but on intermediate and lower winter ranges I can see it occurring.

The health of the range depends on managing things correctly. What's needed is to determine the right mix for the range, and that's difficult and complex. After years of observing this, I've seen too much interference on all sides of these issues from outside interests who interject ideas yet don't understand how things work. All this does is muddy up the water!

I've always had horses. For as long as there have been domestic horses in Nevada, there have also been wild horses. The mustang will never become extinct in the Great Basin simply because even if it were possible for every last one to disappear, all we have to do is open the gate and let some more out!

Ron Hall: National Wild Horse and Burro Program, Reno, Nevada

As a bureaucracy, BLM is just like any group of people. It's resistant to change and has a tendency to get set in its ways. The wild horse program has gotten used to doing things a certain way, too. We've done nothing but try to get numbers in balance with the habitat, and people are accustomed to thinking in a gather-and-removal mode. I do a considerable amount of training to get people headed toward selective management now, and it's a totally foreign concept. If all you've ever done is gather up horses, and all you have to think about is only what you've been told to do, well, that's a pretty simple decision-making process. Some people resist having to think more, but they absolutely do need to start thinking about the age structure of the herd, the sex ratio of these horses, and how to make decisions accordingly. What do they want that herd to be? What type of horse should they manage for? Should they manage for a big, beautiful horse or for something capable of surviving in a particular habitat? These are the kinds of questions we need to ask.

There are value judgments here, of course. What's beautiful and what's not? What's functional and what's not? What has happened is that the entire program has been driven by the adoption market, and in some places we've been trying to grow horses to meet that market. But many of these habitats are not capable of supporting bigger kinds of horses. There's a tremendous gift out there if we can learn how to treat it right.

All of us come to our work with inbuilt prejudices, especially if we're horse people. If someone likes Quarter Horses, say, they're going to prefer a thirteen-hundred-pound horse because that's attractive to them. Or someone who likes endurance riding will be attracted to Arabians or Morgans. People in the wild horse program have different philosophies and opinions, and traditionally each one has gone in their own direction. In my view we should be more consistent. Decisions must still come down to each horse specialist in the field, but they shouldn't be based entirely on the requirements of the adoption market. On the other hand, there are a lot of

people who say we are producing a product with wild horses. Well, nature makes the choice over time, and, yes, we do fool with that. All the color and variety we see in wild horses today were put there and perpetuated by humans.

Evolution is a long-term process of a single species adapting to environmental changes. Sometimes this requires thousands of years. When you take horses from a domestic environment and then turn them out loose on the range, there are going to be some very short-term changes that happen. Horses with poor feet won't make it. Those with genetic defects die out. Horses without good bones and stamina die. Those kinds of changes all happen rather quickly. In areas of the Great Basin where horses have lived for 150 years, you will detect a different type of horse on almost every range. That's based first of all on the original founder's stock, and on the changes that occurred as a result of natural selection since.

My idea is that if we left these wild horses alone for a period of time—not too long, maybe a few hundred years—we would eventually have a bay or brown horse that would be about fourteen hands tall and would be about eight or nine hundred pounds, and would be tough, durable, and smart. It would be a unique wild horse. My belief is that the public will someday recognize the value of a tough little desert horse, and once they do there will be a demand for them. Today, however, any small, brown horse is the least adoptable animal in any BLM corral, since most people who adopt base their selection on color and size.

This argument has been around the wild horse program forever: should we manage for adoptability or adaptability? I believe in survivability. We ought to understand where the process of adaptation is headed. We should be practical to the extent that we can, but we should at least assist the process instead of being opposed to it. If you take an arid environment that's capable of supporting only an eight-hundred-pound horse and try to grow a twelve-hundred-pound paint horse there, it's like swimming upstream.

Sometimes you can have both, especially if you do things properly. Southeast Oregon has the Kiger horse, and it's a unique wild horse that's

capable of surviving in the high desert habitat. They definitely don't have any problem with adoptions. The same holds true for Wyoming horses. Up there, wild horses are as close to looking like a domestic horse as you can get. There's lots of feed and water, and even though winters are harsh, those horses all have a good coat so they stay warm in winter. But if we left any of those horses alone for a certain period and didn't continue to selectively manage for those qualities, they would eventually become a smaller horse over time, too.

There may come a time where certain herds will be managed more self-sufficiently for each region. But there are over two hundred herd management areas around the West, so there will be just as many that are managed according to what each local horse specialist decides. Something I've struggled with for years is that rather than impose our bias on any particular herd, maybe a gate cut is simpler. That means if we're going to remove a hundred horses from one area, maybe it would be better to just go capture one hundred and take whatever comes off, no matter how old they are, and what's left over is what stays out on the range. There are some problems because a gate cut means skewing the sex ratio strongly in favor of the males.

I'm currently working on a national format for population management plans, and selective removal is where we're headed. But our individual field people are going to have to make the decisions. Certainly we need to be up front with the public in terms of what we want and need to do. We also should listen to public input, since some special interest groups definitely have opinions that are opposed to ours. There are also many people who are very knowledgeable about these horses. If the public can see that managing wild horses is a difficult process and that these are difficult decisions, that will be a sign of progress.

We started to selectively manage the Pryor Mountain herd back in 1970. Talks were under way to discuss fertility control back then, and we're still working on that. There have been a lot of good minds applied to trying to solve this problem, but there just doesn't seem to be a solution to overpopulation of wild horses. The adoption market drives what we do in the field,

and we've never been able to overcome the fact that when facilities are full, we just don't gather. There are some herds that have finally gotten down to AML, but there are many others that haven't. That's especially true in Nevada.

I've been in several situations where there were major die-offs because there were too many horses on the range. The first time was during the 1970s, in the Buffalo Hills and the Fox Range. We went through the same thing all over again on the very same mountain range in 1994. It's not pleasant, and we're not doing the horses any good. Nor are we doing the habitat any good. We're not helping anything.

We certainly do need other avenues for disposal of the horses, but that is precisely where this all becomes a political issue. But if there's one thing I've learned in thirty years, it's that you cannot manage wild horses politically. Budgets fluctuate, different people are always coming and going, and no sooner do we do one thing than another bunch comes along and off we go headed in a different direction, with different sets of values and priorities, or for that matter no priority at all. A lot of people in the agency realize what's at stake, and we've gone around and around with all kinds of solutions. We maximized gathers and stuffed every feedlot in the country during the 1980s. Pretty soon that ate up all of the budget, so then we put a massive effort into getting those facilities all cleaned out. Now we're doing the same thing all over again. Politicians are aware these animals are a volatile issue, so no one wants to tackle it.

One thing we desperately need is to get immunocontraception to where it's a viable tool, but it's still not perfected. Right now, whenever we reduce herd populations we increase productivity. Our most significant mortality rate is still with young foals. Some of them just never make it through their first winter. Of course, there is mortality in the older horses too, but it's much less.

In all honesty, the only way to go about managing wild horses is one step at a time. But it seems that just about the time we do manage to get on top of

things, some litigation usually occurs that sets us back. You don't have to be down long before you're right back to where you started.

The function of the Washington office is to set policy for the whole program. Our policies are broad and apply to all the states, not to specific situations, but we do try to get information from the local specialists and understand what their problems are before doing anything. For example, I've been in the field over the past month to assess emergencies. If a fire burned in one area, I went to see how much it impacts the horses and what we should do to mitigate problems. Usually, specific decisions are left to an individual office and to each horse specialist. The forthcoming population management plan will be more specific, but it still won't spell out what strategy every individual should employ. It will just give a recipe or framework.

I adopted two wild horses ten years ago. The first came off the Calico Mountains. I was on the gather when we caught him. He was pretty wild but I still liked him, and I thought that if he were young enough I'd see about adopting him. Well, we put him through the chute and pretty soon he was clear upside down in it, that's how wild he was! After we aged him he turned to be almost five years old, and I thought he'd be too much to handle. So I put it in the back of my mind and we shipped him to Palomino Valley. About six weeks later I was at the corrals talking to one of the wranglers. Just in passing, I asked him, "Hey, there was a buckskin stud we shipped down from the Calicos—you wouldn't happen to know if he's still around?" "Oh yeah," he said. "He was in a pen with two hundred studs and had every one whipped back in the corner—you sure don't want that horse!" I went out and looked at him again anyway, and I decided to take him.

It takes a lot of time and patience to train any horse. I'd been around it some with my own horses and pack animals, and so I trained this one myself. After about two weeks I had a saddle and some weight on, and a day or so later I was riding him. Once he got to a point where he trusted me and I trusted him, we developed one hell of a relationship. In fact, once he came around he became a pest. Whenever I'm out in the field now, he'll come

over and pull at my shirt, or he'll pick up my tools and run off with them! He's incredibly smart.

I've been involved in this wild horse program for thirty years. That seems like a long period of time, but when you think about it, it's really only three horse generations. Working with these horses in their natural environment and understanding what their needs are is what I enjoy. I just like being out where they live. My heart is with these horses out on the range. They are worth it all, and I wouldn't live without them.

Jan Nachlinger: Biologist, Reno, Nevada

My work has allowed me to spend a fair amount of time out on the landscape looking at the vegetation and the natural ecological systems. What I've observed has always been within this plant ecology context. I've never been able to tease out the impacts of wild horses apart from livestock grazing or from altered fire management or other things of that nature.

I recall many encounters with wild horse bands in the southern part of the state, especially around Stone Cabin Valley and Railroad Valley near the Hot Creek Range, in the 1980s. From my perspective, I still see too much use of the native vegetation. Unfortunately, horses have a different way of impacting the native bunch grasses. They rip the whole plant out of the ground. There's a whole spectrum of people who want to see wild horses on the range, and I know they have good intentions. What concerns me is the fact that wild horses are an exotic species, and because of the natural climate conditions they are just hard on the land.

The other aspect that concerns me is the impact of wild horses on the isolated spring systems in Nevada. We have over thirty thousand naturally occurring spring systems here, and there are some really interesting aquatic animals that occur in them. I'm thinking mainly of the spring snail, but there are other aquatic animals and endemic fishes, too. Spring snails are very tiny (about the size of a coarse pepper grain), and the Great Basin is probably the center of their distribution. There's probably eighty-five different species that occur in these springs, and since the Pleistocene they

have evolved into separate entities that are just amazing to me. If their system happens to be a spring that's frequented by horses, livestock, large game, or even people, they're endangered. Desert springs are an incredible resource, and we should be concerned about them. When I see the ripping of whole plants of bunch grasses and see trampling evidence that occurs at spring systems, it's disconcerting.

There are ways of managing springs that can provide a water source to wildlife and livestock as well as provide for the natural habitat of the native species, whatever they are. I usually distinguish between springs that are in good natural condition and those that have been altered, either through diversions or by piping water away from the spring source so there's no native habitat left at all.

I spent a lot of time doing ecological surveys in the Spring Mountains in Clark County, evaluating the habitats and providing management recommendations to federal agencies who manage the land. They're called the Spring Mountains because of the inordinate number of springs there, and a lot of exotic animals have impacted them: burros, wild horses, and elk. We studied about sixty-five springs over a couple of seasons for both the Forest Service and the BLM and made a series of recommendations. We looked at the ecological condition with respect to access for people. Was it easy to get to? Could they drive right to it? Did it entail a short walk? Or if it was on the other side of the hill and without a trail, would it take some effort so that hardly anyone went there? We looked at the natural biodiversity that occurred there, the interesting plants and animals and their condition. There was a definite correlation between the availability of springs to people, livestock, and horses. Then we made comparisons with areas that were fenced versus those that didn't have fencing, and the condition of biodiversity in those areas. It was apparent that the easier the access, the worse was the condition. There were some that were completely without any native biota because of large impacts. Because of our recommendations the federal agencies are now moving those points of diversions away from the spring sources. In two springs in the Red Rocks National Conser-

vation Area, spring snails had been eliminated. BLM is now working to improve the habitat and reintroduce those spring snails (luckily, there was one other spring where that particular species lived so they could do that). There are other instances where agencies have adopted management recommendations based on our concerns about overall biodiversity. In certain sites where we identified a particular wild horse problem in one of our conservation plans, a few federal managers have considered zeroing out a particular herd to improve the situation.

In the Great Basin we focus on sagebrush ecosystems that support many sagebrush-obligate animals, but just about everything on the landscape needs to be managed at this point. We've altered everything to such a degree and there are so many complicating factors that nature just won't work on its own anymore.

Wild horses are an entity that often adds to excessive herbivory on the landscape as separate from livestock. In some places livestock may have had a historic role but not a current one, but even if cattle are currently setting the stage for problems, you can still manage them. To oppose only livestock grazing on the range won't solve any problems at all if the ultimate source is wild horses.

Louis Provencher, Ph.D.: Range Ecologist, Reno, Nevada

Great Basin vegetation did not evolve with large ungulates. There was a period when horses, camels, and sloths were here, but that was all a very long time ago during the Pleistocene. It was a very different environment then in terms of upland vegetation and everything. The sagebrush system we have now dates back to five thousand to seven thousand years ago at most. True, some plants may have prior adaptations to grazing, but in general it's not believed they retained those same adaptations over time. Since then the climate has changed and still continues to change, so you have to put everything in the context of the current habitat. Pronghorns, mule deer, and elk (who were once here historically) are now coming back in eastern Nevada. But it's not just that the plants can't respond to extreme grazing by

cattle, horses, and sheep. It's the fact that the soils are not adapted to it. In other areas of the Intermountain West where vegetation has evolved with large ungulates, it's different. Here, ungulate trampling causes runoff and erosion of the soil.

People don't ever think about soil. We walk on it all the time, but most of us never think about it. Most people also don't know about what we call the cryptobiotic crust. In arid lands (which we consider fifteen inches or less rainfall a year) the cryptobiotic crust is an association between a lichen and an algae. It serves two functions: one, it prevents soil erosion; two, it fixes nitrogen, which in turn benefits plants. It has been shown that if you destroy the cryptobiotic crust, either by stepping or trampling on it (and it really doesn't matter by whom), the soil-binding capacity will come back pretty rapidly in a couple of years. However, on some soils it can take up to twenty years to recover the nitrogen capacity of cryptobiotic crust. You can imagine what happens if you take an arid landscape with no history of large ungulates and then put livestock and horses on it and give them constant, unlimited access. The only difference is that livestock are at least rotated (in other words, managed) but wild horses are not. When wild horses go to these same ravines where there may already be a lot of erosion, you lose the ability both to hold the soil and to fix nitrogen.

· * *

WHEN PRESENT, the cryptobiotic crust is hard enough to prevent cheatgrass seeds from germinating. However, it has been shown that once the crust is broken and there's sufficient moisture over a long period of time, cheatgrass seeds can germinate through it. At one time, the cryptobiotic crust in arid lands and high deserts was all over the place. You still find some layers of it underneath clumps of sagebrush, but much of it is reduced. This has affected the spread of cheatgrass everywhere.

Here at The Nature Conservancy, we do ecoregional planning on a particular region. The Great Basin is one ecoregion. We first identify the landscapes present that have the highest concentration of biodiversity. In some

of those landscapes we may also do conservation area planning. For instance, we will identify the most important targets for conservation. They might be community types or a certain species, whatever is more appropriate. We identify the impending threats that are present, and then we identify the ultimate source of the threat. Following this we recommend a strategy to abate the threat, and then we monitor success of our strategy. We also invite expert opinions from people who actually work on the land, and we ask them to identify threats as well. We consider wild horses a source of excessive herbivory, and we relate that threat to grazing by livestock or wild game managed at high densities. It does happen that of the excessive herbivory category, wild horses are often at the top of the list of the problem, both in riparian systems and in upland systems.

Excessive herbivory is becoming increasingly important because of the sage grouse. Several stresses are impacting the uplands. One result of excessive herbivory is the loss of perennial grasses in the sagebrush systems. If those areas are lost because livestock, elk, and wild horses are hitting it, and the wild horses are not regulated but the livestock and the elk are, then the likelihood is that if the wild horse problem is not controlled we will eventually see successful petitioning of the sage grouse as an endangered species. If that happens, land management will change dramatically. There are presently many people who think of issues surrounding the sage grouse and the wild horse as co-related.

The difference between livestock and wild horses is that you can manage cattle and sheep to achieve certain conservation results that are beneficial to sage grouse management. It may not be perfect, but it can work. For example, you can use cattle to increase sagebrush cover up to a certain point, and then pull them off to do another kind of grazing. You can't do that with wild horses. If the sage grouse becomes listed, the wild horse problem will need to be directly confronted, and the issue may come down to the Endangered Species Act versus the Wild Horse and Burro Act. If that happens it could also be that in the eyes of the public, ranchers will be blamed for excessive grazing, and then *all* of these issues will get even more

mixed up. It's a very complex situation, even though most people never see the difference between horses and cattle and sheep. They're each totally different.

Another important issue relates to fire. Nevada formerly had a fire regime with a normal frequency rate of between 20 and 125 years depending on soil conditions. What drove that frequency were native perennial grasses that grew in the sagebrush semidesert. Once you take away native grass fuel because of historic livestock grazing, you don't have fire occurring as naturally. Pinyon-juniper then moves into the sagebrush systems. This creates the kind of fire hazards that now exist around Reno, and it's also the cause of catastrophic wildfires that have occurred throughout western rangelands and woodlands. Following this, cheatgrass takes over. That becomes yet another problem, because then you have a cheatgrass monoculture where once there were fine native grass fuels and shrubs. Once cheatgrass moves in, it alters the natural cycle again. It provides for a more frequent fire return and a more intense fire than would be normal. In these conditions native plants never have a chance to recoup and reestablish. None of this helps.

It has been proposed to use sheep and goats to reduce the biomass of cheatgrass during critical moments in the growing season. Sheep and goats can be trained to prefer those weeds, and that strategy seems to be working. However, there are so few sheep left in Nevada that this isn't going to solve all of the problem. Cheatgrass is palatable as feed for only a short period of time, and afterward even sheep and goats won't touch it.

Fences are another issue. One arid lands model comes from the Malpai Borderlands Group in Arizona–New Mexico. Because of scant rainfall and the patchy nature of the range on the Chihuahuan Desert, you can't run a livestock operation on a small scale. If a thunderhead doesn't move over your property and deposit rainfall at a key time or place, you'd be in a bad position. What is proposed there is a return to an open range concept. If some fences are removed and ranchers work together, they can move livestock to follow the rain patterns as they occur. This would not only reduce

overuse of the natural water holes and springs but also encourage better livestock management. Wild horses would benefit, too.

We consider cattle, sheep, and horses to be exotic animals. They're not native in that they didn't come from the North American continent. In our view, wild horses are feral animals, as are wild hogs (domestic pigs that have gone feral in other parts of this country). The difference between wild hogs and wild horses is that one species can be controlled by hunting while under current law the other can't.

The meaning of stewardship involves accepting personal responsibility for the management of the land. It's more than being told to manage it well and therefore doing that. There has to be true, deep commitment. We try to be very focused and specific. We want to find the best and most significant areas to capture and preserve the greatest amount of biodiversity of the Great Basin. Every time we perform any action on the ground we try to plan things so that we learn something that is statistically valid, so we can gain something or extract information from that and then show that what we did actually made a difference. We want science to serve stewardship, not the other way around.

Mike Turnipseed: Director, Nevada Department of Conservation and Natural Resources

In Nevada water use is complicated because the state is so broken up with mountain ranges and faults. We have a deep carbonate aquifer, and the limit and extent of that, and how it interfaces with the alluvium, are not well understood. Yucca Mountain, for example, is probably the most studied yet least understood groundwater hydrology in the world. There you find a deep system of flow overlain by volcanics, and then that is overlain by the alluvium. How those interact is still somewhat unknown.

Like all western states, Nevada is a prior appropriation state. This means that the first one to use the water holds the first right to it, and right on down the line. So an 1860 priority water right is filled first, and then 1861,

1862, 1863, and so on. Say you have a 1912 priority water right on the Humboldt River; well, this year you probably didn't get any water because it was so dry. Of course, the larger the property, the larger the amount of water, both in instantaneous flow rate and what we call annual duty or the annual volume. Depending on where you are in this or any western state, you also have warmer and colder climates, and so the amount you're allowed over the full season is less, say, in northern Nevada than it is in southern Nevada. Or it may be less in Montana or Oregon than it is in Arizona, simply because growing seasons are much longer in those climates. Consequently, in a good water year an 1897 water right might last a full season, but in a dry water year an 1897 water right might not receive any water at all.

The legal statute says that all the water in the state above or below the ground belongs to the public. Whoever holds that right doesn't own it; they only have the right to use it. An analogy might be that if you have a valid driver's license it gives you permission to drive the highways, but it doesn't mean that license can't be suspended if you don't abide by the rules. A water right is like this. As long as you use it beneficially and don't waste it, you maintain your right. A lot of states are looking at the West because we're on the cutting edge of developing new laws through these lawsuits. The wild horse and livestock watering issue is at the forefront of these developments.

There has always been a lingering contention that federal agencies shouldn't have to comply with state water laws. That concept was extinguished long ago by an executive order from the president which basically said all federal agencies must follow state law. In terms of livestock use, the rub comes in the form of a question whether the beneficial user is the stockman or the federal land agency who manages the land. In 1994, the new Rangeland Reform ruling stated that all water improvements and water rights would be held in the name of the United States unless otherwise provided by law. Well, in 1995 our state legislature passed a bill saying that unless you owned the livestock you couldn't hold a livestock watering

right. Nevertheless, there is still some apprehension by some livestock-men that if BLM controls the water, they further control the land. I'd say there is a little paranoia on both sides of this issue.

Nevada is the driest state in the nation, and we all know there are a lot more wild horses here than the range can support, and not just from a water standpoint but from a feed standpoint, too. Last year I went out on an emergency wild horse gather in Antelope Valley where the springs had dried up. BLM was hauling water just to keep the herd alive, and I witnessed where the horses had pawed at the bank of a dry streambed at a place where there was only one little spot of mud left, just to get water to drink. There was no feed, so the mares were dry, their ribs were showing, and the foals had nothing to drink. That situation is pretty much universal throughout the state. The livestockmen have all had their allotments cut, which re-duces their ability to survive economically. I hate to be critical of BLM because I know they have a lot of irons in the fire, but in fact they have not reduced wild horse populations to the appropriate management levels that they are supposed to. That is a real-life reality. The horses are out there eating the same grass that cows and sheep eat, and drinking the same water that the cows, the antelope, the deer, and the sage grouse drink. The fact that their populations are so great is causing an impact on everything.

We're always going to have wet years and dry years where the water table will go up and down. What we want to prevent in this office is long-term declines in the water table—the drying up of springs and streams—because we've overappropriated groundwater. In many of the rural basins, if we were to get an application for a well to serve a few hundred horses or a few hundred cows, we would likely approve it because the actual consumption by cattle and horses is not that much compared to a thousand-acre irri-gated farm. In this way the state water engineer has the ability to designate a basin. When I say "designate," it means he can set rules (such as deny all municipal wells and agricultural wells but still approve small wells because they're good for the economic base). In rural basins where there have been extensive fires, we've been pretty liberal in trying to get a well permit for

the range user (whether it's a rancher, BLM, or whoever) to drill a stock water well so they can continue to operate where there is still feed remaining, even though they may be fenced off from the burned area. This hasn't always been successful because of a conflict between the ranching community and BLM over whose name should appear on that water right. BLM actually has quite a bit of money to spend on water improvements, but they're not willing to spend it unless they get their name on the paper. This problem has been at a political standstill for about seven years now. On the practical side, if the agency and the ranchers were willing to share water rights, there could be development of some new water sources. In the meantime, the cow, the horse, and the antelope don't care whose name is on the paper—they just want a drink!

There is still quite a lot of unappropriated water left in Nevada, particularly in the eastern part. We recently finished a very extensive survey with the U.S. Geological Survey, who determined that there's even more water available than we originally thought. For example, about 20 percent of our groundwater is within fifty miles of Ely. The carbonate rock province, which is basement rock for a good two-thirds of the state, is the underlying bedrock from when our mountains were formed. These were filled in with either volcanics or sediments that washed off the mountains and became prehistoric lake beds. If you look at some of those valleys you'll see they get a fair amount of snowpack but absolutely no surface water. All of the surface water that falls on these basins infiltrates and becomes groundwater. Where that all flows is still not well understood. In some eastern valleys it flows off into the Great Salt Lake and evaporates. Some becomes what's called the White River Flow System and comes up in springs such as in White River Valley, Ash Springs, and Pahranagat Valley. A lot of water also evaporates off the playas and dry lakes of Death Valley. There are also some big springs down at Muddy Springs that make up the Muddy River. There are a half-dozen endangered species in those springs, so we're going through a great deal of testimony right now to determine whether new well applications will have any effect on Muddy Springs.

In most of the valleys there's sufficient water resources available for wildlife, cattle, sheep, and wild horses, but it all depends how you manage those populations. For instance, the state Division of Wildlife wanted to transplant elk into the north of Elko County, and they made a handshake agreement with folks in that county that there would never be any elk up on the Ruby Mountains. The elk have done real well, but they transplanted some around Spruce Mountain and those elk managed to migrate into the Rubies. One problem is that the Rubies are in a very cold part of the state where there is a huge winter snowpack, so the elk come off Forest Service lands onto private lands in the wintertime. There lies the dilemma. The ranchers up that way are concerned the elk will use the same feed in the mountains that their cows eat. The Division of Wildlife does have a deprivation program where they will pay a rancher for any losses, but if several thousand elk are allowed to propagate there, there's not enough to pay all the ranchers on that side of the hill if all those elk do come down in their haystacks or onto their meadows in the winter. So here is another situation where elk have been transplanted, and this time the conflict is not between wild horses and livestock but between elk and livestock.

In all of these situations there are philosophical and sociological views to consider. What do people really want to preserve? And where do we draw the line on what species are worthy of protection and which ones might go extinct? The Endangered Species Act was passed a long time ago, and I don't believe that even then it was intended to save every single critter on earth. Right now in Nevada there are hundreds of species with a potential to be listed under the act. We just did a habitat conservation plan for the Amargosa toad, and we're having another meeting today on the sage grouse. Now, there is no question in my mind that some members of the environmental community use the Endangered Species Act to stop growth. However, my question is: if we stop all growth, where will our children live? Where will the water come from and the power and the lumber? Are we going to save all the fish and minnows and frogs? If not, which ones will we

save? Are we going to serve people not only with something to drink, but with something to eat?

We are at a critical point in the West because our renewable natural resources are limited. Obviously, oil and gas are not renewable. However, our water, timber, and grass *are* renewable. To what use are we going to put these resources? That, to me, has become the key philosophical question.

Tina Nappe: Environmental Activist, Reno, Nevada

The photographs my father took of a wild horse roundup back in the 1950s were appalling. It was horrible to see any animal treated so inhumanely! Of course, he was very pleased that his work helped pass both of the wild horse laws. He was always sensitive to the intermix of wildlife, plants, and humans on the land. However, he never supported giving wild horses exclusive rights on the range, which is what eventually began to occur.

I grew up with animals. Although I love horses, my involvement with them now is more theoretical. I taught a course on horses in history and art some years ago and I enjoy the horse for its symbolism. And it's wonderful to see mustangs on the range, but I also know that horses impose on the land. A horse can eat anything; their hooves are large and make huge imprints. As an environmentalist, I take that all in context.

There is at the core a common culture in the Great Basin that is not shared, say, by Californians or New Yorkers. In the long run, most of us who live here and care about open space and public lands have more in common than we are different, and as you work with others who live here, you begin to understand some of those perspectives. But there is always a stridency at the edges of any issue. There is also more safety in stridency, while there is more risk to working together (there's no reward). Generally, an organization raises money by being opposed to an issue.

Nevada is mainly comprised of public lands, and things can get very reactionary here. For years many BLM people thought this was the worst state to work in because of that hostility. It's hard to believe that Wild Horse

Annie came out of this state. Or Congressman Baring, who was very con-
servative yet was the one who passed the first federal wild horse law in
1959. There is a growing public within Nevada now (some who have moved
here as well as some who were born here) who are very passionate about
protecting public land resources.

During the 1970s I was editor of the Sierra Club Toiyabe Chapter news-
letter, and we featured two special inserts on wild horses. At that time
everyone looked at plant life on the range according to its usefulness and
no one cared about the range for itself. That has changed in the last few
years, and for me it has been one of the most exciting developments. I'm
basically an ecologist, so everything has a purpose and value. If we want to
minimize weeds, if we want to minimize fires, if we want to protect many of
our key wildlife species on the range, we need to ensure that we have a
healthy grass forb and sagebrush complex. This means we have to reduce
the thick stands of sagebrush which have moved in because all the grass has
been eaten, and we have to reduce some of the pinyon-pine forests because
they not only create fire hazards but take away habitat from pronghorn
antelope, from sage grouse, and from cows and horses, too. In other words,
we have to *really* manage this land, because otherwise we're going to lose
millions of more acres to weeds and fire. We will have nothing.

When you are dealing with complex issues like this, it's very hard to
make changes. My main priority is to keep the sagebrush component and
riparian areas healthy. Some ranchers still don't think they're causing any
problems. And many wildlife people, while they do have a concept of how
damaging horses and cows can be, don't feel elk may cause any problems
either. Most of the national wild horse advocates don't understand any-
thing at all; they really have no concept of range. On top of this there are
recreational interests, and roads and power lines, and an infrastructure
that is very destructive.

As much as I love all horses, if there is no way to keep wild horses within
appropriate management levels, and if we cannot get rid of them in a timely
manner, then I don't want them on the range. I don't want cows and I don't

want elk on the range if they can't be managed either. The land base must be protected above all. It's very hard to get people to appreciate that concept even when they live here, so how can one expect somebody to appreciate it who lives back East, where forage is not a problem and grass is not a problem and where virtually every children's book on horses fails to address the fact that horses *eat*? Some animal advocates feel all they have to do is fight cows on public lands and there will be plenty of forage for all. Well, the fact is there's not going to be enough forage for any of them. That is my concern.

I don't like to use the words "too many wild horses." What I look at first is the impact on the land, and then the cause. In some cases it could be livestock. Or it could be residual impacts from historical overuse, because another thing we've had to consider is that the land doesn't always regenerate quickly here in the Great Basin. I recently returned from Nova Scotia. Well, if you chop down a tree and remove brush there, the next year it's all back. Here in Nevada it's not. So maybe the range is not being overgrazed now, but the land still needs time to recover. It needs to recover from fire, or from weeds.

So what is the actual impact of grazing in one particular place? If only horses are present, does that mean there are too many horses? Should there be no horses there at all, or should that area be completely fenced off? And if it is fenced off, then what does that do to the rest of the land? These questions take a long time to answer. In the meantime, all these horse herds keep building up and there's no consideration for the other species, no understanding of these other relationships. Wild horses need something to eat, so something must be living there for them to eat it, and that means there are other creatures living there—insects, small mammals, bird populations—all of which depend on those same plants.

Don't get me wrong. I think it's good to have a law, and I would not ever like to see what my father originally photographed happen again. But the wild horse world appears to be very irrational. I traveled with Wild Horse Annie to Tonopah once. She participated in some wild horse forums that I

organized for the Nevada Humanities Committee. She was a very fine lady. During that trip she told me that the 1971 bill basically ran away from her, that the law that passed was far more than she ever planned or expected. All those letters came in from all around the country, and all these newer kinds of animal rights groups appeared on the horizon. Suddenly there was a stronger bill that she couldn't oppose. Annie wanted humane treatment for wild horses, but she never wanted them to be considered superior to other living things.

Public feelings about horses are very emotional. In California, voters recently passed a law not to slaughter horses so they can't be used for meat or dog food. To me that's crazy. But when you look at the horse as it appears in art and history, it has always been perceived as an icon. In John Steinbeck's *The Red Pony*, for instance, the hero stood "head and shoulders above everybody else" because he had a pony. Look at all the Marlboro ads. The American cowboy would be nothing without wide open spaces, but it's even harder to be any kind of cowboy and be unhorsed. Horses symbolize wealth, they symbolize space, they symbolize stature, no matter what kind of horse or where it is. Our society has a need for a sense of freedom and individuality that seems to be growing rather than dissipating. We're never going to get away from that kind of symbolism.

I'm a member of a large number of environmental groups, but ultimately none of them addresses the heart of range issues. In the 1970s I developed a policy for the Toiyabe Chapter that was accepted by the Sierra Club regional committee. Basically, it stated the land comes first, then wildlife, then ranching, and then wild horses. The bottom line was to keep the land open. The Sierra Club wouldn't touch that policy these days with a ten-foot pole! They stay completely away from wild horses now. Many conservation groups are the same, so unfortunately nobody is speaking for the land. I do hope there is an evolving and knowledgeable public that becomes committed to landscape diversity and health, but public education is a very slow process. What also irritates me is that whenever any of these animal rights groups files a lawsuit against BLM, the general public is never in-

volved in the resolution. Usually the public doesn't even find out about any of it until afterward. Meanwhile, none of these groups seems to care whether wild horses suffer or die in the desert. It astonishes me the kind of cruelty their attitude imposes. It's indifference to the land as well as the horses.

The majority of the problems on the range are not wild horse related. However, I do think that wild horses are symbolic of how we've treated the land, and in Nevada we've treated it with tremendous disrespect. I say this as a native. It has been only in the last few years in particular (and not only because of sage grouse but due to the fires and the noxious weeds and the declining deer herds) that we have come to look at the range differently. For that I give full credit to the findings of range scientists that focus on plant succession caused by human interference. How will we as a society here in Nevada, a state which has so little water and which looks so barren, make the range important as a resource in itself—to the rest of the nation as well as to those who live here?

Whenever you see wild horses, you can't help but be thrilled. I enjoy the fact that Nevada is beginning to see them as a tourist resource, and I very much want to keep them on the public lands. At the same time, I'm willing to forgo any wild horses at all if we cannot get rid of them when the land is damaged. That's the same feeling I have about livestock, other forms of wildlife, and recreation, too. For me, the land comes first, and in that I've never changed.

Stacy L. Davies: Ranch Manager, Frenchglen, Oregon

The goal for this ranch is to be ecologically, economically, and socially sustainable. That's lofty and it sounds neat, but there's a ton of details that fall underneath. We really do want to be here for many, many generations, and we work diligently to do that.

In October 2000 a law was passed creating a wilderness area on Steens Mountain as well as a larger designation surrounding it, and this ranch was involved in helping to develop the legislation for both areas. At first the

Clinton administration wanted to designate Steens Mountain as a national monument, but that would have made this entire area into a tourist attraction. Most people who love the Steens, well, the last thing they wanted was a lot more visitors, simply because a good part of the social sustainability is all of this wide open space. And what they really didn't want was any more development—more roads, more trails, more camping areas, more improvements on the existing roads, more off-road vehicles—all those things that a national monument would bring. In working to develop the law, we focused on the impending threats that worried most people and worked to preserve the area from those damages. We mapped out the best area as wilderness, and for the rest of the land that didn't qualify as pure wilderness, a second designation was created. The Steens Mountain Cooperative Management and Protection Area legally protects the land and also protects the local culture and economy of this area. It was designed to stop development, mining, and some other things that would really change the landscape, and otherwise to leave it like it is.

The Steens Mountain area is unique, and Roaring Springs is a unique ranch. We have a very sustainable grazing operation because of the elevation change here. On the valley floor, very little snowfall stays on in the winter. We can go up the mountain in August and September and have green grass at the higher elevations. As long as we manage our grazing properly we can be here forever. Because of the landscape I often say we could continue even without fossil fuels. Right now we do use tractors and pickups and things, and we gain from the efficiencies of mechanization. But the truth is that if you took away all my diesel and gasoline, I could hire another ten people and we could go back completely to horse power. We would never have to burn another gallon of gasoline and the ranch would still be cost-effective.

Our land has very few fences to speak of, although we're getting more all the time to better manage the livestock. As things are, wild horses come right into our yard every year during late summer and fall, when the rangelands dry up and water becomes more limited. They come for the springs,

for the natural flowing water here. There's also green grass all through August, September, and October, so most of these mornings there will be thirty to forty head of horses in our yard. After the October fall rains, the range greens back up and they move out. They've been doing this for a long, long time.

The appropriate management level for the South Steens Herd Management Area is between 180 and 380 if I remember correctly. Today there are well over that amount. It has always been a well-managed herd, and BLM is scheduled to gather again this fall. I like wild horses, but it's very important to gather them every three years. BLM usually gathers the herd down to 200, but within three years their numbers go right back up to 400, so they have to gather again. The South Steens herd is I believe the largest in the state, and they have always been a very productive herd.

The South Steens herd is located on the Roaring Springs Ranch. We also own a ranch over at Diamond, and the Kiger herd is located there. It's a much smaller herd and they have a smaller area. The agency has always been good about gathering both herds, but this year they told me they may not have enough money. Well, that scares the heck out of me. If they don't gather, it means there will be six hundred horses next year and almost a thousand the year after that. The multiplication factor is unbelievable. I asked at the local BLM office the other day, "If you can allow the horse population to double what it's supposed to be, does that mean I can run more cows too?" I was kidding about that, but I did say, "Well if you can't gather this year, let me do it." Of course they can't let me, but I'd do it for free!

Horses can travel and really use up the country. They get into a long trot and they can move a long distance from water, and they can be pretty resourceful. They don't tend to migrate like the deer and elk here. That's partially because there are fences, so their total range is somewhat limited compared to what it might have been before. The Kiger herd in particular also tends to hang on one area. They camp on Yank Springs and Yank Creek year-round. It's a beautiful little area, but I have to say it's in absolutely horrible ecological condition. When we look at the needs of the fish and the

water quality and what it means to have a properly functioning riparian area, including the health of the creek and the uplands, Yank Springs is a good example of what should not be happening. Cattle have hardly used that pasture for years. The area is almost entirely wild horse use now, and if you're going to have a hundred head of horses on an area that is supposed to support only twenty on an annual basis, you're going to have problems. We're talking to BLM about working with them to scatter those horses over the next few years by putting them in different places after they've been gathered and turned back out. We also may put out salt blocks in other places so they move around elsewhere.

All these horses are beautiful to see, but it always surprises me that some wild horse advocates have so little knowledge about the ecological conditions needed for them here. The groups seem very narrowly focused and they don't recognize how bad of shape the Yank Creek area is in. The same holds for a lot of the folks who visit and want to see wild horses. This may be because they don't get the same exposure that I do. A ranch manager is exposed to every interest group, every animal, every habitat type there is. We pretty much have to know what all those needs are because we're constantly working to manage for healthy conditions, and especially on a large scale. There are a whole bunch of "ologists" I deal with regularly—fish and wildlife and range specialists and such—and I learn what all the interest groups and scientific factions are concerned about. We really try hard to work with all the interests on the public lands, and for all the different animals that are out there, to find a balance. In return, we expect people will be willing to work with us. Unfortunately, that's not always the case.

It's frustrating to be thought of as a stereotype. Like, "Oh, you're a rancher, so you really don't care about any of this and you're just finding excuses to get rid of horses or elk or whatever so you can have more grass for your cows." One of my greatest goals in life is to gain enough respect and credibility so that people who know me won't ever share that kind of criticism. As a matter of fact, we're working on a few issues right now with some groups who are what I would call radical. They don't want cows on public

lands at all, but it looks like they are willing to join in defending this ranch in a lawsuit against us by another group. This is why I want to nurture positive relationships with nonranchers and other special interests, so when these frivolous lawsuits do come forward, more people will recognize that we are good managers, that we do care about responsible use, and we care about all of the species out on the range. We're getting close to that point now.

I can accept criticism, even a lawsuit if it's justified. If a group feels I'm causing damage to the land, to the water, or what have you, and thinks that the only way to change my management practices is with a lawsuit, then I can accept that. But if a special interest group is using the Endangered Species Act or the Clean Water Act or the Wild Horse and Burro Act only to further a specific social agenda—meaning to kick cows off of public lands entirely—then that is a frivolous situation, in my mind. Speaking realistically, we can have multiple users on the range and also have a healthy ecosystem. We can also work with social issues. For instance, we created camping areas that we specifically don't graze for people who don't want to camp where cattle are nearby. Naturally I don't expect other people to worry about economic issues on our ranch, but our goal of being economically, ecologically, and socially sustainable works when people who are involved stay focused on a need or on an issue, and not when the intent is to get rid of ranching entirely or because they don't happen to like cows.

It has taken me a long time to understand that even a lot of the best federal agency folks don't get to spend much time out on the land, even though they try. Neither do many of our friends (or enemies, for that matter) or most people who live in urban areas. City folks don't spend much time on the land at all, so they get a tainted view of it. Most visitors come to the Steens in late spring and summer because the weather is better then and that's the time of the year when the grass is green and all the animals are fat, and everybody looks happy. But we live here all the time. We see the land and the animals 365 days of the year. I've seen predators taking down animals. I've watched them tear the back half of a deer apart and start to eat

it when it's still alive and bleeding. I've heard the cry of the deer when it happens. I've seen animals thirst to death and starve to death. It's not a pleasant experience.

There are a lot of good ranches in the West, with good managers, good families, good people living and working there. There are good managers in our federal agencies, too. But one thing that frustrates me is when there is too much control by distant folks and not enough respect for people who live in the local areas. It's the people who live here who really see what is happening and who know when it's an appropriate time to intervene or when it's not, and which action is most appropriate at that time. That's a big part of managing any habitat. When it comes to starvation or thirst or a hard winter, sure, we can run in with feed or water, because sometimes those are the appropriate actions to take. But those actions are also artificial to the point that if we sustain any population higher than it should be, we will pay the piper down the road. This land can support only so many animals.

Wild horses and wildlife are managed less than livestock. Our cattle go in most places for a short period of time and then we move them. We're constantly managing for healthy grasses that way. If horses hang on one area twelve months of the year, the plants never get to rest, and as the herd grows they will hit on a larger and larger area. It can get catastrophic when it finally collapses. It's not healthy and it takes a long time to heal.

On our ranch there is no conflict with wild horses as long as they are managed well. Obviously, we make sure there is enough feed, and we watch and make sure there will be enough water. What's interesting is that for the South Steens herd, nearly all of the water is on private land. Nearly all of the springs, the wells, and the water holes are privately owned. If we wanted to be difficult we could fence off our water, but we never have. We feel that if we're able to use the public land for this grazing operation, and if we manage our livestock properly, we're glad to let the horses use it. I think a lot of groups should realize this. It's not just wild horses but all the other species and users who are dependent on our waters.

Let's say for the moment we were put out of business here. What would we do with our private land? We get calls all the time from people who want to buy scattered chunks of ground on the ranch. They want to build a hunting cabin or a family getaway or some other kind of retreat. To a very large extent, our private lands would probably all become developed if we were no longer ranching. And those lands that were sold wouldn't be available to the public in the same way they are now. This is usually stated as "cows or condos." It may sound like a threat, but the reality is true. There is a true value to having good ranchers and to keep ranching sustainable.

I grew up in a family farm situation and I know some folks don't appreciate corporate agriculture. However, in terms of stewardship, a big ranch (especially if their mindset is proper and they are concerned with more than the almighty dollar) will sometimes do more for the land and the other multiple uses than a small family farm, simply because a big ranch can hire people who are highly educated and knowledgeable, and a small operation may be more strapped for cash and not able to do certain things even if they wanted to. There are positives and negatives within each sector, and opportunities for good or bad, too.

When I was growing up in northern Utah I had some relatives who were renegade mustangers. They were more on the rustling side of things, you might say. I didn't understand what was going on because I was about eleven, but as I got older I began to figure it out. They would always head for the southern part of the state and come back with a load of horses, and they always worked at night. They took some really nice horses off those southern Utah deserts. They would bring them home and make good horses out of them. I'm not trying to justify that, because it was definitely illegal at the time, but when you live on the land you see how these things happen.

When it comes to managing these horses, even though the size of the herds differs, the principle is always the same. You have to look at the natural resources that are available and the size of the area exposed to the herds. The bottom line is that horses are a grazing animal, and too many grazing animals can damage rangeland health. Now, there are areas on the

north end of the Steens where elk are doing the degradation instead of the horses, so it's all relative. But there is a certain capacity, and if animals exceed the capacity they need to be removed.

In our particular area there are no predators that harvest horses on a scale that makes any difference. There are some big cats here, and horses are a delicacy for the cougar. They darn sure come into our domestic brood mare band and take down our colts, but it's hard to know how many wild horses they may be taking. Based on the natural reproduction of this wild herd I'd say it's not any significant amount, because even with the big cats here the horse herd doubles every three years. That's taking into account reproductive inefficiencies and old horses that don't breed, so a 30 percent annual increase is fairly significant. It's a healthy, productive herd! The only other potential predator for the wild horse would be wolves, but there's no conclusive evidence that wolves were ever part of the Steens ecosystem. When people ask if I would support wolf reintroduction here, my answer is that from the livestock standpoint I'm not concerned. But I'd hate to see wolves impact our deer, elk, and bighorn sheep populations, because it's already a struggle to keep them healthy as it is. People are also concerned about the sage grouse, and there's a potential to list them as an endangered species now. Well, why introduce a highly efficient predator such as a wolf which would burden all those game populations? On the other hand, if wolves would control wild horses, maybe it would be a good idea.

The Steens is a beautiful, remote area. Some people argue over how much human influence there has been on the mountain, but it is definitely still vast and undisturbed, and there's no way we can go back to a situation where we don't influence any part of this environment, because we already have. We're here and we're part of it, so let's focus on the goals and values that are important to us and work to preserve those things. Open space is something we all appreciate. Well, this area is all open space. I also maintain that viable ranching operations are important to preserve, and since the one thing that will shut down any agricultural operation is urban en-

croachment, we need open space here. So let's do what's necessary to pre-
serve all this space. We also appreciate and love wildlife and fish as much as
anyone. This is why I say that if someone sees something I'm doing that's
bad for the environment, then I want them to tell me because I more than
likely will change. We strongly sit on that principle. We've learned a lot, and
we're doing many things differently than we've done in the past. I expect
we will always try to do things better.

I've had the opportunity to work with some really good, open-minded,
solution-oriented people. All across the West there are pockets of tremen-
dous success stories, of finding resolution to some very difficult issues.
Every so often I still run into someone whose mind is closed or whose solu-
tion is to eliminate one interest group entirely, and that does tend to be
depressing. Generally, there is power whenever multiple interest groups
get together, and I am very encouraged by that.

This story on the Steens is far from over. If we respect all the values this
land can provide for, we can manage for all of them. They are all important,
and no one is more important than the other. That's my basic philosophy.

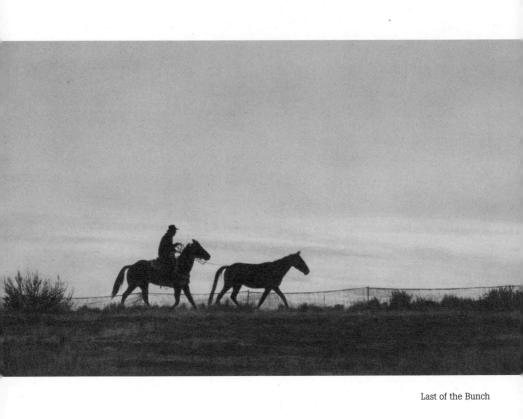

Last of the Bunch

Horsemanship

Dances with Horses

The Big Empty is welcoming territory for horses and humans. Beneath an impeccable blue sky the horizon beckons one ever onward, to roam and to ride. Longtime residents of small rural communities grew up alongside or directly involved with animal agriculture in some form; you might say that horse sense is in their bones. City life also echoes some form of high desert horse culture. Newcomers quickly embrace the refreshing pace of the region's western lifestyle, and many turn to recreational pursuits—raising, riding, or showing horses full time or after hours. Traditional ranch operations utilize horses for daily work routines; several nationally recognized horsemen and horsewomen live and train horses here, and more than one mountain outfitter and ranch crew use wild horses exclusively for their resilience and range savvy. In this setting, a common theme unites everyone in the horse milieu—the never-ending appreciation for a *good horse,* wild or tame.

America seems to be enjoying a renascence of interest in horses. The horse as symbol and reality has assumed an almost exalted place in public consciousness. There are award-winning movies about racehorses and best-selling books about horse whisperers. We refer to horses as compan-

ion animals rather than pets. Yet, like western movies from Hollywood's bygone era, it seems that this country's equine love affair often remains once removed from everyday experience. Strictly speaking, not everyone seized with the desire to become a horse owner has the capability to ensure quality care for their animal, economics notwithstanding. Fewer still actually turn that personal dream into a lifelong commitment. Sadly, the best equine fantasy often turns to dismal failure. In the end it is the horses, wild or tame, who suffer the consequences of our lack of horsemanship.

The art of horsemanship implies a one-to-one commitment between horse and rider, and learning the art is a discipline requiring attention, persistence, and communication, not to mention practice, practice, practice. In our modern society there are fewer individuals nowadays who know the nature of horses well enough to pass it on. Of those who do, many live in isolated areas and are hard to reach. Many championship horse trainers spend most of their time on the road hosting group clinics or judging horse events, and produce videos for sale after the fact rather than working directly with students. Since even a smaller minority of horsemen and horsewomen comprehend the mysterious realm of the wild horse, wild horse trainers and gatherers are a rare and colorful breed, and are legends in their own time.

When it comes to horsemanship in the high desert, our collective stereotypes and fantasies must end. Not all encounters between wild horses and humans are happy ones, and in worst-case scenarios, humans and horses can hurt one another. But sometimes magic happens. Whenever a human and a horse, wild or tame, fit together, a transcendent grace seems to permeate their relationship, leaving each transformed. In the act of kinship with horses, communication becomes a dance of sheer joy, and beholding it takes one's breath away.

Most horse folks in the Great Basin are quick to share their experiences of living, working, and playing with wild horses. Stories abound of chasing unbranded horses on the desert, for generations a recreational sport as popular as skiing or golf. When the goal is fun and the risks are equal for

horse and human, the distinction between what was once termed "wild horse fever" and our modern competitive events (endurance riding, team penning, or roping, for instance) may be only that in one case the action was unsupervised and out on the open landscape, while in the other it is organized and enclosed in an arena or monitored and regulated on marked trails. All else boils down to respect, finesse, and a willing spirit between horses and riders. Horses are herd animals and they are social. They like to be ridden, they like to run, and they definitely like to play.

On the range, mustangs are known to enjoy playing with humans to the point of teasing them. Wild horse runners like to swap stories about wild horses who outwitted or eluded them—on foot, in the saddle, or in a vehicle. During my research I too was introduced to a few mustang "pranks." Once in Stone Cabin Valley a small band sighted the jeep in which I was riding as we inched along a rocky, dusty road. The horses immediately took up chase, picked up their pace, and lessened the distance between us lickety-split. After passing ahead and winning the race, the wild ones still had a point to make. They veered sharply and made a deliberate turn to cut us off, never endangering themselves but literally forcing the driver, a BLM range conservationist, to hit the brakes and stop in his tracks. Then they paused and turned to face us. I could almost hear their laughter. When I shared this experience later on with some old-time wranglers, they smiled and nodded knowingly.

On another occasion I was photographing a herd in a clump of giant sage when seven bachelor stallions began circling around me at a playful lope. I was bewildered but remained still. Gradually, they started to close the circle, shortening the distance between them and me. Around and around they went. Eventually they got tired of the game, moved out of formation, and drifted off, leaving me with some incredible exposures on film and memories to last a lifetime.

The narratives in this section reveal the tradition of horsemanship as it continues to unfold in the Great Basin. These are people who live, work, and are engaged with horses directly, who deal with them "hands on" in

one capacity or another. All have danced with wild horses in their way, although the rhythm of their movements and the melody of the song are unique to each. Collectively, their stories reveal the integrity and honesty of the wild horse–human connection in the high desert as it continues to unfold across a changing panorama of history and heartbreak.

Michael Kirk, D.V.M.: Equine Veterinarian and Wild Horse Commissioner, Reno, Nevada

At Palomino Valley I did just about everything with wild horses. Take the holding corrals. Following a gather, horses were hauled in by truck and sorted for age and sex. If there were sick horses, they would also be segregated, so there would be one sick pen for stallions and another for mares. Each group would have to be processed, and I took blood samples for all of them. Every healthy horse was freeze-branded, vaccinated, wormed, and aged. We had as many as two hundred head of sick horses there once, and I fixed them up and kept track of all the drugs we used. If a horse was wounded anywhere, we would knock them out, clean them up, and put them back in shape. We took X-rays, too. BLM built a special gurney that was low with big wheels on it. We would put them in the chute, administer the injection, roll them out on the gurney, do what was needed, and then roll them back to the recovery pens. After recovery they went to the sick pen for treatment.

At that time BLM gathered all the horses; they used their own trucks and their own cowboys and saddle stock. Today they contract out the roundups. There are very good people doing the gathers who know what they're doing. However, because these operations go up for federal bidding, the government has to take the cheapest one, so it can sometimes be a question of whether these jobs are awarded to people who know and understand how to handle mustangs as opposed to people who know very little about them but cost less. Some contracts have gone to people who thought they could just hire a helicopter and a pilot, and they couldn't get the horses to go anywhere!

Any organization with an interest in wild horses can file an appeal to stop a gather. Usually they criticize the methods used to determine how many animals one area can hold, or how many horses were born there, or how much forage or water is there. Mostly, wherever there is a large population of horses there will be a lot of concern, and where there is a lot of concern there will be controversy. You'll hear some people say filing an appeal doesn't shut things down, but indirectly it surely does. Anytime BLM gets blindsided by a protest they have to stop and redo everything. And if a protest goes to the Internal Board of Land Appeals, it holds things up for years. So whenever a gather is delayed, it means the horses will stay where they are until the matter is resolved. When you've got, say, six hundred horses in one herd management area that should be supporting only one hundred, every year that area isn't gathered means those horses continue to reproduce.

In certain cases these groups have made some valid points. Mainly, however, this is an emotionally charged issue for a lot of folks who want to save *all* wild horses no matter what. One theory that continually comes up is the Darwinian theory. You hear it said that mustangs should be allowed to overpopulate and whoever survives is how it's supposed to be, because that's a process of evolution and natural selection. It doesn't matter that the range is in trouble, or if the horses eat all the grass, or if there's no water, or if there's a hard winter and they die—young ones, old ones, whatever—all of that's okay because the only issue that matters is survival of the fittest.

The Wild Horse Commission hears outcries from local residents who may drive out on a back road and see too many horses fighting and stomping all over each other at a water hole, or people who see the ground getting trampled at another site, or folks who find bodies on the trails. We hear all that stuff. Local folks want to see these horses thrive. They don't want to see them left to die out there, and they usually know what's happening on the range. It's pretty hard to turn your back if you live near or work around these animals.

Stories about wild horses usually fall under the heading of human interest. But even though *National Geographic* films a lion running down a deer and eating it, you'll never see that coverage on wild horses. And whenever a story does get on national television or is a featured magazine article, it's still only one piece of information. What happens is that out of millions of people who see that one piece of information, a small number will grab hold of it and think, "We've got to do something about this!" The next thing you know there's another pressure group formed! Now, if the only thing these people see portrayed is wild horses always running free, and always fat and slick, of course they'll want to fight tooth and toenail to keep things that way. The media never show five hundred head starving to death in the middle of winter.

Everybody agrees wild horses belong here. A certain number should be here forever, and they should be sound and slick; they should have healthy babies, the public should be able to see them, and everybody would be happy. But you have to get rid of the excess before that happiness happens. So now the question is: *how* are you going to get the numbers down? The next question is: *who* is to say how? Let's say BLM brings in a certain number of horses and they take all the ones five years and younger for the adoption program. Well, that means there is another group left to turn back out on the range. Let's say the one herd area where you are doing a gather should have only one hundred head on that area, but they're going to turn back two hundred. Who decides who stays and who goes in that group? The old and the sick are covered in the act, so if a horse does come in from a gather that's crippled or has no teeth, it's okay to put him down. But say there are two hundred to turn back out and they're all ten years and older, and say also that we make no distinction on sex or gender (it could be ten stallions and one mare or whatever—although that's a whole different issue); the problem still remains. Who stays and who goes? *Nobody agrees.*

BLM has ultimate authority because they're responsible for all the horses. But one individual person has to make a decision each time there's a gather. This is where emotions and controversies get going, and then people get

into politics to control the decision and it becomes a big deal, and finally BLM throws up its hands and says, "Just turn them *all* back out, because we're not in the horse business." But back on the range, there are still more horses where once there should have been less, and now they're spilling out of the original herd area. Now the next management question emerges: should we keep one color or a genetic pool? Now, that does mean they're in the horse business! Let's say you decide to keep all the palominos, all the paints, and a couple of bays; and so as to even out the sexes, say one stallion for every five mares. Someone else might say, "Oh no, all you're supposed to do is turn them back out."

In the early days here, ranchers gathered these horses. They'd bring them in, sort out the colts, pick the ones they wanted and any old ones (say, over twenty) or crippled ones. Sure, they took those to the sale. But they turned out good stallions in the herds and they left all the rest to run free. They did it this way for years, and it worked. It was the commercial mustangers who messed it up for everybody. There were some devastating and tragic abuses, and that's how Wild Horse Annie pushed the law through.

Out on the range there is a multiple use concept, and trying to get that to mesh is complex. Groups who try to derail the wild horse program only create a situation where problems continue to grow. There is a big push for marketing adoptions through video auctions now, but there's still a big problem of how to deal with excess numbers. Sale authority was eliminated in 1971, and some folks advocate a short-term sale authority to get numbers down. I don't know if that would fly; a window of opportunity concept is probably about as close as it's ever going to come.

The alternative to sale authority is euthanasia. Now, most Americans are accustomed to the necessity of euthanizing domestic horses. However, when you talk about euthanizing wild horses it's another story because sooner or later there are going to be lots of wild horses to deal with. Pick any number. Say for the sake of argument that there are ten thousand wild horses too many out on the range. Eventually those horses will die or they will have to be put down. How long will that take? Either by the time they

become crippled or lose their teeth, or after they've been hauled back and forth across the country half a dozen times before being sent to a sanctuary because no one wants to adopt them, and then they will die there. These guys in the adoption program know in advance which horses will be adopted and which ones won't, but they still throw them all together and ship them anyway. You hear comments like, "There's only going to be two or three that need to be put down out of this chain." That means maybe twenty or forty head of horses have been shipped and by the time they get back East there will only be three or four that need to be euthanized because they've been sick or injured on the way. But what's three or four when there are five thousand colts born every year? Eventually they'll go through the same system too.

We're fortunate in this society that we're able to relieve suffering animals. That is what euthanasia is for. But when you look at wild horses, it's all hands off—let them suffer, let them die, let them lay there, let them fight! It's easy for any pressure group to become powerful when they don't have to witness these consequences. They don't have to hold the needle or the syringe like I do, or watch these horses fall, one after the other. And even though it's justifiable to put down the crippled, the lame, the old, and the sick, that does nothing to control the population. No one addresses the heart of this problem because people throughout the entire wild horse arena have become very cautious. Legislators are cautious because they're out in front of the public. We commissioners are cautious because there are at least fifty people at every public meeting listening to our every word. At BLM national advisory board meetings it's the same thing. No one hears everything that is needed, because not any one person is going to say it all.

I was chairman of the commission when the events at Nellis Air Force Base occurred. The U.S. Department of Energy flew us over the area in helicopters. I saw a bunch of horses fighting over a mudhole. There were probably thirty head, and that mudhole wasn't as big as this desk. You'd see one mare with about five stallions on her and she was a rack of bones. She's got to try and get away, so she'd leave her foal, so then you've got an orphan

foal laying out there for the coyotes to eat or to die. In one area the condition of the range was appalling. It was nothing but red dirt. The horses had eaten the sagebrush down until there was nothing left but sticks, literally sticks, as far as you could see. The land was as flat as this table, there was no feed at all, and there were thousands of horses suffering. One of the local ranchers was hauling water out to them. He wasn't supposed to do it, because the act says people must leave them alone even in an emergency, but he was doing it anyway. Eventually BLM took those horses off Nellis and the numbers settled down. But in spite of all that damage, one of the pressure groups still tried to stop the gather. It was incredible.

Wild horses could be such a benefit, especially to visitors who want to see them in their natural habitat. But people just have to put their emotions aside and come to the reality of the situation. And even though local residents love these horses, they need to be educated too. There is an obligation to tell the public why certain things are happening, why these things are being done. People should remember this when they're sitting in their warm house during winter, because a lot of these horses are starving out on the range for one reason or another, and in a lot of cases they're stuck there to suit someone else's cause. BLM is caught smack dab in the middle.

Some time after Wild Horse Annie's era there was an interpretation that grew on the part of the public that ranchers were the cause of all the deterioration on the range. Of course there are stockmen who overgraze the land and then blame the horses, but for every one of those there are two or more who take good care of it and who move their cattle off the range when it's time. But wild horses don't come off. Some folks argue it's horses that are eating it down, and some folks argue cattle are eating it off. Well, it doesn't matter who ate it off if there's nothing there.

The public needs to get the stars out of their eyes. It may take time, but if people are willing to see the whole picture about wild horses, I'm sure they'll start to think differently.

Dawn Lappin: Wild Horse Advocate, Reno, Nevada

All these years I've worked to save horses, but we get calls about anything—whether it's horses or cats or dogs or peacocks. Right now we have two lep-pies and a retired Marine Corps palomino who has Cushing's disease. We also have Patches, a young stallion we captured when wild horses were getting shot at Hidden Valley. We have Beau, a red-and-white paint from Soldier Meadows who ran through some barbed wire when he was a baby. And we have Ishi, who was a Nellis orphan. The first time Ishi was adopted, the folks didn't feed him. Then he went to a married couple with teenage kids who mistreated him. When I went out to check, he had welts all over his body, his back was broken down, and he had neurological damage to his face. The vet told us that at some point his facial muscles will go completely lax forever and we're going to have to put him down. In the meantime he's got a home here. We also have a thirty-year-old burro from the Black Rock Desert. And then we have Three Socks. He's in training but I don't know if he'll ever get gentled—he's eighteen and all stallion! The vet advised against cutting him at this age because it's a risk to treat him when he's not gentled.

When I went to work for Annie there was no federal adoption program. Annie and I ran the whole program until 1979. She put me in charge, and that's how I've adopted over twelve thousand animals. Say Battle Mountain was having a roundup. Well, I sent out applications, put notices in the paper, generated all the applications, and screened them. I'd meet the people there and help them load their horses. I did all the follow-up. Well, by 1975 there were 100,000 people waiting to adopt wild horses and it was getting to be a nightmare! So in 1979 BLM took over all adoptions. There are only a few minor differences now. We still want to see that people are financially stable before they adopt, but there will always be some things you can't control. No matter how much you screen people, you just cannot guarantee everything.

I worked with the air force when the situation occurred at Nellis. I was so

frustrated that the problem had been hidden, but because Nellis is closed to the public, nobody saw what was going on. If it wasn't for Dave Cattoor we never would have known about it at all—all those horses would have been left to die. I still think the military will close their eyes again down there. What kind of national wild horse refuge is it with cement bombs dropping all around?

Some horse groups think nature should be left to take its course, but unfortunately nothing out on the range is contrived by Mother Nature anymore. We manipulate it, we say what grows and when, and we cannot be so asinine as to presume that there's one link that's hands off and not have the whole system break down. I've brought several groups around by saying, "Okay, go ahead and try to stop BLM from rounding up these horses. But if you do, I'm going to let people know why those horses are starving to death." What these people don't grasp is that it's the horses who will starve to death or go without water. It's very easy to get wrapped up in politics and in who did what to whom, and much harder to keep attention on the real issue.

Right now there's no way I support sale authority. If the bureau plans it right, and there's no monkeying around with data, and they can say, "Okay, there's this much forage and this many animals (cows, deer, horses, and such) and this how we're going to split the pie," then it doesn't have to be equal numbers for me. As far as I'm concerned, numbers don't mean anything—a healthy horse is what does it. Hopefully, if everything goes as planned, we won't be looking at massive horse numbers from now on. We will collect the animals on a regular basis, take off a few young ones, but leave the rest.

Many people have no clue about how the act started or why. That's why I'm not as worried about how many horses there are. I'm more worried about whether they're harassed. That's what Annie worried about—the fact that somebody wouldn't let them live in peace. So nowadays I work to keep the herd population healthy, not to promote the birth of more animals. And if the bureau has made mistakes, I've made some too because I've been

right there in their tracks. At the same time, some of my most rewarding experiences have come from being out in the field. I love working with different people, and not necessarily always those from my own community of thought.

When I first started I didn't know anything about these horses. Annie sent me out in the field, and it wasn't until I was much further along that I realized why. She sent me out on a roundup done by one old man. He showed me he wasn't trying to harm horses, and not one came in injured. That's still where I like to be, out in the field. I like to talk with people about adoptions, excess horses, injured horses, or whatever.

After Annie's death it looked like they were going to close WHOA, and I tried to keep it alive. By the 1980s we set policies regarding census flights so the government wasn't double-counting or undercounting. I always had an excellent working relationship with BLM. I never used the media on them, and I still am reluctant to do that. It's not that sometimes I don't have problems with the bureau! But I really believe in the system and I believe my participation is one of the key elements that keep the system going. Some other groups still call me for information about certain issues, but they usually don't agree with my conclusions. For any numbers beyond what the range can accept, you better be able to look those horses straight in the eye, and you have to *know* they've got forage and water all year long. You have to manage for the worst-case scenarios, not the best.

I've evolved over the years because a lot of people helped me to learn. BLM people took me out on their monitoring. They taught me about plants, they showed me how to look at systems of management and how to understand seasons of use. There were also ranchers who took me out on the range. They didn't say anything; they just let me draw my own conclusions. Now, I may not agree philosophically with several permittees, but over the years I've been able to learn who they are as people. I used to think, "Jeez, if we just got rid of all the cows there'd be more for the horses." Then I began to see that you can't compare horses and cows—it's like apples and oranges. After a while I thought, "Okay, what's the most important thing?"

It's to create a situation where the horses have the best opportunity to be natural. Maybe it's because Nevada has a gambling state mentality—I've thought often that I'd rather lose half the wild horses than take a gamble on the whole.

One thing that has happened here is that people who have a common love for the land have been pitted against each other. I love that the range is there, and despite the fact that it's ever-shrinking I think it's up to us to try and correct some of these things. Sometimes organizations start out with good intentions, with goals to help the horses or whatever, but they'll soon find out that fundraising gets pretty hard. So then they have to create an argument, or perhaps not resolve one at all, just to keep going. There's an ego thing to this, and I've seen it in myself. Whenever I get too big headed about how much influence I think I have, well, that's when I take a fall!

I won't ever give up on WHOA, but I will pick my battles from here on. For the most part I've gotten pretty much what I went after. I wanted BLM to have guidelines to do their job as scientifically as possible. I wanted them to conduct their monitoring objectively. There are rules and manuals now about how to determine appropriate management levels. Livestock operators just want to know what they have to deal with—say, if there is going to be one hundred horses in a specific HMA—so they can plan around that. But when the horses balloon back up to fifteen hundred in that area, then obviously they'll speak out.

When I worked on the national advisory board we spent a lot of years on the techniques of gathering and processing horses. We set up a five- to six-year plan and went after Congress to support the budget. We really hammered it down that they have to get horse numbers to AML. For the first time I feel there's a chance to get there and stay there, but I do worry about the budget. After all these years I hope they don't cut things off when we're right in the middle of this. But if you ask me is the program perfect? And will it ever be? No. Nothing in life is ever perfect.

One time I went out to Bentover Springs and was standing with a group of ranchers and BLM specialists there. We were talking about horse re-

ductions and I said, "I want this to be fair." The herd wasn't a normal herd. I didn't see any family bands because there were too many horses and they had been harassed. All of a sudden we looked up to see a big dust cloud coming down the road. Those men all knew who it was, and this fellow was moving fast. He pulled up and jumped out of his truck, and he comes right over to me and starts to poke me in the chest saying, "It's a gosh darn good thing you're not Wild Horse Annie!" I mean he was mad! Well, another rancher there stepped right up and said, "Now wait a minute, this lady's here to see if we can solve some problems and she wants to work with us." So he did. Later on we all came up with a plan to reduce the number of horses, and if I remember right, the number we set still holds today.

There's always a certain element of people who harass these horses. That was always Annie's motive. She had nothing against putting animals down when that was necessary, but she hated cruelty! Annie was put on a pedestal by outside pressure groups because they pictured her as a savior of the wild horse. I hated seeing what they did to her. She was such a commonsense person.

When BLM wanted to use helicopters for roundups, I told Annie I thought it would work if there were restrictions about how it was done. I'd been on gathers and I'd seen domestic horses ruined. Annie said, "I know that, Dawn, but my enemies will say I'm for getting rid of the horses." So instead she gave me her mailing list. I went out with Gene Nunn and took time-lapse photographs of how the helicopter brings them in, and then I did an article for Annie's newsletter. Through the years, that evolved into better handling of the horses and the type of contractors who gather them.

Our family has always been involved in animal issues. But at the same time that we have a fondness for all creatures, we're realists, too. I have a son who had grand mal seizures. We went through years of terror waiting for a drug to get approval in our country, and if it hadn't been for animal drug testing that never would have happened. I don't believe in using animals unnecessarily and I don't believe in cruelty, but I also believe that human beings come first. We can't go back to the Garden of Eden.

Early on I decided I wouldn't take any remuneration for my work. I've been offered jobs with the bureau, the state, and the commission, but I don't want to feel beholden to anyone or to have anyone think I have a vested interest in what I do. You can give me gas money, that's all. We manage to operate on less than a $5,000 budget because I won't tell the public a lie.

It's really hard work to open your mind, to read and maybe even reevaluate where you are coming from and admit that in some things you may be right but in others you are wrong. I made a lot of mistakes. Annie always told me, "Dawn, if you make a mistake, as long as you are honest, I will always back you." And she did.

I don't have a college education and I've never taken psychology, but I love reading and I read almost everything I can get my hands on. I believe we have gotten so disconnected from one another that people transfer their need for human connection onto animals. You know, my next-door neighbor may judge me, but I can come home to my dog or cat who won't. This idealism (which is how I look at it) of thinking things can go on forever or that we can take nature back to an ideal state is because people are frustrated by their relationships with other humans. It is hard to keep reaching out and trusting people—*really* hard. My family is really close, so we've always had each other to lean on. Frankly, I don't think our society has that kind of solidarity anymore. We're all too spoiled.

Whenever adopters come out and talk to us, Bert lays it on the line. He tells them about round-the-clock feeding times—every two hours—all of that. People sometimes wonder if he really wants them to take a horse, because he runs them over the coals. But you have no idea how hard the struggle was to save that one horse's life, so we don't treat it lightly. The same thing goes for the family rancher. He gets up at four A.M. when the rest of the world is asleep, while I get up at two A.M. to carry milk to an orphaned horse. So those people who know the least are the ones who miss this link. It's the people who care for animals—whether that's a rancher or farmer or the guy who works for the county animal control office—they're the ones

animals need. It hurts me to see animals go through pain just because people don't want to lose them.

I can't begin to guess how many foals we've saved, whether it was from lions, moon blindness, nutritional defects, or whatever. There was only one I couldn't deal with. She came out of Nellis and had terrible abscesses. I dug holes in the ground and lined them with plastic and put Betadyne on them, laid a sleeping bag over her to keep her legs in the hole so I could soak the abscesses, but her hair was falling out and she was in unbelievable pain. I finally called the vet and put her down. This is what wild horses go through because people refuse to recognize the whole situation.

Part of caring for animals is learning to let go and learning to lose. I had a hard time teaching this to my daughter. She always saw us as saving animals but never letting go. I told her, "When an animal is suffering, the best kind of love to show is to let it go, so it doesn't suffer anymore."

Every one of us involved with wild horses needs to get beyond the controversies and look to what is in the best interest of the range, the horses, and all the other multiple users. But I also think we somehow needed these controversies to get this far. We had to live through them or the pieces would never have worked together. I regret it has taken so long, but every single thing helped. We no longer hear some people calling to get rid of all the horses, even though for a while there was a drive for that. As a collective, the livestock interests are responsible and the wildlife folks are responsible. There is recognition now to work for the horses' best interest on the range, to keep them from dying and from destroying everything out there while they're at it.

A woman from NBC interviewed me once and asked, "Why do you think fifteen thousand horses on the range is fair in comparison with the hundreds of thousands of cows in this state?" I tried to explain that it is an issue of having horses remain healthy, of not having to worry whether they will starve one year or die of convulsions the next. It doesn't matter if there is not one horse for every one cow. It doesn't matter what the pie looks like. What matters is that the horses that are out there will thrive in a healthy

condition and live in a natural state rather than being moved around like some zoo animal. If they are allowed to roam, they will maintain the social connections and herd groups that are important to them.

Sometimes I do get discouraged. But looking back, I'm not sorry; not for one moment. For every mistake I've made I've learned something, and I hope my mistakes weren't so big that I caused any animal, person, or group of persons any great harm; because that's not what I wanted. But I don't understand any group or individual who thinks they can have it all up against everything else. I feel so strongly that everything comes down to compromise. If you look at world issues today—whether it's war or famine or AIDS— it always takes compromise to solve any issue. If you can't become part of a common solution, you're part of the problem.

Glade Anderson: Wild Horse Specialist, Reno, Nevada

My memories of wild horses go way back. My first horse was a little mustang named Ginger. I was eight years old and my uncle brought her back from Dugway Mountain. She was only a week old, and I bottle-fed her. Ginger and I grew up together. I rode with her all across the Utah desert!

In Utah there are about thirty-five hundred wild horses. Central and southern Utah is unique; there are lots of horses there. When I was young I heard fascinating stories about them from some of the old-timers. One old guy, Maurice Brown, lived out in the Cedar Mountain area and talked about his early days catching wild horses with his dad. He said they would put a halter on the mustangs after they caught them, tie them to their old work horse, and then they sent the work horse back to their family's ranch.

There is so much local heritage that ties back to those original pioneer families, and that includes where these horses got their roots. For instance, Standardbreds and mules were brought to Cedar Mountain in the early 1900s. The Brown family gathered and sold those horses to the U.S. Cavalry. This is the region that I came back to when I became a wild horse specialist. It's my favorite area in the whole state.

In Utah we conducted our own gathers for ten years. We had a really good

crew and our own helicopter. Alan Carter is our pilot, and he's excellent. There is an art to flying horses, and there's a shortage of good pilots. Over the years I've watched all three of our best pilots. After a while you can tell who's in the ship because they each do things a little bit differently.

We trained our own Judas horses in Utah. We watched Dave Cattoor work with his Judas horse and we figured, well, he had to start somewhere, so how did he do it? I remember our first attempt. Phil Bennett, who worked with me and has since passed away, had two registered Thoroughbred mares that were full sisters. They were just in love with each other. We put one in the corral and we figured the other would just run to it. That was our theory, anyway, and it worked! If we took one mare out and she didn't have her sister to run back to, she just wouldn't ever run as good. Another one of our crew members, Dick Hunter, had a Judas horse too, and so we always used two Judas horses on our gathers. We did that for about ten years, and then our best mare, Jalouse, broke her leg. The accident actually happened at home in Phil Bennett's pasture. After all of the rocks and rough terrain that mare had run through on the high desert, she up and twisted her leg in a pasture ditch! We couldn't believe it.

Abe was the name of Dick Hunter's Judas horse, and he had a partner as well. For a while Abe was listed as "Employee of the Month" at the Cedar City field office. Abe was a real nice Quarter Horse, but he was a little slow; he'd just lope along when he was bringing in the mustangs. But Jalouse was fast! So the way we utilized those two horses is we would put Jalouse out on the wings of the trap, and we would time things to turn her loose first. She'd pick up the mustangs as they came in, and when they got to the mouth of the trap we'd turn Abe loose so he'd finish off the job. Alan Carter knew those horses and how fast they could run. We all had radio contact, so Alan would tell us which horse to turn loose and when. We caught a lot of mustangs with those two Judas horses. Abe and Jalouse were probably two of the most valuable members of our team for a long time.

Once they got to the corral our Judas horses *hated* to be in with the wild ones. As soon as that gate closed they just wanted out! They'd kick and

strike, and it was clear as heck they didn't want those mustangs anywhere near them. They'd separate from the wild bunch as soon as they could and deliberately maneuver themselves so we could get them out of the pen. I really don't know why. Maybe it was the smell.

I don't think anybody can capture wild horses as good as Dave Cattoor. He thinks like a wild horse! He taught us how to find capture sites, and he told us to always do our homework on the ground. I remember watching him go out to see how the horses moved. He always puts the traps where the wild ones naturally travel, so that's what we did, too. A good pilot starts moving horses with the helicopter and then basically sits way back and lets the horses move. Maybe the last stretch he'll push things a little. But things can get pretty dangerous up there. Luckily, Alan never had any accidents.

Once those mustangs get in a pen they just don't look the same. Phil Bennett and I used to joke that wild horses in a corral had shrinking disease! We'd see a certain band out on the mountain, but once we gathered them in and took a close look later on, we'd always think, "Those can't be the same horses—they're so small!" Horses in the wild always seem larger because they're free and prancing all over. When they're in a pen that spark is gone. I wish we didn't have to gather them, but this is a job that has to be done, so I think we should do it the best way we can.

If you compare Utah to Nevada, Utah horses aren't as colorful. Some of them are what you might even call ugly. Our horses are also two or three generations further away from founder's stock. Plus there were never as many Utah ranches that turned out quality stallions or manipulated the herds like Nevada ranchers. So Utah horses are generally smaller, even nasty little things. We also had some inbreeding because of some small, isolated horse populations there. In one group called the Chloride herd there were dwarf horses; there was another herd that was going blind. Those blind horses were actually moving around by sound! Some geneticists took blood samples on those horses and found that as the horses matured they developed cataracts as a result of inbreeding. So as the older horses became blind, they followed the young horses by the sounds they

made. Handling a wild horse that's blind can be very dangerous, so we were lucky to place a number of them at a private sanctuary. The geneticists advised us to put new stallions in those herd areas so that new genes would take care of the dwarfism and blindness in those bloodlines.

The Sulphur herd in Utah are unique Spanish-type horses. Gale Bennett, Phil's brother, did quite a bit of research on them. As near as we can tell, the Ute tribe traveled frequently to southern California in the 1600s. They traded or stole horses or whatever else along the way, and they spent their summers in the Uinta Basin. They used a route through Cedar City, Millford, and then up to Vernal. Well, when we started reducing herd numbers in those areas we caught several groups of horses. At the time Gale figured we'd find Spanish-type horses in the Vernal area, and we did! He'd read accounts from the early settlers of sightings of little buckskin horses there, so those horses either were originally turned loose or escaped from the Indians. That Spanish influence seemed to run through the whole area. There are still a large number of Spanish-style horses on the Ute reservation today, too.

What's odd about those Sulphur horses is that through the years they never seemed to mix with other herds. When BLM came on the scene there were some larger-type mustangs moving from Nevada into Utah, but even then that Sulphur herd kept themselves separate. So those horses have stayed pretty pure. Most of them are buckskin, dun, and grulla, and they all have a dorsal stripe and tiger stripes. They're similar to the Kiger mustang or the Pryor Mountain horses but smaller. The Oregon and Utah wild horse people have started to breed the two herds back and forth now.

These Spanish-type horses are a fiery little horse! I've talked to some BLM wranglers in Burns who told me they don't like to work with Kiger horses in the corral. That's interesting, because our Utah crew never liked working with the Sulphur horses in the corrals either. Spanish horses are just always harder to handle. They cause problems in the chutes and they bite; that's just how they are! Gale Bennett took a little yearling from the

Sulphur herd from one of our first gathers. He kept him as a stallion, but he gentled that horse and he used him on all of his BLM work afterward. Cortez was his name; he was only fourteen hands and weighed, oh, maybe nine hundred pounds. Gale is a big man, and Cortez would carry him all day in the mountains! Gale said he was the most nimble horse he'd ever ridden, especially on rough terrain. Cortez had strength and endurance, and he was perfectly mannered, so Gale took him to a lot of elementary schools for demonstrations. For a while we all hoped the bureau would use Cortez for public relations events back East, but the national office said he wasn't a "typical" wild horse, and if we were going to demonstrate wild horses to the public it should be a typical mustang. To this day I'm still not sure what a "typical wild horse" is. The only thing typical at all is a horse that's brown or a bay.

Phil Bennett and I developed a horse that was more adoptable, in our eyes, on the Cedar Mountain herd. About twelve years ago we went to Wyoming and saw some nice horses there. We got some grays and paints from up around Rock Springs and brought those back to Utah. Phil's brother K. Lynn was BLM's associate state director in Nevada at the time, so we asked his help to get a few horses from there. We got some paints and a few mares from the Granite and Lahontan herds in Nevada and brought those to Utah, too. Overall, we introduced about thirty horses from different areas to the Cedar Mountain herd. We put color, size, and conformation back into that herd, and because of that those horses will never be the same. The last time we gathered Cedar Mountain was a couple of years before Phil died. We sat around the campfire talking about how we changed the herd. Some people may object, but as I reflect back, I think it worked out really well. Because one thing everyone should keep in mind is that there is no typical wild horse *anywhere*. Everyplace you go there will be something different about the wild horse simply because mustangs are tied to the local history. Some horses may be descended from one of the early Spanish mustangs, some may be connected to Standardbreds or Thoroughbreds

from cavalry remount programs, some may be descended from draft horses or ranch stock or mules or Indian ponies. Together they are all a part of the western heritage. I think the strength of our program is in that diversity.

Over in central Utah, in the Sinbad area, there are some little tiny gentle horses. We did some research and learned they were a Welsh Pony cross. They were used in the coal mines, and when the miners switched to mechanized labor they turned those little ponies loose. A lot of those horses were only five hundred pounds, but they were just so gentle. We sent them back East and they were all adopted by people who used them as carriage horses.

I love being outside and working with horses in all of these remote places in the Great Basin. It's so special to know there are still places in this country where you can get up early in the morning and see five mountain ranges stretched straight out ahead of you, one right after the other, as far as you can see. It's part of my personal history. There is still a lot of wide open country in Utah and Nevada, and as long as those wild horses are there I know there will always be a remote place in the West where there's still a beautiful sunrise. A place where man hasn't put in another subdivision. A place where it's just you and the horses.

I've seen thousands and thousands of horses in the wild, and it's still a thrill.

Sam Mattise: Wild Horse Specialist (Retired), Boise, Idaho

In the early 1900s there were many more wild horses here. One old cowboy told me there used to be over a thousand mustangs just between Boise and Mountain Home. Another gentleman said he was on a roundup south of Twin Falls where they gathered twenty-five hundred head. Just before the 1971 act was passed a lot of herds were gathered up, so by the time the law took effect there were fewer horses left. There are only six herds in the state now, about eight hundred horses total.

We have three herds in southwest Idaho: Hardtrigger, Sands Basin, and Black Mountain. In the Hardtrigger and Black Mountain region, the old

families had contracts with the government and they released Quarter Horse and Thoroughbred stock into the herds. Over in Sands Basin they released Morgan studs. Those with Thoroughbred and Quarter Horse bloodlines were used for cavalry remount horses, and the Morgan bloodline was for horses who pulled light artillery. Those bloodlines can still be seen today.

North of Emmett, the Four-Mile herd had a lot of big black horses. Those horses were very gentle and easy to train. In 1986 the Squaw Butte Wildlife Complex burned some 220,000 acres and completely destroyed the habitat in that entire herd management area. We removed the remaining horses and released them into the Black Mountain and Hardtrigger herds. Later on we reestablished the Four-Mile herd with horses from these areas.

The Challis herd usually has bigger horses. You can still see the Belgian and Percheron bloodlines because some of those horses have bigger heads and hoofs. The Saylor Creek herd on the Bruneau Desert is also interesting because initially it was very small. Those horses were definitely strays from local miners, ranchers, and cowboys. Water was a determining factor there in how large the herd got. Wildfires also burned the greater part of that area, so BLM rehabilitated it and planted thousands of acres of crested wheatgrass. That gave the herd unlimited forage. Today, with miles of pipelines and water troughs that local ranchers put in for their livestock, the herd has really increased. Forage and water are not a problem there at all anymore.

During our last gather we noticed that horses from the Sands Basin herd wouldn't settle down. During haltering and loading, if we had trouble with ten horses, nine of them would be out of Sands Basin. Those horses just fought everything tremendously and they would hurt themselves. We have big, heavy steel gates at the corrals, and one Sands Basin stud, who we called Zipper, crashed through three of them! He never even tried to jump. He just put his head straight down and tried to run right through those gates—three, mind you, not just one! There was another sire and his get

who we called Jaws 1 and Jaws 2 because they always came at you with mouths open, baring teeth. I mean it; they clearly intended to do some serious harm! Some folks who adopted Sands Basin horses later told me it was harder to work with them and took much longer to get their animals gentled.

But because these Idaho herds are small and isolated, I can take some mellow studs and mares from Black Mountain and put them in Sands Basin or vice versa, or bring some horses from another area and introduce them into the Four-Mile area, for instance. Genetic research states that in these small herds we should introduce at least one or two breeding-age animals every generation. I wanted to change the attitude of the Sands Basin herd by introducing breeding-aged animals from other areas. We want to see these horses adopted, and we also want adopters to have a positive experience with their animals.

I'm still intrigued with the aura of the wild horse. There's not much left of the Old West, and in that little tiny bit that is left, there are still these wild horses. I feel fortunate to be here to experience what this all means. When I'm out on a gather and I see a bunch of wild horses coming into a trap, it's always a thrill. It's a link to history. Sometimes I sit and wonder if a hundred years ago someone would have set their trap right there in the exact same spot as ours, to catch some other mustang band. Maybe they'd have set it up differently, or maybe they'd be running them horseback, or maybe they closed some other kind of gate. It's something to ponder. I guess I've always thought I was born a hundred years too late.

Bruce Portwood: Wild Horse Specialist (Retired), Elko, Nevada

I love horses! I've been involved with them all my life. When the BLM Wild Horse and Burro Program started, I said to myself, "That's what I want to do." As soon as there was an opportunity I became the wild horse specialist in Elko. I pretty much ran the whole program here until I retired.

Before the act, horses were all around up this way, but they weren't in huge numbers. There would be maybe a band of fifteen in one area, and

then another little herd a ways off. They stayed scattered because local people went out occasionally and gathered them. The reason the law passed is that there was a lot of inhumane treatment going on at one time, and the law meant to ensure that wild horses were protected from that kind of treatment. But any law always seems to have unintended consequences, and the way the Wild Horse and Burro Act was interpreted put a complete stop to all wild horse gathering for a while. By the time BLM finally got going with a claim program in 1975, the herds had built up again, and in some areas they built up big. We'd fly over to count them. It looked like ants pouring out of an anthill in some places! There were lots and lots of horses all through these draws and hills.

The Elko District gathered over six thousand head of horses during the claiming program. At the time there were horses running free that had brands on them, but lots of others were unbranded. They might all be running in the same bunch, but if you looked at them you could see they came from the same sire, so the law allowed any rancher to claim his own horses that were out there. Of course, the rancher had to prove ownership. In our district we wanted to remove all the privately owned horses, particularly on the checkerboard areas (those are areas where private lands are adjoining public lands).

I think our program was successful because we had more flexibility. For one thing, we didn't charge as high of a trespass fee, and for another we operated for three years. There was no official allotted time for the claiming period, but we felt that as long as there was a horse out on the range that was branded, its owner could make a claim. We finally terminated claiming after some protection groups gave the state office a lot of flack. There were several areas where we knew it would be difficult to prove ownership, and we kept those as official herd management areas.

We didn't round up horses in summertime or during the foaling period. We'd stop about April and then start back up in the fall. There weren't too many opportunities for water trapping, so at first things didn't work very well and we got only a few. Then the law was amended to allow helicopters

under BLM supervision. If a rancher made a claim then, he had to pay for the helicopter and the gathering operation but BLM still supervised it. Dave Cattoor gathered lots of those claim horses. When he first came up this way he worked all by horseback and he had only a few portable panels. Then we got to use a helicopter and things improved. Dave did the best job gathering of anybody, and I still think he's the best there is. He understands these horses, he's good with them, and he's as easy on them as can be. I've worked with a lot of mustangers and there's just no comparison.

There were some big ranches up in northern Nevada. Utah Construction had a really big outfit. They took over most of the northeastern part of the state at one time. There's the Winecup, the Gamble, the Salmon River Cattle Company, too. But other than the cavalry remount operations, most ranchers didn't really have any breeding program as such. They just put out a better-quality stud to go with the wild mares. Plus all the mares were theirs, too, at one time. They were either turned out or they got loose, so it wasn't like they ever belonged to anyone else or came from anywhere else. The ranchers let them keep running out there, so essentially they were raising those horses, and since that may not have been noted on their livestock permit, in a sense they were getting something for nothing. Well, once the act passed they had to do something about it, and that was what the claiming period was about. Still, those horses were living in the wild and you couldn't just go out and get one. They had to set up a trap or do something elaborate to gather them.

There were some areas up here that didn't have any horses. They either had all been pretty well fenced out or the rancher in question had removed them and hadn't turned out any more. But some of these big outfits used to run lots and lots of horses. So if they didn't gather them all during the claiming period, well, that's why out on those big open areas there are still wild horses today.

Ranchers used those herds to get colts for their saddle horses. Whenever they needed horses they'd go out and round them up and bring in a few. They sold the really old or sick ones to the canner. They'd keep the

colts, make geldings of the young studs, and break them for saddle horses. Now, you'd think that since they already had a permit for so many head of livestock, that if they turned horses out on top of their cows they'd overuse the range. But up here a lot of times horses graze the high country, so they don't affect a cow operation that much as long as they stay in small bunches. Once horse herds get into big numbers, well, you bet, they get competitive! Generally, though, horses and cows use different areas. The horses go farther to water and they head up the hills where cattle won't go. Yes, in the winter, horses come down to where the cattle have been and things can get pretty rough because there isn't much feed left. But they make it.

As you go into different areas in Nevada you'll see a different mix of horses, all with different conformation. But conformation and size have a lot more to do with nutrition than anything else. Horses up in this northern part of the country have much better feed, so they grow bigger. If you go down south, where feed is sparse and waters are far apart, those horses are a lot smaller. You can almost draw a line. So even if a lot of what went on back then was haphazard, you can still see how different people were putting different studs out and where. Some of those original horses were draft-style horses, and a lot were Percherons. For years, people up here crossed Percherons with saddle horses to make a bigger riding horse. Gradually what happened after the act is that when those horses were left alone, the horses with a draft background kept the big frame. Their heads and feet stayed big, and their tails got long, but what's left in between isn't always all that good anymore.

There were a few old-time horse runners around this way. One guy, Gilbert McCauley, worked for the uc. He quit that outfit and gathered him up a little bunch of horses. He took them down on the Goshute Range and turned them loose, and he ran a little horse operation there for years. That was a long time ago, before the Taylor Grazing Act. After the law, he couldn't get a grazing permit because he didn't have any base property. He didn't own any private land or have a homestead or anything. He was just living out there pretty much under a rock! But he still had all these nice horses

that were his, and he husbanded them. McCauley built some elaborate water traps. He used water traps because it was really dry country. He gathered only what he needed to get enough money to live on, and then he turned the rest back out. He operated that way a long time. BLM would fine him with a trespass fee every once in a while, but nothing much ever came of it. By the time the claiming period came along McCauley was getting awful old, and I think he wanted to get out of the business. He water-trapped the rest of his horses and left just a few out there as a nucleus for a wild horse herd.

Water trapping is not as easy as it sounds. Some of these horses can get pretty spooky, especially if it's a new corral. They'll sit out there and look at it and snort and carry on for maybe three or four days before they even come in to get a drink. Sometimes they'll drink too much and they'll colic and stuff, so you have to be careful. You can have a problem there. McCauley's trap had been there for years, and his horses were used to it and him. He had a fence around the water and a little holding corral off to the side. They'd come in and get a drink, and he'd shut the gate and move them on into the corral with no problem. He could control how much water they would drink at one time like that. He'd push them on in the corral and let them set, and then he moved them back in to get another drink. It was a pretty elaborate setup, not just a little old circle around the water hole. He had another little pen where he'd keep them, and he'd always feed them a little while before shipping them. He built a little chute off to the side for that. McCauley was a whole lot different from just any mustanger who might go into an area, set up a makeshift corral around a water hole, flag off the rest so the horses can't drink, wait, load them up, and get them off in a hurry.

Running wild horses was exciting as hell. I didn't do much until we got the helicopter, but after that I'd go out as part of our crew. The helicopter brings in the biggest bunch, but there will always be a few horses that miss the trap, and we'd go out horseback to bring them back. I never told BLM how much fun I was having running horses, but it was more fun than I ever

had! If you were on a horse that'd done this for a while, well, once he heard that helicopter coming, even if it was from a long ways off, you could hardly hold him, he'd be so ready to run. I'd be sitting there trying to hold him back, and he'd be all revved up, *zoom-zoom*, all ready to go. Right about that time here they'd come. We'd just fall in behind, hoping they all went in. Any horses that veered off, well, that's what I'd go after.

We always rode horses that liked to run. You can get Thoroughbreds crossed with Quarter Horses now; they're a little better-boned. Every once in a while one would blow a tendon or they'd come up lame, or they'd just get burned out to where they didn't want to run anymore. But most of them were ready to run. It's like a race to them. They know they're going to run; they know they're going to catch something. You take them out and they like to go!

Usually there were three or four guys who'd go after the loose mustangs. Sometimes we'd go quite a ways before catching them. You rope them, sure, but you don't choke or drag them. Generally, one guy gets behind and another gets off to one side. I'd be on the other side with a loop over its head, dallied up. The guy behind usually keeps the horse headed where you want it to go, and if that wild horse decides to take off somewhere else, you just let him jerk himself around a little. That gets him moving again, and pretty soon you've got him in the trap. We seldom lost any. If the terrain was bad, like in a big, deep gully, we'd tie them down and bring the trailer out to bring them back. It's pretty dangerous to go get a horse down a steep gully and then bring him back up. You can get hurt pretty easy. If he's up ahead of you it's one thing, but if he decides to come back down while you're heading up behind him and he jerks on you, well, you can get in a pretty bad place.

We set up traps with all kinds of things. Sometimes burlap hung over fences, sometimes portable panels spread out, sometimes steel cable with burlap strung over it as camouflage; anything to keep the horses away from it. It depends on how elaborate somebody wanted to make it and how long they wanted to work. Sometimes the wings were short, and sometimes

pretty long; it depended on the lay of the land. Sometimes there would be a rocky outcrop you could use for one side of the wing and they'd set the trap around it, and only one wing went out on the other side. It varied area to area. In juniper country they'd cut down a bunch of trees and make wings out of the brush. They'd stack them up and it would be all strung together, just one long pile. Anything worked fine as long as horses couldn't see through it, because if they don't see a trail they stay in line. Sometimes we'd put the trap on old horse trails where they usually run. Sometimes certain things work out better than others.

One time I watched a guy lasso one of those wild horses right as they were coming in. His own horse was played out, so he took the saddle off his horse and put it right on the mustang. The wild horse jumped around a bit, but the rider took his snaffle and put it on the horse and he just kept steering him like that. Somebody went out and got behind to help follow him in. He rode that mustang straight on back to the trap!

You take any of these horses who have come in off the range, well, they're scared, and if you start to fighting them, they'll fight you. But some of them make really fine horses. The best way to work with them is to take things easy and let them get them used to you. There are some good horse-training programs, and there are a lot of good horse trainers around. But someone who trains quality show horses or does other stuff with horses may not ever have spent time training mustangs. Right now, BLM puts a halter and a lead rope on a wild horse, and they put it in the trailer and say to the adopter, "Here, take it home—it's yours." Well, I've always thought that's just a recipe for disaster, for the wild horse as well as the person who gets him. When you take somebody who doesn't know a heck of a lot about horses to begin with and you let them adopt a three-year-old mustang stud, obviously they're not going to know how to handle him. But it's against the law for BLM to do anything else.

* * *

HORSES CAN BE very destructive when it comes to grazing. A horse has teeth and they can get right down to the dirt, and they can paw to get the plant roots. There's a certain train of thinking now that says if these horses are left alone and the feed gets so bad they starve, they won't reproduce as much. Well, sure, there were once two million horses in the West, but it was down through that prairie country and grass was high there. We've never had grass like that here. I don't think people understand just what these horses go through in the Great Basin when there's a fire or not enough feed. Sometimes in late winter you can go see these old horses just standing in snow and eating up sagebrush. Their bones are all sticking out, they can hardly move around, they're like the walking dead. It's so sad. Nobody wants to see that. I certainly don't.

My grandfather was an old-time cowman who came up from Texas into southeastern Montana. He gathered mustangs whenever the opportunity arose. I guess it was a pretty wild time—great for men and cattle, hell on horses and women! During the 1920s, when Montana rounded up all their feral horses, he got the contract for Rosebud County. My mother told me that when they got those old mares and colts back to the corral, there were burrs all through their manes and their tails all dragged the ground. She said half were on locoweed; they ran straight into fences and they'd break their necks. I can still remember my granddad telling me when I was just a kid, "Don't ever start running wild horses cuz it'll ruin you for everything." I must have not listened very good. Once I went to work for the wild horse program, I never wanted to do anything else!

E. Ron Harding: Wild Horse Specialist (Retired), Burns, Oregon

I've had a sixty-year love affair with horses. My father took great pleasure in his horses, and if ever there was a hero in my life it was my father. Wherever there were horses, that's where I always wanted to be.

In the early 1970s I hired on as a range conservationist with the BLM district in Burns. When I arrived, the area manager said there were wild horses here, and it wasn't long before we started to make preparations to

gather them. It was the second wild horse roundup the bureau had ever done and happened at the East Kiger Herd Management Area in October 1974. There were news media and people from horse protection groups all over the place!

The first day we gathered maybe eight or nine horses. On Saturday the horse runners and everyone got the feel of things. We gathered a significant number; if my memory serves me correctly, it was ninety-three horses. On Sunday there was a drawing to see who got first, second, third pick of the horses, so we brought them to the fairground. We had them in pens where they were all moving and mingling. Chris Vosler was the number one man on the district then, and he was standing right behind me when a lady came along and said, "I want that black filly there." Well, I had a lariat in my hand and I threw a loop and missed. Then Chris said he wanted the rope, and he missed every loop too. We weren't having much luck catching this filly, and I sure wasn't going to take my boss's rope away from him, so I went over and got a foot rope. That's a cotton rope, and it was like roping with a washrag it was so limp. So I climbed up beside Chris and I threw it and caught this filly. I sucked in some slack and jumped off into this pen of wild horses, and I hollered out, "Get this gate open and help me get her out of here before she chokes down!" Things continued like this all day long.

On Monday one of the guys said the boss wanted to see me in his office. I thought I was really in trouble for bossing him around the day before at the corral, but I went up and knocked on his door. He didn't smile, he just looked at me. Then he said, "Harding, you've got the wild horse job."

In the early days we gathered the wild ones horseback. It's rocky terrain in that area. One time I asked one of the lead horse runners, "How do you negotiate through all this stuff?" He said, "Well, you're too scared to look up and you're too scared to look down!" And that's how it was. You don't have to be that good of a rider; you just have to know how to hang on. It's interesting. Once people gather wild horses, they come back year after year. There's something about it, whether you're running them horseback or bringing them in with a helicopter. It just gets in your blood.

Those saddle horses we rode, we never had to teach them anything. They were spirited and they liked to run, and they got addicted to wild horse running the same as we did. We knew where the bulk of the horses were. So we'd set the trap on a major trail and try to head the horses onto that trail. They'd run into a trap that was camouflaged with sagebrush, juniper, or whatever. Initially, one guy would start running horses down the trail and toward the trap, and from then on it went like a relay race. You'd set riders every quarter to half a mile. If you were a rider you'd be pulled up, waiting behind a juniper tree where the wild ones couldn't see you. I guarantee you those saddle horses felt it in the ground. You never had to worry about knowing when those wild horses were coming, because boy, oh boy, that saddle horse, his head would be up and you better be ready to ride!

I rode Old Salty Dog a lot. I remember how the muscles in his shoulder and his neck would just get to quivering; it was like he was hooked up to something electric! He'd just go to shaking all over, and when he saw those horses he was going to chase those wild ones, and it didn't matter whether you wanted to hold him up or not! He wanted to stay with the pack just the same as the last horse in that wild group wanted to stay with the band, and he was going to do everything in his power to stay right with them. Wild horses generally follow around a hill on the trail, and the trails tend to follow the terrain. Well, Salty Dog would cut right across to catch them. If they were getting out of his reach, he didn't pay any attention to the perils out across the country.

One time I saw this string of boulders coming at us. It was probably about eight or ten feet across, and I knew he couldn't jump that string of boulders. They were about the size of your head to a bushel basket, so I was ready for a crash. Boy, oh boy, that Salty Dog horse hit right in the middle of that string of boulders coming down off that hill, and he lost his feet and here we went! I kicked out of the stirrups before he ever hit the ground and just spread-eagled to his right. That horse catapulted across this boulder patch and hit on the other side on his chest with his legs all folded back. I don't know who got scared worse—me or him! But he got right back up, and I

gathered him up and we just headed on again. That's the way those running horses were. They were used to being in the rocks. They were about as wild as those mustangs in their way.

We always rode with a snaffle bit, because if you had a curb bit and you fell it could knock their teeth out. Billy Z. Evans was one of the first runners. He had a horse called Old Yeller. One time we were over in that East Kiger area, and he came down off the hill and was making about a forty-acre circle, just going round and around and around on his horse. One of the guys rode out and hollered, "Hey, Billy, have you lost your mind?" He hollered back, "Heck no—I'm trying to stop this darn fool!"

A lot of those running horses we rode were outlaws; they were just like renegades. One of them was even called Outlaw, in fact. Then there was Cougar, Salty Dog, Old Yeller, and Burnt Mare. Some got skinned up when they lost their footing in the rocks, but I don't remember any one of them ever breaking any legs. We had a lot of injuries to the men, though. Our lead runner, old Beetle Bailey, he ruptured his spleen on a fall, and if the helicopter hadn't gotten him to Boise he never would have made it. When you ran wild horses, there was no way of bringing them in easy; it was just full tilt all the way. So the danger was not only to the wild horses, but to all three—injuries to the wild ones, to the saddle horses, and to the men.

In Burns we had the responsibility of doing compliance on all the adopted horses in Oregon, Washington, and Idaho. I'd go all over when there was a problem. BLM state offices had jurisdiction back then, but they really didn't want anything to do with the wild horse program because the issues were so sensitive. Even the local sheriffs and brand inspectors didn't want to have anything to do with it. For one thing, people weren't allowed title at that stage, so there was no way of tracking the horses. After all, a wild horse looked just like any other horse, and there were wild horses on Indian reservations, too. So there were some real problems that way. Quite often we were called to look at situations that didn't even fall under the act. Finally BLM started to freeze-brand the horses, so now every one of them

can be identified. But freeze brands only help track them. The compliance problems grew, and BLM didn't have the manpower or money to handle it. The best way to ease the whole situation was for title to be passed to the adopters. Nowadays a state brand inspector won't allow the sale of any wild horse without a title.

* **

THE SPANISH MUSTANG was really a conglomeration of the early horses that traced back to the time the Spanish first settled the West. The Spaniards came over with Andalusian horses and with horses called the Goranno and the Sorraia. They also came with a horse called the Spanish Barb. The Barb actually came out of Africa, and there's no telling its origins. Whenever you hear terms like "pure Spanish mustang" it's important to remember that those early explorers and colonists brought a mixture of different kinds of horses to begin with. When they got loose, they bred and mixed on their own.

Chris Vosler, Willy Bill Phillips, and I used to talk a lot about the old Spanish horses. We knew there were different colors of the early mustangs and that the most primitive marking was the dun factor horse, and we wondered whether there were any in Oregon. As it happened, Beetle Bailey's dad, Tom Bailey, had been a mustanger. One day Beetle told us there used to be a horse on the south end of the county, down toward Nevada, that folks called the Oriana mustang. He described what they were like and said that if there were any left, they'd still be over on Beatty Butte.

The first time we gathered Beatty Butte was in 1977. When those first horses came out, there was just no question in my mind—I knew we had the real stuff! They were all relatively small and had the dorsal stripe and such. I selected the very best out of that bunch and put the mares in one spot and the studs in another, and then immediately off to town I went to see Willy Bill and Chris. We all agreed these horses were the real thing. Once these were gone, well, there just weren't no more, and so we wanted to preserve

them. At the time we were getting around to go into the East Kiger area to reduce the numbers there. So we gathered all those horses at East Kiger and we turned about twenty-one from Beatty Butte back out, of which two were stallions. We also turned back two East Kiger mares which showed the same characteristics. Then we turned out four two-year-old stallions and two mares on the Riddle Mountain herd. Eventually, as we started removing horses from the Riddle Herd, we would turn back some of the Kiger dun horses there as they were available. And then we'd turn horses back out of the Kiger herd onto Riddle. The reason was we wanted to have a second gene pool in the Riddle Mountain area just in case of an emergency. It was also clear that horses in the Smith Creek area would eventually get onto the East Kiger herd because all that divided them was a fence line. So the management plan was written to combine both those areas together, and that became the Kiger Herd Management Area. It wasn't too long before people started talking about these little dun horses, and the name finally stuck: the Kiger mustang.

But this is where people get mixed up in their thinking. There is a real difference between the early Spanish mustang (which was also a feral horse) and most ordinary wild horse stock today. The Kiger herd is different in that they are a breed of horse by modern-day standards. We may not be able to call them "pure" this or "pure" that, but they *are* pure Kiger. The Riddle Mountain herd is also that same kind of horse, so they are both "Kiger mustangs." All the other herds in Oregon are descended from other kinds of domestic saddle horses gone wild.

There are some things that are true about managing horses, and one is you've got to look down the road, especially if there's going to be an excess. In my experience there's always a demand for a good horse. In the first roundup on East Kiger, we kept two of the best stallions and turned them loose in the Warm Springs herd. It was all with the thought of having good horseflesh. Every time we gathered, if there were good stallions we turned them back on the range, and if there weren't any good ones we didn't. We

also moved horses from one herd to another. We didn't pollute the Kiger horses, but if one horse fit a given herd and would improve the situation, we did that. I submit that if the public wants to adopt these horses and does not want them to be wards of the government forever, they must be acceptable and desirable.

In my career I've had an opportunity to talk to just hundreds of people. Without fail they've told me they want a nice horse. Here in Burns we advanced with that kind of thinking. We selected wild horses that were quality animals, fifteen hands or better, and horses that weighed a thousand pounds. There were also other herds in eastern Oregon that showed specific characteristics, and we emphasized those. One herd is called the Palomino Butte herd. The buttes were named after those yellow horses, and so we stayed with red duns and palomino colors there. In the Warm Springs herd there were Appaloosas, so we stayed with appies there. Steens Mountain had pinto horses, and we've gone with those. The herd at Jackies Butte was primarily a straight Thoroughbred herd; we knew their background. Through the years this made our program very successful.

I'm not sure BLM is convinced they're managing horses. They know they have an edict by law, but in some places minimal feasible management only means gathering horses and getting them adopted. Well, it's much more than that! In my belief the answer is found in management of horses in the broad spectrum.

It's also a serious misconception that you can manage horses without experienced horse people. I guarantee you that the people who deal with these horses every day know a *lot*. Wild horse employees deserve a career ladder so they can bring young people into the program who have some basics, so they can train them and then let them stay and progress within the specific field of wild horse management. That way they understand it; it's what they think about when they get up in the morning and when they go to bed at night. I also think that the person at the top of the national program needs to know and love horses. You've got to know what these horses

are and what they need, what people want, and what needs to be accomplished for this program to work. There is a whole picture to deal with, and boy, you better not be dealing with just one little part!

* *
 *

LITIGATION is like anything else in life. Anyone can thrive on controversy for a while, but most people don't thrive on controversy; they need some good stuff, too. The real question is: do these pressure groups do anything positive? People who go after lawsuits only cause more wheels to spin, because all the lawsuits in the world will never take away the problem. One court decision may force somebody over in one area to do a certain thing over there, but in ten years they'll have to force them to do it again. But when someone comes along and their heart's desire is to help, then they are going to be there to figure out exactly what needs to be done. I do believe minds can be changed. I've always said a smart man will change his mind but a fool never will!

The Steens Mountain area is changing. The Donner and Blitzen River has been declared a wild and scenic river, water gaps have been placed to allow horses to move back and forth, and there will be fences removed or fences put in. At least things are planned that way. Wild horses need a strong advocate to see that what happens will be good for them twenty, fifty, or however many years from now. I feel I know enough about wild horses on the mountain so that when issues do come up, I'm qualified to speak toward them, or at least listen to all the facts and then speak toward them. I appreciate every resource use, and there's a place for it all. I don't want to see horses out there in numbers to the point that they damage the range— be it the soil, the vegetation, or whatever. So that's where I'm at now. It's still a labor of love for the horses and the good Lord who made them.

Leland Arigoni: Retired Buckaroo, Coalville, California

I was running wild horses all my life. I did it to get a good horse because I couldn't afford to buy one. My people were Italian but I had been raised

with the Indians. I made money working on cow outfits, riding bucking horses, and roping. I roped with the best and the worst. All it took to run wild horses was guts, a good horse, and being able to rope!

Back then you could buy a broke horse for $15, but those mustangs were just as good as any horse that people raised. I ran them all through Railroad Valley, all over the hills from Pinenut clear to Dayton, and then out there over all those alkali flats, too. Some of those guys sold them for chicken feed, and if you got 35 cents a pound that was good money then. I also went up with Bud Moore in his plane. Old Bud was good at flying but he wasn't a horseman, so I'd spot the horses to see which way we'd go. With an airplane a lot of times we could catch twenty-five head in a day. Mainly, I never got paid. It was a challenge, and the challenge was what I liked. I probably had as much fun running mustangs as some guys have chasing girls!

Whenever I went, I'd always try to catch the best one there. Mostly when I caught one I'd give it away to the people I went with, because they furnished the trucks and equipment and I mainly went for fun. But as far back as I can remember there were always people against catching mustangs. Guys like me who did it were looked down on and degraded. People would follow us with cars or they'd fly over to try and catch us, and sometimes we'd get in arguments.

Sometimes I did go alone. At other times I took my daughter out. If I roped one, she'd take the horse and hold it while I'd go get another one. There was a horse called Old Bald Face over on the other side of East Walker River. I went out a few times to try and catch him. Then there was another gray stud down in Pinenut I caught by myself. I had a horse named Gray Ghost who used to be a racehorse, and a buckskin that had been a polo pony. I used them all the time to chase mustangs. They'd get tired, but I didn't ride them all-out and they would always go again the next morning. With the buckskin, he had one gait and I could run him forever. With Gray Ghost, I would trot him out a little ways and then gallop him a little, and then just open him up.

One time we were after a little yearling pinto when I was riding Buck. We

could see that yearling and his bunch down below. I told the guys, "You go around the other side and I'll jump him, and by the time they get to you they'll be pretty winded so you guys can catch him." So I got on old Buck and was walking him because I didn't want to start the bunch running. Well, that old stallion turned right around and he came back after me, but just as soon as you'd notice I roped him! I carried two lass ropes and there were juniper trees out there, so I rode over to a big tree and tied him to it. Then I took off and caught the little pinto. Kenny Chichester was along and he wanted the colt, so I gave it to him, and I gave the black stud to the other guy. I bet he was fifteen years old but they broke him. They castrated him and used him up at Lake Tahoe as a dude horse after that.

The horses we caught over on Sweetwater and up on Bald Mountain were bigger, probably a thousand pounds or more. The Conway Ranch used to haul stuff over to Bodie with teams. They ran their horses out on Sweetwater Mountains. They were gray and part Percheron. Probably a lot of them bred and intermingled with those mustangs there. Down in Railroad Valley at the uc outfit they used Percherons to breed their mares too. They all looked good. They made good saddle horses because it was seldom that any of them bucked.

When we were running horses those mustangs didn't know what a fence was. If you built a corral and didn't put sacks or limbs on it to stop them, they'd run right into it. Nowadays, they all know a fence when they see one.

One time we were chasing mustangs and there was a guy called Whispering Pat. They called him that because when he went out in the hills he'd always whisper. We were about to corral a bunch in a pen when this young kid came up yelling, "Lightning hit Whispering Pat!" There were about seven of us, and we all went back out. When we found him, you could see where that lightning burned him and his horse. It hit him in the head and went right down through the saddle horn and straight out the bridle. It killed them both, and he probably never even knew what hit him.

When we caught mustangs with a box trap it was the same as catching a coyote. When those horses went to water, the stallions would always go in

one place. We called that the "stud pile." We'd put our trap there and cover it. It had a rope and a spring and a tire at the end of the rope where the horse couldn't see it, and when that spring jerked the hondo, it was like roping him. It would catch them by the leg. You still had to go after them because otherwise they'd drag that tire along behind.

When we went after a bigger bunch, we built corrals. Down there in the alkali there'd be a canyon with some timber, and where it got narrow is where we would put the fences. Then we would hang sacks around it. Those horses would go right in because we would leave it open. Then we would rope them and take them down one at a time to get them in the truck. We put a rope across the back of the truck and hooked it up, and then we would shove the horses in. You stood right there with them, and you'd put your legs in between their legs and grab onto their tail so when you were pulling they couldn't kick you. When they got in the truck you'd want to get away quick and take the rope off because they'd jump or something.

A mustang's foot is hard and tough. They're not near water, and they can run forever out there. Lots of times back then, the Indians would never quit running wild horses. They ran them over all the rocks and those horses never got to sleep, so some of them would get sore footed. It's just like a saddle horse. If you run him out in a meadow it won't hurt, but if you ride him hard down a gravel road he'll get sore in a hurry.

I've had all this experience with horses all through my life, but never any educated experience. There's a lot of guys who think I'm bragging. Well, there's no BS at all!

Sheldon Lamb (Deceased): Rancher and Horseman, Fallon, Nevada

We had lots of horses all my life. I grew up ranching, riding, and breaking horses, and ever since I can remember we gathered mustangs. My dad told me that way before he came to Nevada, horse thieves came through Pahranagat Valley. There is lots of water down there, big lakes and springs and lots of meadows, and those outlaws came through with a bunch of stolen horses. Some old-timers said they were eastern horses, but I don't think

anyone knew for sure. Anyway, they camped in that valley and some fine studs got loose while they were there, so the story goes. My dad put his horses out there. One meadow was twenty-five hundred acres with springs all around, and he'd put his horses in there to let them rest. They all stayed nearby because of all that water. It was just natural mustang country. There was lots of feed, and they always came back to that valley. Some of my dad's horses got stolen too.

We got some fine saddle horses out of that country. They were nice, big horses; they were just right. My wife, Isabel, had a nice little mustang called Ginger, and I never saw his equal. Why, you could run him all day, but he would always just walk with her. He was a real nice traveler.

The ranchers used to catch those horses down there and geld the stallions. They'd put some good studs in with them and take some other ones out. Now they're so damned inbred it's hard to get a good mustang anymore. And they breed faster than they can ever catch them. If I could do anything I would take the culls and send them to poor people who are starving to death. Gosh, there's nothing wrong with that.

I know how to do everything with these mustangs. But some guys today are so used to horses that are raised in a barn that they won't get in the same corral with a wild horse. My son-in-law is like that. He's been around racetracks all his life, and all he's used to are barn horses.

The first thing to do with a wild horse is get them so they're not afraid. What I'd do is put a pair of hobbles on them. Then you tie a rope from the front hobbles back to the hind ones so they can't jump. Then you just start petting them a lot. Then you get a burlap sack and sack them out, all day long. You put it on their back and slide it on and off, just nice and easy. They may throw themselves around a little, but eventually they'll quit. If you go real easy with them, after a while they get as gentle as dogs. But if you go to rough-necking with one, well, he's gonna stay scared, and it can be a problem. There's darn few guys who really know how to do it well.

When I was at the ranch, I put a pack on the young horses, sometimes a bag of salt or a few Christmas trees, and I would lead them up the moun-

tains. Those two-year colts would follow along with me. It's good when you're out with them like that, so they get used to everything. Then you can put a snaffle on them and drive them in the corral and get them to rein, and then you get on them. Then you can handle them. But you've always got to go easy with them.

We raised a mare here, and she was a little bit mean; she'd buck. I put a pack on her and tied her behind my saddle horse and away I'd go. I'd trail her, real easy, around our field. It was just about a mile and she got just as nice as she could be. This big sorrel out there now, he's about twelve, but I put a light pack on him when he was still sucking his mother. He sucked on her for way over a year. I always train them to stand and wait for me to get on them, too.

We made saddle horses out of the best mustangs and we'd sell the others. All the ranchers in Lincoln County rode those horses. Why, Will Stewart, his whole cavvy were mustangs. Will had a roan, a bald-faced, stocking-legged horse called Tango. He was a famous horse in that country. Those wild horses made just wonderful horses, some of the finest horses I've ever seen.

A mustang is a damn sight smarter than people give them credit for. But the thing now is they're getting inbred. I was riding up in the Stillwaters once and there was a black mare with a bald face up there. She was a pretty mare and she had three stud colts, and all three were breeding her, a three-year-old, a two-year-old, and a yearling. It was the damnedest thing. Who wants to adopt those?

The government pushes the adoption program, but I bet they haul back as many horses as they ever take out. One of the government guys pulled into our ranch one day. He had about ten halters in the back of his truck and they were all real bloody. I said, "What in the hell is that from?" He said, "Those are from horses that were adopted out. The kids that got them didn't know anything and damn near killed some of them. They tied them up and beat them." It was pitiful; you could just see what had happened. He said those horses were so bruised he had to drag them into the trailer.

When we ran horses we always lost more than we caught. Most of the time we were catching them horseback. You'd have to run them twenty miles just to get to one place, so our saddle horses would get winded. Mustangs in those days could travel a hundred miles easy. It was rough to catch those horses then. Water trapping is the best way in the world to catch them. When we could get them that way, we always had better luck.

We caught some horses with water traps around Tonopah. They watered in those springs all their lives. You have to be careful about moving or making any sound. You just hid in a hole somewhere and you tied a rope on the gate, and when they came to drink you'd pull it shut. One time we must have gathered 150 head of horses in two or three days. The guy who was supposed to meet us with the trucks didn't show up, so we had to drive all of them out of there. We let those horses go and we just let them run along. Then we gradually circled them, and when we got them quieted down, pretty soon they'd go to grazing as they moved. We grazed them all the way down the Wild Horse Pipeline like that (that's what they called it then). We put them in the field at night and herded them by day. Why, I bet we lost only one horse out of that whole bunch. We even got a blood test for them before we shipped them to California. Doc Clark came up from Las Vegas and did it, and I remember it was expensive.

I pretty much quit mustanging after Dad died. For a while my uncle and I had a mustang car, and we used that over in Railroad Valley. My uncle would bring them over with the car and I'd rope them horseback, and then I'd jump off and sideline them. I tied a hind foot to a front foot with a rope long enough so they could get up and move but they couldn't run. I'd set up posts, and I made a hitching rack and I'd break them to lead right there. That mustang car worked because we couldn't water-trap in that country. There weren't any corrals there and it was all open, just one great big white flat, so there was no place to hide. We had our own trailers and we took the horses up to Cedar Pipeline. There were a lot of big corrals there, so that's where we fed and watered them.

We used to fix up places to catch horses that looked natural. We poured some water out so they'd smell it and go in. But you always had to be careful. If they got scared, it was hard to get them back. One time, we built a corral and those horses came in at night and didn't know what to do. They had never watered there and they didn't know what was going on. The next day we dug a little ditch and took a bucket and poured the water down. We let it run out the gate and down a ways, and those horses just walked right on through. That's how we caught those horses there, but you have to be in a place where there isn't a lot of water anywhere else.

Another time we fenced a creek near Horse Canyon. We put a strand of electric wire on both sides. Those horses had been trotting in there to water at night. Well, gosh almighty, they trotted up to that wire—you talk about a stampede! They went right straight across that canyon and out the other side! We fixed it and put it back up several times, but they finally got to where they figured it out and wouldn't go near that water anymore.

I probably broke at least half of all of the wild horses we ever caught. And after we stopped running mustangs I still broke and trained them. Isabel and I raised Quarter Horses on our ranch, but up until last year I still worked with mustangs. The last one we had was a little yellow horse named Lucky. He had a lot of sense. After I got cancer, I had to stop.

There are too many darn horses in this country now. But these mustangs are sure beautiful to see, a bunch of them running. They'd still make some nice horses if the government ever did things right.

Ed Depaoli: Rancher and BLM Manager (Retired), Fernley, Nevada

Years ago a lot of people had government horse permits. Our family had one on Pah Rah Mountain and we ran our horses there a long time. There were other horses that went back and forth from the Indian reservation, plus another little bunch called the Spanish Peak mustangs. So there was probably three hundred head of horses altogether. We worked the whole mountain and kept all of them in check. When the 1971 act passed, we

didn't file a claim because it was common for the reservation horses to mix with ours. In 1985, BLM took seventeen hundred horses off that mountain. That's how those herds built up in just fifteen years.

We tried to keep our own horses up top. We didn't fool with the Spanish Peak horses or try and introduce any new blood. Sometimes by accident other horses would cross over and mingle. I remember one time the 102 Ranch lost a good Arabian stud. He got with those Spanish Peak mustangs and there were some pretty nice colts up there for a while. We caught two, a roan and a bay. They were really nice but they had lots of fire—probably too much! We had our own stud bunch so we put in some good horses. One of our studs was the son of Poco Bueno. We got some really fine colts out of him.

We had our own corrals on the mountain, and we gathered by horseback. It was usually my uncles and me. We'd run them along the upper fence and then we dropped them down the hill, right on into the trap. We'd get some of those other mustangs too, sometimes, but not in any orderly way like we did with our own horses.

We also had a water trap. Every August after haying, we went over to fix that trap. We would stay there and water-trap the mustangs, and if we were lucky we got five or six. Back in the forties and fifties you could still sell them. There was a fellow named Smiley and he took them to southern California. The price wasn't much, but there was still a good market.

Some of those early mustangers were poor. Plus they didn't have portable panels like there are today. Those are fairly new. That many years ago, why, we never even thought of anything like that! There were no roads, and we had to haul everything in with pack horses. We made our corrals out of net wire, and there would be lot of sticks in it to make it visible. The water traps were net wire, too, with cables around the outside. We had it fixed in a figure eight. The spring would be there, and we'd get a bunch of mustangs and put them in a catch pen. We kept the traps there all the time because the only way you could catch horses at a water trap was if they got used to it. August was the driest time, so we'd watch for them and then we'd catch

them. Sometimes we'd stay up there waiting two or three days. We'd take enough food for one day, but then we'd always stay for more. We'd get damned hungry, I can tell you that!

Sometimes the horses could smell you. We had the gate propped open with a set of cables and pulleys, and we'd get in a hole clear down the canyon on the other side of the corral. When they went in, we'd shut the gate behind. Then we'd rope them and tie them from the front leg to the tail, just a little shorter than a full step, so we could turn them loose. We'd put in two or three hours getting them together and then getting them going. They'd soon learn to walk out and go. There'd be horses just everyplace, but once we got them lined out we'd just trudge right on home. We brought them all the way back like that, about eight or ten miles. It was a big job.

When I worked in Oregon there was a bunch of horses in an area east of Paisley. Nobody had gathered them for some time, and in 1970 there were something like ninety head there. By 1977 there were nearly three hundred and we had a heck of a drought. It started just like this one we're having now. We didn't have any snow, not a thing all winter, and where those horses ran there were no springs. It was all just lake bed pits and holes in the ground. Well, by spring it looked like there wasn't going to be any more water, so we gathered those horses back down. They were in poor shape and really sorry looking. By the time we finished, the ones that were left were pretty well mixed up. The stud bunches were changed around and the mares looked okay. In 1981 we went back and set up a couple of water traps out there. Those horses were a much better quality by then. There had been no new blood put in there or anything. It was just because we mixed them up. You could really see the difference.

When you see some of these wild horses out in the distance, with their tails and manes flying, they look a sight to behold. But sometimes when you get them in the trap, a lot of them have crooked legs or they're knock-kneed or they've got big heads. I've seen a lot of this over the years. Take those horses down around Mina or Hawthorne. Some of that country is really poor, and those horses if they're left alone will become worthless,

just little bitty, ratty things. Now, those horses that run up north in the Owyhee Desert, well, they don't seem to go to hell as fast. There's more room; it's bigger country and there's more feed there. There are also more of them, so there's more blood to get infused with other blood. Down around Mina, that bunch just stays there. They're going to go to hell before too long. They'll look like dogs pretty quick.

Some people talk about one major dominant stallion who breeds all the mares in his bunch. Well, I've sat on the hill and watched one big stud run off a younger stud from his mare, just eating on his rear and running him plumb off. While he was doing that, another stud from the same bunch bred that mare right in front of my eyes. When the big stud came back, he just walked right on by. So some stallions do try and kill the younger ones, but with another individual he may not even bother.

It shouldn't take a rocket scientist to understand how things work with these herds. Let's say you've got a hundred head of horses. Say half of them are studs and half of them are mares, so now you've got fifty head of mares. Now take half of those mares that don't breed, either because they're too old or too young or something, and now you end up with twenty-five mares. Say you have 5 percent death loss for those mares; well, you're still left with a 20 percent reproduction rate. That's going to happen all the time, and some of these herds increase even more. It's a fact! So if we know that we're going to have 15 percent more horses the following year than however many there are now, we've got to deal with it. Those horses are not all going to be special. If there are some nice ones in a herd, yes, sure, let's adopt them or what have you. But with the others that are left? Well, let's sell them. It's just like with anything else. What can be wrong with that?

It's obvious that wild horses should have quality. Take that Kiger mustang that sold for $19,000 last year. Somebody wanted that horse enough to pay that much for it. But if there's an old mare with a big sway back and she might have another colt, what's her future? Quality doesn't have to mean a special breed. If people want color or black zebra stripes on the leg or a pinto or whatever, well, let's aim for that.

BLM had a wild horse sale recently over at Burns. It was a big promotion deal and they videotaped it for TV. I watched it pretty close. The minimum bid was $125. Well, there were a whole bunch of horses there that were solid bays and solid browns, and BLM couldn't even get a $100 bid for them. Even though they weren't terrible to look at, nobody wanted one. But if there was a horse there with color, even if it was ugly, it brought $1,000. We should aim for that same kind of quality here. Take some of these cream-colored pintos that come from Lahontan area or some of those big horses out of Soldier Meadows. Those are really nice horses. I adopted a one-of-a-kind mustang stud in 1981. He came from right up by Rye Patch Reservoir. He was a really nice horse; you should have seen some of the offspring he produced.

The old way of out-thinking wild horses to catch them is going by the wayside. Most of the guys who knew what they were doing are gone. It used to be that people would talk for hours about how to outsmart these horses! John Rattray is the fellow who got all those wild horses off Hart Mountain Refuge. He went up alone and followed them around for days. He figured them out, and then he built traps and he caught them. To get wild horses that way you've got to think about them and you've got to know what to do. You can't be distracted. Maybe it's the coyote in me, but I think there should be a place for that part of our heritage, some area where horse gathering isn't allowed by helicopter but where there can still be a place for someone to go watch them and follow them and figure them out and then gather them horseback or by foot.

The only thing about gathering wild horses is—it teaches how to gather more wild horses!

Don Pomi: Cowboy and Horse Trainer, Fallon, Nevada

I've been around horses all my life. I came to Nevada in 1948 and bucka-rooed at the TS for a couple of years, and then I worked at Marvel's 25 Ranch until about 1955. There were some really good wild horses in the mid-forties and mid-fifties. Not all of them, naturally, but most were excellent,

outstanding horses. South of Battle Mountain, in what they call Antelope
Valley and Jersey Valley, there were thousands of horses. There are still lots
of horses there today. Some of your better horses come from that area.

Everybody has their own taste in a horse, so when you gathered you'd
pick out the ones you wanted. If a horse moves nice and he's got a good head
and a kind eye, that's generally what you want. South of Jersey Valley, the
roans made excellent horses. I had one that was outstanding. Tom Marvel
rode two or three, and Melvin Jones had one too. Everett Jones had a sabino
from a different area.

Most of the time we used a little Cub airplane to catch them. Leonard
Sheperd was one of our pilots. You'd have a parada out there, and the plane
would run them into the area where the wing of the trap was, and then right
into the trap. The traps were a lot different then. For one thing, they didn't
have steel panels like today. We had to cut cedar posts and use other mate-
rials, and it was a lot of work to build it. The Izzenhood Ranch, north of
Battle Mountain, had a trap set at what was called Wire Corral. They ran a
lot of horses in there. There was also a trap at Sheep Creek. On that one we
couldn't get a truck in there, so we had to drive all the horses out horseback.
We'd have them cross-hobbled or neck-reined to other horses.

When Clark Gable and Marilyn Monroe made *The Misfits*, that was filmed
right by Dayton. They call that little playa "Misfit Flat" today. Those mus-
tangers out in those alkali flats used tires to slow those horses down back
then. It does seem really gross, and I've never done that, but that's what
they did. However, I've also seen several movies and documentaries where
wild horses are really glorified. Either way, things just don't happen like in
the movies.

In the past, nobody caught big bunches of horses like BLM does now. The
only time was once in Battle Mountain. It was the winter after World War II
and several thousand horses were caught that year. Usually you gathered
only a few hundred. Most guys would go out and spend a month or two and
just get whatever they could.

I went to work at BLM when the wild horse program was established at

Palomino Valley. There were only a few corrals there and we expanded it to handle more animals. Each BLM district did their own gathering then, and we kept somewhere around two thousand head of horses there. Later on we had one centralized gathering crew. Things stayed like that until BLM put gathers up for contract.

We processed and shipped horses all over the country from Palomino Valley. It was a lot to handle! The old studs and the sick horses were always the hardest to give away. But in those days any individual with a power of attorney could adopt a big number of horses. People can't do it now because that system was abused.

Some of these horses are plumb mean! I've seen them come in off the range like that. It's hard to say why any horse goes mean. Some may get that way from poor training, but some are born that way and you're just never going to gentle them down. With most wild horses, after you lay a hand on them and start playing with them they gentle down like any domestic horse. And with the right care the majority will get just like a dog, especially if you get them young enough. But some first-time horse owners can cause problems, usually because they don't know how to take care of a horse. There are just as many other people, even first-time adopters, who get right in and work with their horse and they do a really good job. I used to get calls from all over the United States, and I always tried to help people with their animal. But even though you tell people how to handle their horse, whether they take your advice or not is something else again!

When I was at Palomino Valley the adoption fee was $25. Then it was raised to $125. When it was lower, people adopted horses that never should have been allowed to. They could hardly afford to feed themselves, let alone a horse, so raising the fee helped eliminate those things. We also used to move the horses through the corrals fairly well, but after group adoptions were stopped that slowed things down. I don't know what it costs to maintain these horses in facilities now, but I imagine it runs into quite a bit.

It seemed for a while that every time I turned around somebody was suing BLM. The first situation I was involved in was during the late 1970s

when Palomino Valley got a court order saying we couldn't put down horses with a gun; we could only euthanize them with an injection. Another time a complaint was filed saying we were mistreating horses by feeding them bad hay. A bunch of folks showed up at the corrals one day and said they wanted to look at every horse in every pen, and they wanted to see all the hay, too. Well, I didn't know what was going on, but I took them around and showed them everything. One of them said, "You've got some hay that's supposed to have a lot of cheatgrass in it." I told him, "That hay was rejected. It wasn't acceptable, and the guy who brought it here hauled it all back." They didn't say any more and just took off. About five days later they asked if I would come to Reno to meet with them. So I did. I found out that it was just one person who filed that complaint, and that he had done this kind of thing quite a few times before. They didn't find anything wrong at the corral at all, and they told me they wouldn't take his complaints seriously anymore. That kind of thing still happens all the time.

In 1985 we gathered ten thousand head of horses in Nevada. There were five thousand at the feedlot in Fallon, and horses were coming in to Palomino Valley from Wyoming, California, Oregon, plus all around the state. The horses from Wyoming had strangles, so we lost some. Strangles can occur whenever horses congregate in large numbers. They have a snotty nose and fever, and they break out underneath their jaw. They have difficulty swallowing, so a horse can suffocate. There were different opinions from veterinarians about how to treat it. The majority said to let the disease run its course, because when you give a horse antibiotics all you're doing is prolonging it. But other vets said to give antibiotics because the horses would have had better luck. Personally, I've seen cases of strangles in domestic horses where the horse still dies even after they had the drugs. On the other hand, you probably could save a few because strangles is usually harder on young horses and foals. So it's a risk either way. One of the horses I rode at Palomino Valley got strangles. He got awful thin, but he made it through and was fine after that.

They don't train horses at all anymore like they once did. Now, there's

some things I still do today that are the same as when I was young, but there's others I've changed. For one thing, I don't go into the western bridle like I used to. Generally, it used to be that you rode a horse in the hackamore before you'd go to the bridle. You went from the snaffle to the hackamore, then to reins, then straight up to the bridle. Some of the new trainers don't do that; they go right from the snaffle to the bridle. A lot of people also don't hobble horses anymore either; they just handle them and talk to them. They also do a lot of lunging now, like running horses in the round corral. But I still hobble them all the way around, and I still sack them out, too. I think sacking out helps get a horse gentled.

Right now I've got a little yearling filly. I put a kid's saddle on her and I tie sacks of straw on either side for weight. I just turn her loose and let her drag those ropes and sacks to get her used to such things. She's plumb gentle now, and this winter I'll probably start riding her. I also have a long plastic pole with sacks on it. I'll get horseback and sack them out that way, too, while the horse is moving. Most of all, you have to be kind and gentle with any horse. You can't ever be rough. In the old days, they'd jack up a leg, throw a saddle over, and get on. Nobody does that now!

I still ride pretty near every day. I work mostly with young people, and I help train their horses as well as help them prepare for events. When you get over seventy you've got to take it easy.

It's a funny thing. Fifty years ago there were twice as many cattle, twice as many sheep, we had plenty of wildlife, there were some outstanding horses, and everybody seemed to be getting along all right. Now there are less of them all, and nobody gets along. It makes you wonder why.

Cliff Heaverne: Helicopter Pilot, Fallon, Nevada

My grandfather rode with the Buffalo Bill Wild West Show, but originally he raised saddle horses for the U.S. Cavalry. He had a place near Grangeville, Idaho, then one on the middle fork of the Salmon River, and then a ranch over by Wallowa, Oregon. That's where I was born.

All around Grangeville, Silver City, and Boise is where they once trailed

horses. He'd trail a bunch down to the White Horse Ranch, north of McDermitt on the Oregon-Nevada border, and they'd sell them to the government there. The cavalry would send letters announcing that they needed so many horses of a certain age or color, and they had other requirements. Like, some horses had to be broke to ride, some had to be halter ready, some just handed over. Oregon and Nevada were sparsely populated then, and everyone had lots of horses in those days. The Nez Perce were all around with their horses, too.

The Dorrances pretty well raised my father. Tom and Bill grew up in the Wallowas, and Dad learned a lot of what he knew from them. They remained close friends for years. I've got a riata Dad got from one of the Dorrance boys who died some seventy years ago. It's never been spliced, so you know they took good care of it! It's through my father and people like the Dorrances that I came into this life.

My dad trained horses his whole life. When I was two he trained horses for the Circle A Ranch in Paradise Valley. A lot of those horses were still branded with a *U.S.* The army would ship a couple of stud horses out, like Standardbreds and Thoroughbreds, and they would put them out with the mares. The yearlings all had to be branded—some on the hip, some on the jaw, and some on the shoulder.

The government quit buying horses sometime prior to World War II, and the ones that remained basically all went feral. The army still bought a few during the war, but they were mostly mules. A lot of these Nevada outfits had plenty of horses left, and it wasn't too long before there were lots more. That's when these old mustangers would go and catch them. There used to be some pretty good fights back then. A rancher might tell a mustanger, "That's one of my horses." Well, if it wasn't branded, boy, the fur would fly!

Dad came down from Imnaha to Jordan Valley to work for the Grassy Mountain Cattlemen's Association. They hired him and old Walter Bowden, Fred Scott, Shorty Scoggins, and several of the old-timers to go down along the Owyhee River and gather horses. He shipped over ten thousand

head of horses out of there in the early 1940s. All those horses were still good-looking then. Later on they became inbred. The type of horse we have on the range now is not really a fair representation of what used to be.

Some of these horse enthusiasts think that all of these mustangs have stamina and such. Well, they do to a certain extent because of what has happened to them. They've been stunted because of the food situation, so only the hearty survive; so in that way, sure, they've got a pretty strong gene pool. But in a lot of areas in this Great Basin country you've got a seven-hundred-pound horse with a foot that belongs on a thirteen-hundred-pound horse. That's because there was a lot of draft stock that was turned out, too, after tractors and machinery took over. Also back in those days, if you couldn't feed a horse over the winter, people either turned them out the gate or they went for chicken feed. Later, a lot of them also went into canned dog food. Nowadays there's a stigma attached to that, so none of the dog food manufacturers will touch a wild horse. But when you think of it, everything in this world that eats grass gets eaten itself. We eat cows, we eat game, we eat lamb. Most European countries still eat horse meat. They have a taste for it because after World War I they didn't have anything else.

Before the act, everyone had their own way of catching horses. They trapped them by their feet, they'd set snares, they water-trapped them. Some mustangers did things that weren't too humane. Like, they'd cut the tendons in their legs after they got them in the trap so they couldn't pick up their feet or try to run. Some of them put sacks over their heads. Or they sewed their noses shut so they couldn't get enough air. It was all so they wouldn't run very far. Wild Horse Annie was looking for humane treatment of these animals. She realized it's not good to have too many, because then they starve to death. Or it creates even more problems, like with some of these idiots who go around shooting them lately! I think those shootings are a sign of the times we're living in—not because they pick on the wild horse specifically, but because some people like to destroy things.

There are certain areas in Nevada where horses were raised right up to the 1970s, like up north around Elko, Ruby, Deeth, and all around that

country. There are still some really nice-looking horses up there. By the time the law passed, ranchers had to claim their horses or they reverted back to the government. Well, the government has since built a whole bureaucracy around the horses! The wild horse business is big business now, and the government is like anything else.

Take that deal over in Utah with those horses that had equine infectious anemia. That disease is transmitted by flies and insects; it's called "brain fever" by some. Basically, a horse keeps getting skinnier and skinnier until it dies. Well, there were some wild horses up around Vernal that had equine infectious anemia. Now horses with EIA have to be destroyed, so the state veterinarian gets involved. A state veterinarian takes an oath for the welfare of the people and the animals in their state. If anything requires an animal to be euthanized, burned, buried, or whatever, the state vet is bound by law to do that. In this EIA situation, it got to be such an emotional issue that the government tried to gloss it all over. They acted like nothing happened and just tried to keep everything quiet. I don't know what they were thinking, because something had to be done, and covering these things up just makes it worse.

My dad and his crew always gathered horseback. They used what's called a parada (or caveata), which means a group of saddle horses. Like, if there were two hundred wild horses to gather, the cowboys would bring all their horses for that. My mom had an old car, a 1932 Ford roadster, and we had an old trailer behind it with a tent, and we'd all go out. My mom would do the cooking for these guys and wait at the water holes. They'd say, "Reta, you go about ten miles down the road and we'll get down later." They'd follow the mustangs, and the horses would run from them, and these guys would have these camps set up. They would change saddle horses two or three times a day so they'd always be on a fresh horse, a shod horse. The wild horses, well, their feet would get tender and they'd get tired because they weren't getting much time to eat or drink. They'd follow them maybe fifty or eighty miles one way and then bring them back. They had a place down around the Owyhee River, near Rome, called the Dairy Pasture. It was

a big box canyon with a fence around one end, and they'd run the horses in there. When they brought them back, they'd mix them in with their gentle horses, into the parada, so they'd all go in together. When those old wild studs would get to fighting and looking for their mares, that would throw things into turmoil. But when the domestic horses were around, it made them easier to handle. So they would take them all in that way and shut the gate, and then they slowly would get them out. They'd gather anywhere from fifty to four hundred horses like that, whatever they could handle.

I was just a little kid then, and I got to run around in the car with my mom. My sister Patty was there, too. We had an old tent set up out on the Owyhee Desert. I think the only place in that tent that didn't leak was the corner where Mom put Patty's crib, because the rest of us all got rained on!

One time, Dad and all the crew had just left, and they got down the road about ten miles when they saw a bunch of foot tracks coming the other way. Some other cowboys had gone out earlier, and Dad could see where this guy on foot had left the road when those cowboys rode by, just where he'd stepped out behind the brush, and where he'd come back on the road after they'd passed. He couldn't figure who'd be out that far in the desert—it was like fifty or sixty miles from the highway—and that scared him. So he took off trailing this guy. Well, right after Dad had left camp, this guy came walking in. He told my mom he was hungry, and so she cooked him some bacon and eggs. She had baked a bunch of bread, and he took a loaf and a part of a slab of raw bacon, and then he left. They found out later he had escaped from the penitentiary in Idaho and came through the desert to get away.

Dad always broke colts for these outfits. Once when he was at Jackies Butte over by Burns Junction he roped a two-year-old buckskin stud and broke him to ride. Well, before it was all over that horse won everything in the state of Nevada. He won at the Elko Fair, all the way from snaffle bit and up through the Nevada bridle. Dad finally sold him to Harold Smith Sr. for the handsome sum of about $5,000! That was back in 1952, and it was a whole pocketful of money in those days! Everybody wanted to know where his horse came from, but all he ever said was, "Oh, it came from Oregon." It

looked just like one of these Kiger mustangs. That's where those Kiger horses came from originally, down around the Sheepsheads and Jackies Butte.

Dad started me riding colts when I was about six. He'd saddle the colt and then he'd snub it up to the saddle horn on one of his horses, and then we'd go out. We always rode colts when we calved heifers, so he towed me along like that. When the colt got going pretty good then he'd turn me loose. That's what I did all day when I wasn't in school. I didn't know there was anything else to do.

I joined the army at seventeen. I was a paratrooper and served my time. When the Vietnam War cranked up, they offered anyone who wanted the chance to fly if they could pass the test. Well, I figured I could do it because I used to fly along with Ted Barber when I was little. Ted's wife, Margaret, was my teacher, and Ted flew us to and from school every day. My dad used to say, "Ted Barber ruined a good cowboy, because every time my kid saw an airplane he wanted to go up!" I started my business doing crop dusting and some predator control and a little work on the horses.

When Ted Barber flew, he used several methods. You basically have only one try to get wild horses with an airplane. Mainly he'd go out and start them. Like, he'd bring them down off the mountain, and they'd have a real long trap wing built someplace or around some natural rock formation, a river, a cliff, something like that. The cowboys would be on the other side. He had a tin bucket tied on the end of a fifty-foot rope to the gear, and he'd go down and drag it along by the horses, and that made them turn and go the other way. If he didn't want them to go somewhere, he'd throw a roll of toilet paper out through the brush so they wouldn't want to cross it. He also had a string of tin cans tied to a rope that he dragged through the brush; that's an old trick the sheepherders used. You'd put pebbles in a tin can and shake it, and it was a noise they hadn't heard, so they'd turn. The cowboys would be there waiting, and they'd run them into the trap. They built these big, long trap wings out of brush and juniper—some of them might be two or three miles long! Those old boys spent a lot of time with an ax in those

days; it could take forever to build one of the old traps! But people had a lot more time than they had money then; they worked a lot harder than they do now. When Ted wrote his book, he said he caught somewhere between eight and ten thousand horses in his whole lifetime. We do that in one year now with a helicopter.

Running horses by air is similar to crop dusting. You work at real low altitudes, close to the ground. A good pilot knows what that horse is going to do before the horse does. Horses have all these ways of telling you what they're going to do. They're not a reasoning animal that thinks ahead; a situation presents itself and they react to it. Now, I've showed horses, I've broke horses, and I've been around them all my life, so there's things you learn about them that you don't even realize. I'm trying to teach a new pilot now and he'll say to me, "How did you know that horse was going to do that?" Well, you tell from experience. They'll do little movements with their ears that tell you what they're thinking, and if you're alert, you're ready to react. The other thing you need is patience; you always need patience with a horse.

A horse won't look up and he can't see behind—because to do that he either has to turn around or put his head down between his feet. So once I get to working a bunch I get off to one side, back over the point of their shoulder someplace, and they'll go forward. If you get a little bit farther than that point, that will start turning them. A lot of horses are real easy to handle; they'll stay in the bunch until you get them to the trap. But a lot of others have little tricks they use to try and escape. Like, they'll hide in the trees and they'll stay hidden there for as long as they can. Then they'll peek out, and just when they know you've seen them they'll take off! Or they'll cut off onto other trails. They do all kinds of things like that.

A helicopter is really just a horse that doesn't get tired. When mustangs don't have a rider behind them, they'll stick to the trails pretty well. They're familiar with the country. To get around them on horseback you have to get out on the rocks, and that's tough. Saddle horses get tired awful quick doing that, and it's tougher on the mustang because you've got to wear them down

to where you can handle them. With a helicopter, you can turn these horses and then you can back off. You can let them get their air, and you can let them go at their own pace as long as they're headed the way you want. A lot of times that isn't directly toward the trap. They've got to work the terrain their way. That's one of the things new pilots have to learn: the shortest distance between two points is not necessarily a straight line! So time-wise, these horses are working their trails, and they'll go over the country and see where we've set our traps. Normally, that's what we take into consideration—the terrain, the features, the trails, and how they all come together—for the ideal place to set that trap. If there's a highway close by, that's better, because then you don't beat your trucks up getting in and out. Oftentimes these places are also out in the middle of a rock pile or through a mudhole. It can be real tough country.

Some wild horses are smart, and a trap will work only a couple of times if you use it every year. If you've got two traps in an area, then you use one trap for one year and the other one four years later. By the time you get back to the first, hopefully, maybe some horses are gone and the old ones may have died, and the young horses have forgotten about it.

I've always liked horses. I've been doing this so long, there probably isn't anyplace with wild horses where I haven't been.

Gene Nunn: BLM Wrangler (Retired), Cowley, Wyoming

When I started, the Pryor Mountains had been designated a national wild horse range. Pretty soon, along come the act, and after that we were gathering horses all over the West. Montana just had one small herd, but in Nevada, California, Wyoming, and Oregon there were wild horses everywhere!

Back then we gathered by horseback. But when I got to California we didn't meet with much success that way because we didn't know the country that well. I visited with the Marr brothers and some other people who had lived there a long while. They had a lot of knowledge about wild horses and helped us learn how to gather in that Susanville country.

In 1977 Congress passed an appropriation bill that allowed the use of helicopters. I still think that was the best thing we ever did, for both the people and the animals. Up to then we were chasing those wild horses maybe forty miles a day. We would be doing nothing but circling around and riding up and down hills all the time. A helicopter with a good crew saves the wild ones a lot of steps. The cowboys and saddle horses are saved a bunch of steps, too.

It has always been a big problem getting quality help. It's hard to get a crew of knowledgeable people in any business, but in this wild horse program it's not like you can advertise and then go pick the best people, because the government picks people for you. When it came to hiring a wrangler, well, where in a government agency would you even find a wrangler? In this job you're putting men and animals at jeopardy, and you can be putting all kinds of ordinary folks at jeopardy, too, especially if you hire people with little or no experience either riding or rounding up horses. People who come into this program with no experience will always be at the wrong place at the wrong time, each and every time.

It's very tricky to gather horses with helicopters. There are a bunch of good helicopter pilots around, but unfortunately very few have enough background to know how the horses are going to react—what they're going to do or where they're going to go. Cliff Heaverne was lucky. He had the opportunity to rub elbows with Ted Barber, who was one of the great airplane horse pilots in the West. There aren't many other pilots who have that kind of horse savvy, and if they don't have any horse savvy at all, it makes the job a whole lot harder.

Almost everything in the wild horse program is dictated by politics. Even though we know what needs to be done and how, and we know someone who can get it done, it gets discouraging to see nothing happen because of all the politics. Recently, BLM put together an extensive five-year plan to get down to AML. But we needed money, we needed sanctuaries, and we needed all this stuff lined up to make it happen. They had contracts out for the whole time period but canceled them because they didn't think they

would get funding. Then politics changed and—bingo!—they got money. But by then they're already a year behind; so now they're really behind the eight ball, and they're charging around trying to get everything all set up rather than laying it out on the line about what was needed first, before anything got started. It's really hard to make anything run smooth this way. I think BLM should take at least a year to get their ducks in a row, so they can handle things efficiently once they set a plan in motion. Instead, they're always backed up, it's always crisis management, they're always out there running and gunning. It's all chickens today and feathers tomorrow!

Now there's a plan to remove all ages of wild horses whether the animals are twenty years old or not. That means you need a sanctuary to put those excess horses in, and you just don't go find a place to put two thousand head of horses overnight, especially with all the red tape required. That stuff should be ready and done with before you even start gathering a two-year-old or ten-year-old or twenty-year-old animal, so you won't have to go back and gather him again next year or a year later or the year after that. And what else happens all too often is that, even though BLM might have a whole ton of money, just when they think everything is going fine they'll face some kind of injunction or lawsuit from a special interest group.

It all boils down to the same thing every time—you can't mix politics with a wild animal! Because if you're behind time, well, in the meanwhile that animal keeps on eating and reproducing, or he's going to go without water, or he'll get trapped by some other emergency while all the politicians back East are still arguing or talking away in their offices. Now, I can sit and whine and bellyache or moan about this and that, but I still collect my check every month and buy my groceries and whatnot. But when we don't do the job right in this program there's always two things that suffer—the horses and the land. The land comes first, and then the animals. They're tied to each other. When one starts to die off, then so does the other.

In the areas I've worked, most of the horses and burros haven't gotten into any critical situations. But I've seen what happens when horse numbers aren't kept down for whatever reason, and things get really desolate.

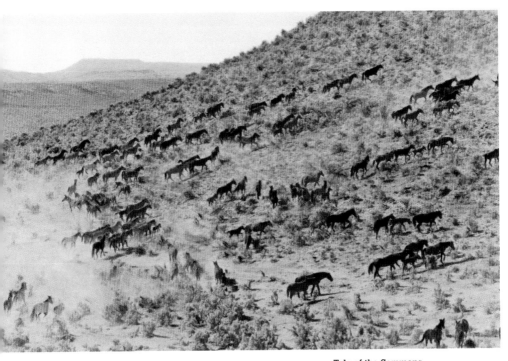

Tale of the Commons

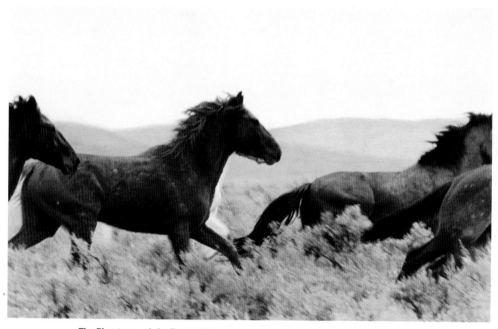

The Phantom and the Broomtail

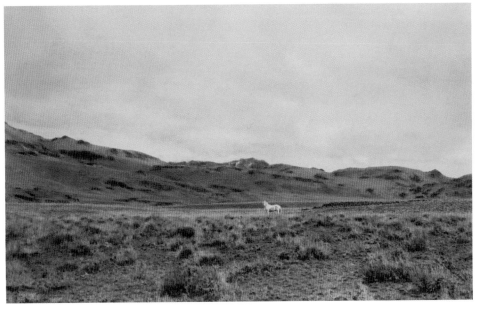

Out in the Great Alone

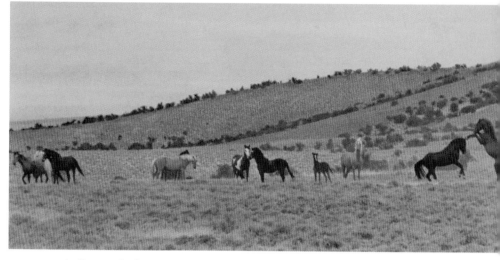

Home on the Range

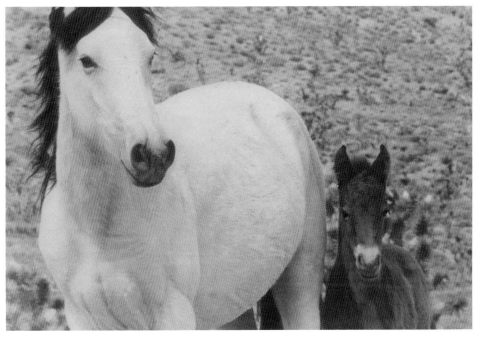

Natural Balance

No Quiet Death

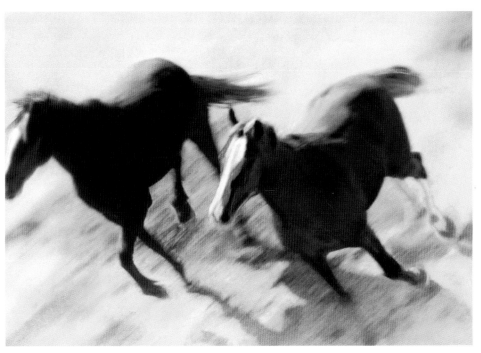

Running Shadows

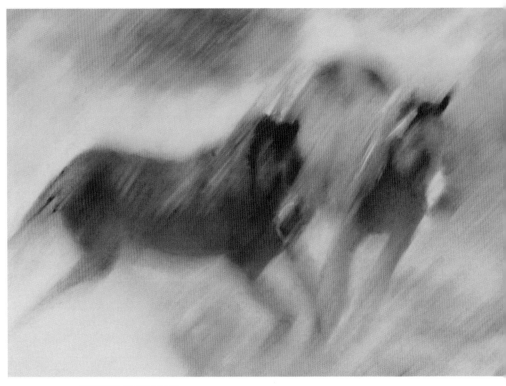

The Wild and the Tame

There could be great devastation, because these horses will eat everything to the point where it wouldn't be there anymore. They've got to be controlled. And so do wild burros. A burro can survive on very little, and they are a good scapegoat. They get blamed for a lot. They are a strong little animal; they can carry that load. But if we didn't gather burros, they'd breed forever, too. There'd be burros everywhere!

When I talk to some people about this, I can see their ears slam shut. They don't want to hear it. All the public knows is what they've been told or what they've thought up for themselves. It's usually that wild horses are such beautiful animals and they should remain out there to roam free and uncontrolled. People don't realize what can happen in these situations.

The answer to having too many horses is not to have any horses at all. I had the privilege of working with Wild Horse Annie. Annie started this campaign, and after she went to Washington and got the whole shebang, that set her back on her heels. She didn't expect it, but being who she was she immediately tried to make things work. She was working on a solution for the excess animals, and if she had lived I think this situation would be a whole lot different now. She just died too soon.

Getting wild horse numbers down is going to take some real doing, but somebody has to bite the bullet here. The gathering plan that's in effect now is about the only thing that's going to happen for the short range. But eventually we may have to take away some of the best land or take away some more livestock to house these horses. Because if you take one of these ten-year-old studs, geld him, and then put him out on a sanctuary like in Oklahoma or someplace, well, he might live until he's thirty years old. So this will go on. There is a real down side to this.

* * *

I DON'T LIKE to see any horse slaughtered for no reason. Yes, once you get all these herd numbers set up there will be some natural die-off from old age and disease. But to leave these animals out there as we are now, and to let them continue to breed up like they are now, and then to leave them all

out there to die, well, that's pretty gruesome stuff. If we're willing to accept holding these animals in sanctuaries for an extended period of time, then the main thing needs to be a real push to get the herds down to AML, and to let the public know why.

Usually, all that these radical interest groups do is help to create another wreck! A lot of groups go to all the government public hearings just so they can start putting sideboards on any plan the bureau makes. Pretty soon things are all tangled up again and we can't do anything. We've got to have some energetic, knowledgeable, serious people in charge of this program, who will be given the authority to act and who have an ability to get things done. They need to move the animals through the system whatever way works best and whatever way will be the most humane, too. And if there are certain groups of old or sick horses that should go to slaughter, then we should make sure that happens under the most humane, clean, and controlled conditions possible, and have someone ethical and responsible in charge of it.

If BLM can set up their management programs to get the herds in balance and stay that way, then after a certain period of time they should never need to do this again. They can gather and take the foals, yearlings, two-year-olds, or what have you and remove them for people to adopt, and then they can leave the rest out there with enough young ones to keep up the herd. If they want to, they could even leave them out for three years. That would be nice because it just gives the wild horses that much more freedom. I wouldn't leave any herd alone beyond three years, because then the animals that are removed become less adoptable.

All horses are good horses, but some are better than others and some are much less desirable. The biggest share of people who adopt these animals are real novices, and I think we're asking them to do us a big favor by taking a mustang and supporting it for the rest of its natural life. We should try to give them the most desirable animal, and one they will have the most positive encounter with, so if they can't keep it for whatever reason they can pass it on to somebody who will want to own and appreciate that horse,

rather than presenting them with a problem that winds up with them having to take the adopted horse to sale. So the more we can do to make that wild horse adoptable the better! And if there is some three-year-old horse that even as a colt we can see has a bad attitude, well, obviously that's no horse to give to a novice. First-time horse owners don't understand what a horse is capable of doing or becoming. Now, someone raised around horses all their life may think people are stupid to want to adopt one of these wild horses when they don't know any better. But to me, all that means is these people haven't been taught. So we need to get these numbers down in the most humane way possible, and with the least amount of draw on the taxpayer, and still have a really good adoption program that puts good horses in good homes with good people.

When you get down to it, wild horse specialists are mandated to protect the horses, and range specialists are mandated to protect the resource. They should be working close together. The public needs to be educated in the same vein so everybody strives to preserve the land and the animals with it. I hope there will be some way for people to learn that it is a whole lot better to have a hundred healthy horses on the range than to have over three times that many who are on the verge of dying and just barely getting by. Because—bingo!—if just one wrong thing happens, they will all be gone!

Dave Cattoor: Wild Horse Gatherer, Nephi, Utah

There's a lot of work and a huge safety factor in a wild horse gather. You need people who know what they're doing. You can't bring some greenhorn out there, because pretty quick you're going to be carting them off in a stretcher. Wild horses kick and bite, and they jump the panels, and you can't get behind them.

When I was growing up in Colorado, all I ever thought about was horses. Everybody was poor, and making a dollar was a hard deal. A lot of guys would go out and get the wild horses, trying to make a few bucks. When I was about six I watched them come by our house. There'd be six or eight cowboys, and they'd be trailing about fifty head of horses. They'd spend

days out on a gather, and then they drove them in, put them on the railroad, and sold them. That's how they survived. And as far back as I can remember I wanted to help out. They'd sit and talk about going to find some wild horses, and I'd say, "Will you take me?" They'd say, "Heck no, we ain't taking you; you're too little." But when I was about twelve they took me along. I loved it. I got to asking, "How do you learn to do this?" This one guy told me, "If you want to know about the horses, take your bedroll and go out and live with them. Find out what they do and how they think. So I packed my bedroll, a can of beans, and some jerky, and I'd go live with the horses. I stayed for weeks with them. When I ran out of groceries, I'd come back in and then head right back out again.

One day these old mustangers roped a two-year-old and brought him in to me. I said, "Now what do I do?" They said, "He's your horse, do what you want." I'd never broke a horse before that. I spent months getting him gentled. Luckily, he wasn't a bad one. I broke that little horse to ride, and then I took him to the hills with me. He was a really pretty little buckskin horse. I had him about ten years.

Every weekend me and that horse went to the hills and followed the wild horses. Summertimes, that's how I spent my time. I'd stay within two hundred yards of those horses all day long. If they moved, I'd move. If they'd run, I'd keep with them. I'd get up on a rock and sit there for hours, watching them. Then I'd ride around and move them, this way and then that way. Wild horses just really fascinate me. They've dominated my whole life, these wild horses.

I think I must have been reincarnated from one of those old-time mustangers. When somebody dies, I believe their spirit goes on living in another form. Sure it must, because people pick up certain traits and attitudes and for some reason they want to do this or that. They've got no reason; it's just strong in their mind and they're drawn to it. That's the way it was with me. I had six brothers and sisters, but no one in my family ever rode a horse or was even interested in horses. But from the time I was six years old I only thought about one thing.

After I turned sixteen I started entering rodeos, but the calling was always back to the hills. All the time I kept wondering about this band of horses I'd seen. I wondered where they were, and why that one stud left the bunch and another one took over, and where did that mare go that was supposed to have her colt? I had to go back and find out. So I'd rodeo a little and then I'd go back to the hills. By the time I was eighteen I'd learned to rope the wild horses and take them home.

One wild horse I had for about twelve years was terrific. This horse looked just like one of those remount studs. I caught him when he was about five, and when I broke him to ride, he bucked like a wolf! All I had to do was get on him wrong or too quickly, and he'd buck for five minutes. After he finally quit all that bucking he was a terrific horse.

You used to be able to buy a mustang for under $30 at the sale. The guys would bring them in and you picked one you wanted, just like now. The guys who got me started hated to sell them for slaughter, but even back then, say if you caught a hundred, there would probably be no more than ten you'd want to take and try to ride because of their age structure, for one thing. And the ranchers, the sheepmen, and the cowboys, well, they'd usually never ride mares. You could take a stud horse and cut him and get him gentled, and he might not head back for the hills. But if you had a wild mare and she managed to get away, you'd never get her back because she'd get in with another wild stud and his band. Or say you went out to gather cows, well, you've got to pen your horses overnight. If you've got a bunch of geldings and you put one mare in with them, the next day half of those geldings are crippled because they're fighting over that mare.

Sue and I got married in 1964, and I was trying to figure out a good way to make a living. Rodeo wasn't my bag of tricks, and I still kept thinking I had to do something with wild horses. Along about 1968, it came on the news that there was going to be a law to protect them. That seemed pretty much like a joke then. They were all over Utah, Colorado, and south-central Wyoming, and Nevada was just full of them. But by 1971 the act passed.

The wild horse program changed everything for me. One day I was doing

some branding work and I heard this guy say, "I'm thinking about buying a ranch south of Elko and there's about a thousand head of wild horses on it." My ears pricked up and I said, "Well, what's the deal?" He told me the rancher made a claim on his horses but he couldn't find anybody to gather them up, and he gave me his name. So I called him up. I found out nobody had been able to catch his horses, and I said, "Hey, I can—this is what I do!" He told me he'd furnish the bunkhouse and cook and groceries and I could have all the horses if I could just round them up. So we went out to Nevada for about six months. We found about seven hundred horses and trapped them. A lot of cowboys fell and got crippled up. I broke my shoulder hitting those bog holes and falling. When our horses wore out we went home, rested up, and once we got some fresh horses we went back.

Every rancher back then had a right to claim horses if they proved to BLM the horses were theirs. Up where we were working the allotment had been fenced, so those horses were inside and always belonged there. A lot of other ranchers tried to claim their horses, too, but didn't have any re- sources to catch them. We caught a lot of horses up there. When we'd get done with one ranch we'd move on to the next. The Gamble, the Winecup, Devil's Gate—they all had lots of horses on the range. We did that from 1975 through 1981.

The ranches furnished us a bunkhouse, and most of them furnished a cook while we were gathering. We caught all those horses the old way. We roped them or trapped them, and it was really hard. We'd be on our saddle horses all day, riding out back and forth. You'd run after horses over these big ledges, and at least once a day your own horse would be falling over you. When you've got wild horse fever like that, you come across that stuff. Every time we'd get back to camp somebody would be saying, "I was trying to turn them but my horse rolled on me. I'm kinda sore, but I'll be alright."

Later on, BLM advertised for contract cowboys to gather wild horses. Man, oh man, I was right there! My first contract was to move horses onto a preserve in Colorado, and I gave the lowest bid. That's what put me in business. That job was a tough deal and we weren't making a lot of money,

but for me it was terrific. I had six weeks to catch seventy-five horses with eight or nine riders. That was the roughest, toughest country I'd ever seen— nothing but big canyons and lots of heavy junipers. When I first went down to look at it, I just about cringed. I couldn't imagine how we were going to do it horseback. But we did.

We used nothing but Appendix horses (seven-eighths Thoroughbred), just any we could find. I'd go to all the sales and the ranches and ask if they had any big, tall horses they couldn't use. They'd say, "We've got two or three but watch out, they buck." Well, we knew if they bucked they'd run pretty hard, too, so that was right down our alley. Things went on like this until 1977. That's when we needed a helicopter and I hooked up with Jim Hicks. Jim and I have been working together ever since.

This is a way of life. People can cry all they want, but any horse, when he is born, well, he is going to die. The best thing you can hope for is that he doesn't suffer. When you leave horses out on the range, eventually they will die, too, and they will die hard. If you send them to a slaughterhouse they will die, but they will die quick. For folks who grow up in a city it's easy to think that everybody should just leave wild horses alone or leave all the deer alone. Well, try it! People keep fencing up this country. BLM is trying to manage the range. The ranchers are trying to manage their cattle. You've got to manage it. You can't let ten thousand horses die because you're too lazy to manage. Most people have no concept what's going on.

We worked with the University of Minnesota for three years. We caught fifteen hundred horses for one of their research deals. They implanted pills in these horses to sterilize them for one year. So we caught and haltered them, and they did all this stuff, but it was just one big fiasco. Then another fellow came along and says he can give the horses a shot to sterilize them for a year, so we worked on that bunch, too. Let me tell you what happens. Say you have a herd of horses and they have an 18 percent colt crop every year. That's their survival rate. So you give them a shot and it's effective, and now the mares have a colt one year but for one year they don't breed back. But what happens the year after? Every damn one of them

breeds back, so now you've got about a 75 percent colt crop! So a shot, even when it works for two years, just allows those mares to build their systems back up. Right now the youngest mares down on the Nellis range are eighteen to twenty-five years old. That is almost the maximum lifetime of *any* horse, and they still got a 65 percent colt crop from those mares, even at that age, after holding them back with a shot. I asked BLM why they were working on all these poor old mares and why they didn't just cut the studs instead. Because if you do that, two things will happen: you'll hold down the colt crop permanently, plus you'll get a bunch of geldings. If those geldings are out on the range they will get fat, they won't fight, and they'll run in their own bunch. They'd live their life out there and you'd never have to gather them. There'd be enough studs left to pick their mares, and those bands would go on. But some of these groups won't allow BLM to castrate a horse and put them back on the range. They say it deprives them of a normal life.

We've gathered horses all over for BLM. Out in Montana or Wyoming and other small districts, they can build up one herd, like those Kiger horses in Oregon. Colorado horses are prettier because they keep the numbers down better there. We've gathered in the Pryor Mountains. They used to run those horses every two years by horseback, and when we went there lots of people said it was terrible to use a helicopter. Well, in three days we had them all sorted and in the corrals, and we never even had a skinned nose.

Wild Horse Annie wrote me a real nice letter once. She said she was tickled that someone who knew how to catch horses would help BLM. It's in my scrapbook. I bet Annie would go nuts if she'd seen what has happened.

For years now the adoption program has been controlling everything. The situation has been that if you can't adopt them or there's no room in the corrals, they get turned back out on the range. It shouldn't be that way. You should be able to go through any herd and pick out an age structure, say yearlings up to age six or eight, and then take off the old ones. Younger horses, even yearlings up to two-year-olds, are good for adopters. But if you don't keep a structure, when a hard winter or a drought comes it'll kill

them all off, especially three-year-olds who are shedding their teeth or the old horses who don't have any. Since 2000, the policy changed. Now we gather to preserve the band structure, including different ages.

Is it really right to let so many horses die out on the range? When a horse needs to be put down, I think it should be done humanely. Do it quick, do it easy as you can, but be humane no matter what. I've had lots of really nice horses, but when they got where they were stove up, I couldn't bear to watch them go downhill. I don't like to shoot a horse. I want to say, "Bye, old feller. You treated me pretty good and I'm going to try and treat you pretty good." I made sure when it was time for them to go, that the truck that took them had lots of room and they were treated right on the way—like they weren't beaten with a two-by-four or something. I've gone along and watched them trot down the alley to the end just to make sure.

A lot of these horses that come off the range and go through the chutes are old and injured. Some of them are so old their teeth are all gone, but we still have to turn them back out. We shouldn't be doing that. We should put them aside and humanely destroy them. The law says that if they can't be managed any other way, a wild horse can be humanely destroyed. They can be given a tranquilizer so they just go to sleep. There are millions of folks who don't understand this, or who think BLM should never put down a horse. It has nothing to do with what's right for the horses; it's all politics.

When these horses get old or sick, they can't survive out here. People can argue all they want, but try and match up dying out on the range to going to sleep. One time, Jim and I flew over a mare that was laying down. She had a big colt about six months old standing out a little ways away, and we turned around and saw about six coyotes eating on her. She'd pick her head up and look at them, and then she'd lay it back down. She couldn't get up. I said, "Let's chase those coyotes off." So he spun around and landed and I walked over. Those coyotes had already eaten two-thirds of her hindquarters, and they had almost gone up into her stomach and she was still alive, looking at them. We had a gun, and we put her down.

That shows you how horses die out here. When a horse stays down it's

because they're weak. And they're lucky if they can lay there two or three days and die, because the coyotes will come around and see one sick or thrashing around and they'll converge on them. Coyotes are vicious little bastards. They start from the back and eat on the hamstrings on their prey until the animal can't get up. Then the pack joins in and they'll eat it right up through their brisket. With a horse, they have to get halfway up the body and into their stomach, their vitals, before shock sets in. With that mare, I couldn't believe it. I went all around her where her hindquarters once were. That colt was still standing right by its mama, so you know they'd probably have gotten it too. Some folks say, "That's nature, that's the way it is." To somebody who loves horses, well, that's a pretty tough deal.

I've lived my whole life in the West, away from towns and out on the range with these horses. Maybe you could call it an obsession, but I've just had to do something with them, to be working with them, to be following them around. My life belongs with them, these wild horses.

Tom Marvel: Rancher and Horseman, Elko, Nevada

I never knew anything but good horses. Our family always raised them. We've had some cattle, but mainly we're horse and sheep people. My youngest brother is quite a horseman, and my sons are rodeo boys, and my grandson starts horses too. We all came up in this background.

My grandfather came to Nevada at the end of the Civil War from Wales. After his death my grandmother took over the ranch, and then it passed to my mother, and finally to us. During World War II we had about five hundred mares for the remount program. There were two men who started horses for us full time for that. Even when we were kids in the sheep camps we rode good Standardbred-Thoroughbred horses. We were the best-mounted sheepmen around!

The first really good cow horses I ever rode were mustangs. It happened one day when I was out with our buck herder. We were coming into Antelope Valley and we passed by Harry Holiday's place, and there was a little roan horse there. The buck herder said, "Buy that horse, he might be a good

one." Well, that was Sleepy, and he was an outstanding little horse who won just about everywhere we went. Don Dodge was a noted showman back then. He came to the Elko Fair one year and saw Sleepy and he bought him from me. Don went on to win a lot of money on that horse.

When I was young, the wild horses ran north and south of the railroad. The Southern Pacific came in 1869 and the Western Pacific in 1913, and they were the only fences in the whole state, actually, so those horses had a lot of room. Most of the northern horses were ranch or remount horses and very seldom mixed with horses on the other side. My understanding is some southern horses came from the Shoshone Indians. Sontag Jackson had several hundred head around Antelope, Alpine, Fallon, and New Pass, and he used them for trading. Somewhere along the line, and way before my time, Sontag murdered another Indian and fled the area, so his horses went wild. There were a lot of roans and paints there then, and they made good saddle horses. My first experience gathering horses was down in that country.

Lou Minor also ran horses, north from Battle Mountain to the river. His outfit had several traps set up and he caught them that way. And the Double Square outfit north of Winnemucca ran all types of horses out on the Owyhee Desert. They had several thousand mares and some mules out on the range. All those horses were shipped to eastern markets. When the army started to be mechanized, they went wild, too.

I'm not a person who is against federal or state ownership. And I'm not against people who want their children to grow up seeing wild horses. I love the wild horse. There should be a place for them. This country is not the way it once was. When fences weren't in, those mustangs had a long ways to drift and they didn't inbreed like they do today. Now, some people might think that one herd area of several thousand acres is large, but not when bunches and bunches of horses continue to breed and eat the country out. These days BLM gathers mustangs, but they still turn some of them back. The adoption program works, but only up to a point. What is the government going to do with all these horses? There's thousands of them!

During the airplane era some of the more modern wild horse–running operations became big business. It didn't make any difference how they caught those horses or what happened to them, because all they wanted was to make as much money as they could. They used various methods to bring those horses out, and there was some cruelty in those ways. For instance, when a horse gets overly hot it will lockjaw. A lot of those horses came into traps lockjawed, and that's a real bad death for a horse. Or they would cut their tendons to slow them down and other things like that. When I was with the state Department of Agriculture, Wild Horse Annie asked us what could be done about branding wild horses, because back then any estray horse was state property, and mustangs had no brand. Annie saw these kinds of cruelties in the way wild horses were being treated. She wanted a humane way to gather them.

But not all mustanging was evil. The old-time mustanger was different. He loved the wild horse, and it was a thrill to him to be able to catch that horse, and he made a decent living working with them. Harry Holiday was an old-timer who ran hundreds of wild horses in the Antelope-Alpine area. He had a parada. Now, a Judas horse is a tame horse that leads in the wild bunch. A parada was a little bunch of gentle horses that would be in the corral as the wild horses got in. Harry would spend several days gathering up a bunch of mustangs, and he put them in with his parada. He would catch fifty or sixty head—it all depended what his field would hold—and he would work with them a little bit every day, getting them gentled. After a while, when he had them handled well enough, he trailed them to Fallon. It was probably a sixty-mile trail. So there are very humane ways to capture horses.

The old mustang herds always had an introduction of new blood, whether it was from outside stallions or remount stallions or draft horses or anything. Last winter I went out to look at a bunch of wild horses in Fallon. They mostly all had big feet and big heads; they were very inbred looking. There are still areas in this state where there are good horses, but you don't see near as many as before.

Some people claim there should be one stallion for every fifty mares to keep a viable herd, but I've seen some stallions with two mares and some with fifteen or twenty. Some of those stallions were very dominant horses who kept a lot of mares. It depends how powerful a stallion was if he could keep his herd together. There would be young stallions who maybe weren't dominant to start with, and they would be kicked out of the bunch and might have only one or two mares they could steal. You always would see little bunches of straight studs running together. A dominant stallion kicks the young studs out. If one stud got whipped over in one part of the country, he would move over to another area.

I'd watch for wild horses at water holes. You'd see several bunches coming in to those waters at once, and it was really something to watch those stud fights. If a horse filled up on water they couldn't run so hard, so that's the most opportune time to trap one. They would all be bunched in together, and before they can get going you could get in close and rope the one you wanted. You had to lay low, and you always wanted to stay away from the wind that's carrying you. But if you come at them quick while the studs are fighting, you could get one or two pretty easily. I watched water trapping down in Antelope but I didn't participate. There were some pretty good springs and they had the corrals fenced. They had big tongs on the gate, and the horses would go in. When they tried to come back out, they couldn't go through the same way they got in.

Humans have always moved these mustangs around. If you think about it, when Lewis and Clark came through in 1804, the Shoshone had large bands of horses on the Snake River. They evidently got them from the Spanish, or maybe some horses migrated up north on their own. Either way, Indians had already picked them up by then. Of course, any horse will go wild if we let them. You can take your horse and turn him out, and the first thing you know you can't corral him anymore, because once a horse gets outside he'll probably forget about you! Then if you go out and try and get him and he outruns you (which he's pretty apt to do), by the next time he's that much smarter. A lot of times today you'll still find a domestic gelding

that got loose and fell in with a wild bunch, and you'll have just as hard a time getting him as the others. A wild stallion may not whip a gelding completely out of the bunch, so they'll stay out a ways and take up with the young bachelors.

In my time there were no fences through Dixie Valley and Jersey Valley, and wild horses would move a long ways. They'd drift from Shoshone Mountain down to Cherry Mountain out of Alpine and clear in above Austin, and around that Fish Creek Mountain area up to Manhattan above Reese River. That's a good sixty or seventy miles. They might take a year or so to cover that territory, and if one group got to be too many in one area, they'd move on farther.

Before I went in the service we gathered horses every year, but never on a scale bigger than to just get enough saddle horses for the following year. After 1939 things changed. The horse population exploded because there hadn't been any gathering during the war. When I got home in 1947 I heard they were using airplanes to catch mustangs. Walt Whitaker out of Fallon approached me about capturing some. We built a trap, and the first year we caught two thousand head. We went at it very carefully. Of course, some horses went to the sale and some went for chicken feed, but we also held a certain number out. The same problems occurred farther north. Out on the Owyhee Desert, Ted Barber flew for Marvin Myers and lots of other people. It was Ted who taught me how to fly. I'm not sure, but I understand Ted and Marvin caught fifteen thousand horses during one period of about ten years, all through Gerlach and out on the Owyhee. Marvin associated with a lot of different people on those ventures. He and I were partners on another gather north of Battle Mountain of about fourteen hundred head of horses.

Whether we were after a big or little bunch, we always did things the same way. We would gather only what we could handle in a day. If we were set up to truck out fifty horses, that's how many we tried to get. If we could manage a hundred, well, we tried for those. Then we'd go to the ranches with them, take off the ones we wanted, and feed the rest until we could sell

them. Usually Bill Knutsen bought them for the Santa Rosa Meat Company. Bill bought thousands of horses through the years.

After 1971 we still let a lot of our own horses mingle with the wild horses on the range. The last time I gathered was when we wanted to cull our horses. BLM gave us permission for that roundup, but somewhere along the line a rumor started that we were deliberately trying to catch the wild ones, too. From then on I decided raising horses to any great extent was dangerous.

We always had about two hundred horses in our caveata (we call them caveatas or cavvys here; up north they're called remudas), and they were a nice bunch. About half of them were mustangs. We rode the mustangs a couple of years before we'd ever shoe them. We turned our saddle horses out, too, so sometimes it would be two to three years before we'd shoe them. Once you've trimmed their feet, a horse loses the natural barrier on the wall of the hoof.

Once in a while we'd get a mustang that was just outstanding. Maybe they weren't the same caliber as a well-bred remount horse, but they were very agile; some were exceptional cow horses. Some of the men who trained them—then as well as now—were better than others also. Pat Heaverne had a horse that was half-mustang and half-Arab, and he did a beautiful job with him. Melvin Jones had Little Smarty. He was a great horse that came out of Antelope and won just about every major show in the country. It goes to show you the quality of those early wild horses. Recently, Bobby Ingersoll has done some nice work with his Kiger horse, but in my view still nothing as great as before.

We always started our horses with a snaffle. The snaffle has taken over the nation now, but years ago it was primarily used in English riding or in certain areas of the West like Nevada and Oregon. By the time I came along, a lot of the old cowboys and vaqueros never owned anything but a snaffle bit. They didn't have money enough, which may be one reason why, but that's all they rode. There were those who used hackamores here, too, but mostly the Californian was the hackamore man. In Nevada we grew up using snaffle bits and worked on from there.

I think those older wild horses had better blood. They had the environ-
ment in them! And whether it was their breeding or the space, those old
mustangs had *heart.* Any great horse needs heart, whether it's a cutting
horse or a racehorse or whatever. Nowadays I understand if BLM doesn't
want to put some powerful Quarter Horse or Thoroughbred stud in with
these wild horses, but they could take a nice young stallion from one area
and move it to another to improve the blood of these herds. Otherwise I
think the taxpayers are being taken. I know it also offends some people to
think about taking extra horses off the range, and it sounds cruel to think
about shipping them to a sale so that someone or something can have food
to eat. But that's no more cruel than leaving hundreds of mustangs to stand
around in some feedlot. It breaks my heart to see that. It's not natural. A
horse doesn't want to be stuck in a corral, and they're not like a dog or a cat
you keep in a house. I don't mean every horse has to become a show horse,
and people certainly should be able to enjoy a pleasure horse, but to keep a
horse just as a pet is unhealthy for the horse. A horse needs to be ridden
and used. They enjoy it.

We've come to a much different era of the cowboy and the horse. It used
to be there were long days of work for these horses, a lot for them to do.
Today the outfits aren't as big, and the ones that are usually truck their
horses out. There are smaller pastures now. There's not the same amount
of range. When I was young we'd have ten horses in one string, so you'd ride
one horse every ten days. A lot of times we'd change horses at noon or one
might get lame or something, but it still took that many to do the job. But
then Texas or California began all these breeding programs. They bred for
certain qualities in a horse, like disposition and agility and such, just like
dogs. So now we have jumpers and cutters and reiners and racehorses, and
we have rodeos that breed certain horses to buck. We've gotten much more
specific about horse breeding, but the mustang was left out. There's not
one area where he can be useful anymore.

*　*
　*

YOU NEVER LEARN it all with a horse. I don't like to use the word "trainer," because some trainers can be crude. A good horseman is something else. When we were young, we did throw the horses down. Or we rolled them in the saddle because we all fancied ourselves to be such good riders. As time progressed, I saw there was a better way of doing things. People like Tom Dorrance and Ray Hunt had a lot more finesse. I watched Tom particularly, and then I had the real pleasure of working with him for fifteen years. He is a fine man and has a great mind. Even now, when I get in difficulty or get a horse I can't figure, I'll call on him. I'll say, "Tom, you're twelve years older than me, so you have to tell me what to do." He'll answer, "No, and if I was able to ride I'd still be learning too."

I'm seventy-eight and I still ride every day. I don't feel old, and I have to look in the mirror to remind myself about it sometimes. But I am, and when you get older your mind and coordination aren't as fast. I take a few gentle horses now and then, though, just to help people out. The love of horses never leaves you.

Al Cirelli Jr.: Equine Specialist and Professor, Reno, Nevada

Shortly after I came to Nevada I received a call from a lady who had adopted a wild horse. Her horse had exceptionally long feet and needed farrier care, and so she called me for advice. I told her that all horses need to have their feet checked on a regular basis, generally every six to eight weeks. She said, "Oh, I'm surprised—I thought horses needed their hooves trimmed only once a year!"

This lady was a first-time horse owner who was completely caught up in the romance of owning a mustang. She didn't have any background, information, or training relative to keeping a horse at all. Well, it wasn't too long after that before someone else called, this time asking how to feed a wild horse. I soon discovered that the primary qualification for obtaining a mustang was simply to provide the proper facility. I began talking to some BLM people, and we decided to offer some preadoption clinics so that people who were new to the horse world could get information on the biologi-

cal needs of horses, their nutritional requirements, general animal hus-
bandry and horse behavior, and feeding and handling.

During the clinics I explain all the responsibilities involved with horse
ownership. I make it clear that wild horses can provide for themselves in
their natural habitat, but when a person takes them off the range and puts
them in a paddock or pasture, their ability to provide for their basic needs
has been taken away and the owner must provide that. Sometimes people
attend my clinic and decide horse ownership isn't for them. That's fine,
because if they're not willing to make a commitment to provide for the
well-being of that horse, then they shouldn't adopt one. Frequently,
people get a horse and after finding out what's involved, they decide to get
rid of it. Well, I don't feel good about that. If I discourage them, I feel I've
helped save that horse, because a horse in the wrong hands will be a horse
that's not treated properly.

Wild horses are different in that they use all their senses all of the time.
They're highly aware of conditions in their environment. This is part of
their self-preservation behavior. Domestic horses use their senses also,
because the first line of defense for any horse is flight, but wild horses are
initially handled differently because of this sensitivity. Horses are also
highly adaptable. When you think how the horse evolved from a little ani-
mal about the size of a dog with five toes and a short mane, and how they
adapted to the changing environment over time, you see how the horse is a
great survivor. They're still adapting, in fact! Horses are also intelligent. It
all depends on how we handle them as to how well they adapt to *any* new way
of life.

It's important to allow the wild horse to understand you're not a threat.
A horse is a prey animal and his eyes are on the side of his head. But we
humans are predators and our eyes are in front, so in a certain way the
horse considers humans as a predator. Some people will look a horse in the
eye to gain control; however, that can also be a challenge. I advise people
not to do that because it puts the horse in a defensive mode, and one thing
we don't want is to put them in a defensive situation. We can get in a dom-

inant position with a horse without being forceful, just by being consistent in what we do, by always doing the same thing the same way. That's how we gain control. That's also how a horse survives, by doing the same thing in the same way.

Some individuals think the purpose of putting a horse in a round pen and running them around is to tire them out. That's not the idea at all. The purpose of a round corral is to get the horse to look at you and respond to your movement. You can teach a horse to walk, jog, stop, and canter without ever putting him under a saddle. You can teach him basic terminology like "whoa," and you can teach him it's okay for you to penetrate his personal zone without causing problems. You can also teach them it's *not* okay to penetrate your personal zone unless he's invited. If we're not communicating with the horse, if the horse doesn't understand what we're asking, then he gets frustrated—he feels threatened, he loses focus, and he becomes defensive. So the whole idea of training horses is to get them to focus on us and the task at hand. At our clinics we demonstrate how to do these things so people can have a positive relationship with their horse.

Once you get a wild horse home, he needs to have his feet trimmed every six to eight weeks. He needs to have immunizations once or twice a year, he needs to be dewormed, he needs to be fed regularly, he needs fresh water—all these things. People say, "Oh, he's a wild horse so he's got hard feet." In this country a horse in the wild walks thirty miles every day and wears his feet down. Look at their habitat—there's a heck of a lot more rocks between bites of grass than there are bites of grass between rocks! So they're constantly traveling over all kinds of rough country, and that wears their feet down. But when you look at these horses you'll see that some of them still don't have good feet. A lot of them are sore or lame before they are ever gathered.

Wild horses are not all Black Beauties. However, there's nothing that says they can't be good pleasure horses, good using horses, and companion animals. It's just how we handle them. There are people that shouldn't have cats or dogs either, let alone a horse. And there are a lot of people that ride

horses yet are not horsemen. A horseman has a feeling for the horse. A good, experienced horseman can train any horse.

If you think about it, everyone has their own temperament and personality, and they respond to situations differently. It's the same with a horse. If you spend time working with your horse and observing him, you'll get an idea what's on his mind. You will begin to work off of that bond. Horses are constantly talking to us, and what's really neat is that most horses want to be our friend.

I always tell people that a horse and a rider must work as a team, and the rider is the team captain. When you have a horse that's got a problem temperament you try to work around it. Professional horse trainers recognize various problems, and they can either work the horse out of it or they work with it. In a sense, we can't change a horse's personality but we can change their attitude if we give the horse a chance and present him with a different view of the situation.

As riders, we create the conditions that allow a horse to do what we want. Sometimes I ask students to ride with their eyes closed. When you do that you feel every move that horse is making. The horse is a living, breathing being with feelings. But a horse isn't going to feel the same every day, so it's up to you to figure out why!

Having horses is a whole way of life—a philosophy of living and a lifestyle. Owning and riding horses is only for those who will do what it takes. Many horse people today don't have all that much time to spend with horses—just sitting around them, standing by them, watching them. I always tell my students to pick up a camp chair and just go sit and watch their horse. Observe their interaction with their peers; see how they interact with the environment. That tells you about their personality, and it gives a key to some other things going on.

In some ways horse ownership is more complicated now than in the past. Years ago, horses were "broke to ride" and that was about as far as it went. Today we have better trainers who know and understand more, so horses are better off as a consequence. This means the horses' knowledge

is also better, their skills are better, they're conditioned to do what we ask of them. I try to get new horse owners to understand that if you want to do something with your horse, you've got to make sure he is conditioned for the job, mentally and physically.

Mustangs in the wild are a picture of their environment. Out on the range there is so little nutrition. Any opportunity to improve their quality will always be limited by the available nutrition. If horse numbers are kept in harmony with the environment, you'll eventually see a change in their appearance for the better. They will be healthier individuals, they will be bigger individuals, they will be stronger individuals. That's the value of proper feed.

Many mustangs in Nevada are descendants of horses turned out in the last thirty to forty years. In one area near Reno the herds have increased to such high numbers that several local groups want to feed them. Well, yes, you can feed those horses. However, in the long run that only does them a disservice. Once any wild horse knows feed is freely available, they will no longer go out and graze. They won't try to take care of themselves anymore. Plus, very often those horses that need the most supplemental feeding will be driven off by the strongest ones, which means those dominant animals get stronger while the weaker ones die anyway. So while it might be nice to see lots of horses out there, the range won't support it. It's not fair to these animals to let them increase, because there isn't enough nutrition to begin with, and once you start feeding them it upsets the whole balance.

Whenever I read books about the West I always consider how close to reality it is. Has it been romanticized? Have things been taken out of context to make a point? Wild horses are difficult to manage because there are so many special interest groups. Most of them never agree, and many people who belong to them aren't able to see what's happening here. Yet, if something gets them inflamed, they feel they have a mission to accomplish. But our environment here is unique and fragile in many ways, so sometimes doing what is right for these horses may actually be what is more difficult.

Basically, it keeps coming down to the same thing. Mustangs can be tremendous animals, but with any horse it's always a matter of getting everything off to the right start.

Sunny Martin (Deceased): Curly Horse Advocate, Ely, Nevada

When I got my first Curly I didn't really need another horse. I already had about fifteen down in the field. But my husband and I went to town one evening, and we stopped at the Hotel Nevada for a cocktail before dinner. Gailin Manzoni was there, and he came over to sit and talk awhile. Well, we got to talking horses and Gailin said, "Sunny, I've got the cutest horse you ever saw down at the ranch. I've been chasing him for two years, and Stump Halstead and I finally got a rope on him. We brought him to the ranch, and the next day he acted like he'd been raised in the barn, he's so gentle. He's just really cute." I asked him, "What exactly is so cute about him, Gailin?" He said, "That little horse is curly all over." Right then it was like a big light went off in my head—I knew had to have that horse! I said, "Are you going to keep him?" and he answered, "Well, I don't really need him so I'll probably sell him." "Don't let anything happen to him," I said. "I'll be down in the morning!"

The next day we hopped in the truck to go down to Gailin's ranch. As we started to leave I said to my husband, Sarge, "Wait a minute, I forgot my saddle." He said, "Sunny, this is a wild stallion, and you don't need your saddle because you're not going to ride him." But Sarge was the nicest man in the world. He went down to the barn and got the saddle anyway, just because I asked. So away we went. When we got to Currant Creek, we went out to the cow pen. Well, here was this little three-year-old bay mustang, and he was just curly all over from his nose to his toes. I fell in love with him the minute I saw him! He'd only been off the range a few days, and he had a halter on. This little horse looked at us for a while and then, very gingerly, he started walking right to me. Now, usually, mustangs are wild-eyed and running all over trying to get away from you. This little guy got right up close and started sniffing me! I said, "Let me see if I can lead him." And so

I led him around a few times and he did just fine, and I stopped and petted him. Then I said, "Sarge, go get that saddle; I want to put it on." He answered, "For heaven's sake, Sunny, you're going to get yourself killed!" But I know a lot about horses, and I took one look at those eyes and they were the softest, sweetest eyes I'd ever seen. I knew that if that horse was going to be mean he wouldn't be following me around with those eyes like that. So we put the saddle on and he never even fussed. Then I tightened up the cinch and fastened the rope on the halter, and I got on. He just stood there. Now, I've tried that with other horses who would stand and then all of a sudden come unglued, but this guy stayed right where he was. So I nudged him a little and got him to take a step. Once he started, I rode him around about a dozen times. I pulled the reins back, and he just buried his little tail and stopped, right there. I couldn't believe the intelligence of that little horse. Curly Q is what I named him. All his offspring have "Q" in their name.

Peter and Bernard Damele found the first Curlies out on their range in 1898. It was a mare and two colts, and they just left them out there. Things went on like this for some time, and then in 1934 we had a terrible winter. Everyone around had turned their saddle horses out as usual, but when they went to get them in the spring, there wasn't one left. But those Curlies on Damele's range made it through fine. By now, of course, there were quite a few more because that Curly mare had been bred to their stallion. The Dameles went to town that year and they bought some more horses to replace the ones they lost, and they came home and went on working as before. Well, in 1949 there was another bad winter. That year the wind blew so bad, and there was a lot of snow piled up in big, huge drifts. All the animals were stuck out there, and not one of the stockmen could get to their cattle, their sheep, or their horses. The government brought in great big cargo planes and threw out hay all over the Nevada and Utah desert, but by the end of that winter there still wasn't a saddle horse left. Except for those Curly horses. Now, some of the older Curlies and the small colts didn't make it, but the rest were still standing. So this time when spring arrived,

the Dameles brought them onto their ranch. They started to break them to ride, and they found out how good they were. They never used anything but Curlies on their ranch afterward.

These Curlies are the most intelligent horses I've ever worked with in my life. You've got to stay ahead of them because they're thinking all the time. But these little horses have had to prove themselves. I was involved in about every horse event there was here in White Pine County, and I had a lot of horse friends. But when I took up with these Curly horses, people thought I went insane. "Ill-bred, inbred, scroungy, mangy, wormy-looking mustangs"—that's what they'd say. But I knew Curlies were good. They're smart, gentle, sturdy, and friendly. They're hypoallergenic, too!

My old gray Curly mare was named Pello Cheno. I taught my niece Debbie how to ride and she became good at showing horses, so she started showing Cheno. That old mare was 15.3 hands and weighed thirteen hundred pounds. She used to stand hipshot with her belly hanging out and her head hanging down with her eyes closed, not paying attention to anything. She never got excited. But once you opened that gate to the arena her belly went up, her back went straight, her head went up, and her ears went forward, and she walked in just like a queen! Debbie entered her in her first jumping class. There were four jumps: a brick wall, a brush jump, crossbars, and a flat jump. The rider took it one way and then had to turn around and take it the other, so there were eight jumps total. Cheno watched the horse in front go over those jumps, and she watched that horse go all around the arena, and she watched her all the way back. When her turn came she took all eight jumps like she'd done it all her life.

In 1971 I started the national Curly Registry with twelve people, including three of the Dameles. We realized how great these horses were and thought they should be bred seriously. We selected horses from other breeds to mate with our Curly horses. We picked the Arab for stamina, the Appaloosa for stamina and bone, and the Morgan. The grandmother of Justin Morgan's horse was of unknown ancestry, and Curlies and Morgans

to this day have wavy manes and tails. The fourth breed was the Missouri Foxtrotter because there are more curly coats in that foxtrotter group than any other. Those four are the only horses we will breed our horses with. If a horse was born with a curly coat it was registered as a full Curly. We included a register for half-Curlies and a registry for straight-haired horses that had Curly blood but no wavy hair. We registered only mares and geldings for that, because stallions could change the breed. Today the American Bashkir Curly Horse is recognized as a legitimate breed, with four thousand registered horses.

These Curlies are amazing little wild horses. I like to think I did something good for them—that makes me glad!

Katie Blunk, D.V.M.: Wild Horse Adopter, Mogul, Nevada

I've been a field veterinarian for twenty-two years. In the 1990s I developed an idea to forge a new partnership between the Department of the Interior/BLM Wild Horse and Burro Program and the Department of Agriculture Animal and Plant Health Inspection-Veterinary Services. I made recommendations about how to cross-utilize resources between the two agencies so our vets could serve their needs. Five years later the project became a reality, and there's now a special fund to utilize our services to assist the wild horse program.

Through this partnership I got involved in the wild horse gathers. I help with on-site injuries and genetics testing. Many times BLM has also been criticized when some wild horses are put down. I think most of the wild horse and burro specialists, especially those who've worked in the field for many years, can make that call better than I can, but if a vet is on the scene it becomes more palatable to public perception.

One day I was out walking around the corrals, when all of a sudden it felt like this one horse was reaching out and grabbing me! He was two years old and I was drawn to him by his flash and color. I wanted to see his natural athletic ability and how he moved, so I climbed into the pen and started

walking him up and down the fence. Well, pretty soon here was this whole herd of wild studs, all turning back and forth with me. I really had no intention of adopting him, but I did.

The year before, I adopted a wild burro. I was only going to look at him, too, but that day I had my horse trailer hooked up and that donkey ended up coming home with me! He's solid black. Black Jack was a free leppy who soon became a $600 burro because it took feeding him six months with a very expensive milk replacer. So altogether now I have two domestic Quarter Horses, Black Hawk the mustang, and Black Jack the burro.

I trained Black Jack myself. He was two weeks old, so there was no wild to take out of him. But actually, for the last few years I've had to *untrain* all the spoiling I caused. My friends tried to warn me. They told me I was creating a monster by not establishing dominance and personal space with him, and as he grew older all the things he got away with as a youngster began to get dangerous. He was body-slamming doors and other stuff. I allowed him to come in the house when he was little, and one time I couldn't get him back out! He was about eight months old then; shortly after that is when I castrated him. Finally, when he was four, I put a saddle on him and rode it out of him. He weighed about seven hundred pounds, and when I climbed on I thought to myself, "Uh-oh, I'm going to get killed!" Instead, he mellowed out. Recently I got a pack saddle and I've been putting that on him. I just let him cruise around. He likes that and he's doing fine—all he needed was a job.

In Oklahoma, where I grew up, horses were broke the old way, and I'd always acquired broke horses. I'd never taken one from ground zero to finish work, and even though I'd ridden all my life it wasn't like I was a finesse horse trainer. I watched Bryan Neubert down at the Wild Horse Show and I started paying more attention to other nonresistant training ideas. I really got into watching my horse's body language, reading the horse. Bryan did the first groundwork on him, and then I went to a few other clinics. Later, I took Hawk to a Les Vogt clinic, the famous cutting horse trainer. Well, he loved my mustang! He used me as a guinea pig

because Hawk hadn't been monkeyed with—he was green, green, green. I applied Les's strategies and techniques and demonstrated them all on Hawk to this big group of pros on their highbred Quarter Horses!

After the adoption I brought Hawk home, unloaded him, and cut him loose in the corral. I went out and caught him about twenty minutes later, just doing the give-and-take thing. I had somebody climb up on his bare back that was more athletic than I, but I didn't lead him around or risk uncorking him right away. I gave him a bath and clipped his bridle path and his feathers because he was scruffy looking—all on that first day. I also cut a swatch of skin off his eye that he had banged in the chute, and I doctored it every day for a week. As long as I used nonresistant techniques I had him in my pocket. He has never kicked, struck, or bit at me. One time when I was picking up a front foot, he did give a rapid stomp with the hind foot. He wasn't really trying to kick me, but he sure could have taken the top of my head off real easy. I had him shod a month later because he was out of balance on the hind and I thought I'd see if we could set it up. I went natural again with him after correcting his imbalance. He's got great feet!

I did have one pilot error when I was training him. I didn't do the proper preparation on one ride. It was my third time mounting him, and I was excited and I rushed things, and he poked my head right through the round pen! After that my neighbor did a few mounting drills with him, so now Hawk parks for me! I think mounting your horse from a block is much more polite. No matter how big or little you are, it's a nicer thing to do for the horse. You know how it is when you carry a purse on your shoulder or drag a big suitcase with one arm? Well, it's the same deal for a horse when you jerk him around to climb on. I noticed that when Bryan first worked on Hawk, he got up on top of that big corral, and the only time that horse wouldn't feel pressure from his rope was when he would be in this *perfect spot*, and that's when Bryan would put a leg over him. He just lowered himself down off the fence onto him, and then he would just as quickly pull himself off. I used that same technique. To this day I can put a saddle on Hawk and step up on anything—a bumper, a tailgate, a horse trailer, a stump,

a rock. I'll say, "Park it, Hawk," and my horse will just swing around and put his body right so I can step up on him. These old cowboys down here at the stable couldn't believe that when they first saw it. They were making fun of me, but by the time it was all said and done, they were parking my mustang to mount him, too. It was a hoot!

I've never been bucked off. Since Hawk has gotten older and stronger and fiestier he has gotten a little fresh, but he never really learned how to buck. I didn't scare the hell out of him, for one thing, and I've never picked a fight with him, either. In the beginning, when I saddled him he'd squat down on the ground like I was getting ready to hurt him or something, and I'd say, "It's alright, it's alright." I knew when I could go to the next stage, because I learned how to recognize his body language—the eye, the sigh, the licking of lips. That's when I would take the pressure off. Lately, I haven't been on him for several months. When I got on him last week I thought, "Uh-oh, he's going to forget all that good stuff from last year." Boy, oh boy, he was right there. He needed to work a little steam out of his system, but I had him collected in a pleasure horse gait and he was dropping his head. He did a lot better than my domestic horse.

There has to be an innate desire to want to work with a wild horse. With Hawk, every day is a new day to see what I can learn. I quit when we're at a good place, as opposed to thinking I'm going to make him learn one thing, and that we're going to do it over a hundred million times until he does. He's definitely a project, and it's fun to let things be natural. In the last five years he has taught me more about horsemanship than I'd learned all my life on the ranch.

The whole philosophy is to make what's right easy for him, and what's not right difficult. He has never been snubbed or tied down. Within a month I loaded him in my trailer. Mine has a single door in the back because the other side has a feed room, and that's scary for a horse to enter, because it's solid and not open. I backed the trailer up to the round pen and lunged him around. I took the pressure off right in front of the trailer, and the next

thing you know, he's galloping right into it. I did that a couple of days in a row. That's all it took.

I was in the Sheriff's Search and Rescue Posse awhile. Hawk was still green, but I took both him and Black Jack to get them exposed. It was a great forum for desensitization. They set up gauntlets with flapping streamers and fired off guns and waved flags and such. It taught me a lot: how to hold him and learning when to take the pressure off, to let him go through it rather than kicking him through it.

There are good and bad wild horses. Sometimes you don't get the best choice when you adopt, and I do think there are some horses that should go back. This is also America, so once people have title to their horse they should be able to do what they want with it. Actually, I'm surprised the process takes a full year. Humans don't usually have to wait that long before they legally adopt a child! I also think BLM should have authority for euthanasia and slaughter. In circumstances where there are deformed or unadoptable horses, why should we burden the taxpayer to maintain these animals in sanctuaries when, really, there are starving people somewhere in the world who could benefit more? Our society presently says it's not okay to kill a horse but that it is okay to kill a dog or cat. The government is trying to preserve a balance on the range. Wild horses aren't the only animals there.

Some aspects of the adoption program scare me, particularly how so many people manage not to get themselves killed. Some folks adopt a mustang just for the sake of having a "living legend." A lot of them don't know which end of a horse the food goes in, or even realize that they need water to drink. We all have to take a test to drive a car, because a car is a lethal machine. So are these horses.

Hawk is my best and my most loyal friend. He still has a half-wild streak in him, but I trust that horse more than any of my domestic horses. And when I go down to the corrals, it's Hawk who whinnies and comes running over to me, not one of them. So go figure.

Joyce Brown: Wild Horse Adopter, Henderson, Nevada

Romeo is three years old now and I've had him since he was a four-month-old colt. I saw him at a National Wild Horse Association rally when he was a leppy. His mother had died and he was trying to feed off the other horses. He was gangly and undernourished and looked really bad. I thought I'd like to adopt him, so I filled out the papers and sent them in. I really didn't think very much about it. All I knew was I felt I could do it.

At the time Romeo was at Dave Tattam's house, and I'd go see him there. I'd feed him and lead him around a little bit. I didn't know what was involved in having a baby horse—what you have to do or how much work is involved or what the costs are. I didn't read anything. Everything happened fast! I found a stable with a barn. He was a little undernourished, and the vet gave him vitamins for about three months. Then he started to fill out real nice.

I never had a horse but I always loved them. When I was a little girl I loved playing horses. Later on I had a friend and she had a horse. But I never ever thought horses could be in my world. When I heard about wild horse adoption as an adult, I thought I could help save a horse. I saw Romeo only about three times, but I just fell in love with him. I knew there was no turning back, and I thought I'd have him for the rest of my life. Now I know he's a lot of horse. He's a good horse, but we have difficulties.

I know Romeo well, but he knows me better. It's terrible because he's so smart. He knows what I'm thinking every minute, and I don't know what he's thinking. He's young and playful, and he always gets one up on me. I'm not able to get one up on him because I'm just learning.

When I first got him, he'd come out from the barn running and playing and jumping, and it scared me. I thought he was coming after me! Well, that seemed to make him even happier. I was leery because I didn't know what he was doing, and being knocked down wasn't one of the things I wanted to know! Also, when he was little and I would be leading him, I'd look back and he'd get all excited. I didn't know why he was doing that either. Lead-

ing is still one of the big difficulties we have. It's funny. I was probably
more scared of him when he was little than I am now that he's bigger.

I've had stages with Romeo where everything would be good for a while.
Then he'd grow a little and figure something out, and he would try out new
things on me. He's like a kid that tests you to the limit, and he's going to
make you work every inch for whatever you get.

I had no clue of what to expect with Romeo. I'd never even had a dog!
There have been maybe ten people who have told me to sell him, but I'm
stubborn and determined. He's not going to hurt me unless it would be an
accident, and if I'm easy and calm I know he'd never come at me. When I
first had him I would panic. I didn't realize you were supposed to stay quiet
and that the calmer you are the better the situation will be. Since I didn't
know that, he'd react. He knows my feelings, and I don't like that. He
knows what I'm doing but I don't understand what he's doing. It will be bet-
ter once he learns that I'm the boss.

At the beginning nobody told me very much. But I didn't ask, either. I
did go to some clinics, which were wonderful, and I learned about feeding
horses and other things. I thought that if Romeo had good training, maybe
I could control him better. Well, the first gal who worked with him wasn't
consistent. She wanted to work Romeo all by herself, and I wanted to work
along with her. It wasn't a good situation, and we didn't share the same
ideas. Romeo was so smart and cute, and it was easy to enjoy him. I thought
this gal was having fun with him when he needed more work. I should have
found a different trainer after about a year, but I didn't know what was right
and what wasn't. Then another gal said she'd help. Well, one week later she
got hurt. We were in the round pen and I was lunging Romeo. Something
startled him and he got away from me and went straight into her. She got a
concussion from that and I felt really bad. She helped me find my current
trainer, Laura, who I like very much. We can work together.

Laura always tells me to remember that I know Romeo better than any-
body. Maybe I can't do everything that someone else can, but I do know my
horse. When a horse is smart like he is, he's always trying to get one up on

you. For somebody like myself, who doesn't know what they're doing, I've had to learn everything by error.

My trainer broke Romeo to ride. When I ride him now, it's wonderful. I could probably ride him out the gate, but I might scare myself, and I want riding to be a good experience. So I'm riding him in circles. He turns well and he's doing good. I've been out in the desert on another horse when Laura was riding Romeo. He's calmer in the desert because it's his environment. The first time we went out it was unbelievable! He was so happy; you could see the wonder on his face and in his eyes. That was really neat to see.

Right now, Romeo is at an age where he gets really goofy and silly sometimes. He does this thing with his lip on the railing and blubbers like a baby. When he does that I laugh. But part of our problem is that when he's being a brat I think he's being funny, and those are the things I should be getting after him about. I don't have that confidence yet. I have to get to that level.

When I first got Romeo I just wanted to be around him and bond with him. All horses have traits, and how can you learn about them unless time gives you that? When you see who they are repeatedly, then you know what to expect. I'm starting to know what response I'll get now. I can read him faster. I've learned that control comes when I have the right tools, and that confidence comes from knowledge. It's like any other thing you learn.

Romeo is a very honest horse. He's sensitive and aware. He's almost too much in tune, but his level of maturity is behind what it should be. Part of that is because my maturity was low and I didn't know how to give him what he needed. We still have a problem leading, and if he decides he wants to take off, he just runs over to see one of the other mares. He gets frantic if one of them leaves. He has also gotten away from me and from other people. It scares me that he could get hurt or that someone else could get hurt.

It has been heartbreaking to see how I haven't done the right things for Romeo. When he learns that certain things aren't proper behavior, I know it will click for him. I work with him four times a week now, and if I'm not

lunging him I'm grooming him or checking his feet or just walking him around. He has done real well. He gets right in the trailer and walks right out with no trouble at all.

At first I thought there's no way I would ever get rid of Romeo because he needs a good home. Then I thought I would never sell him because he needed more training. I'm the one who made him spoiled, even if it was by accident, and I was afraid somebody else might abuse him. But no matter how good a horse is, you still have to put in time with them. Wild horses are appreciative when you learn to understand them. They have that little bit of freedom in them; that's the big difference.

Romeo is like the air that I breathe. If we ever get to the level where we really come together, I know I'll have a piece of heaven on earth.

Dave Dohnel: Wild Horse Outfitter, Bishop, California

When I started my business I had no prior horse experience—none at all! My grandfather had been an outfitter, so I thought it would be interesting. Then I met an old mustanger named Bill Hizer who had the idea to use wild horses for pack animals. We went to Susanville because they had some big half-draft ranch horses there, and that's what we wanted. We got ourselves an old one-ton pickup and we drove on up there, and we came back with six ten-year-old wild studs. To this day I still have no idea what we must have been thinking, because those horses were really tough, rangy horses! We worked with them for ninety days, and we did everything the old cowboy way, and that's how I learned. We never choked them down or anything. We'd put a rope around them, and we'd get out about sixty feet with a saddle horse and then dally off. But things were crashing, and we were breaking corrals, and they'd kick and bite and buck—it was really wild! I got kicked so many times that after a while it didn't even hurt. But I was still athletic then, and I thought I could do anything.

We named those horses Sooner (he'd sooner kick than look at you), Stanley (he'd hammer his head against the fence), and Digger (he dug holes). Then there was Chewey (he ate all the nails out of the chute), Ted,

and Blackie. Blackie is still with us today. The rest didn't work out; they were way too old and rank.

The next year BLM called to say they had a good horse for us. They got him from Devil's Garden, out of the Modoc herd, and we named him Modoc. He was a two-year-old and sixteen hands, and thank God he was gentle because I still had no idea what I was doing! Everybody just loved Modoc. He was big and gentle and you could get on him and just go anywhere.

One day Hizer and I decided we could get people to pay us to take them to the backcountry to see wild horses. On our first trip we brought our friends. Of course, we had no idea how to find the wild horses, especially with a group. We'd go out in the middle of the day during summer when it would get about 100 degrees, and naturally there weren't any horses around then because they were all treed up. Finally we went out one night, and there they were—they were everywhere! Well, the next year we organized a trip with University of California at Santa Barbara. They ran a little ad in the *Los Angeles Times* and got twenty-five people in one night. It turned out to be great. The *Times* ran a big article about Modoc looking for his lost friends, and that helped a lot.

By that time it was no big deal for Modoc to see another wild horse. They were just another bunch of horses to him then, because his band was the saddle horses in our pack string; that was his herd. Modoc was so gentle! We would put him up on the ridge, and you could go up and lie on the dirt next to his feet and listen to him whinny at those wild horses. He would stand there and nicker, and, boy, pretty soon here came all the bachelors! Modoc was our decoy for years, but then he got the wobbles and died. I felt so bad when we had to put him down. He was just the nicest, nicest horse.

We've used wild horses in our pack string ever since. We put them to work when they're colts. The area is nice and gentle with rolling hills, and it's not hard country for them. We put them under a saddle and it gets them used to the concept that they'll be caught and ridden every day. There have been a few horses who reverted back; we just couldn't get the coyote of them. We don't hobble our horses when we're out with them, because in the

Sierra there are canyons and draws and meadows where they graze and physical boundaries where they won't go. And we have a bell mare. When that mare comes in for grain in the morning, the others all follow. But one of our horses named Blackie used to take off sometimes in the middle of the night, and Bob, another big bay horse, took off once, too. That time we were on a trip in the Kern Plateau. One morning around 4:30 I went out to bring the horses in. Well, Bob was missing. He had headed east in the night and went all the way over to the crest of the Sierra, where the mountains meet Highway 395. We didn't find him for forty-five days!

We coordinate our trips when we know the wild herds are moving from winter to summer range. In the summer they'll run up the mountains around seventy-two hundred to eight thousand feet. We go out for four days, from one weekend to the next, so we're not harassing them. We head to the water holes and track from there, and back at camp we talk about their history and behavior.

Where the horses travel has changed through the years. Fifteen years ago, for instance, they started down in the flats and moved up the mountain. Nowadays they head to the high country right off the bat. We usually never see the same horses, even though there are over two hundred in our herd management area. I can't figure out why. Like, five years ago there was a nice band of eight or ten horses with two white lead mares. I saw them a few years afterward, but I haven't seen them this year at all. No one knows where they winter.

One day I spotted a drag mark in the sand, and we followed it to a fresh lion kill. It was a nice little colt. We ran the cougar off before he had a chance to eat, but we never saw him. Another time we watched a female cat with two cubs drag a colt across the flats. They all munched on it for a week. Lions are the reason why a lot of horses don't go to the water hole at Jacks Springs.

We train all our own horses. In 1983 my brother and I got a video on the Geoffrey method out of Australia and started experimenting. We had two big bays at the time, Leon and Bob, that we had just broke to halter. We

watched that video a little bit, and then we ran out and worked on Leon and Bob. We looked at each other and said, "Gosh—this really works!" Then we ran back in the house; we watched the video a little more and then we ran back out and worked some more on Leon and Bob. Pretty soon my brother had Leon saddled and was riding him in the corral and I was on Bob bareback, and that was our first day! The Geoffrey method is like any natural technique. Tom Dorrance, Ray Hunt, Bryan Neubert—they basically all do the same stuff. You don't come at the horse like a predator, and you take it slow, advance and retreat. We probably train two or three horses a year, but I don't think of myself as a professional. I do it because it's my interest. And now my daughter helps a little bit, too.

Whether it's a wild horse or a regular horse, they're still just horses, so not every one is a good horse and not every one works. One year I saw this one horse and I just had to have him. That son of a gun worked great for about a month, and then that was it—he just would not leave the yard. After that he started flipping up and over backward. We took him out on the trail once. He started to flip over backward, and he rolled himself down a cliff. It didn't hurt him, but it sure didn't make him any smarter! Obviously, that horse had a problem. We work with a horse trader, and he took him. This is one reason we don't like our guests riding our horses right off the bat. We don't want them teaching the horses bad habits. But if I could pick a great horse every time, that would take all the fun out of it.

When I pick a horse, I don't look for the king stud. I don't want any aggressive colts and I don't want a thunderbolt who bites and kicks. That's a dominant horse, and they don't ever work out. I got a yearling palomino once; his name was Prince. He was a really nice-looking horse and he didn't look aggressive. But when I got him home he was really tough! He absolutely did not like his introduction to humankind! I have a chute, and sometimes I put the horses in there while I pet them. Prince kicked that chute probably 150 times in a row. I watched him the whole time, and he kicked so hard he knocked off half of the sole of his foot. I thought to myself, "This isn't good; this horse is half mean." I put him in the round

corral and we started working. Well, he wouldn't join up, he wouldn't get close, he kept striking at me. So I backed off. Then I isolated him. So now he's all by himself and I'm the only one coming to give him attention. Then I started working with him again, advance and retreat, advance and retreat, and I did that two hours every day. I'd touch him a little here and there, but I still didn't put on any pressure. Then I put the saddle on him. Oh my Lord did that son of a gun jump! Well, my wife rides dressage and she's a Pat Perelli fan too, so she said, "Go get the little stick." So I did. I rubbed that stick around his belly for half a day. Then I used both the rope and the stick. I did all the tricks. Finally I put the training saddle back on; it has no stirrups, just a cinch. I cinched him up and I walked him, and then I cinched him up some more. I backed him up and we played a few more games to get him to forgetting, and finally—*finally*—he got it! Prince is just a great horse now. Last week I glanced outside and saw Katie, my little two-year-old, leading him around. But it took three weeks working with him like that, every day, just to get him to come around.

Once I got a really good-looking bay horse out of Susanville. We were getting ready to load him in the trailer, and as we were standing there he jumped right over an eight-foot barrier—*kaboom*—just like that. I brought him home anyway because I liked him. He gave me the bluff for a few days, but I kept on petting him and being real quiet. The next thing I knew that son of a gun had ripped through my shirt and had taken a bite out of my stomach and was stomping on my hat! I called BLM right away, and they took him back. That horse was just a bad-ass horse; there was something in him like that. Mostly I've been really lucky with wild horses. I've gotten a lot of them, and most of them really come around.

We keep all our horses until they die. They might last twenty years on the pack string. The guides ride them first, and then we give them to the guests to ride. After about fifteen years, when they start to show their age, I don't work them as hard, maybe just half days. And after they can't make it in the mountains at all anymore, then I let kids ride them. They are still good for hour rides. When they're really old they spend their days at the house and

watch my girls. We have Topaz and Flipper now; they're about thirty, and you can't get any better. Where are you going to find a horse that will let a little two-year-old girl reach up between their legs and walk underneath them with a hose to give them a bath? Those horses have seen everything.

I've watched and tracked wild horses for years now. I really like the challenge of looking for them. We do six or seven trips a year, and my brother and I both like going out every day to find them. We're real fortunate to have this government permit and to bring people along who like looking at them too.

John Sharp: Horseman, Prineville, Oregon

I rode the freights out to Oregon in 1932. I met a fellow who had been raised in the high desert, and he was telling me about all these big ranches with thousands of cattle and horses, and that's where I wanted to go. Four of us grabbed a freight train and came across the mountains.

After we got there I headed off to Prineville and caught a ride to Paulinha. I found out they needed a couple of boys over at the Lester place for the first haying, so I signed on there. One day one of the hired men was starting a mare that belonged to the outfit. I was watching that fellow when he came over and asked me if I wanted to ride one of the colts. I said, "Sure, I'd like that." Well, before too long the boss put me to working colts. I was going to stay through winter, but when fall came around I wanted to head home and finish high school. The boss said, "That's the smartest thing you could do, and you've got a job when you come back." So I came back in the spring. After that I didn't do anything but buckaroo.

The Lester Ranch ran all their horses out on the range. They'd do a roundup every fall and cut out what they wanted, brand all the foals, and take whatever brood mares they wanted to keep and put them with their stud. That was part of their operation. The largest herd of wild horses I ever helped handle was a little over 450 head. We gathered them all in one bunch out there and put them in holding pastures. Those horses were halfway manageable. They were wild, but at least we could still drive them.

After the Taylor Grazing Act came in, there was a job gathering some of the last remaining mustangs off of government land. I did that with Cecil Reynolds. We gathered all the horses off Jerry Mountain and brought them into the Coal Springs Ranch. People who owned branded horses were notified to come pick them up or they would be shipped out. We gathered a lot of Bill Brown's horses then, too. Bill Brown was one of last of the old horse kings. Bill was originally a sheepman. He came to the desert with a bunch of bummer lambs and became one of the wealthiest men in that country, and then he went broke during the Big Depression. When we gathered those horses they were mostly old and gray-headed.

After we finished that operation I don't think there was twenty head of wild horses left on the range except for horses that still belonged to individual owners who were pasturing them there. And after that the horse market went *kaplooey*. Tractors came in and farmers quit working with horses in the 1940s, so people pretty much quit horse gathering. For a while, when you could sell those horses for a pretty good price, why, everybody would go out and try to catch one that was loose and didn't have a brand. If you found one or more it could be worth a little bit of money; it helped to make ends meet.

I don't know if I was much different than any of the other buckaroos or if I was just lucky, but I caught horses that other people couldn't. It's a funny thing about wild horses. They can be running away from you, but if you drop out of sight and get around in front of them you can stop them and turn them. If you try and run along by them, they'll go in all directions. I remember one mare out there. She got loose as a yearling and she'd been out on the range about six years. She was a well-bred mare, faster than greased lightning, and everybody in that country tried to catch her. I happened on her one time and I got to tracing her. She was with a stud and three other mares, and she had two fillies by her side. I corralled them, and since the stud already had a brand on him, I let him and the other horses back out. Then I brought her and her babies back home. I took them plumb around by Paulinha. It was probably about twenty-five miles the way we went.

When I first saw that mare I knew where she'd go. You always find them in the head of canyons and gullies, so I knew she'd go up by what they called Jake's Canyon. She ran out on Twelve Mile Table or Maupin Butte most of the time, so instead of chasing her I just headed to the top of Twelve Mile Table. I knew the country. The trail came up over the rimrock of the canyon where the fence crossed it, and the canyon and the fence paralleled for 200 or 300 yards, so there was a barrier there on each side. There was a gate at the corner going into what they called the Rye Grass Ranch. I opened that gate, and when she come over the top I was sitting there waiting. She got all excited but she had a lot of room to play in. She'd start up to the fence and I'd just ride over from the rimrock and sit there. We went back and forth like that until she saw that gate open, and then away she went! Well, she could still go south the way she wanted, but she didn't realize she was fenced in now. So I went east, opened the gate into the little pasture into the Rye Grass Ranch, and then cut across. Here she was, back up from the corner and two miles south from where I'd let her in, running the fence back and forth and trying to get on out on the table. I just started back down the fence. I'd stay away from her, oh, say probably 150 to 200 yards off to one side and a little behind. We drifted down the fence like that, and pretty soon they were in the pasture.

Baldy Socks was our stud, and one of the best in the country. I broke a lot of his offspring, and every one would work a cow. He was half Hambletonian and half Thoroughbred. I love to ride a good Hambletonian; they're the kind you can ride! We rode a lot of trotting horses. They can move, and they'll trot any one of these other horses to death. Yep, Baldy Socks was one smart horse. He was a horse to love.

When I went to work for Shorty Severance they had another mare there. She had a sorrel-blazed face and four stocking legs just as even as could be. Her daddy was a Hambletonian and her mother was mostly Hambletonian, too, by a stallion that had been a champion harness horse in the Northwest. One Saturday morning I brought her in the corral and decided to do a little experimenting. I went up to Paulinha and got two bamboo fishing poles;

oh, they were about fourteen feet long and they were little teeny poles. I took that mare out and put her in the square pen. I never put a rope on her. I don't think I was there over an hour or two, but by the time I was done she was following me all around the place.

When I get a horse in the pen with those poles, I get him going in circles. Then I'll get him to stop in a corner. I'll take that pole and lay it on his neck, right in front of his withers. If you want to soothe a horse, you rub him there. Then I just push down and touch him, little bit by little bit. The next thing you know I'm rubbing him up and down his ears, down to his heels, under his belly. I've never touched him with my hands, but pretty soon I'll slide up the pole, and I've got my hand on him.

I took that mare out of the square pen and into a big corral. I had her in the little corral following me around, and by reaching to tap her I'd get her to move. Then I'd move ahead, and then I'd pet her. So I took her through the barn. She had to step up onto a wood floor and walk through to the other side, then down a dirt ramp and out to the front corral. I got brave and opened a gate and went out into the road. I crossed the yard, and she followed me right up to the house. I remember there was a big rock for a door step; it was probably a three-foot oblong. Sure enough, I propped the screen door open and she came up onto that rock and put her head right into where the door was. So I hollered to my boss, "Hey, Shorty, come take a look at my horse!" He said, "John, you keep doing whatever you want, just as long as you keep working with these horses."

When that mare was a three-year-old I had a job salting. I used her as my camp horse. She'd follow me all over the mountains with my pack on her. I suppose it was sixty pounds at most, just two or three days' grub supply for me and a little bit of grain for her and my saddle horse. I had a range of about six or eight miles wide and some twenty miles long to look after the cattle. I rode her all around.

That mare was pleasant by nature. A lot of horses are born with that kind of disposition, but some people can make even a pleasant kind of horse turn into an outlaw. I tell people it takes a horse only about two seconds to

figure me out when I walk in the pen with them, but it takes me at least twenty minutes to figure them out. Horses are not dumb.

It's for sure I have to prove to a horse that I'm not going to hurt him. I also have to prove I'm going to control him. You don't have to be cruel to dominate a horse. You definitely have to let him know you're the boss, and you may even have to spank him, but it's more of a matter that I build a little trust. I'll get that pole on him, and once I get to working, it feels good. It's just like currying a horse. You've also got to get a rope on them. I have a twenty-five-foot, three-eighths-inch cotton rope, and I'll get that over the horse and all around him. I hold it at both ends and I'll seesaw it back and forth, and then I'll flip it. Then I get a squeeze halter on him. I teach him to lead by using a squeeze halter. Some people call that a war bridle and some call it a come-along rope. I call it a squeeze halter because it squeezes up on the horse, but when they give, it releases. It works on the nerve back of the poll and the two nerves on each side of the jaw. They learn to give to pressure. A horse has to learn to give to pressure if you're going to do anything with him.

I'm a snaffle bit man. I use a single snaffle, but any bit that pulls from the side is considered a snaffle. A broken mouth snaffle is one that hinges in the middle. A twisted wire snaffle is what we used to call a mule bridle. I'll just put that snaffle on a horse. I might not even put any reins on. I just let him wear it until he gets the feel of it. I also used the side pull for about forty years. A stud halter is a metal nose band with a ring on the back that fits loose. I started using that for lunging a horse. I put a strap on each side with a little ring to snap my rope into so I'd have a side pull. It made a real good lunge holder. I still use that. You can throw a kink in your rope, a riffle, and thump a horse with just a little curl of the rope. When I want him to stop, I just throw that riffle, and that band will bump his nose down and he'll start putting his feet under. When I first get on, I start with this metal noseband and a split rein. I have the snaffle in his mouth, and these two leather straps are fastened around, and then there's little d-rings on that to pass the bridle rein through. I ride them with that because when you

pull, it wiggles and moves but it doesn't hurt. It just wiggles the bit before it puts any pressure on their nose. Pretty soon, whenever that bit wiggles they start giving.

I've gentled quite a few wild horses for people. BLM had a Kiger sale recently, and two people from Bend adopted a colt and a mare. They had a love for wild horses and they lived on a few acres, but they didn't have any inkling whatsoever what to do with them. They came over and paid me a visit. At the time I was working with another mustang and they liked what they saw, so they brought over their two horses. The mare turned out to be a pussycat, but that little colt was a devil. He wanted to strike and bite, and he took a little bit of work. I got him so he was safe for them, and they had him gelded. A horse can be dangerous, there's no *ifs* or *ands* about it. A little common sense and patience can keep you out of trouble most of the time.

At my age it's hard to get on a horse anymore, so my granddaughter does most of the riding for me now. It's like that old saying, "The good Lord seems to look out for fools"? I've lasted this long for a broken-down buckaroo, anyhow.

Bryan Neubert: Horseman, Alturas, California

I was raised around horses. I worked at my family's ranch and at some different ranches up near Elko, and most places put me in charge of getting horses started. I'd spend time in California in the winter starting horses there and I'd come back to Nevada in the spring. I did this for about twenty years, and in 1992 I struck out on my own. The pastor at our church is a cow boss on a nearby ranch, and he's a good hand with colts. BLM asked him to do some demonstrations with wild horses once, and since he already had a full-time job he put them on to me. That's how I started with BLM's horses.

For a time all I worked with were wild horses. Now I work with every kind of horse. I help people with their horses in Canada and all over the United States.

When I first came to Nevada the big outfits used to have lots of horses on

the range. They were way wilder than any BLM horses I've worked with. These BLM horses have been through chutes, they've had tractors feeding them, they've been on trucks, through traffic and towns, and all kinds of things like that. Those ranch horses would just be weaned off their mother and branded, and the studs would be castrated, and then they'd be turned out until it was time to gather them in to start them. Some would get some age on them, so they might be eight-year-olds by the time I worked with them. All this time they had never been in a corral; they had never been handled at all.

Quite often there's a bit of genetics that enters into any horse's disposition, wild or domestic. Environment enters into it, too. A lot of times with a BLM horse, their breeding hasn't been monitored for generations, so some of them may have grand dispositions and some might not be so sweet. With a mustang, it's the toughest stud who gets the mares; that's how it goes. When horses are raised by a private breeder, if any colts come along that are difficult to get along with, the owner will usually hunt up another stud to improve their disposition. So registered horses are popular because they're bred to get along with people. But regardless of whether humans have anything to do with their breeding, there's still a lot of wild BLM horses that can be really nice.

When I start a horse I use a halter, a rope, and a flag; and a saddle, of course. Sometimes a snaffle bit and a hackamore. And a blanket, spurs, and chaps. That's about it. I don't use driving reins unless it's a draft horse. I think it's fine for people to do whatever it takes to get a horse started, as long as they don't hurt them or get themselves hurt.

I like to wait and see what a horse is like. I might be starting a dozen horses, and I just vary things as I go. A friend of mine used to start horses, and people would say to him, "Why is it that last year you did it like this, and this year you're doing it like that?" His answer would be, "Well, that was last year and this is this year!" People try to pin me down for some kind of system, but I don't have one. I adjust to the horse and try to make things as

simple as I can for him. A horse has all different kinds of levels of security and confidence, just like people. Some people are more timid and others are more bold. It's about the same. I'll just try to get on a level that the horse can understand, try to present myself in a way that I can be understood. I'll constantly be experimenting with their different personalities. Often-times I'm guided by instinct or intuition.

A wild horse can really hurt you; they can even kill you. I'm sure a lot of first-time horse owners have had their dreams turn into nightmares, because if things get in the wrong hands it can be a disaster. Some people ask me, "Isn't it pretty dangerous?" Well, yes, it can be. People get killed in cars every day, and I'm not going to let a ten-year-old child take my car and go downtown with it. That's the way it is with horses, and you hopefully learn how to stay out of trouble. I don't know anyone that's ever done much of this work that hasn't gotten hurt. It's part of the deal. And in order to learn how not to get hurt, you may have to get hurt first. So you try to remember what things looked like before, and then you change your course when it looks like that could happen again. Each horse is an individual, and I just wait and see what they can handle and what I can safely get away with.

The government adopts mustangs for $125, so anybody that ever had a dream of owning a horse can get one if they come up with the money. A lot of times it's a way different deal than they thought. I can tell by the questions people ask. One time I was giving a demonstration and a couple said, "We've got a trail ride coming up next weekend. If we buy a few of these wild horses, would there be any kind of preparation involved before we take the horse on that ride?" Now, those horses weren't even broke to lead then, so I said, "Heck, yes, there will be preparation; that's for sure." But they didn't even understand. That kind of thing happens a lot. I think a lot of people wind up feeding mustangs until their dying day because of those ideas. But with other wild horses, some folks have a ball with them! They'll get one right after another.

I've never seen a mustang do very well in competitive horse events, ex-

cept maybe endurance riding. Mustangs are tough; they usually have pretty good feet, and some have good endurance. People think they're descended from Indian ponies or from Spanish horses who got away, but most of them are descendants of horses from the Depression. It's not as romantic as people think.

Adopting a wild horse is a pretty cheap gamble because if one doesn't work out, you can haul it back to BLM. In a lot of cases, people don't know what they're getting into and bad things can happen. Even an experienced rider can get hurt. With any kind of green horse, wild or tame, if people took the money they might spend on hospital bills they could probably buy a nice, gentle, seasoned horse to have fun with.

Working with horses has a lot to do with experience, and with other things you can't put your finger on. Sometimes you may get an idea, and sometimes you're wrong so you may get hurt, and then you get a little smarter next time. The main thing I'm after is to get as much done as I can with the horse in whatever time I have to work with him. But a lot of times the fastest way to get where you want is just to slow down and go slower. There's a whole lot of timing and a feel that really can't be taught; it just has to be acquired. I try to help a horse get to a place so that where I am is where they're wanting to be, so that mentally their idea and my idea become the same and there's no argument between us. That starts on the ground. If you don't have that bond working for you, it's tough.

When my kids were little, they'd watch me drive a car. Later on, when they started driving, they'd let the clutch out too fast or not fast enough. Well, if you just let them alone it isn't long before things smooth out and they're on their way. It's a little like that with a horse. A horse is different from a pickup, of course, but horses are all so different. Some are more defensive, some are more insecure, some are more bold or aggressive. Some of them will take a run at you, and some are more willing. Some of them aren't very flexible mentally, and some have a great deal of mental flexibility. Some of them are just craving to get into your world, and others are just the opposite. Some have a lot of desire and not much ability, others

have a lot of ability but not much desire, and some others don't have much ability or desire. The best have quite a bit of both.

I don't call myself a trainer. I'm a student of horsemanship mostly; I just want to learn how to get along with a horse better. I'm paid for what I do and I can educate myself. But there's been times when I felt I was really starting to get good at this. Well, right about then the Lord would send me a horse that shows me I'm not quite so smart as I thought! So I've learned not to get too cocky, because there are some horses out there that can be tough. People talk to me about their horses, and when somebody gets one that's difficult I tell them, "The Lord made the world full of horses, but he only issued each of us one body, and when you mess that up, the fun is over. If you adopt a horse and if it doesn't fit you, there are others."

I like every creature, just all of them, but I really enjoy working with horses. I praise God that I can feed my family doing what I'd do even if money had no bearing at all. If I won the lottery I'd still be out working with horses. It's what I love. Anybody that can do what they love is blessed, and to have a family that shares that, why, I'm double-blessed.

Richard Shrake: Horseman, Sun River, Oregon

My dad was a horse trader who used to gather wild horses over by French-glen. I used to go with him. He was known as a guy who could take any horse and be on it in thirty minutes, but he did it in a very traumatic way. He was a great man and I love my dad a lot, but my work now is an immense contrast with how I grew up.

Gathering wild horses was exciting back then, but the horse really didn't have much of a chance. We'd run them into the pens, and as one came in the chute we'd put a "running w" on him. It's a hobbling effect that takes away their flight mechanism, and the horse would thrash and struggle. To watch a horse get thrown down and then see someone get on him and see how the horse got "tamed" like that was a big thing for me. There was also something else that went right to my soul, and that was the wild horses who screamed. If you've ever heard a horse scream when they're in panic, you'll

never forget the sound. So even then I knew this was something that wasn't quite right. As I grew up I saw there were other ways to do things with horses that respect the horse.

I call my work resistance-free training. It's a way of listening to a horse that tells me when he's ready to learn. It's also a way to watch him progress and see that he's never put in a stressful situation. When a horse is willing, when they have a free choice, they learn so much quicker. I've worked with all kinds of horses over the past forty years, and it's wonderful to see that potential develop.

The wild horses that my dad gathered looked just like the reining horses you see now at the National Quarter Horse Congress. They were a little higher in the front end than the rear, and they had a little more head carriage, so when they stopped and turned, their shoulders and heads were right there! They were very short backed, real lateral animals, and they had a natural bridleness. They could turn and move like a ballerina, and mentally they just had "cow" bred in them. In the 1940s and 1950s, when they turned out Morgans and larger animals on the range, that took away from the older wild horse. Morgans aren't necessarily quick cattle-running horses, and some Thoroughbreds don't have the brains to stay settled and quiet. That older type of wild horse had low hocks, he had a lot of spread, he was always sound, he had a cute little head and ears. There are still some nice stud horses out on the range now, and those Kiger horses have been kept pure enough, but I don't think the others are as true to that older style.

When we gathered horses my dad would put me in a certain spot and say, "Stay here and wave when you see them coming down the canyon." Well, I would usually fall asleep, but if I cracked even one branch those horses would still hear that branch even if they were a half a mile away. That's what makes a good horse, that sensitivity. If you steal that sensitivity from him, the horse loses his athletic ability. That's the sad part.

In my father's time, a "trained" horse was a nonresistant, quiet, walk-up-and-stick-your-halter-on-him horse. A lot of those guys would actually take a horse's potential away from them because total submission does

that; it takes away their sensitivity. Well, I had the good fortune to work around some great horsemen, from Don Harris to Clyde Kennedy to Jimmy Williams—really the best of the best—and I saw that the quiet, bomb-proof attitude wasn't what they wanted at all. If a horse is going to be a world champion, he has to have a cleverness and an alertness like those older wild horses. Whenever you got them out in front of a cow and that cow would even flop an ear, boy, that horse would make a move!

I do approach a wild horse differently from a domestic horse, but it's still a matter of building trust, of advance and retreat. If you take a fresh horse that has never been around humans, and he has never been roped, choked down, or hurt, well, he'll have a curiosity that you can use as you get in the pen with him. If you read him well enough, he may actually step into your space a little quicker and give you a head drop, a chew, or a head turn. He'll communicate with you. But if he's been rope-burned or hurt or stampeded around, that won't come out as naturally.

I worked with BLM for several years on some wild horses and really enjoyed it. But after a while they brought in a few horses with extreme problems, and that was a whole different story. But from growing up around these kind of horses, I still had a sixth sense. Like, if I see a horse run by with one ear forward and another back and his shoulders are up, I automatically know not to step out in front of him. There was one time when we were separating out a bunch for BLM and I was deciding which horse I wanted to work with. I said, "Let's try to turn this one back." And I stepped out in front and flagged my hand. I could tell immediately that horse wasn't going to stop, so it was a natural thing for me to step up on the fence, and he just went on through. Another fellow was right behind me and he tried to flag that horse too, but he didn't step up on the fence. The horse went the full length and hurt him pretty bad. I didn't say anything at the time. I just remember thinking how lucky I was to have learned those instincts as a kid or I'd have been on the ground, too.

What you have to get in your mind is that a wild horse doesn't want to hurt you on purpose. It's all flight to save their life; that's the only thing

they know. Once you understand that you can begin to manipulate them and herd them and get them to talk with you by moving in their space. You can speak the horse's language. Like, if a horse is watching you and gives you an ear (just by turning his head a little bit toward you and lifting it up), he's saying hello. If he snorts and blows a little, that's hello, too. Then you've got to turn the heat on or off. If you see that he wants to come toward you, maybe by just putting one step forward, then you use that. You say, "Oh, you want to talk?" You don't step toward him, because that would push him away; it would put him to flight. You step back, which says, "Okay, come on over, and let's talk a little." So you have to keep reading their body language. If you see a clamped tail, a raised head, or a quick hold of the breath, you're putting on too much heat. Then you round your shoulders, exhale, look down, and step back. That says to the horse, "I'm going to be passive here."

One time I was in Reno doing a demonstration for BLM, and the announcer introduced me by saying: "And this is Richard Shrake, who is going to take this wild horse that has never been touched and in forty-five minutes he is going to have his hands on him!" Well, there were about five thousand people in that audience. After about forty minutes I still hadn't gotten within twenty feet of this horse, but this announcer kept right on going anyway. "He's got just four more minutes now, and then he's going to get his hands on him." I was feeling pressured and I wished he would just shut up, but I went back to one of the first things my dad taught me, which was to get really, really quiet. I thought, "Right now the only way anything is going to happen is if I build trust." So I dropped my eyes and I got so quiet inside I thought my heart would stop. As soon as my mind let go, I felt everything settle in my heart. I held onto one thought: "There's no way I'm going to hurt you, there's no way I'm going to scare you, let's be friends." Well, I had my hand behind my back, and just then I felt his whisker. It had a little sweat on it. Then that horse just put his head right there, in my hand. You could have heard a pin drop in that audience. It was a true spiritual moment for me as a horseman.

A horse is much more than a riding animal. He's also the greatest psy-

chiatrist, the greatest mirror you can be around. With a wild horse, it's that level only stereo! If you get even a little bit angry with him, he'll not only get angry—he'll run right through you. If you're not forgiving, he'll show you. If you're impatient, he'll teach you patience—that quick! But if you're smart enough to look at yourself, he will be your teacher.

People who adopt a wild horse and have the time to spend with him can learn so much, especially if their heart is right and they respect that horse as a wild animal. They should understand what knowledge they need and go through the process to learn all the steps of handling him. If they do, they will learn a lot and they will get back a lot from their horse. But there are a lot of folks who don't educate themselves, even people who have a fascination for the mustang. Once when I was doing a clinic there was a guy in the stands with almost a full body cast on him. He told me how his wild horse broke through a round pen and drug him right along. I could see he felt that cast was some kind of badge of achievement. These drugstore cowboys who try and conquer wild horses are often the ones who get themselves hurt.

Another time some people asked me to take a look at a wild horse they inherited. They kept the horse in their garage and gave him water in a dog pan that they slipped under the door. My heart went out to that horse. This poor fellow was all dehydrated and scared to death because he had been kept in a dark room with no feed or water. I really got angry with those people at first, but after talking to them I could see it was all ignorance on their part. We got that horse out of the garage, and we got his feet trimmed and put him into a program. Luckily, when he found out he could drink twenty gallons of water a day and not just one, we were able to rehabilitate him.

The beauty is when you can work with the potential of a horse and don't have to steal it from him. Jimmy Williams had a favorite saying: "Never force your horse to do what he can't do." If Jimmy wanted to teach his horse to jump a six-foot fence, he'd do all the little things that built up to that one big step, and then he put them all together. I've watched these champion horsemen give world-class performances, and you can see the passion in

their horses' eyes. That doesn't happen by whipping or forcing, but by letting a horse reach up and use every cell in his body to fulfill his potential. Their horses wanted to be great, too!

When I was coming up, I was very impressed with the old vaquero method of horsemanship, but performance horsemen were always like the first chair in the orchestra to me. The show horseman puts his whole reputation on the line every time he rides in the ring. He's saying to the public: "This is my work of art." And to the judge he's showing the communication that happens between him and his horse: "This is what the two of us can do together." So the rider who enters a cutting horse show and who just happens to hold his breath out of stride can lose because his horse is that sensitive. Or the reiner at a national finals who asks for a big, long stop but then happens to look down can take the stop right out of his horse, too. That older wild horse had this same sensitivity. It's like picking up a peach at the grocery store—the guy who overrides has put his finger in the peach!

Instead of teaching mechanics (heels down, chin up) I try to get the rider in tune through finesse, to become part of their horse through breathing, rhythm, timing, muscle memory, through the eyes. This is what's called "feel." When I started teaching in the 1980s people thought that feel was something the good Lord gives you, so you either had it or you didn't. It certainly wasn't something you could ever teach the masses! After watching and judging all those great riders in the Quarter Horse world, the Paint world, the Appaloosa world, and the Arabian world, I decided my students would become my experiments. Well, this is a new millennium, and all kinds of people are writing articles about natural horsemanship and feel today. But most of this is not anything new at all. Xenophon, who was a great horseman two hundred years before Christ, also talked about positive horsemanship. Any good horseman listens to his horse.

The wonderful thing about horses is they are very forgiving. If you make a few mistakes, that horse will come back and give you another nice ride. Any horse is a follower, and the wild horse especially is a herd animal. Out on the range he looks to the leader of his herd, the horse with his head up

looking for danger. In the rider-horse relationship there's a leader, too. It's the rider who has that responsibility to lead. So when a horse feels that trust and confidence, that you will take care of him just like that lead horse out on the range, his eye will go soft, he will go into that herd mode, and he will follow you up the river or down through fire.

Throughout my career, I've done the whole spectrum with wild and domestic horses. And I've always prided myself as a teacher, someone who helps people. I've never done anything in my life but be with horses, and I've been very lucky.

Tom Hartgrove, D.V.M.: Equine Veterinarian, Pilot Point, Texas

One of my earliest recollections of working with wild horses is driving through Las Vegas with a foal that was deathly ill. It was one of those fire-engine kind of emergencies where we put in a catheter and tried to do whatever we could. To be honest, I don't even recall the outcome. I just have this vivid memory of one little foal who needed care.

Another memory was the time of the foal rescue off the Nellis Wild Horse Range. BLM brought in about a hundred foals because of the drought. They were all dehydrated, so my wife and I went down to help. From that point on, my involvement with wild horses grew. I've been to Nellis several times. A few of those times were not under very good circumstances.

The worst situation was when I went to inspect a bunch of horses in extremely poor body condition. Conditions everywhere on Nellis were really severe at the time. There were eight or ten thousand horses on a range that can support only one thousand, and to see those horses suffer so immensely wasn't right. The horses I saw that day were basically just skin over bones. They were mainly older stallions and mares, but there were some young horses also. I remember a baby about two years old who had a wry nose, which occurs when a horse's nose is set off and turned to one side so their teeth don't meet. Some were stallions whose teeth had all been kicked out, and some had bad teeth problems, and some others had lameness issues. All of them were unable to take care of themselves in the wild,

so a choice had to be made that day whether they should be sent to a sanctuary or euthanized right then and there. For humane reasons I made the decision to euthanize them. Those horses were all so far gone they would have done very poorly and eventually died at a holding facility, and left to the desert they would certainly have died a horrid death. It was a large number of horses, maybe fifty or more, that had to be put down that day.

Because of military security, only government representatives from Nellis could perform the actual shooting, but I instructed them how to do it humanely. The whole experience was unbelievable. I came home in complete shock and I stayed that way for days. Later on, I was asked to write a letter to justify my decision. In it I stated that Mother Nature is a harsh taskmistress, that she allows no room for error, and that in many instances I think it's better for a horse to be humanely destroyed than to be left to starve or die of thirst on the range. I also wrote that anyone who questioned my decision would have a difficult time accusing me of being an overzealous government-employed veterinarian who didn't care about these horses, since I had already donated so many hours of my professional time and medicine to help them in the past. I truly care for them, and that was the primary reason I made that choice. Sometimes it's *because* you care that you must let go. That's a hard fact for people to understand, but as much as we all love horses and want to help them, there are times when letting go— and by that I mean removing them from the range or if necessary destroying them for humane reasons—is the best thing to do for them.

None of the solutions to this wild horse problem are easy. To start with: do these animals belong out there on the range as natural inhabitants? No, they were turned loose at some point in time, whenever that was, and there are no natural predators. Is sanctuary a solution? As a veterinarian, I think placing excess horses in a feedlot until they die isn't much of a life for a horse. There are many people who advocate leaving wild horses alone on the range and letting Mother Nature do the rest. The other view is that we should take them all off until the range gets back down to appropriate numbers. But that's no solution if their numbers eventually go right back

up again. And if you view the mustang as wild, then things become complicated once more, because we do manage our wildlife, and whenever there are too many deer or elk we offer more hunting permits. This isn't to say that I advocate hunting a wild horse, but it does imply the necessity of controlling their population. Is adoption the solution? There are some holes there, too. Nowadays you hear people complain that some adopted wild horses go to slaughter. I suppose some do, but some live in homes that are probably far worse than that.

A situation like Nellis should never be allowed to repeat itself—in spite of rules, laws, politics, regulations, emotions, or anything. Sometimes I wonder about the people who are so adamant about letting nature take its course with the wild horse. That is just a horrible way to go. The foals suffer; they're trampled, they're abandoned or savaged, and they die of dehydration when they can't keep up with the herd. I've heard the outcries of all these groups. It makes me sick to think that any animal organization would fight in the courts for the right of horses to remain free like that.

The mustang cries out for someone to help them. My dream would be for all the factions to meet and talk intelligently and arrive at some acceptable solutions. Because if we continue to allow horses to proliferate, the consequences will be disastrous. To see hundreds of horses heading off toward one thundercloud on the horizon that was dropping rain, as I have, just so they could get a drink of water from a pool full of mud, is a sobering sight. To see them as skeletons with nothing but hair stretched over them is also horrible. Thankfully, when I go to Nellis now the numbers are down and the horses for the most part look pretty healthy. That makes me feel good.

As a veterinarian, I chose to work only on horses because I admire their courage, their strength, and their beauty. They are majestic, wonderful animals. Of all God's creatures, a horse suffers in silence; they are noble to the end. That's why I started working with wild horses, too. Being able to save one wild horse and see them grow up and be productive is extremely rewarding.

We adopted two wild burros, Milton and Marl Burro. The dogcatcher

found Milt up at Red Rock, and his leg was mauled so badly he had to carry him off. I decided to use Milt as a veterinary project. We grafted skin on his leg about four times, and now he's our pet. Of course, we had to get another because Milt needed a companion—that's Marl. They're part of our family.

As a society, I think we're raising a lot of horse owners but not very many horse people. There are many people who own horses, but a lot of them don't have a clue about their nature, physiology, or behavior, and that affects how we train and interact with them. Up on my wall is a picture of a horse named Del Air. She was a horse that for some reason I bonded with. Was she particularly kind or talented? No—but she attracted me like a magnet! Whenever things were bad I walked up to Del Air, and I would put my arm around her and lay my face on her neck, and I felt my burdens lifted. Can I explain why? No. I've definitely known more talented horses, and I've also known kinder horses. It was just something about her. I've learned that the horse that matters most is the one who draws you in and seems to be there for you.

My experience with burros also taught me something. Within the wild horse world burros are considered castoffs. When Milt came along I felt it was an opportunity to help a burro, but ultimately it was Milt who helped me. I had never done any skin grafts, and I've since applied the techniques I used with Milt to help other horses. Milt taught me, in his own quiet way, that it's always okay to try something new.

In terms of euthanizing any horse, if you shoot them properly they die instantly. One of the problems with a wild horse that has never been touched by human hands is that if you need to give them any kind of injection it's very, very dangerous. So if it's a lethal injection and you don't get the medicine in just right, they won't die easily. But by the same token, if you don't aim and shoot properly, it can be equally horrible. This becomes a matter of protecting the people involved as well as the animal. Thankfully, I've never been hurt by a mustang. But as much as I love all horses there isn't one whose life is worth the same as a human life, so no person should risk their own life needlessly just because a mustang needs a shot.

Each time I have to put an animal to sleep, whether it's a wild or a domestic horse, I say the same prayer: "God, forgive me for those that I put to sleep too soon, and for those that I wait too long."

The human-animal bond is a curious thing. In our society we derive a lot of pleasure from our animals. We also experience a lot of angst when we perceive things we don't see as being right with them. But we tend to apply human feelings to animals, and we need to remind ourselves of that. A dog or a horse does not keep track of time like we do. They wait for the moment someone throws them a flake of hay or comes over to pet them and give them a kind word. Do they miss people? Sure they do. They make bonds and they seem to remember some things forever, but they're still not like you and me. Do animals have legal rights? Not like you and I have. However, all animals do have the right to be treated humanely and to receive adequate care. That is their given right as God's creatures, and I see that as a legal as well as a moral right. When it comes to protecting wild horses, this means they have a legal right to run free and a right to be treated humanely. Now, is it humane to have ten thousand horses on one area that will support only one thousand? I don't think so.

Try reading *Black Beauty* again—it's interesting to read as an adult. Anna Sewell was a great advocate for animals, and within the book are some very telling passages. In one chapter she describes the kind of people who abuse animals. Another poignant passage is when Black Beauty meets up with the horse Ginger later in life. Ginger was the high-spirited horse who refused to submit to what people wanted from her, and by the end of the book she'd been abused and broken down. When Beauty sees her, Ginger says in effect that she wishes she could die, because humans will always win simply because they are stronger. Later, Black Beauty watches when the meat cart goes by. He's happy for Ginger because she has finally gone to her rest. My point is that all animals have a will to live; however, only some have a strong desire to survive or even to fight for their survival. Some animals just lay themselves down and give in, while some only relinquish their will to live much later, like Ginger. At the end of the story Black Beauty also fancies

that he's back in the orchard talking with all his friends. Now, do horses really imagine things like this? I do like to feel that somewhere, hidden in the depths of their being, a horse understands a human touch or a voice. It does seem that a horse can sense whether a certain person is kind, and they are obviously able to recognize someone who is rough or abusive. If you take any animal that has been abused and approach them with a harsh voice or a raised hand, they'll immediately dodge or shrink. Now, is that the cue, the tone of the voice, the vibe, or what? I really don't know.

You can't ever get a complete education about wild horses by reading a book or seeing a movie or talking to someone on the phone or over the Internet. You've got to experience these things for yourself. What I know about the mustang as a vet is small compared to what the people who work in the field with these horses know—the wild horse specialists and the cowboys who gather them. Anyone who says wild horses should be left alone to run free should go out on the range. They would gain a much greater appreciation of the animal and understand why they can't run free by themselves.

The question always comes: why don't you castrate all the male horses? Well, you can't really do that because then they wouldn't have a place within the herd. A wild male horse has to fight to gain position. He keeps a herd until he becomes too old and can't fight, and then he becomes a solitary stallion who lives his life alone. BLM is trying to figure out how to keep female horses from being able to reproduce now, and they're also talking about chemical sterilization of males to where they can't transmit sperm yet would still be able to breed. That sounds like a great solution, except what happens if the male horses who always win are the ones who have non-sperm-producing testicles? Humans must select all these dynamics. We must always intervene somehow.

We can't expect to adopt them all. With a certain number, sure, adoption is a wonderful experience for some people. But that too is a great expense, and you can't ever ensure that a wild horse will go to a good home any more than you can ensure a puppy or a kitten will. Does this mean we should take

the old excess horses, humanely slaughter them, and ship them to another country that appreciates eating horse meat? If we did that, and that money came back to manage the other mustangs in the West, well, they could help pay for themselves in a certain way. It may sound horrible to some, but in certain cultures eating horse meat is better than beef. If you're a vegetarian, sure, it's valid to believe that wild horses shouldn't be used for food. But for those who eat meat, there's no argument except the idea that horses should run wild forever. We all know that doesn't work.

We could have saved a lot of misery on Nellis if we had taken all those horses off the range and never let them accumulate. There were probably ten thousand excess horses that had to be rounded up before those herds got back in balance with their habitat, but for simplicity's sake, let's start with six thousand. If you have six thousand horses suffering for ten years (which is the amount of time they were left out there), that's ten years of suffering per individual horse. Multiply that six thousand times and it just boggles your mind! So as horrible as it may sound to some, if we had taken those horses and humanely slaughtered them, it would have saved *sixty thousand horse-years* of suffering. That's why I submit to anyone, whoever they are, to come up with a solution for ten thousand horses in an area that can support only one thousand. It is *the* burning question.

The horse has made a huge impact on our society ever since it was introduced in North America. Our human nature is intertwined with theirs. Good people, bad people, all different kinds of people—we are all mixed up with horses. For the love of all horses we must reach solutions for these wild ones to allow them to live in harmony with nature and with humans. This is a story that goes on and on.

Frank Cassas: Wild Horse Advocate, Reno, Nevada

I've always had an interest in horses, particularly performance horses. My wife and I owned horses, and we belong to a number of local horse organizations. We've always been big fans of the Reno Snaffle Bit Futurity. We love to watch the bridle horses spin and stop.

In 1978 I won the raffle filly at the futurity. It was a beautiful mare; Doc's Foxy Socksy was her name. Well, when you win the raffle your horse is automatically entered for the futurity for the following year, but it's up to you to get it trained. I took my mare to Pat Heaverne, Cliff Heaverne's dad, out in Fallon. Pat was a legend here. He was a wonderful horseman and a real cowboy, and he was cut from the old school. One day I went down to meet him, right out of the blue. Of course, he had already heard who I was, because everyone knew that somebody from Reno had won this raffle horse. So that began kind of a long love affair with Pat Heaverne. I competed on that mare for twelve years, and it was Pat who trained and introduced me to the world of showing bridle horses. He was an incredible, sensitive man. Our relationship lasted twenty years and I gave the eulogy at his funeral. I really miss him.

While I was still showing horses in snaffle bit, the Commission for the Preservation of Wild Horses intended to draft a wild horse plan for the entire state. They wanted to hold public hearings all over Nevada, and the governor was looking for a chairman who was an attorney and who was also familiar with horses, someone who could handle an audience and be comfortable with making rulings and such things. I was asked to serve and I accepted.

During the time I was chairman the commission completed the statewide plan on behalf of the horses. It was a two-year project and I enjoyed working on it. However, one of the biggest problems I encountered was trying to get people to understand that the state of Nevada can do nothing to change the national wild horse program, and it also cannot create policies about wild horses. The reason is that although these horses live here, they are under the jurisdiction of the federal government. To be truthful, the first draft of the plan had to be completely rewritten because of these kinds of misunderstandings. The Wild Horse Commission was intended to be an advocate for the state of Nevada, and there's nothing wrong with being a sounding board for people and even for taking a stand on certain issues. However, legally, Nevada has no jurisdiction whatsoever about any-

thing the federal government does with these animals. I had to remind people of this repeatedly.

After this experience I came to the conclusion that creating a different foundation might be a better way for people to get involved with wild horses. That group is the National Wild Horse Foundation. We do not advocate for policy in any way, shape, or form. In fact, one of the main criteria to be a member of the board of trustees of the foundation is that an individual has no baggage in the wild horse world.

* * *

I LIKE TO THINK of things this way: there's a supply side of the wild horse—the health of the horses, the health of the range, getting to AML, the inadequacies of the adoption program. Many of these are unsolvable without making huge changes in the national program itself; nevertheless they are still supply problems. The other half of the equation is the demand side. This is where our foundation is focused. Realistically, it's in the interest of people who own a wild horse to be educated about what these horses are all about, what the adoption program is all about, all that sort of thing. The foundation will have no interest, no time, and no resources to solve any of the issues or problems on the supply side. However, there is complete linkage here in that major problems with the wild horse program all stem from the fact that BLM cannot adopt enough horses to get the program in balance. If the foundation can help solve that logjam so BLM can manage horses where they should and the horses remain at appropriate management levels on the range, then everything will flow more smoothly and the wild horse program could be a success. Right now the inadequacies of the adoption program are the tail that wags the policy dog, and it's a vicious circle. But once we get more professional help and can provide BLM with more expertise and better marketing ability—all of the things normally done by any other horse association in the contemporary horse world—they'll be able to adopt out more horses and solve the dilemma.

When I first came to the commission I asked for all the information

about wild horses that was on hand. Among other things, BLM provided everything the government published—all the reports of the National Wild Horse Advisory Boards and things of that nature. The only time I could sit down and read was during Christmas break because the courts aren't open then, so I spent one entire holiday season poring through all the material printed about the wild horse program, including reports about its inadequacies and all the other criticisms. Probably the most significant information came from reports by the solicitor general at the U.S. Department of the Interior that addressed the inadequacies of the program—why it wasn't working, how it wasn't doing this or that, how it had been charged to do thus and so, and just how terrible the adoption program was—all these criticisms came from right within the government itself. In fact, the idea for a foundation was listed in an early published report from the National Wild Horse Advisory Board, but nobody had ever acted on it.

I thought this was a good idea to pursue and started looking at some other literature. I found what you might call BLM minority reports, and in those one BLM employee in Idaho had also suggested the same thing. So here was an idea for a foundation that had been circulating all around the bureau for years. The Nevada commission seized on the idea when I presented it, and we took the whole concept to the state legislature. The governor thought it was a good idea, the Department of the Interior thought it was a good idea, and the state of Nevada came up with half of the funds to get it started.

The Wild Horse Commission is a good place for the public to sound off about wild horses. If there are major issues, the commission can try to do something to help. One summer we had devastating wildfires and there wasn't enough funding to gather the horses and restore the range. It was a real emergency situation. One of our commissioners, myself, and our administrator went to Washington, D.C., to help get the budget approved for that.

I don't want to speak too much on politics, but the reality is that, say you're a senator from Michigan. You don't have wild horses back in Michi-

gan and your constituents don't have any problems with them, so you don't hear about them and you couldn't care less. The senators who have the most interest in wild horses are from Nevada. Mustangs are not as serious a problem in other western states, but we've got 60 percent of the horses here, a small population, and a very fragile environment. In other words, the wild horse problem is here. And if a wild horse issue ever comes up in Washington, most politicians follow whatever lead the Nevada senators give to the problem. That's been a problem in and of itself.

The truth is the national wild horse program has not been a successful program in the Department of the Interior. When I was back there I was told, "Frank, this is the year you showed up. But two years ago we gave BLM a bunch of money and they squandered it." So the program has this kind of reputation. I was on the phone with some people today hearing all about all kinds of other stuff that has been going on. It sounded just like the same old stories from before all over again.

What little experience I've had with the bureaucracy in Washington is that it is terribly inefficient. Every time we get a new president there is a change in the Department of the Interior, and then a change in the director of BLM, and a change at the head of the wild horse program. After that change you'll have all the changes within each state itself. State directors are political appointees, too, and they come and go; so then there are all these turf battles. The whole thing can be pretty frustrating.

One of the biggest markets for wild horses is in a belt running from east Texas up through Ohio. Down in the eastern part of Texas or Oklahoma, they don't see wild horses as any problem. They see them as a great animal. Our foundation is going to push hard to get more wild horse shows similar to the National Wild Horse and Burro Show held here each year up and running in places like Texas, Oklahoma, Georgia, the Carolinas, Tennessee, and Florida. They have water and grass there and they have facilities there. They *want* wild horses there!

All this involves trying to get government bureaucrats thinking more like horse people, and that's not easy. Obviously, a bureaucracy is no way to

run a horse program; however, that's how Congress set it up, and Congress doesn't seem inclined to change the law. The bottom line is that Congress has commissioned BLM to get these horses in balance for the health of the animals and the health of the range, so that's what they have to do.

I've learned not to be too critical of BLM. However, I sat in a room one time with all the so-called wild horse specialists. You know how it feels to sit in a room when you're comfortable among your peers? As I looked around that room, I could tell who among them were truly horse people, and there weren't many. Most of them were bureaucrats.

I see the foundation helping the wild horse program in a number of ways. One of them is to sponsor a wild horse association which would be patterned after other professional horse associations, such as the American Quarter Horse Association, the Paint Horse Association, the Cutting Horse Association. They would offer membership, a registry, a title service, a newsletter, horse shows, and other events. When people see these horses groomed and doing all these things in these various classes, that's what builds desire to own one.

I don't think any of this will be difficult for a nonprofit foundation to accomplish. A separate wild horse association can stand alone as a corporation, so it can address other aspects of owning and showing a wild horse. Perhaps it will address breeding, because breeding is obviously a big part of the horse world. Of course, purists may want only horses with freeze brands, so these are some of the things that wild horse owners themselves should decide, and they will be able to do that through the association by establishing their own rule books, their own standards, and that sort of thing. This is another reason why wild horse advocates aren't welcome as trustees on either our foundation or the association. A nonprofit foundation such as this deserves to have fresh ideas. Unfortunately, those who come from a background of wild horse advocacy groups come with baggage, they come with an agenda, and they come with political ideas.

Since I resigned from the commission I've put politics out of my mind. I'm convinced the wild horse program could be very successful. It just

needs to have a professional level of pizzazz the government does not have! The foundation will exist to help the adoption program in this way, and we do not intend for politics to interfere with that mission. Our attorneys and our advisory board went over this many times, and we drafted very strong wording about this into our articles of incorporation. We will not become involved in any political activities or propaganda, or be involved with any policy-making about wild horses. It is absolutely critical to understand this.

Historically, the Wild Horse and Burro Act was the most popular statute ever passed by Congress. There was not one dissenting vote. If the wild horse program would ever get in balance, which is what the legislation says it's supposed to do, I have the idea that a lot of other problems would finally go away. The program could be funded reasonably, BLM personnel could become more animal oriented, and they could truly manage these horses. If the foundation can help make this happen, I think a lot more could change in time. I hope we accomplish something good.

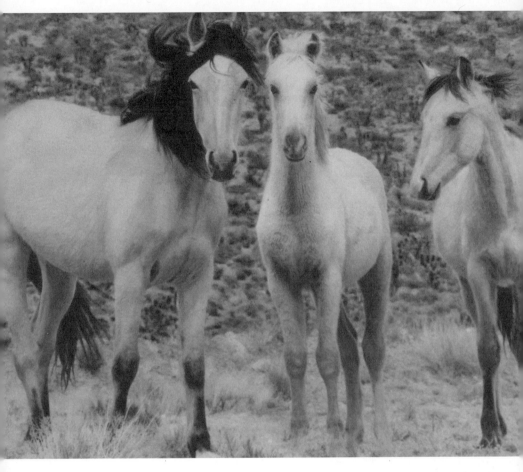

Family Ties

Conclusion

The Future of the Wild and the Tame

Plus ça change, plus c'est la même chose. The old French saying is right: the more things change, the more they stay the same. For better or worse, the way people perceive wild horses influences how they are handled and why. Thus the many bureaucratic complexities, stakeholder agendas, legal struggles, and personal and political ideologies that envelop them can be viewed as telling examples of one noisy band of controversy that repeats itself in varying guises over time. There are other haunting questions, however, that are seldom discussed in the glaring light of day. We ignore them at our peril.

The philosopher George Santayana once warned that history tends to repeat itself when its lessons are ignored. There is no doubt about it: on or off the range, the principles of stewardship and horsemanship must intersect for the health of land and horses to prevail. The relationship of nature's benediction between water and grass is nowhere more apparent than in the Great Basin. And the connection between human and equine ecologies is nowhere more obvious than in the high desert as well. Why, then, are these relationships so often confused or obscured? Excellence in horsemanship is and always will be rooted in time, talent, commitment,

and experience. Rephrased, this implies that excellence in horsemanship must enfold wise stewardship, and vice versa, or both human and natural ecologies are doomed. The implications cry out to any thinking and feeling person drawn to the predicament of the wild horse. Moreover, whether we speak of protecting the life of one horse or preserving thirty thousand or more, the primary dynamics of our responsibility within this equation endure. This is our legacy to the generations to come.

Since passage of the 1971 Wild Free-Roaming Horses and Burros Act, most serious attempts to resolve the problems posed by the overpopulation of wild horses on the range have foundered in a quagmire of red tape, intellectual rationalization, political stonewalling, adolescent sentimentality, or plain wishful thinking. Americans' intense cultural investment in our idealized fantasies about mustangs seems to have us hitting a collective wall of denial whenever those perceptions are challenged—by facts or by fate. Perhaps this is because in the process of confronting this paradox—that is, the real versus the perceived nature of wild horses—we are forced to shed our illusions and confront our limitations. Caught in such a quagmire we find it easier to climb on a new political bandwagon or cling to an ideological abstraction than to enter with eyes wide open into an uncharted yet critical arena of social justice, moral conscience, and personal discernment about the care of these animals and the land. However, if a holistic approach—including scientific discovery, humane compassion, cultural awareness, environmental understanding, and an ethical hierarchy of needs—is what must be embraced to begin a meaningful dialogue about wild horses, then let us take it with open minds and hearts and with respect for the fundamental realities at stake. Let us proceed on behalf of the common good.

The wild horse heritage of the Great Basin holds a special significance in the history of the American West; it is a heritage that makes perennial demands on the landscape and on humans. Today we are challenged to look beyond the safe and simple realms of emotion and ideology, on the one hand, and legal rights and partisan politics, on the other. We must become conscious of how this legacy is being lived out in concrete, everyday terms,

and above all how it serves the needs of the wild horses themselves. This awareness must imply an endorsement of sensible parameters that serve the vitality of all species on the landscape. By continuing to ignore this challenge and glorify the wild horse—whether by casting it in a role of heroic victim, mythic icon, or historic misfit—we are not only performing a disservice to the animals and the range, we are aiding and abetting an immense social tragedy on a grand scale. The horse in general, and the wild horse in particular, has never lived in a vacuum—here, there, or anywhere. All horses live and move in a reciprocal relationship with humankind in the larger universe of which we all remain a part—a small part at that.

Any public strategy that seeks to define and maintain a viable, healthy environment for free-roaming horse herds cannot afford to shy away from the ultimate consequences that lie beyond the veil of our noble intentions. It must include the style and manner of how and when these horses die, something all mature horsemen and horsewomen understand. Wild Horse Annie acknowledged this privately, and it is unfortunate that she kept her view hidden from the general public. Like others, I have witnessed suffering horses on the range as well as old, sick, and displaced horses removed from it. This is a tragedy that can be avoided. It is infantile to continually seek scapegoats or perpetrators when the responsibility belongs to all of us. A solution will, I believe, surface when candor is allowed to reign.

Broader and more penetrating perspectives revealing the nature and significance of the wild horse as both myth and reality are offered next from individuals in the fields of range science, equine genetics and contraception, western art and history, animal behavior, agricultural ethics, and cowboy poetry. Together these contributions form a synthesis and a conclusion to this book. I hope that their insights will provide a focus for deeper reflection on matters concerning not only the care and management of wild horses, but also how our society can begin to shape a more appropriate perception of and relationship to them for the future. If all horses are able to transform between the wild and the tame and back again, their well-being must be linked to a mature public understanding of this,

connected in turn with a coordinated management effort that proceeds in a consistent manner and above all without strife. This must be done if our national desire to celebrate the wild horse is to become as concrete in practice as it is embedded in our popular mythology. Only a balance between perception and reality can ensure true freedom for the wild horse.

Wayne Burkhardt, Ph.D.: Range Scientist, Indian Valley, Idaho

I've fussed at understanding the evolution of the range for so long that 10,000 years doesn't mean a thing anymore. However, even in the sciences, the academic establishment has been slow to appreciate that what happened 2 million years ago, 100,000 years ago, or even 10,000 years ago has had a direct bearing on what we see on the land today.

Eohippus was a little creature who once lived in the neotropical forest of the North American continent. Over time, as the mountain ranges to the west were pushed up and the climate dried out, the semitropical forest went away and was replaced by arid steppes and shrublands, so that *Eohippus* evolved into *Equus caballus*, the form of the horse that eventually became extinct in North America. The fossil record indicates that *Eohippus* evolved as slowly as those mountain ranges, and that goes back 15 million years, so we know he was a very old little creature. It took essentially 12 million years more for that mountain building and climate change to arrive at what I call the intermountain shrub environment, so the same kind of country we have today was in place 2 million years ago. As this climate started to dry out, little *Eohippus* also began to get bigger and change.

Before 15 million years ago, the Intermountain West had nonseasonal precipitation. There were no winters. There were mild temperatures year-round, a year-long growing season, and lots of rain. It was wet like the tropics. That's because there were no barriers to stop the storm masses moving inland from the Pacific Ocean. Today the west side of the Sierra-Cascade Mountains does have a winter growing season with green grass. That all occurred because those mountains built up and produced a phenomenal change in the environment, which in turn affected both plants

and animals. That evolutionary period lasted about 12 million years and transformed the neotropical condition into what we have now: seasonal patterns, cold winters, snowfall. The bulk of our precipitation in the Great Basin still comes as snow. Snowfall is not good for grasses, although it is good for woody plants because it melts in the spring and goes down in the soil. Grasses are shallow rooted and can't pick up deep moisture, but trees and sagebrush can. This is why woody plants dominate the vegetation on the east side of the Sierra-Cascades.

Starting around 2 million years ago we come to the ice age period. The flora then was the same as today, but the fauna wasn't. Mammoths, camels, sloths, horses, and other mammals, plus some very big predators—saber-toothed tigers and dire wolves and such—were here. We had what I call a natural herbivory that evolved together. It was a mutual coevolution of plants and animals, predators and grazers, existing in a sustainable system.

By interpreting the fossil record and by reviewing the work of a variety of archaeologists, paleobotanists, anthropologists, and so forth, one learns there was indeed this kind of system. The plants supported the grazing animals, and in turn those animals provided something beneficial for the plants or the system wouldn't have been able to sustain itself. Some benefits might be transporting seed, planting seed, or breaking up the crust of the soil to recycle nutrients in decadent tissue—that sort of stuff. The system was functional for the flora as well as the fauna. It was balanced and it worked. Then, about 10,000 years ago, generally speaking, there was a lengthy period of time in which major animal extinctions occurred.

Let me back up a bit. There were numerous glacial and interglacial periods (ice ages) during that 2 million years. The earth was drying and wetting, wetting and drying, getting cold and warm and cold again. But the system held together; no extinctions of any significance emerge from the fossil record during this time. The Pleistocene occurs here, the continental ice sheet. If you visualize those drastic fluctuations in that period, it's obvious the biological system moved and migrated along with the climate. It moved elevationally up the mountain as the ecosystem dried out and

warmed up, and it moved northward as well. As the reverse happened, plants migrated to lower latitudes and lower elevations. The animals followed this as well, so the system responded during ice age fluctuations yet never collapsed. Some of the more recent ice core isotope work has helped define this better, which is important because there were maybe fourteen of these climactic fluctuations. So this system continued to hold together nicely throughout all of the various ice age fluctuations until we get to one certain point in time. The precise date is still unraveling, but somewhere between 20,000 B.P. and 11,000 B.P. a two-legged predator appeared.

We definitely know that man was in North America 11,000 years ago, and there is now some evidence he may have arrived 20,000 years ago. That was a period in which the glaciers melted and the climate dried out again. During a dry climate period plant production would go down and some of the big animal herds might starve. But although the system was in stress biologically, it had been through this before, so the only thing different was that the two-legged predator was added to the mix, a creature who hadn't evolved on this continent and who furthermore was a hunter. It's theorized that the introduction of an entirely new predator during this period is what may have caused many of those big animals to disappear. In other words, it was man who hunted those animals to extinction. This is the theory of "aboriginal overkill" that the evidence suggests. A tremendous amount of anthropological and archaeological work has been done over the last 15 years to support this notion.

The point is that, biologically, humans were the straw that broke the camel's back. The natural system was in stress during one particular period, but that same system had survived numerous and previous interglacial periods that were every bit as severe. The only difference in this one period approximately 10,000 years ago is the addition of this entirely new major predator component: our two-legged human hunter. After this the plants carried on; the flora continued, and some minor fauna also continued (deer, antelope, jackrabbits, coyotes, and other little critters). What became extinct after man arrived were the large herbivores and the preda-

tors who lived on them. So the small-bodied buffalo were here, *Bison bison*, but the larger version, *Bison antiquitus*, disappeared. *Equus caballus*, the horse, didn't survive either.

Let's move through time to about the year 1800, when the first European expeditions began to seriously explore the western frontier of North America. History shows there were vast stretches of the Intermountain West where these expeditions had trouble feeding their men because there were no animals to hunt. Now, north of Alturas is a little winery along the California-Oregon border that makes wine from wild plums that grow in a nearby canyon. An excerpt from Peter Skene Ogden's journal is on the wall of that winery, and it quotes how he and his party arrived there in 1823 and how wonderful it was when they found those wild plums and one mule deer doe which they were able to eat, because they had been traveling for days through that southeastern Oregon country without coming across any food source. Now, think about wild chickens, the sage grouse. The common assumption nowadays is that there should be an abundance of sage grouse on the range. However, when one reads any of the early pioneer journals, not once is there any mention of wild chickens in the prime sagebrush country of the Intermountain West. They were not abundant, and neither were deer, for the reason that the habitat wasn't suitable for them. It was a grass-land, not a shrub, environment here then, and both deer and sage grouse don't like that. Human activity created the habitat for deer and grouse when livestock arrived in the 1800s. The cows grazed the grass, which fire-proofed the range; brush succession followed, and suddenly there was a habitat for deer. By the 1940s there were vast numbers of livestock on the range, vast numbers of sage grouse, and vast herds of deer.

The northern part of the West is a much different environment. Eastern Montana is a prairie environment while west of the Rockies is a mountain environment. Early expeditions found lots of wild game there because that country had warm season precipitation. What is the difference between an intermountain shrub and a prairie environment? Summer precipitation. With summer rains there are warm temperatures and shallow-rooted

grasses that have access to water, and where those grasses grow you won't find vast expanses of sagebrush. Some shrubs will be in the draws or in timber at higher elevations, but periodic fires would push the brush back and keep trees in the mountains. In an intermountain shrub environment it's exactly the other way around.

Also in the Intermountain West, once the Indian tribes who survived European disease obtained horses and rifles, they quickly eradicated the buffalo in their area. Plains Indians, on the other hand, didn't eradicate bison there because that vast grasslands complex was biologically more productive, and much larger herds survived as a result. Small bison herds did exist in the Intermountain West and went extinct about 1800. Larry Agenbroad is a well-known archaeologist who studied buffalo jump complexes in Owyhee County on the Idaho-Nevada border. Those complexes were in continuous use for seven thousand years until local tribes got the horse and rifle in the 1700s. After Indians acquired a more efficient tool and a different way to hunt, they no longer needed those jumps.

Nevertheless, much of our conventional literature continues to imply that bison never existed in the intermountain region. This misunderstanding is typified by a monograph entitled "The Agropyron Province." *Agropyron* is wheatgrass, and the province discussed is the Intermountain West. The authors of that paper conjectured this environment had formerly been a wheatgrass grassland in which sagebrush invaded due to overgrazing, and that the intermountain system evolved without grazing animals, so therefore it is not adapted to grazing. This concept was prevalent for decades. We've since learned that sagebrush has indeed been around for fifteen million years and that the intermountain system had several million years of large herbivores within it. When Europeans arrived the biological system was in a state of flux, still trying to adjust to those earlier extinctions.

The time period extending backward from 1800 to animal extinctions at 10,000 is about seven or eight thousand years. How does a biologic system adjust to a massive extinction? Either evolution has to create new fauna

to fill a niche or immigration from other continents has to occur. Both of those processes are exceedingly slow; evolution as a process takes place over millions of years. It may seem like a long time, but eight thousand years is a drop in the bucket in terms of new life forms. It took twelve million years to go from little *Eohippus* to the form of the horse known as *Equus caballus*, so ten thousand years since the extinctions has been insufficient to create new forms to fill the vacant energy niche the flora provides. Plants are still growing and producing, yet ice age grazers are missing. All except for the horse.

The horse is the only member of the extinct ice age fauna to be reestablished on this continent. I love this part of the story: the reintroduction of the horse to North America was humankind's first and most successful reestablishment of a continentally extinct large fauna, and we didn't even know we were doing it! *Equus caballus* had been continentally extinct, but after we brought horses here as domestic animals they were marvelously successful at adapting because this is where they originally evolved. However, the horse is only one of the large animals that had once been present. There was a long list of herbivores (mammoths, mastodons, sloth, camel, and the large bison) that no longer existed. In my thinking, this leaves some niches which can potentially be filled by other grazing species.

I believe we can tailor management to emulate how the biological system worked before all those herbivores became extinct. Here in the Intermountain West we have mountains and valleys and short green-feed periods due to dry summers and a preponderance of winter precipitation. Large-bodied animals have to ingest a certain amount of protein to reproduce and lactate, which requires green forage. At a given spot in the landscape, green forage adequate for animal growth and reproduction is available only during the short spring period each year. Cured forage (dried grass) is a submaintenance ration and does not supply sufficient nutrients for animal growth and reproduction. In order for large animals in the Intermountain West to get adequate protein for reproductive purposes, they had to migrate seasonally. They had to follow the green up the mountains ele-

vationally, they had to use riparian areas, they had to become browsers—all of those things—to get adequate protein. The lowly cow (who has been domesticated only five thousand years) does this. Deer, elk, and horses also follow the green up the mountain. Again, this is a much different system from a prairie environment where there is warm season precipitation and all summer long there is green feed. In the prairie you see nomadic grazing without concern for elevation, so animals move latitudinally north and south.

The difference between what horses, elk, cattle, and deer eat is a matter of degree. Horses and cows are primarily grazing animals but will eat browse when grass dries up. Deer are primarily browsers but will eat grass at certain times of the year. Cured grass has 1 percent to 3 percent protein, and an animal cannot successfully breed, lactate, or grow on low protein intake. Browse (brush species), on the other hand, retains high protein in its dormancy. In winter when grass becomes straw, it creates heat and body warmth but carries little nutrition. They browse on shadscale and winterfat to get protein intake, with energy intake from dried grass.

Seasonal migration (following the green in the spring to the mountains and back to the desert valleys in winter) is *how* the system works in the Intermountain West. Yes, a lot of grazing problems have occurred by keeping livestock in one place and not moving them. But the plants didn't evolve for season-long use; they evolved for seasonal use. We did unravel some country here by season-long grazing, and that's why environmentalists say this doesn't work. In my view that's half right; it's the way we did it that didn't work! The other detrimental aspect is there were far more animals on the range back then than the system was capable of handling.

There are three aspects that should be included for the intermountain system to work. One is seasonal versus season-long use; two is the number of animals using the system; three is periodic fires. Think about it. If you follow the green up the mountain, there is still soil moisture left behind in which plants grow and seed out and cure in place. That provides a seed source for the plants when the animals move back down in winter. It also

provides fuel for periodic fires, and fires provide the balance between woody plants and grasses. Fire is what made this country grassy. When we overstocked the range in the late 1800s and 1900s, the livestock ate all the grass. There was no fuel to carry fire, and more brush came in.

Periodic fires were part of the original system in the Intermountain West. They still should be. But now we have brought along all kinds of other things to the landscape—our communities, our buildings, our homes, and so forth; all of that throws a whole different element in the works. There are pros and cons about fire management today, but the biologic system origi- nally included periodic fires. It was an important part of the ecology in the region, both natural fires as well as fires set by Indians. Years ago I recon- structed fire histories of Owyhee County back to 1620 from living juniper trees that had been burned and scarred. There were frequent fires all dur- ing that time. The habitat might go seven years and then burn, ten years and then burn, fifteen years and burn, then three and burn. Still, it was all burn, burn, burn until 1880. After that the juniper took over this landscape.

This is a complex story with many pieces. Livestock came to this coun- try to feed miners in the 1880s. The cows ate the grass, so there was no more fuel to burn. Sagebrush filled in, and by the time it had a big enough canopy to burn, we had roads and trails and fire prevention policies. An- other complexity affecting the system was the inadvertent introduction of preadapted exotic plant species such as cheatgrass. The presence of cheat- grass has entirely changed the role of fire throughout the drier portion of the sagebrush zone, which is an immensely complicated issue in and of itself. What's important is that fire was the stand renewal process of the sagebrush-steppe environment, and in the absence of fire woody plants will dominate.

When European man brought horses back to North America the horse was one component of the natural herbivory system that evolved here. But as I said, we didn't bring back other grazers that were part of that original ecosystem. Also missing were the natural animal control mechanisms here then, the big predators like the saber-toothed cat, the dire wolf, the cave

bear. Without any predators horses will expand and eat themselves out of house and home. The fact that we brought these horses here seems to me to suggest a moral and ecological obligation to provide that missing link known as the predator. This in my mind is the philosophical basis for managing wild horses: in the absence of the other large ice age predators we must control them.

There is a segment of the population now which abhors the idea of removing horses from the range. However, by failing to do this we do the horses as well as all the other animals on the range a terrible disservice. Unfortunately, I also think wild horses have become a convenient political tool for certain extremist groups to pursue an agenda that plays to the eventual removal of animal agriculture from our society. The easiest place to start for that agenda is on public lands, because it is much harder to eliminate meat-producing agriculture with animals raised on private land. These kinds of influences may be only a minority, but the press often panders to it because it's exciting coverage, and an uninformed public becomes bombarded by emotionally slanted messages and often gives support in return. In this way, many problems are created where none existed.

I don't think it's always appropriate to define the optimum relationship between horses, livestock, and wildlife in terms of exact percentages or numbers. The rangeland ecosystem evolved with niches for multiple grazing animals: shrubs, grasses, and forbs. The diets and habitat needs of the different grazing animals (horses, cattle, and wildlife) differ widely, so it's not a one-for-one relationship of one cow equals one horse equals one elk. If you have only one species of grazing animal that focuses attention on just two or three plant species within a complex system that has numerous species, it destabilizes the plant ecology overall. For example: with only livestock grazing any one given area, palatable plants like grasses are at a disadvantage while unpalatable plants such as sagebrush are favored. If you put a series of grazers on that same piece of land, it spreads out the grazing pressure and the system becomes more sustainable and more ecologically

stable. In my mind this a good argument for horses, cows, sheep, and deer to share the range together. Wherever we've done this, the stability of the plant community increases and productivity goes up. The range will sustain multiple grazers adequately because it evolved like that. It was always a multicultural herbivory.

We should all be concerned with what occurs in our environment, and globally we need to be absolutely concerned. To my way of thinking, our concern has often been directed at so many little pieces and not the larger problem of too many people who want to use it. We've focused on such things as fighting over cows versus horses when the truly important issue is: just what is the total human demand on this environment?

We are all critters here, and we must take our livelihood from the environment around us. We tend to forget how important this is. We not only must take our livelihood from the resources of the environment, but in so doing we alter that environment. Every population of organisms extracts their livelihood this way, and the natural system can tolerate only a certain level of alteration before something happens. Humankind is insignificant in this larger sense of life. Nature creates exquisite biological and physical systems and then rends them asunder to re-create another. We definitely must maximize technologies based on renewable resources to the extent that those resources will support them. The caveat here is always sustainability! To lock up all of our renewable resources or deny the biological necessity of taking our livelihood from the resource is arrogant, in my view. Because if we do lock up renewable resources in this country, then our society must either replace it with nonrenewable technology altogether or shift these activities onto other nations who because of poorer economic conditions don't yet have the same environmental concerns we do. If it's the latter, does that entitle us to sit back in a prettier environment just to make ourselves feel good?

I grew up in this landscape. All of it—the culture, history, biology—is dear to me. Studying it and putting pieces together to help others under-

stand how exquisitely the system works is what I've been working at for a long time. Whenever I give a lecture, I always wonder: "Do they see how it fits together?" Because it does—it all fits.

Irwin Liu, D.V.M., Ph.D.: Equine Veterinarian and Professor, Davis, California

The idea to research an immunocontraceptive vaccine came about in 1982. Because of my understanding of how equine fertilization occurs, I had an ability to learn quickly how to prevent it. Although it was not initially de signed to use specifically with wild horses, it happened that way gratu- itously. At the time there was a fierce battle between the government and wild horse advocates over the capture and slaughter of these animals. The atmosphere was very tense, and BLM was caught in the middle because they are responsible for managing the land on which the horses live. I thought the vaccine would be a good adjunct to the adoption program.

In our initial study we took the zona pellucida membrane, the basic membrane surrounding the eggs of a pig, and used that as the major com- ponent in a vaccine to prevent conception in mares. First we had to test the program on domestic animals to make sure that it worked and had no ad- verse effects, so it was about 1989 by the time we got it out in the field. Since then we've probably inoculated some twenty-five hundred wild horses with variations of the original vaccine. It has been quite effective.

The vaccine has been partially accepted by most of the wild horse groups. I say "partially" because there are some who still don't agree that con- traception is ideal. From my perspective it's a fairly good alternative to slaughter. The problem is that it is not being performed on a wide scale. To inject two thousand horses won't have any effect on the total population when there are some fifty thousand wild horses roaming around the West. Presently the vaccine is effective for eighteen months, so that also implies gathering horses repeatedly in order to inject them. It is possible to im- prove the vaccine so that it will last for a longer time period, but that would take more research. For a vaccine to last three years, it would take three

years' research to test a new variation on domestic horses prior to administering it in the field.

Any type of project like this takes research, and research takes money. When there's no money, there's no research. And it appears that the only source of funding for this kind of research is the government. Now we're getting into the politics of the situation. How does the government spend its money? There doesn't seem to be a strong impetus to go any further with this program now. Of course, there are other pressing problems in the world, and wild horses are certainly not the biggest. I understand that there are other priorities.

One of the present requirements of contraception for wild horses is that it cannot be permanent. There is an argument put forth by certain groups that if you inoculate a wild horse and permanently sterilize it, you could deplete the gene pool by sterilizing preferential mares. In other words, no one knows for certain whether one particular mare might have the most desirable genes. Whether or not that's a good argument is another matter; however, it is an argument that has been raised time and time again with any animal. We've inoculated elephants, elk, white-tailed deer, and black bears, and every time we must make sure it's reversible. Obviously, on a domestic horse several permanent vaccines are available, but with a mustang it must be reversible.

Currently we inoculate wild horses on an experimental basis. We select fifty or a hundred mares that have been captured during a routine gather, identify them with a freeze mark, turn them loose, and then come back and count the foals by the mare's side. If it were ever to become a widespread effort, we would need FDA approval, and that would be another barrier, so to speak. However, the vaccine has proven itself over the years. It's safe, it has no adverse effects, and it's very effective. Most of the animals on which it has been performed have been horses, but it has been given to other animals also. It doesn't work on dogs or cats, but the goals for dogs and cats are different. For dogs and cats, the goal is sterilization. For wild horses, it's contraception.

The way the basic mechanism works is that when you take the zona pel-lucida membrane of pigs and inject it into a horse, the horse recognizes it as foreign and develops antibodies against it. The antibodies attach to the horse's own zona pellucida, and that prevents the sperm from penetrating. We produce the vaccine here by grinding up eggs from pig ovaries, and we obtain the ovaries from the slaughterhouse and store them in the freezer. There are about two hundred eggs in every pig ovary, and each injection requires five thousand eggs.

Presently, the cost to inoculate each wild mare is about $50. It may go lower, but that's still a reasonable amount compared to how much it takes to round up and adopt out one wild horse, or for the government to keep it in a sanctuary for the rest of its life if it's not adopted. However, widespread application could mean the government might not have to capture so many wild horses, and in the long run that might even save money. It could also give the adoption program a break. I do think a lot of people adopt wild horses because they feel sorry for them, and with a contraception program the public wouldn't feel so obligated. By far, the most impressive thing to me about this entire contraception issue is that it seems to have eased the battle between the government and many of the wild horse groups.

My perspective is that a contraceptive vaccine does no harm to the ani-mal and it may be an effective way of controlling overpopulation. It's a hu-mane method, and it's a better use of technology. When I think of the tremendous costs of the wild horse program and what might happen if we vaccinated a whole bunch of horses, it seems there are some very worth-while possibilities.

Bob Morris: Genetic Analyst, Woodland, California

This laboratory was contacted by BLM some ten years ago to get a genetic handle on breeding populations of feral horses in various herd manage-ment areas in Nevada and Utah. We were curious to find out if feral horses in the Great Basin had similarities to domestic horses. We thought it would

also be interesting to know if we could detect distinctively different genetic profiles of each breeding population.

Our first sampling came from four or five breeding groups from the Black Rock Herd Management Area. Blood samples were taken from individuals in herds that were separated either by fences or by some natural barrier. The question was: how did these individual blood types compare with domestic breeds such as the Arabian, the Appaloosa, and the Thoroughbred? Could we use blood group frequency data to identify certain herds located within certain areas?

Our first time out we collected upward of one hundred blood samples. We brought them to the lab and ran them through a conventional blood-type test. That consists of a cellular antigen-antibody test for the red blood cells and a biochemical and enzyme test whose types are detected by a process known as electrophoresis. These tests are highly specific, and the probability of two horses having the same type is extremely remote. The blood types are inherited from their parents. Genetic analysis of family data reveals that the segregating blood factors fall into one or another of a limited number of blood group systems. Eight blood group systems and eight electrophoretically defined genetic markers are routinely used to type a horse.

We received blood samples from eighteen different herd management areas, and we weren't surprised to find that these horses possessed blood types that were in common with domestic horses. The blood types, however, occur with different frequencies between breeding populations. For example, in humans the blood factor o in the ABO blood group system occurs more frequently than the factor A or AB in some but not all of the human population. In horses it's much the same. We can count the genes producing certain blood types and create a gene frequency analysis that is useful in comparing one herd with another. We can plot the frequency of certain blood groups on a graph and match them against frequencies calculated for another herd, and we can easily see the different genetic profile that has been created.

There is a general array of equine blood types. In Arabians you have a certain high frequency of a certain group, in Quarter Horses you have groups with a distinct high frequency, and so forth. These equine blood groups are coded. They're in blood group formulas that fall into genetic systems. Those systems are put to a statistical test, and we give them frequencies.

In terms of genetic viability of a herd, every time you halve one generation you're halving the genetics. Let's say you have a stallion and a mare. They each contribute half of their genetic content to their offspring. For any particular herd to evolve into something else assumes that something new is introduced in the gene pool; different blood that's put in the herd makes that change. If you're dealing with the same type of animal over time and without any type of introduction, there's no way you can lose that gene pool and transform, say, a "Spanish mustang" type of horse into something else. But if you took a small population of twenty-five wild horses that have been breeding just fine for one hundred years and then introduce twenty-five Arabian-style domestic horses into that group, you're definitely going to cause some turmoil. So whether you introduce random selection from another herd or specifically controlled matings, it will dilute the gene pool that was originally there. Generally speaking, if one breeding population remains isolated and is large enough, their genetic pool won't change.

There are actually very few Spanish-style mustang bloodlines left. All kinds of things happened over time that contaminated those particular lines. But there are still some very hardy individual horses out there, simply because a horse has to be tough to thrive in that kind of country. So whatever the original breeding stock was, it has now developed into a very hardy type. Our interest is how a specific population illustrates a particular genetic profile that's different from another breeding population, but we don't put a type to it. In other words, we didn't take the genetic profile of one group and try to trace its origins to early colonial horses or some such thing. Our interest was only if the horses are stable in their present population in terms of their genetic frequency, how one population differs from

another population in that frequency, and how those populations may change for some reason over time. Over the past ten years we've tested some of these herds at least three times, and we found no big drift in gene frequency at all.

BLM wants their horse specialists to have some handle for management, especially how to sift individual horses out from the herds and how to turn some back. Many of the specialists are not experienced horse people, so without a genetic tool such as this they don't know how to do that. Some of them rely on age and sex and the normal techniques of culling any animal herd, but if they have a genetic reason not to deplete certain gene types, that could help.

There are different management philosophies and strategies for these things. The work we've done on Nevada horses shows they're not bothered by inbreeding problems. Certainly, if you have a small population of horses where stallions are breeding their daughters and daughters breed back to their sires over and over, you would surely get genetic problems. But those would be self-eliminating because the offspring simply wouldn't thrive. In stable breeding populations, where herds are sizable, there will be enough of a genetic mix so the herd won't die out.

We've used our research in a few cases involving horse rustling. About three years ago BLM suspected that some Indian tribal members were taking horses from government land. One night they stopped a trailer loaded with ten horses. The driver said the horses all came from a certain location on the reservation. The bureau confiscated those horses and took them to Palomino Valley; they took blood samples and brought the samples here. We typed them and compared those with each of the horses. Those horses had markers that weren't found in the herd the rustlers claimed. When we looked for those types in the herd BLM suspected they were from, they found three specific markers there. When the thieves were confronted, they confessed.

Many people do worry about inbreeding. There's an impression that if you see ugly-looking wild horses it must mean the herd has become in-

bred, while actually all that shows is that the horses were probably ugly to start with. In other words, usually you must have ugly times ugly to get more of ugly. The real sign of inbreeding is unthrifty-type horses. That means the horses become susceptible to various diseases and to all kinds of deformities, and that they won't have viable offspring. True inbreeding means you double up the deleterious genes because you're mating relatives and close relatives, and that means you start doubling up. We call that "homozygous." Homozygous characters can be deleterious, meaning that they are susceptible to all kinds of genetic deformities and all of that. You'd get a poor foal crop or the mares provide less milk or the offspring would be so ugly or crippled they couldn't breed. That's where the evidence would be.

The big problem with wild horses is population. What are we going to do with all these horses out there? There's a rallying cry to protect the wild horses, but you can't save anything by not managing them. It's the same with any population that isn't controlled. The population doubles exponentially, so something has to be done, whether it's geese or horses or what have you. From a geneticist's standpoint the question goes back to how they are culled. They have home ranges, so leave them there. Thin them; but if there's a certain type there, let them be amongst their own as long as their numbers are controlled. But some of these populations are really in trouble. The hard winters are going to get them, and some of them will die a cruel death out there. During winters like that it's possible to walk right up to some of these horses to shoot them. They can't walk, they've been laying there for weeks, and some can't even recognize you as you approach, they are so malnourished. They will surely die if they're not destroyed, yet apparently that seems more acceptable to some people than humanely destroying them first. But if there are one thousand horses on an area that will support only one hundred, and a hard winter comes along and they're not healthy, and the next year the herd will become a skeleton of itself, is that the correct way to manage?

Coat colors are also a matter of controversy. You can't rely on whether some people label a horse one certain color or another. For instance: what

you may call a bay horse is what someone else may call a chestnut. Or what some people call black is not really black. If I cross a bay horse with a black horse, that black horse may be a dark-colored bay; you can't tell the difference. These things are genetically related and you need genetic samples to show how they work. When you get around to duns and line backs and grullas and that sort of thing, sure, people can say that these markings or colors mean more of a wild type or historic type horse. But that's like saying that just because my hair is blond I'm more likely to be German. There's much more to it than that. It's terribly complicated and it carries on from generation to generation. Everything that's in an individual's type must be present in one or the other or both parents, but it doesn't have to be present in one or the other grandparent's type. All this can be lost in five or ten generations.

I grew up around animals and horses. I'm glad there are wild herds on the range, bands of horses running free in the wind. But wild horses need our help. Anything we can do in our work to shed light on how to manage these horses, and to show how interesting and how diverse they are, will always be something I'm interested in.

Dan Flores, Ph.D.: Western Historian, Missoula, Montana

One aspect of horses that intrigues me is that they went wild so easily and quickly in North and South America. There were other places where Europeans tried intentionally to introduce horses but they just didn't take. The Boers tried to introduce horses to the veldts of South Africa, but after a century they still had a herd of only about six hundred animals. Yet in the American Southwest horses went basically from zero to as many two million in about the same amount of time! I see that as one of those tidbits of documentation that tells us horses had indeed returned to their native habitat. The fact that North America had lost many of its grazing animals ten thousand years ago meant those niches were left open for Europeans to bring horses, cattle, sheep, and goats to North America, and for them to do extremely well here. In South Africa there were not those same extinctions,

and because the plain was already filled with grazing animals there wasn't room for the horse. This is one of the interesting things about the wild horse in America. The fact that the fodder was here helps explain why, once a few horses got loose, they exploded. We're talking about a family of animals that's fifty-seven million years old in this part of the world. They had been gone only eight or nine thousand years, and in the blink of an eye this country was covered with them.

This becomes the explanation for why a commercial trade soon developed around them. Horses are animals for which there is a demand, and wild horses seemed to offer an inexhaustible supply. From the eighteenth century on, every group of people associated with the West (and the Southwest especially) became interested in capturing, trading, and selling horses. So from the moment they started running wild across the landscape, horses were immediately also viewed as a commodity. That perception continued from the seventeenth century, immediately after the Spanish reintroduced them, up through the middle of the twentieth century.

America has always had an insatiable appetite for horses. In the nineteenth century, as homesteaders under the American land laws were advancing westward territory by territory toward and beyond the Mississippi River, they needed horses for riding stock and for farm work. There was a demand for all of that. Good stock of wild horses sometimes sold for as much as $125 and $150 in the markets of Lexington, Kentucky, for instance, so people got good prices for them. Another reason people on the advancing frontier seemed to be interested was because these horses exhibited Spanish Barb conformation. They were sure-footed and small and hardy. People began using them to interbreed with northern European stock to get some of those qualities.

Wild horses also appeared intriguingly wonderful to people, particularly when they were viewed from a distance. To see bands of horses running free was something compelling! It's a common story from the nineteenth-century horse trade that people would see a certain horse and go through

tremendous efforts to catch it, yet within a few hours after capture discover it didn't look any better than the one they were riding to start with.

There's a famous story that I used in one of my books about a fellow named Philip Nolan, who captured thousands of horses on the Texas frontier. Nolan once started to take a wild paint horse to Monticello with the intention of presenting it to Thomas Jefferson. Jefferson was fascinated with the idea of wild horses in the Southwest. In a letter he once wrote to a colleague at the Philosophical Society he indicated his interest in mounting an expedition to observe horses in a wild state. So Jefferson wanted to meet this famous mustanger, and in the year 1800 Nolan started eastward from Natchez along with this animal and a letter of introduction to the president from the American consul in New Orleans. Once Nolan got to Lexington, however, he turned around and went back to Texas, apparently to gather more horses. The letter of introduction eventually arrived at Monticello without either the mustanger or the horse, and we know that because among his papers Jefferson later wrote that Nolan never appeared. My speculation is that when Nolan reached Kentucky somebody simply offered him a good sum for the wild paint, and he wasn't able to resist selling it.

During the 1780s, in both Spanish California and Texas, wild horses had so overspread the country that they literally became a nuisance. Because there were so many, the government declared them all the property of the king (*mesta*) and created an economy around them by placing a tax on their capture. Feral horses and cattle were soon called *mestenos*, and those who captured them were called *mesteneros*. On hearing these words Anglo-Americans coined the term "mustang."

The number of horses captured in the nineteenth century was phenomenal! When Zebulon Pike came through Texas in 1810, he wrote in his journals that no one on earth equaled the Spaniards in their ability to catch wild horses. There is a wonderful detailed description of early mustanging written by a French scientist, Jean Louis Berlandier, who worked for the Mex-

ican government in 1830 and observed several operations during that time. Berlandier described possibly six occupations in the task of capturing horses. There were certain people who started them running, certain people who herded them from the sides, others who handled the pens, and still others who gentled them afterward. Everyone had a specific job. To give his story even more context and color, there are documents which indicate that for every one hundred horses that mustangers ran into the corrals, they would often end up with only a handful at the conclusion of the whole process.

Berlandier outlined an early Spanish vocabulary based on what happened to horses after they were caught. One term was *sentimiento,* which meant a horse that died of heartbreak after being captured. Another, *despecho,* designated a horse that died of nervous rage. *Hediondo* referred to a pen that was ruined because so many horses died there. It became impossible to drive any new horses into it because they veered away from the smell. This was a commerce that sometimes carried a measure of cruelty with it that could be pretty draconian by modern-day standards.

I once edited the journal of a horse trader, Anthony Glass, who lived among the Comanche and Wichita tribes in 1880. He witnessed how the Indians captured mustangs, and later on he tried to capture them himself. However, most Anglo-Americans relied on the Indians to do the actual horse capturing, and they would then trade with the tribes for horses they wanted. They didn't seem willing to put the effort into learning how to do it themselves.

Most people today are aware of the beaver trade on the American frontier, and of the stories of the early mountain men. Just to put the wild horse trade in context, there were probably as many horse traders on the Southern Plains as there once were beaver hunters on the Northern Plains. The wild horse trade was an economy that western historians largely missed, and I think one reason is because the big fur companies involved with the beaver trade kept more accurate records of their transactions. In contrast, the wild horse trade was never a corporate enterprise. Mustanging was the

work of individuals or small groups who were mainly self-funded, entre-preneurial frontier opportunists. They didn't enjoy backing from big com-panies, so there isn't the same kind of evidence.

There were several merchant trails in the West with the same name. For instance, there was more than one Old Spanish Trail. One went from San Antonio, Texas, to Natchez, Mississippi, so when you speak of the Old Spanish Trail in that section of the country it goes east to Lexington, Ken-tucky. Westward, the Old Spanish Trail from Santa Fe to California featured a lot of horse movement. One story from that territory deals with a group of horses from a Spanish colonial ranch in California that were originally stolen by a group of Mission Indians. A little later on the Mission Indians were raided by the Utes from southern Utah, so now the California horses were in the hands of Indians on the eastern edge of the Great Basin. Then a bunch of Navajos stole those horses from the Utes, and following that a group of Cheyenne on the eastern side of the Rockies stole several from the Navajos. The Cheyenne traded those horses to some Americans on the Arkansas River at Bent's Fort, and the Bent brothers then drove them east-ward to Saint Louis. In Saint Louis they sold them to a party of emigrants who were headed back for California. Those horses ended up going all the way back to where they came from! I wouldn't be surprised if that type of thing happened lots of times.

The Pueblo Revolt of 1680 was the major event that caused the spread of horses across the West. After seventy years of Spanish rule, the Pueblo Indians of northern New Mexico drove off the Spaniards and regained control of their homeland for twelve years. During the rebellion the Indi-ans captured several thousand horses, and since there were too many for them to use they traded them to other Indians. That original network trav-eled mostly west of the Continental Divide, first from the Pueblos to the Navajos; then from the Navajos to the Utes; from the Utes to the Bannocks and Shoshones; and from the Shoshones to the Salish, the Nez Perce, and throughout the Northern Plains.

During that dispersal period the horse provided an immense opportu-

nity for Indians to change their entire lifestyle and identity. Many of the Shoshonean people were among the first to become horse dependent, and they moved out onto the plains with horses. These people eventually became the Comanches of the Southern Plains, among the greatest of all the horse tribes. Another group was the Crows, who originally sprang from the Hidatsa people, an agricultural group along the Missouri River. The Crows mounted up on horseback and rode out on the buffalo plain. They too became known for their great horse culture.

An appreciation for horses runs in my family. I grew up in a small town in Louisiana and I learned to ride at an early age. Also, one of my family ancestors, Pierre Bouet Lafitte, was a player in the eighteenth-century commercial horse trade. Back then, Lafitte had a fondness for paint horses. I don't know whether that has anything to do with my family's present-day penchant for paint horses, but I wouldn't be surprised—the bond between horses and humans is mysterious and ancient.

Stephen Budiansky: Nature Writer and Editor, Leesburg, Virginia

From a scientific aspect, North America was the evolutionary cradle of the horse. I'm using the word "horse" in the generic sense of all equids. We know from very good fossil evidence that the horse, along with a great many other large mammals, went extinct on this continent at the end of the Ice Age. There hadn't been any horses here for tens of thousands of years when Columbus arrived, and that is a significant amount of time when you are talking about a period that saw such rapid climatic and landscape changes.

It's hard for us to conceive of geologic time. That's partly because of our relatively short life spans in comparison and partly because it's hard to imagine how different things actually were fifteen thousand years ago. For instance, the idea that what is now New York City was once buried under a mile-thick sheet of ice seems fantastic, yet this is part of the history of the planet. My point is that the period from fifteen thousand years ago to the present was a time of extraordinarily rapid change when new ecological relationships were being established. Some people may argue that because

the horse in America was at one time natural in the wild, after the horse became extinct it left a vacant ecological niche that in a sense has been waiting or reserved for them. I think that's a specious argument, in particular because what caused the horse to go extinct (along with a lot of other big mammals) was that their niche was already vanishing at the end of the Ice Age as open tundra gave way to forest. The more important point is that as the ice gave way, other plants and animals moved in to establish entirely new sets of interrelationships, and the horse was never a part of that. It's naive to think we can throw horses back into this mix now, after tens of thousands of years have passed, without causing some disruptions in relationships that have since been established.

The damage that feral horses are doing now is significant in some places. I'm not an expert, but I've read much of the scientific literature, and many of the studies are done by people who don't have a vested political interest in the wild horse either way. One scientist I interviewed for my book *Nature's Keepers* made a very telling comment about the condition of the Atlantic barrier islands due to wild horse herds there. He remarked that if a real estate developer had done to those islands what the wild horses have done, the developer would be in jail. My point is that uncontrolled horse numbers cause a disturbance to the ecological relationships that have established themselves, and that you can measure that damage. I don't think we can shrug this off by saying that horses have a right to be protected.

From a scientific standpoint, it's not as if the wild horse is an endangered species. It's not even as if feral horse populations are somehow different or not fully represented in the domestic horse population in America. These horses have been let loose over the past few hundred years and have been allowed to overpopulate. On the other side of the coin, they are an invasive species with demonstrated harmful ecological consequences. They don't belong here! The odd thing is when people claim that wild horses are part of the natural ecosystem and add to biodiversity. Now, "biodiversity" is one of the greatest buzzwords you can use these days! The truth is that if you introduce any invasive species it will temporarily add to bio-

diversity until it starts wiping out native species. But our society has grown accustomed to thinking that anyone who says we should keep our hands off nature and leave things alone is automatically perceived as a preservation-ist or an environmentalist and therefore is not driven by venal economic interests. Along with that notion is the idea that anyone who *does* say they want to manage things on the landscape, or even that certain adjustments are needed there, is pegged as having exploitive motives. I'd argue, how-ever, that we've already messed things up on the landscape. I think it's far too late now to adopt an attitude that we can take our hands off from here on and everything will be fine.

It's very interesting that wild horses have such a hold over us. I think the reasons we have these feelings go deep into our views about nature and the wild. As an example: if you asked people in this country what African wild animals they like best, a lot of them might say zebras, giraffes, or ele-phants. However, they're not *crazy* about zebras in the same way people are crazy about wild horses. I think part of the appeal of the wild horse is that on the one hand we want to say they are wild, but on the other they are very familiar. The horse is an animal we know and love from our domestic rela-tionship with them. There's a real paradox at the base of this: we're trying to make them into wild animals, yet part of our feeling is that they *are* familiar—they're not wild. So I don't think we'd feel the same about wild horses at all if it weren't for the fact that this is a domestic animal which has had a special relationship with humans for several thousand years.

The romance of the wild is a complex story, and it's filled with ironies. It may come as a surprise to many, but up until a few hundred years ago people generally did not like nature very much. When the early explorers came to America, for instance, they often referred to wild places as being "hideous." They spoke of mountains as "warts" or desolate places. Today when we use the word "desolate," most people respond as though it's a positive term, but in 1700 it wasn't meant that way. The wilderness then was a threatening place, and for good reason. It was filled with wild animals who could kill you, with people who might rob or hurt you, and dangerous

weather that came without warning. So people didn't like mountains and forests; they were scared of them. This is why people always settled in villages; they were afraid of being alone out in nature. Looked at in this sense, it was only when we felt we had finally tamed nature that we were willing to like it! This is a very deep paradox: that the very thing that made nature something admirable, and that made wild and untouched creatures desirable, is that we had in fact touched and tamed them. Then we began to romanticize them.

This is partly why we like all charismatic megafauna so much. Big, furry animals—elephants, bears, lions, and the like—are impressive. In my view, we like animals such as wolves and horses in the wild so much more because they reflect familiar animals which are not threatening, dogs in the case of wolves, domestic horses in the case of the mustang. When we see these creatures in the wild we're drawn to them out of our familiarity and with an added tinge of excitement.

Whenever you want to manage anything in the wild, it spoils our collective idea about what the wilderness is all about. The American West is perceived by many people back East as untouched wilderness because any place where you don't see highways and people every few feet must be the real McCoy! However, take a look at what Native Americans were doing when Europeans first came here. They were practicing landscape management on a truly spectacular scale. The Indians probably set fire to hundreds of square miles at a time, thus altering the forest landscape, and their hunting practices had a strong influence on native deer populations. When the early colonists arrived, what they saw was not any sort of unspoiled American landscape; it simply echoed their preconceived idea of what an ancient wilderness should be.

Another popular contemporary social message is that the best way to protect any wild animal species is not to kill them. Certainly human predation is not what it once was in many places, but nowadays the idea of hunting as a natural part of an ecosystem goes against the grain of people who want to maintain an idea of a pristine wilderness—meaning wherever hu-

mans don't intrude. More than this, even those people who would not in the least mind shooting an elk for dinner do not like the idea of shooting a horse. This message mixes together several different things. It's certainly true that some animal species were endangered as a result of overhunting through human exploitation. But that has somehow been conflated with an idea that usually comes from the animal rights groups: that you can never kill any animal without being cruel to it. Or the idea that while perhaps it's allowable in theory that slaughter can be done humanely, in practice, as soon as a price is attached or people are involved, killing any animal becomes cruel. In my view we've mushed together two things with this message: our environmental concern over endangered species and our humane concern of the individual suffering of an animal. And there is no more charismatic animal than a horse!

However, if you look at what threatens endangered species today, human exploitation is probably a minor part. Were you to go through the list of threatened and endangered species worldwide, you'd find that a very significant percentage of threats is the result of introduced species, and a significant percentage comes from loss of habitat, but only a very small percentage is due to direct exploitation by humans. Nevertheless, that's the model that a lot of people have, and it's certainly the model that is implied in the message of many animal protection groups. What's unfortunate is that it is a great tool for fundraising.

There's a lot of willful ignorance at work on all of these particular points. Part of the myth of natural management is that if we just leave things alone everything will be alright and natural harmony can be achieved. People who don't have firsthand experience can perhaps understand an image of one hunter shooting something. However, they can't imagine one or more animals suffering from parasitism or starvation or even predation, for that matter. There are all these fairy tales, which are extraordinarily resilient, about how animal populations automatically regulate themselves so that nature will return to a Garden of Eden and there won't be any more suffering. Anyone who has actually studied wild animal populations can tell you

that parasitism is not a pleasant thing to endure, and whenever a boom-and-bust cycle occurs it means a lot of animals are dying. These aren't pretty things!

I am not at all in favor of inflicting suffering on animals. On the contrary, I think we have a great obligation to do what we can to minimize animal suffering. But as a society we cannot afford to look at only one-half of the picture. We can't say, "If we don't do anything everything will be fine," because suffering is a constant fact of life in the wild. With respect to hunting, from my experience, the overwhelming majority of hunters do not go out to inflict needless suffering. The death that they deal out to the animals they shoot is typically quick and painless and infinitely more merciful than the lot of most animals in the wild.

Currently there are an estimated seven million privately owned horses in the United States. There may have been more during the 1930s, but the number today is definitely larger than at any time since tractors overtook agriculture and the U.S. Cavalry was disbanded. This says something interesting, since the only reason horses existed in such numbers before is that they were work animals, war animals, and meat animals. Going further back to Europe, horses were also never as widely owned there as people often imagine; draft animals were mostly oxen. Horses have always had an association with the wealthy and knightly class because only noblemen could afford the very significant amount of feed and upkeep necessary to maintain them. Today in America the situation is much more complex. In our wonderful way of doing things, horseback riding and horse sports are in the reach of essentially anyone now. We haven't lost the allure of our domestic relationship to horses, and this development has probably changed the lot of all horses for the better. Throughout this country horses are no longer the preserve of the rich and the few, on the one hand, or the property of people who view them only as a commodity, on the other.

One theme I wanted to address in *The Nature of Horses* is that most people who own horses still don't know much about them. They don't know about their evolution or the scientific basis of their behavior or the history

of their domestication, and they know very little about equine genetics and breeding. Centuries' worth of lore has grown up around horses. The entire tradition of horse training has always been much more of an art than a science, and that's fine. However, I think it's unfortunate that more people aren't used to thinking about these things scientifically as well, especially because our society is going to be faced with settling many more serious issues about horses, of which the problem with feral horse populations is but one. My hope would be that the constituency of horse owners might become more knowledgeable and a force for understanding these issues, because thinking through them more deeply is definitely what's required.

I have no illusions that science is the definitive answer to all our problems. Obviously a lot of issues about horses involve value judgments as well as human psychology, prejudices, and emotions. That's the way things are, and we should recognize that. However, it's one thing to recognize that there are different issues which involve value judgments and quite another to come up with realistic solutions, whatever course you try to take. I do think that with environmental issues we often tend to mix up means and ends. This is a common human failing. People become so invested in the means and the symbolic value of the means that they often end up with ends that are the opposite of what they intend.

It's a perfectly legitimate public policy to say that the American people want horses roaming freely in certain places on our federal lands. However, we must take the next step, which is to ask: how do we do that in a sustainable way—in a way that actually works? You can't make something work by wishing it or by holding value judgments. This is why we can't let emotions and feelings dictate how that is done, and why it's so important not to blur the ends and the means. Without sweeping aside people's real concerns, we must apply scientific understanding to devise meaningful solutions. It's essential to understand all of these things if we're ever to come up with a lasting solution about the wild horse problem.

Steve Davis, Ph.D.: Animal Scientist and Ethicist, Corvallis, Oregon

The question of whether wild horses have the right to exist in the West can be answered a number of ways. Probably most people would say that wild horses have been part of the western heritage for centuries, and so it's reasonable to say they have a right to continue to exist. But what conclusion flows from that? How should they then be treated? This is where the rub comes. Some animal rights people would maintain that wild horses are a part of the range and therefore should be allowed to live without human interference. In my view, one has to go beyond the question of whether they have a right to be there or not and move into an analysis of the consequences. In other words, how can we protect not only their right to be there but at the same time protect the right of the range as a healthy ecosystem to exist, plus protect the rights of all the other animals who use that same resource, and even the right of a rancher who may have an interest in using some of that resource too? If we simply say that the right of the wild horse trumps all the others, we find ourselves in a situation where the horses will totally destroy the habitat. Therefore, the consequence of a theory of the noninterference right of wild horses is likely one of habitat destruction, the suffering of other animals that also depend on that habitat, the disappearance of those animals from that habitat, and ultimately the pain and suffering of the horses who die because there's no longer enough food and water because their population has gotten so high. So when you move beyond the question of rights and look at the consequences of lack of management, you can say the consequences would be pretty damn harsh. It would seem logical to suggest, then, that some kind of human interference and management system is in order.

I do think the matter of the carrying capacity of the range relates to the question of whether wild horses have a right to exist in the West. An ecologist might answer "no" to this question, however, because the plants and animals didn't evolve with large herbivores, and therefore if you put those animals on the range (even if you keep their numbers in control) they

may cause damage because those ecosystems didn't coevolve with large herbivores.

What kind of management system is yet another question. When you speak about wild horses there is a broad array of stakeholders involved in the discussion of what should be done with them. Each stakeholder has a just interest in the animals and in the resource, so all their interests must taken into consideration whenever any type of management plan is put together. A good question is: whose interests count most? Now, in the world of power politics that's a moot question because most people try to force everyone else to do things the way their particular interest group wants to see things done. Those answers can be found with experienced people who know wild horses and understand their behavior and social structures, as well as with range ecologists and managers who can determine what the resource is capable of and how to maintain some kind ecological balance within that system.

If you're going to have any kind of management for wild horses, there are only three realistic options of what happens to them once they are removed from the range. One is that they are adopted by someone willing to take care of them. Two is that they stay in a feedlot or sanctuary for the rest of their life. Certainly many people would say that keeping them alive in a sanctuary is an acceptable way to treat them; however, I'm sure there are just as many taxpayers who would also say they don't want their tax dollars going to feed horses to stand around in feedlots and so they should either be sold or euthanized. The third option is that they would be slaughtered humanely and used for food, either for human or pet consumption. Clearly, most people would prefer adoption; however, the adoption program has its problems and its limits. I don't think it makes sense to keep horses in holding facilities and just feed them for the rest of their lives. Therefore we really need to consider seriously the possibility of humane slaughter of any excess animals.

Although I believe a sound case can be made for killing wild horses, the difficulty would be which ones and how many. The animal rights groups

would not want us to slaughter any horses at any time. That has other consequences that lead to other unsatisfactory circumstances. The animal rights laws passed in some states that prohibit the slaughter of all horses are equally misguided in this sense. What are we going to do with *any* horse— wild or domestic—at the end of its life? Not all of us have deep pockets or can continue to try and keep a horse alive for as long as possible. Moreover, when an animal dies of natural causes, what are we to do with *it*?

Besides the issues about wild horses, there are some very serious problems with domestic horses in America. Horses are animals that need to be used and exercised on a regular basis. Presently there are too many people who buy a little place outside town with an acre or so and then put a little barn on it and buy a horse. Unfortunately, many of them don't exercise the horse, and they quite often don't feed the horse or supplement its diet very well, and just as often by fall there's no more grass growing for the horse to eat because there's been no water to make that grass grow. I'm not certain, but I think the problem with backyard horse owners in this country may contribute to even more horse suffering than the whole dilemma of wild horses on the range.

There are no absolute or easy answers. Given the fact that wild horses are in our care, we are responsible for them. We are morally obligated to give them a quality life and at the very least to minimize their pain and suffering. It's relatively simple to do that if we leave them out on the range in conditions where they have enough to eat and drink. This would seem to be the ideal solution. However, once we know we must manage their numbers, the options to meet our obligations to not let them suffer diminish. We can keep some in feedlots, we can adopt some, or we can humanely slaughter some of them. Which should we do? Perhaps all of those things are what we should do.

Temple Grandin, Ph.D.: Animal Behaviorist, Fort Collins, Colorado

A few years ago I studied how mustangs are handled in BLM holding facilities in Nevada and Nebraska. You always want to handle horses so they stay

calm, and I was encouraging BLM to score how wild horses are handled in the corrals. For instance, they've got to handle horses to freeze-brand or vaccinate them, and it's possible to objectively measure how fast the horses move as they're being handled for these things. I wanted to see them at a walk or a trot, not running and jumping. You also count how many horses rear. If you observe a lot of horses rearing it means they're getting too excited, because in a good job of handling you'll see almost no rearing. It's simple: if you get too close to a horse when it's in the chute, it's going to rear. If you back up, they don't.

Some facilities were better at handling horses than others. My assistant went to one where there were some very low scores. Over half of the horses were rearing and crashing into things, and a lot of them were falling down. When horses were moved quietly at a walk or a trot and their natural flight zone was respected, everything went a lot smoother and falls were eliminated.

Good handling can be taught, and handling will stay good in places where management insists on it. The biggest thing is getting people to calm down. There are some people who like to get animals excited, and those are the kind of people who shouldn't be working around animals at all! I've done a lot of work at meat-packing supply plants for McDonalds and Burger King, and some employees there had to be removed for this reason. So it doesn't matter if it's a slaughter plant, an auction, or a facility where they're working a lot of animals for some purpose. People get desensitized, and you need to have a manager who insists on quiet handling methods.

I certainly don't think letting animals starve or die of thirst is ever all right. Wild horses are no way near to being endangered, and we shouldn't let them overpopulate. But there are people in this country who are out of touch with what's real. They don't know what's going on out in the field, and until anyone does it's an abstraction. That's how some of these ideological arguments emerge. There is a perception right now that anything nature does is inherently good, and letting horses die off because it's nature is supposed to make everything all right. Well, nature is very harsh about how

it adjusts a population, and that is something we can do something about. In my work I do what I call "getting the suits out of the office." You've got to get people who live in cities and work in suits to come out of their office and go out to the field. Then they can see what happens.

I also find that people who work in the field are more moderate in their views. I don't care what the issue is or even what side they're on, but radical people to the right or the left of any issue are never in touch with what's actually going on. I've noticed everywhere that most of the people who are pure activists have never actually worked with animals. Everything becomes totally abstract, an ideology that isn't based on reality.

Wild horses are adopted in language only. People adopt a horse, and after they keep it for a year they get title. They own that horse and they can resell it. But I don't care if you call it adoption or a sale, there are always going to be good mustangs and crappy mustangs. Some wild horses are quality animals, but some are gnarly old wild stallions and are not adoptable. I saw some mustangs up in Wyoming that are really nice. In Nevada there are some little scrawny things that aren't very nice to look at. That's because the range is sparse and there's not enough feed to support them.

* * *

I WOULD LIKE to discuss the horse slaughter issue. My basic concern is that if people don't have a reasonable way to get rid of a horse, that horse is going to get neglected. And if horse slaughter plants are eliminated in this country, it is going to be a giant mess.

I recently completed a survey to compare what kinds of horses go to an auction yard with what kinds of horses go to slaughter plants. In this country, horses that go to the auction tend to be in much better body condition and have much better feet. Horses that go to a slaughter plant have much poorer feet than auction horses. What that tells me is that by the time a horse shows up at a slaughter plant, most of them are at the end of their useful life; it's because that horse is sick or old. If you do see a good-looking horse there, it's always because of a behavior problem or he

wouldn't be there in the first place. For instance, when horses arrive at a slaughter plant, they are unloaded into the stockyard and then put through an inspection chute and given a tag. A horse with a behavior problem will be rearing up in the chute, but none of the other horses will be doing that. I also saw horses with behavior problems at auctions. If you see a really nice-looking horse at an auction and he's bucking or rearing or displaying some other kind of poor behavior, that's obviously why he's there.

Most auction horses are bought by dealers. The horse dealer today is just like the old-time horse trader of yesterday. In our research we talked to a lot of dealers. Dealers want to get the most money they can out of a horse. A dealer might go to a big auction, and say he buys twenty horses. Well, he might take only four or five to slaughter and maybe sell the others for riding horses. In other words, a dealer wants to get as much money as he can, so he unloads the horses in the best market he can. So it isn't really that there are slaughter buyers at an auction as much as it is that slaughter plants link up with dealers who go there to buy horses. A slaughter plant is just one market for the horse dealer.

Let's say a dealer buys a bunch of horses at a sale up in New Holland, Pennsylvania. There are a lot of old Amish carriage horses and draft horses there. Now, Amish horses usually go straight to a slaughter plant because they're at the end of their useful life. But the dealer also might buy some other horses there at the sale, and they may be pretty nice. He'll sell those as riding horses and get a better price. Or sometimes he might take a horse to a better auction and sell it there; that happens, too.

A horse dealer buys and sells based on the current market price for horse meat. When mad cow disease broke out in Europe, the price for horse meat immediately went up. Whenever something like that happens, well, yes, some better horses may go to the meat market that probably shouldn't have. Usually the meat market price for horses is below the price of an average riding horse. Most horse dealers also do business by word of mouth. My aunt used to buy horses for her dude ranch from a dealer in Arizona.

Everybody knew him! She would tell him what she wanted and he would get them, and they would be just exactly as advertised.

Many Native Americans take mustangs off the reservation and ship them straight to slaughter. That might not be something that people want to hear, but that is where they come from, since reservation mustangs aren't managed by BLM. So there is also a market there. In my research I found that most of the wild horses that go to slaughter are coming from those channels. Only once in a while does a BLM freeze-branded horse come to the slaughterhouse.

Different cultures think differently about animals. Part of the problem in America is that so many people think about horses as pets. They also may care more about rescuing one individual wild horse than about looking at how to make a sustainable system for wild horses as a whole. That's the same as saying your pet dog is very precious but you may not care about what other people do with dogs in general. We have to look at where and how animals live and what is sustainable for the habitat. Wrecking the range is not desirable.

When a horse goes to slaughter, it's just like a cow at a beef plant. Most of them walk right in and they don't have any idea where they are going. They are shot in the middle of the forehead and it's an instant death. It's over with immediately and there's very little stress. There is a certain amount of noise, and I'm not going to say there's no fear, because any time you put an animal in a new situation you're going to get some fear. There have been several studies comparing cattle put through a chute for veterinary work with cattle going up the chute at a meat slaughter plant. The stress hormone levels were identical in both places. It's the same with a horse. If I take my horse to a veterinary clinic, there's going to be stress because it's a strange place and the vet may do some things that hurt. You can also stress a horse at a horse show, especially if it has never been to one.

A beef slaughter plant and a horse slaughter plant are the same kind of operation. When the horse dies there is a lot of reflexive kicking. There's a

propaganda video out right now that shows reflex kicking and claims horses are being cut open while they're still alive. That's not true! The horse dies immediately, and then they hang it up and bleed it out. After that they remove the hide and the insides, and then the carcass is cut down the middle like two sides of beef. It goes in a cooler, and after the meat is chilled it's cut into large prime cuts. Those are put in boxes and shipped overseas.

The biggest problem with slaughter plants is getting the horses there. The plants are a long way away, so horses go through a lot of channels before they get there, and the truck ride is stressful. I was talking to a fellow recently who butchered his pigs at home. He wanted to make sure his pigs went to "Hog Heaven," so he went to the donut shop and got all the leftover stale donuts. He laid out a whole row of those for his pigs, and while they were dining on stale donuts those pigs went straight to heaven. He said his pigs always died happy and their meat was always good. Research on farm deer also shows that the lowest stress is to shoot them in the field while they're grazing. So maybe it would be better to sharp-shoot wild horses while they're out on the range to spare them the stress of transportation. If I was a mustang I'd rather end my life going to a slaughterhouse than being left to starve or die of thirst on the range.

I am a big believer in stewardship over animals. I eat meat and have no intention of ever giving that up, and I don't have any problem with raising animals. That is their purpose. Fortunately, beef cattle live outside, and as long as they live out on the range and continue to fend off the elements they can still be a real animal. I was in Israel about five years ago and talked to some people there about the meaning of the word "dominion." In the original Hebrew, as I understand it, the meaning comes closer to stewardship.

Whenever you get to the subject of horse slaughter, a lot of people become totally irrational. But the average person may not know anything at all, so a lot of laws are passed because the public doesn't know enough to consider the consequences. If we don't have horse slaughter plants in this country there are going to be a lot of horses that people won't know what to do with, and so they will neglect those horses. It will force people to take

horses to dog food factories which may be totally unregulated. Or there will be more horses turned out in the "back forty" or just let loose on the range somewhere to fend for themselves. There are huge public health issues at stake! Horse slaughter plants are performing a service, and people must realize the ramifications.

Right now there are only two Department of Agriculture horse slaughter plants left in this country, and those are in Texas. One plant in Nebraska was closed and one in Illinois recently burnt down. Burning down horse slaughter plants doesn't solve anything. Neither did the California horse slaughter law, which states no horse can be slaughtered for human consumption. Since that law passed, the incidence of horse neglect in California has gone way up because people have no place to take their horses. Some groups are concerned about injuries that happen to horses on double-deck trucks, but those are *minor* compared to the disgusting condition some people let their horse deteriorate to before they finally get them to a slaughterhouse.

Horse slaughter plants for human consumption are regularly inspected and well controlled. If we lose our plants in Texas or the plant in Canada, the alternative will be either to take horses to slaughter plants in Mexico or to open more dog food factories to slaughter horses in this country. Now, a dog food plant does not include a USDA veterinarian and it also may have no inspection whatsoever. But a USDA veterinarian must be on hand at any plant where meat is processed for human consumption to enforce the Humane Slaughter Act.

Another related problem to uninspected dog food factories is the underground trade for illegal meat. There are a lot of low-income people and poor immigrants here who would eat uninspected meat. Or it could wind up being fed to greyhounds on the racetrack. It is possible to have an inspected dog food factory, but usually that's expensive. An operator can't sell dog food for enough money to cover those inspection costs.

This is a serious matter for all horse owners. What are you going to do with these horses when they come to the end of their useful life? What are

you going to do with the horse's body? BLM sometimes puts down a wild horse, so they have to figure out what to do, too. What are the Amish going to do? In some states you can't bury a horse anymore because of ground-water contamination. Rendering plants are also getting fewer and farther between. A rendering plant makes products like tallow and glue from the dead carcasses of horses, cattle, sheep, and pigs. Nowadays most beef slaughter plants already have self-contained rendering plants, but twenty years ago there were lots of them. If a horse died or had to be put down, the owner called the rendering plant and the plant would actually pay the owner for the body and come to pick it up. As there got to be fewer plants, the owner didn't get paid but the plant would still pick up the body for free. Nowadays it's to the point in some areas where the owner pays the plant. In other areas there's nobody to come get the horse's body for any amount of money.

We have to treat animals right in this country. I'm not going to say that animal agriculture is perfect, because it's not. There are a lot of things we should be doing better. Wild horses are part of the West, but they must be managed and not allowed to overpopulate or overgraze the range. When any horses get old, people need to have a way to get rid of them. I don't want to see horses neglected because there is no decent way for them to die.

B. Byron Price: Author and Art Historian, Norman, Oklahoma

Wild horses were one of the first cultural icons to emerge in western American painting and literature. In the first half of the nineteenth century, romanticism was the order of the day and artists were looking for the exotic in nature and ethnography. They were attempting to look beyond their European roots for inspiration, and the American West offered some wonderful possibilities.

The idea of capturing wild horses on canvas grew out of a romantic desire to discover and portray the exotic, and the first images emerged through the art of exploration. When Lewis and Clark returned from their expedition in 1806, the horse had been dispersed throughout the West for over a

century by Native Americans. Wild horses were so ubiquitous that they were seen by nearly every painter who went to the plains, and artists were taken by how primitive tribes harnessed these animals for their own use.

Artists Samuel Seymour and Titian Peale went west in 1820; they were followed by George Catlin, Alfred Jacob Miller, John James Audubon, and others. Each carried cultural baggage along with them as well as romantic notions about exotic people that influenced their work. They viewed wild horses in much the same way: endowed with mythical qualities, untainted, and untamed except by the indigenous "noble savages" themselves.

Many artists observed large horse herds in the wild and portrayed them on canvas. Alfred Jacob Miller depicted wild horses as well-bred Arab steeds rather than wiry mustangs. Catlin, on the other hand, was less technically skilled, but the mustangs of his paintings probably resemble more closely the way wild horses really were. Written accounts by these artists describe mustangs in very romantic terms. They often endowed the animals with human qualities, and so the wild horse in some ways became more human as a result.

Writer Washington Irving also toured the West in the 1830s and encountered some early stories about mustangs. The early frontiersmen often told about a mythical horse known as the White Steed of the Prairie, the Pacing Stallion, the Phantom Stallion, and the Ghost Horse, among other names. This legendary horse represented nobility and freedom, and was endowed with strength, endurance, and courage. The story plots always involved futile attempts by humans to capture and tame the white stallion, but he was so wily that he usually eluded his captors, although in some versions he was captured and then died by accident or of a broken heart.

These were the literary and pictorial references that occurred in the context of the first half of the nineteenth century. Jacksonian Democracy emerged at this time, with its belief in the individual, and there was an overlay of European romanticism on top of this—a great awakening of religious fervor that prized emotion over reason. So here were all of these artists portraying the wild horse with human qualities of spirit and strength,

and they endowed the landscape with the same human qualities. Other artists who sought to understand the West scientifically would classify wild horses within a taxonomy of species, a Great Chain of Being. They compared the mustang with domestic breeds and made value judgments based on the mustang's appearance. But those observers who had the most experience with wild horses (mountain men and the like) knew these animals more intimately and noticed qualities a casual encounter could never reveal. They knew mustangs were hardy and bred to survive, and they knew not be fooled by their often small and wiry conformation.

Americans encountered large numbers of wild horses in all the Spanish- and Mexican-held territories, and fortunes were made in the commercial horse trade back then. Also throughout the West, there were many geographical references to the mustang: place-names like Wild Horse Desert and Wild Horse Canyon in Texas, for instance. Such references in art, literature, economics, and geography were reinforced by constant repetition and combined to make wild horses icons.

By the beginning of the twentieth century some artists began to portray horses and the West more realistically. Artist and writer Will James, a former Nevada cowboy and wild horse runner, often expressed reservations about mustanging activities. James's notions were not that different from those of earlier artists who saw Native Americans as doomed to extinction by progress. Wild horses likewise appeared doomed, so those artists sought to capture their spirit on canvas or in print before the inevitable occurred. But James also understood mustangs. He questioned depriving them of their freedom, and he also pondered the good of capturing, taming, and making them useful versus leaving them alone, because he knew they could eventually exhaust the range and starve. James expressed these opinions in more than one of his books. I really think that this kind of epiphany came from his close observation and experience with the wild horse, because such empathy can only come from being out there with them day after day after day. Most easel painters visited the West on a casual basis, and even fewer lived there for any length of time. There weren't many artists who

remained long enough to fully understand what they were seeing, but Will
James was one.

Charlie Russell was another. Russell did a wonderful painting called
Wild Horse Hunters in which he shows the power of one animal nearly jerk-
ing a cowboy out of his saddle. It was the resistance of nature to the taming
influence—you can see that this horse wasn't going to take any of it lying
down! Russell clearly had a sympathy for the animal, and he went to great
pains to portray the struggle between the wild horse and the progress of
civilization. I often like to think that whatever turn that struggle takes often
depends on the tiniest thread: if the lariat breaks there is one outcome,
while with a rope that holds there will be another. I'd say the same holds
true with public policies about wild horses today.

There has always been a tremendous gap, whether over the fate of the
environment or Native Americans or wild horses or whatever, between
public perception and reality in the West. Not only is there a gap, these per-
ceptions are so intertwined that separating them is impossible. When John
Ford said, "Print the Legend!" he was in effect saying it's impossible to
divorce legend from history. You print the legend because it contains the
moral imperative within it; that is what is useful!

It may be that we have yet to tease out a moral imperative about wild
horses. This is why it is good for us to revisit the artists and writers of the
past. Currently I teach a class in western American art history, and not one
student even knows who Will James was, much less anything about his
books or art or how many movies were made from his books! These kids
come from rural environments, but they are all into modern popular cul-
ture so they know little about western art and western history. I think you
must have knowledge of *both* to truly understand any of the issues related to
wild horses. One has to understand the historical developments of such
issues to have some basis on which to decide what to do about them in the
future. Scientifically we know so much more than ever about these animals,
yet nowadays courts often make decisions based on dated laws.

Another thing that has interested me for some time is the changing

image of wild horses. The fate of wild horses has come to be a metaphor for the fate of the American West as a whole. In other words, if wild horses disappear, then we will have lost another chunk of the "West of the Imagination." As long as people know wild horses are roaming free out there, *somewhere*, then the *idea* of the West as the repository of American hopes and dreams is still intact. And I do think the American West represents our personal connection with nature. Our society has ceased to understand nature, which in itself is ironic since there is so much emphasis these days on conservation and good science. But many myths about wild horses still have an impact on public policy, and so we must eventually change the paradigm.

Cultural icons give one a frame of reference that's established through constant repetition. It's like the "types" Frederic Remington painted. In Remington's work, certain types of people and animals came to stand for the whole. All of his soldiers have a certain look, for instance; likewise Remington's horses. Remington created icons deliberately, and because his types are always portrayed a certain way, that's what the public has come to expect. In my view, the public is lazy. They prefer being fed a distilled view of types or icons without having to grapple with nuance, and since nuance takes time and effort to understand, they're content to let somebody else do it. "Let's turn it over to the courts" or "Let's turn it over to the judge" (because that's what laws are for), never understanding that the courts are probably the least able to interpret nuance because all they can do is look at the law and not at the reality of the situation, or at ethics, or at the landscape—at any of these factors.

Imagination is always greater and more interesting than reality! Cultural icons have always expressed just enough reality to seduce the viewer into believing that whatever is happening there is true. In the early nineteenth century, the White Stallion was described with such detail that people were seduced into believing there really was a horse out there like that. He must be real, and what he does must be real, because he is described so convincingly. This is what western art does. And realism in por-

trayals by artists like Remington, Russell, and others tends to seduce the viewer to believe that the scenes and actions in their paintings are real, too, when actually they are a metaphor and a symbol. The painting might to some degree be realistic in that it's based on a specific incident, but it's easy to overlook the essential fact that above all, it's art. And all artists editorialize.

By the time western painters abandoned the wild horse as a subject a few photographers became interested in them. The only early photographers I'm aware of who portrayed wild horses were Edward Curtis and a few contemporaries who photographed Native Americans with their horses. It's only after the 1950s that we begin to see contemporary photographers take to the mustang as a valid subject for their camera.

Coincident to this, wild horses emerged in western movies, although mostly they were played by trained horses. There were several movie versions of Will James's novels, but it really wasn't until *The Misfits* that the wider range of wild horse activity came into focus. That movie encouraged Wild Horse Annie's campaign to protect wild horses, and the public attention prompted even more photographers to take to the field. Most of these photographers (with the exception of Gus Bundy, who worked in the documentary tradition) glorified the mustang as an expression of freedom and the fate of the West. Their images conveyed the idea that wild horses still roamed the range and that something was being done to preserve them. Most photographers still present them this way, in fact. One never sees photography books that show ugly wild horses, or horses about to expire because they don't have enough to eat, or horses on the way to the rendering plant. I think there's a lot of manipulation going on between contemporary photographers, their images, and the viewer. Certainly that's acceptable in that all photography offers a certain viewpoint; however, a viewer should not accept a given image at face value that this is the way things are, any more than one should look at a Russell or Remington painting this way. Part of my work with students is to help them understand what messages paintings and photographs convey and to be critical in their

thinking—to take time to look deeper. In other words, let's not be seduced by the beauty these images convey without understanding other dimensions of the wild horse experience.

One test of the power of any cultural myth is that those that endure are the most flexible and inclusive. The myth can be molded to what you are, no matter who you are or where you live. This is the way with the myth of the American cowboy, for instance. All one needs to do is put on a pair of boots, add some clothes and a hat, and any dude can participate in the cowboy mythology.

The key to the continuation of any myth is also related to its diminishing reality, since the more something we love is portrayed as diminishing, the greater is our desire to preserve it. In my book on western photographer Erwin Smith I noted how prevailing anxiety about the disappearance of the Old West drew so many photographers and writers to the range to capture what was left before it disappeared forever. Well, that is the same motive that drew George Catlin to capture Indians on canvas decades before! What's ironic is that Indians, cowboys, and wild horses are still on the range today, and they are constantly morphing into new incarnations to meet the needs of contemporary society. People don't seem to want to face the day when there are no more cowboys, no more Indians, no more majestic landscapes, no more wild horses in the West. It is the work of artists, writers, and photographers that continues to confirm this fascinating relationship between the myth and the reality.

Waddie Mitchell: Cowboy Poet, Elko, Nevada

All I ever knew was ranching, horses, and ranch people. It's the world I lived in until about a dozen years ago when I started traveling through this poetry of mine. I was pretty much established as to who I was by then, so I had some real strong ideas and I was very close-minded about a lot of things. I've since gotten a much broader perspective on who people are and what they think. I hope with age comes a little bit of wisdom.

When I was growing up on Sherman Creek there were always wild horses

down by Buck Springs and Cherry Creek. In the wintertime after we got done feeding cows, it was a big deal for me to go along and rope some of those horses. That's what we used for our saddle horses. Now, I'm not saying there weren't some guys who tried to catch them and make some money whenever the prices were up, but there was actually very little of that going on, from what I could see. Mostly the ranchers took care of these horses. Maybe some of them didn't always admit it, but they liked the idea those horses were out there. But anytime you've got a wild animal like this, nature plays a big part. Drought, feed, wet years, disease, predators—there's just so many things that affect them. If there was a stud colt out there that was crooked legged or had bad feet and was crippled up, it sure would never survive fighting with the other wild studs. A crippled-up colt is the easiest kind of prey for predators. So I know of some people who went out there, too, and if there was an old ugly-headed stud there, or if they caught a few of his colts and it was obvious they weren't going to make good saddle horses because they were crippled or they didn't have a good temperament, then someone just dropped that old stud with a rifle. That's not something I say with any pride or that I think of as the best way to handle the horses; I'm just being honest.

There are so many issues out West, and I know most people don't have the time or inclination to study them. From my experience talking with folks, I think that many people take on a certain cause, whether it's about the environment or animals or what have you, and sometimes they have very little knowledge about what's actually going on. With these wild horses we have a situation where there are some wonderful caring people, and perhaps they see a photograph of a mustang and they want to make sure their presence doesn't leave us. What they don't understand is that, first of all, there's no such thing as a real wild horse. I'm sorry, but that's just like saying that there are still dinosaurs on the range. What we know of the horse today was manipulated by thousands of years of domestication, and the best reality is that these are feral horses. Now, it's wonderful if there's one little canyon with a hundred horses where somebody can say, "These

horses have been virtually unchanged for two hundred years." But really, what's two hundred years in the scheme of time? But we accept this ro- mance because we want there to be an original, pure, untouched horse.

When it comes to nature, there's nothing wrong with learning from books, but learning has to be coupled with hands-on knowledge. BLM didn't know anything about managing horses when this all started, but now the government is stuck between a rock and a hard spot because they have all these horses and no place to go with them. How *are* they going to manage them when their numbers are jumping tenfold? We used to worry up here about sixty horses in one area growing to seventy-four the next year if we weren't careful. Now they're worried about six hundred in one allotment one year because they'll be close to two thousand by the next few.

While all this is going on we have some ranchers who going broke and are naturally trying to get their voice heard. I think for a long time BLM pre- tended a lot of these problems weren't happening, but finally they realized, "Maybe we should have established numbers for these horses a long time ago and just kept everything to that number."

Okay, so we've got to put these horses somewhere. Well, then, let's adopt them. Everybody wants a wild horse, right? How much more romantic can you get? I don't think that was very well thought out either. Say some guy and his wife show up with a Datsun pickup and they've made a makeshift plywood rack in the back. They think their new horse is going to be like Fury. They're going to open the tailgate and say, "Get in!" and that horse will jump in the back, and they'll take it home and put it in the backyard, and they'll turn it loose, and the kids will fall in love with it, and they're all going to ride together, and there's going to be a beautiful relationship, and everybody's going to be fine. But usually what happens is they let that tail- gate down, and the first thing is they get kicked, and the wrangler who is trying to help load that horse has to ask them to get the hell out of the way. And then they may get the horse in the truck and drive four miles down the road when the horse busts everything loose, and because he's tied down in there he gets all banged up. So now they're really feeling terrible, and they

take the horse to the vet and spend $600 getting him fixed up, but in the meantime they can't go home and doctor him because that horse will kick. I know I'm making fun of things, but the truth is the mistake belongs to all of us. And who has really suffered? Well, some of adopters have suffered. And ranchers have sure suffered, which touches close to me. But what's suffering in the big scheme of things is the wild horse. We must all relate to this.

The whole situation has gone way past the point of some nice ideas. We have dug ourselves in a hole with these horses, and now something needs to be implemented to get out of it.

BLM's job is political whether they want to admit that or not, so they're probably right to say this is the public's decision. Well, that's easily said. Let's say you are an aspiring politician. Are you going to commit political suicide by approving the slaughter of any of these animals? Do you think there won't be militants out there chaining themselves to trucks? Do you think it won't be on the six o'clock news with someone demanding on a sixty-second sound byte that there has to be an immediate resolution? Who is going to want to have their name associated with a problem based on a mistake that happened years ago when they weren't even in office?

We have to look at the reality of what has happened here. And this breaks my heart. It breaks the hearts of many others who know about it. That's why I'm still looking for a politician with guts, the kind of person who'll say, "I'm sorry, we've got to do this; we've got to clean up this mess."

We Americans may lack education in many areas, but we still have access to more information than anybody else on this planet. It's our lifestyle. I'm convinced that if the American people understand the truth about what we're up against out West, they will respond. Anybody with a heart would answer the same. The wild horse situation is like a train heading down the track, and all we can do is try and clear things out of the way. And why? For what originally came from the goodhearted gesture of people who wanted to give this animal a chance to continue on for generations.

This is my lifestyle and Nevada is my state, and over the years I've seen

what has happened. People want to treasure what's left of the romantic Wild West. That's a wonderful gesture and I applaud it, but romance is a state of mind. Reality is day-to-day life. Romance is what gets us through that reality, but if you live strictly in the idea of romance you won't ever have a full life. After September 11 I wrote a poem about this and I think it applies here:

> I used to wonder it takes so many scars for us to learn,
> Seems we can't relate to hot until our fingers have been burned.
> But like cream destined to be butter, first we've got to take a turn
> Through that churn we call experiencing life.
> For we'd not know what's meant by wind unless we'd felt it when it blowed.
> We can't judge the weight of burden 'til we've packed a heavy load
> Or appreciate a ride 'til we've walked some lonesome road,
> And broke the code to that experience in life.
>
> When you're fighting every dragon that you meet
> You tend to learn the times to charge and to retreat.
> We need to know of good and bad, of some rapture and of some sad
> If we're to make this life experience complete.
> For we wouldn't see the joy in pleasure without knowing first of pain
> And if we're truly to forgive, sometime we've had to bear the blame.
> And if there were no threat of loss, why would one ever strive for gain,
> While in this game we call experience in life?
>
> It's through doing we learn there is wrong and right,
> It's through feeling we learn sorrow from delight.
> Just believing there exists some chance for finding happiness
> Will always pull us through the darkest of our nights.
> When we accept we'll have some triumphs and defeats
> And we consent to take the bitter with the sweet,
> It's then, those opposite extremes and all their levels in between

Will help to reconcile our balance sheet, so our life experience will
have been complete.

We shouldn't beat ourselves up over where the wild horse issue is today.
But we should start beating ourselves up if we know what's wrong and don't
deal with it. We still have a long way to go on this environment, and we bet-
ter not use scare tactics to get things done. We better use true knowledge
and experience. We saw how this thing happened. Let's learn from it and
let's not let politics rule.

Afterword

See, Lord,
my coat hangs in tatters,
like homespun, old, threadbare.
All that I had of zest,
all my strength,
I have given in hard work
and kept nothing for myself.
Now
my poor head swings
To offer up all the loneliness of my heart.

Dear God,
stiff on thickened legs
I stand here before you:

OH! of your goodness,
give me a gentle death.

"The Prayer of the Old Horse," by Carmen Bernos de Gasztold (translated from the French by Rumer Godden).

PUBLIC LAW 92-195: THE WILD FREE-ROAMING HORSES AND BURROS ACT

92ND CONGRESS, S. 1116
December 15, 1971

AN ACT

To require the protection, management, and control of wild free-roaming horses and burros on public lands.

Be it enacted by the Senate and House of Representatives of the United States of America in Congress assembled. That Congress finds and declares that wild free-roaming horses and burros are living symbols of the historic and pioneer spirit of the West; that they contribute to the diversity of life forms within the Nation and enrich the lives of the American people; and that these horses and burros are fast disappearing from the American scene. It is the policy of Congress that wild free-roaming horses and burros shall be protected from capture, branding, harassment, or death; and to accomplish this they are to be considered in the area where presently found, as an integral part of the natural system of the public lands.

Sec. 2. As used in this act—

(a) "Secretary" means the Secretary of the Interior when used in connection with public land administered by him through the Bureau of Land Management and the Secretary of Agriculture in connection with public lands administered by him through the Forest Service;

(b) "wild free-roaming horses and burros" means all unbranded and unclaimed horses and burros on public lands of the United States;

(c) "range" means the amount of land necessary to sustain an existing herd or herds of wild-free roaming horses and burros, which does not exceed their known territorial limits, and which is devoted principally but not necessarily exclusively

to their welfare in keeping with the multiple-use management concept for the public lands;

(d) "herd" means one or more stallions and his mares; and

(e) "public lands" means any lands administered by the Secretary of the Interior through the Bureau of Land Management or by the Secretary of Agriculture through the Forest Service.

Sec. 3 (a) All wild free-roaming horses and burros are hereby declared to be under the jurisdiction of the Secretary for the purpose of management and protection in accordance with the provisions of this Act. The Secretary is authorized and directed to protect and manage wild free-roaming horses and burros as components of the public lands, and he may designate and maintain specific ranges on public lands as sanctuaries for their protection and preservation, where the Secretary after consultation with the wildlife agency of the State Board established in section 7 of this Act deems such action desirable. The Secretary shall manage wild free-roaming horses and burros in a manner that is designed to achieve and maintain a thriving ecological balance on the public lands. He shall consider the recommendations of qualified scientists in the field of biology and ecology, some of whom shall be independent of both Federal and State agencies and may include members of the Advisory Board established in section 7 of this Act. All management activities shall be at the minimal feasible level and shall be carried out in consultation with the wildlife agency of the State wherein such lands are located in order to protect the natural ecological balance of all wildlife species which inhabit such lands, particularly endangered wildlife species. Any adjustments in forage allocations on any such lands shall take into consideration the needs of other wildlife species which inhabit such lands.

(b) Where an area is found to be overpopulated, the Secretary, after consulting with the Advisory Board, may order old, sick, or lame animals to be destroyed in the most humane manner possible, and he may cause additional excess wild-free roaming horses and burros to be captured and removed for private maintenance under humane conditions and care.

(c) The Secretary may order wild free-roaming horses or burros to be destroyed in the most humane manner possible when he deems such action to be an act of

mercy or when in his judgment such action is necessary to preserve and maintain the habitat in a suitable condition for continued use. No wild free-roaming horse or burro shall be ordered to be destroyed because of overpopulation unless in the judgment of the Secretary such action is the only practical way to remove excess animals from the area.

(d) Nothing in this Act shall preclude the customary disposal of the remains of a deceased wild free-roaming horse or burro, including those in the authorized possession of private parties, but in no event shall such remains, or any part thereof, be sold for any consideration, directly or indirectly.

Sec. 4. If wild free-roaming horses or burros stray from public lands onto privately owned land, the owners of such land may inform the nearest Federal marshal or agent of the Secretary, who shall arrange to have the animals removed. In no event shall such wild free-roaming horses and burros be destroyed except by the agents of the Secretary. Nothing in this section shall be construed to prohibit a private landowner from maintaining wild free-roaming horses or burros on his private lands, or lands leased from the Government, if he does so in a manner that protects them from harassment, and if the animals were not willfully removed or enticed from the public lands. Any individuals who maintain such wild free-roaming horses or burros on their private lands or lands leased from the Government shall notify the appropriate agent of the Secretary and supply him with a reasonable approximation of the number of animals so maintained.

Sec. 5. A person claiming ownership of a horse or burro on the public lands shall be entitled to recover it only if recovery is permissible under the branding and estray laws of the State in which the animal is found.

Sec. 6. The Secretary is authorized to enter into cooperative agreements with other landowners and with the State and local governmental agencies and may issue such regulations as he deems necessary for the furtherance of the purposes of this Act.

Sec. 7. The Secretary of the Interior and the Secretary of Agriculture are authorized and directed to appoint a joint advisory board of not more than nine members to advise them on any matter relating to wild free-roaming horses and burros and their management and protection. They shall select as advisers persons who

are not employees of the Federal or State Governments, and whom they deem to have special knowledge about protection of horses and burros, management of wildlife, animal husbandry, or natural resources management. Members of the board shall not receive reimbursement except for travel and other expenditures necessary in connection with their services.

Sec. 8 (a) Any person who—

(1) willfully removes or attempts to remove a wild free-roaming horse or burro from the public lands, without authority from the Secretary, or

(2) converts a wild free-roaming horse or burro to private use, without authority from the Secretary, or

(3) maliciously causes the death or harassment of any wild free-roaming horse or burro, or

(4) processes or permits to be processed into commercial products the remains of a wild free-roaming horse or burro, or

(5) willfully violates a regulation issued pursuant to this Act, shall be subject to a fine of not more than $2,000, or imprisonment for not more than one year, or both. Any person so charged with such violation by the Secretary may be tried and sentenced by any United States commissioner or magistrate designated for that purpose by the court by which he was appointed, in the same manner and subject to the same conditions as provided for in section 3401, title 18, United States Code.

(b) Any employee designated by the Secretary of the Interior or the Secretary of Agriculture shall have power, without warrant, to arrest any person committing in the presence of such an employee a violation of this Act or any regulation made pursuant thereto, and to take such person immediately for examination or trial before an officer or court of competent jurisdiction, and shall have power to execute any warrant or other process issued by an officer or court of competent jurisdiction to enforce the provisions of this Act or regulations made pursuant thereto. Any judge of a court established under the laws of the United States, or any United States magistrate may, within his respective jurisdiction, upon proper oath or affirmation showing probable cause, issue warrants in all such cases.

Sec. 9. Nothing in this Act shall be construed to authorize the Secretary to relo-

cate wild free-roaming horses or burros to areas of the public lands where they do not presently exist.

Sec. 10. After the expiration of thirty calendar months following the date of enactment of this Act, and every twenty-four calendar months thereafter, the Secretaries of the Interior and Agriculture shall submit to Congress a joint report on the administration of this Act, including a summary of enforcement and/or other actions taken thereunder, costs, and such recommendations for legislative or other actions as he might deem appropriate.

The Secretary of the Interior and the Secretary of Agriculture shall consult with respect to the implementation and enforcement of this Act and to the maximum feasible extent coordinate the activities of their respective departments and in the implementation and enforcement of this Act.

The Secretaries are authorized and directed to undertake those studies of the habits of wild free-roaming horses and burros that they may deem necessary in order to carry out the provisions of this Act.

GLOSSARY

Appropriate management level (AML) The number of wild horses designated in a geographical area to be in balance with their habitat.

Bachelor A young male horse without a harem.

Bachelor band A group of young male horses.

Band A small family group made up of mares, foals, yearlings, and a lead stallion. Also called a harem.

Broomtail A derogatory term for a scrawny, ugly, inbred, or otherwise unhealthy wild horse.

Cavvy (caveata) Saddle horses used by a buckaroo crew.

Cayuse A slang term for a small wild horse. It often refers to horses owned by Native Americans; borrowed from the Cayuse Indians on the Columbia Plateau.

Colt A young male horse or foal, especially as distinguished from a filly.

Creasing An inhumane frontier method of temporarily stunning wild horses by nicking them with a bullet across the lower neck.

Dally up To turn the rope one or more times around the saddle horn after catching something in the loop with a catch rope, lass rope, lariat, or riata (leather braided rope).

Dam Female parent.

Dawn horse *Eohippus*; the original prehistoric form of the horse that evolved on the North American continent.

Dun A traditional buckskin coat color associated with primitive horse characteristics.

Feral Referring to a domesticated animal that returns to the wild.

Filly A young female horse or foal.

Foal A young horse up to one year of age.

Frequent flyer Slang term for an undesirable wild horse that has been repeatedly recycled through the BLM adoption program.

Gather A wild horse roundup to capture, sort, brand, and manage mustang herds; also to monitor, track, or collect information about their populations.

Grulla A coat color consisting of various shades of silver-brown.

Hammerhead Derogatory term for an ugly or inbred wild horse.

Herd management area (HMA) A BLM-designated habitat boundary within which wild horses and burro herds are managed.

Hobble To bind the front feet to discourage travel.

Holding facility Corrals or pastures where BLM wild horses are maintained after capture.

Home range The territory of a wild horse band.

Judas horse A trained domestic horse used to lead mustangs into a trap.

Jughead Derogatory term for a scrawny, ugly, inbred, or otherwise unhealthy wild horse.

Lead mare The mare who takes first position leading the herd as it travels the range; the stallion usually drives or directs the band from the rear.

Leppy A foal abandoned by its dam or orphaned by her death.

Mustang A wild horse; from the Spanish term *mesteno,* meaning "stray horse."

Mustanger A professional, semiprofessional, or amateur wild horse gatherer; a wild horse runner.

Mustanging An overall term for the practice of gathering wild horses applied to individuals, local ranch roundups, and large or otherwise independent commercial horse runners. Methods are based on herd size, water sources, and geography.

Mustang fever The thrill of running, trapping, and outsmarting wild horses. Also called "wild horse fever."

Parada The saddle horses used by a buckaroo crew; also called a "cavvy."

Pony in the sky Helicopter used to herd and gather mustangs.

Range *Traditional:* a vast, isolated region of the West where grazing animals roam. *Scientific:* a natural biological complex with plants, bacteria, insects, birds, and animals interspersed and feeding on one another, dependent on soil and water resources.

Remuda Same as a cavvy; typically used more in Texas.

Roping and running Method of capturing mustangs by chasing after them until they tire, then corralling and roping them. Historically popular as recreation for the excitement of the chase and capture and for the opportunity to own one or more horses.

Sabino Pinto; having a coat marked with patches of brown/black/red and white.

Sacking out The practice of establishing contact with a wild or untrained domestic horse by using a blanket, rag, or feed sack to accustom it to human touch, voice, and other movements; can be done roughly or gently.

Sale authority Authority granted to U.S. Bureau of Land Management and U.S. Forest Service to transfer ownership of excess wild horses and burros by public sale.

Sanctuary An area on private or public land where old, sick, or unadoptable wild horses live out their lives.

Satellite stud An old stallion or bachelor without a harem who follows an established family band at close proximity.

Stove up A horse sore to the extent that it cannot be ridden. This is usually not the same as being lame.

Stud pile Fecal droppings made by a stallion and/or his family band on the range.

Walking down An almost lost method of capturing and outsmarting wild horses by walking (on foot or horseback) behind a small herd until they lose their fear of pursuit, and then herding them into a trap. Walking down requires great skill and patience and is extremely time-consuming.

Water-trap Method of luring wild horses to a water hole by hiding out of sight, then trapping them by closing a gate on a corral built to surround the spring. Water traps are often permanent structures left at the water hole to accustom mustangs to their presence. Impractical in areas where there are numerous water sources or large numbers of horses.

Wild rag Slang term for plastic bags waved at horses during gathers to humanely direct them into a corral; also a traditional term for the large silk scarves worn by working cowboys.

Wing trap A trap using fences set up in a v shape to lead horses into a corral; the fences must be made of material that horses cannot see through so they neither escape nor harm themselves. Historic wing traps were made of available materials and occasionally remained as permanent fixtures on the range. They often incorporated natural features such as rock outcroppings. Modern trap fences are made of jute hung on metal fence posts, which are lightweight and portable, along with movable steel corrals.

BIBLIOGRAPHY

Amaral, Anthony. *Mustang: Life and Legends of Nevada's Wild Horses.* Reno: University of Nevada Press, 1977.

———. "The Wild Horse in Nevada: From Glory to Cauldron." *Nevada Magazine* (c. 1960).

Austin, Mary. *The Land of Little Rain.* 1903. Reprint. Albuquerque: University of New Mexico Press, 1974.

Barber, Ted. *The Barnstorming Mustanger.* Orovada: Barber Industries, 1987.

Barnes, Will C. "Wild Horses." *McClure's Magazine* (January 1909): 285–98.

Berger, Joel. *Wild Horses of the Great Basin.* Chicago: University of Chicago Press, 1986.

Bergon, Frank. *Shoshone Mike.* New York: Viking Penguin, 1987.

Berry, Wendell. *A Continuous Harmony.* New York: Harcourt Brace, 1972.

———. *The Unsettling of America: Culture and Agriculture.* New York: Avon, 1977.

Boone, J. Allen. *Kinship with All Life.* San Francisco: Harper Collins, 1954.

Bowman, Nora Linjer. *Only the Mountains Remain.* Caldwell: Caxton Printers, 1958.

Budiansky, Stephen. *The Covenant of the Wild.* New Haven: Yale University Press, 1999.

———. *The Nature of Horses: Exploring Equine Evolution, Intelligence, and Behavior.* New York: Free Press, 1997.

———. *Nature's Keepers: The New Science of Nature Management.* New York: Free Press, 1995.

Bundy, Gus. "Wild Horse Roundup." *Reno Pace,* December 1952.

Burkhardt, J. Wayne. *Herbivory in the Intermountain West: An Overview of Evolutionary History, Historic Cultural Impacts and Lessons from the Past.* Idaho Forest, Wildlife, and Range Experiment Station, Station Bulletin 58, 1996.

Catlin, George. *Life among the Indians.* New York: Dover Reprint, 1973.

Clark, Kenneth. *Animals and Men.* New York: William Morrow, 1977.

Clark, Walter van Tilburg. "The Rise and Passing of Bar." In *The Personality of the Horse,* ed. Brandt Aymar and Edward Sagarin. New York: Wings, 1963.

Cline, Gloria Griffen. *Exploring the Great Basin.* Norman: University of Oklahoma Press, 1963.

Clutton-Brock, Juliet. *Horse Power: A History of the Horse and Donkey in Human Societies.* Cambridge: Harvard University Press, 1992.

Clymer, F., and C. Preston, eds. *Unbroken Spirit: The Wild Horse in the American Landscape.* Cody: Buffalo Bill Historical Center, 1999.

Crowell, Pers. *Cavalcade of American Horses.* New York: McGraw-Hill, 1951.

Curtin, Sharon. *Mustang.* New York: Rufus Publications, 1996.

Daggett, Dan. *Beyond the Rangeland Conflict: Toward a West That Works.* Layton: Gibbs Smith, 1995.

Davis, S. L. "The Least Harm Principle May Require that Humans Consume a Diet Containing Large Herbivores, Not a Vegan Diet." *Journal of Agricultural and Environmental Ethics* 16, no. 4 (2003): 387–94.

Denhardt, Robert Moorman. *The Horse of the Americas.* 1947. Reprint. Norman: University of Oklahoma Press, 1974.

Dines, Lisa. *The American Mustang Guidebook.* Minocqua: Willow Creek Press, 2001.

Dobie, J. Frank. *The Mustangs.* 1952. Reprint. Austin: University of Texas Press, 1999.

———. *Mustangs and Cow Horses.* 1940. Reprint. Dallas: Southern Methodist University Press, 1982.

Dorrance, Bill. *True Horsemanship through Feel.* Diamond Lu Productions, 1999.

Dorrance, Tom. *True Unity: Willing Communication between Horse and Human.* Tuscarora: Give-It-A-Go Enterprises, 1987.

Ehrenfeld, David. *Beginning Again: People and Nature in the New Millennium.* New York: Oxford University Press, 1993.

Elliott, Russell R. *History of Nevada.* Lincoln: University of Nebraska Press, 1973.

Emmerich, Fay L., James A. Young, and J. Wayne Burkhardt. "A Nevada Ranch Family: Their Success through Four Generations." *Rangelands* 14, no. 2 (April 1992).

Eustis-Cross, Barbara, and Nancy Bowker. *The Wild Horse: An Adopter's Manual.* New York: Howell Books, 1992.

Evans, Bernard, and Gregory Cusack, eds. *Theology of the Land.* Collegeville: Liturgical Press, 1987.

Ewing, Sherm. *The Range.* Missoula: Mountain Press, 1990.

Findley, Tim. "The Mustangers." *Range* 5, no. 64 (Winter 1998).

Fletcher, F. N. *Early Nevada: The Period of Exploration, 1776–1848.* 1929. Reprint. Reno: University of Nevada Press, 1980.

Flores, Dan. "Where Have All the Pretty Horses Gone." In *Horizontal Yellow.* Albuquerque: University of New Mexico Press, 1999.

Ford, Sewell. "Black Eagle Who Once Ruled the Ranges." In *The Personality of the Horse,* ed. Brandt Aymar and Edward Sagari. New York: Wings, 1963.

Foss, Philip. *Politics and Grass: The Administration of Grazing on the Public Domain.* Seattle: University of Washington Press, 1960.

Frémont, John Charles. *Personal Journals: The Expeditions of John Charles Frémont.* Vol. 1: *Travels from 1838–1844.* Ed. Donald Jackson and Mary Lee Spence. Urbana: University of Illinois Press, 1970–84.

Ganskoff, David, and Martin Vavra. "Habitat Use by Feral Horses in the Northern Sagebrush Steppe." *Journal of Range Management* 39, no. 3 (May 1986): 207–11.

Gasztold, Carmen Bernos de. *Prayers from the Ark.* New York: Viking, 1962.

"The Ghost Horse." From *Long Lance,* by Chief Buffalo Long Lance, 1928. In *Random House Book of Horse Stories,* ed. Felicity Trotman. New York: Random House, 1996.

Goble, Paul. *The Girl Who Loved Wild Horses.* New York: Simon and Schuster, 1978.

Goetzmann, William H., and William N. Goetzmann. *The West of the Imagination.* New York: W. W. Norton, 1986.

Golden, Lily, ed. *The Literary Horse: Great Modern Stories about Horses.* New York: Atlantic Monthly, 1995.

Grandin, Temple. *Animals in Translation: Using the Mysteries of Autism to Decode Animal Behavior.* New York: Scribner, 2005.

———. "Handling Mustangs." *Western Horseman* (April 2001): 180–86.

———. *Thinking in Pictures.* New York: Doubleday, 1995.

The Great Basin: Healing the Land. Washington, D.C.: Bureau of Land Management, April 2000.

Green, Ben K. *A Thousand Miles of Mustangin.'* Flagstaff: Northland Press, 1972.

Hadley, C. J. "Wild Horses: No Home on the Range?" *Range* 1, no. 2 (Fall/Winter 1992).

Hanks, Edward M. *A Long Dust on the Desert.* Sparks, Nev.: Western Printing and Publishing, 1967.

Hanley, Mike, with Ellis Lucia. *Owyhee Trails.* Caldwell: Caxton Printers, 1973.

Hearne, Vicki. *Adam's Task: Calling Animals by Name.* New York: Vintage Books, 1987.

Henry, Marguerite. *Mustang: Wild Spirit of the West.* New York: Macmillan, 1966.

Hillenbrand, Laura. "What's Best for America's Mustangs." *Equus* (August 1998): 45–58.

———. *Seabiscuit: An American Legend.* New York: Random House, 1991.

Houghton, Samuel G. *A Trace of Desert Waters: The Great Basin Story.* Salt Lake City: Howe Brothers, 1976.

Howard, Helen Addison. "The Horse That Helped to Win the West." In *American Frontier Tales.* Missoula: Mountain Press, 1982.

Hullinger, Pam, and Carolyn Stull. *Emergency Euthanasia of Horses: Consideration for Owners, Equine Facility Managers, Auction Market Operators, Horse Transporters, and Law Enforcement Officers.* University of California, Davis, Veterinary Medicine Extension Booklet, November 1999.

Hunt, Frazier, and Robert Hunt. *Horses and Heroes: The Story of the Horse in America for 450 Years.* New York: Charles Scribner's Sons, 1949.

Hunt, Ray. *Think Harmony with Horses: An In-Depth Study of the Horse/Man Relationship.* Tuscarora: Give-It-A-Go Enterprises, 1978.

Jackman, E. R., and Reub Long. *The Oregon Desert.* Caldwell: Caxton Printers, 1964.

Jackson, Jaime. *The Natural Horse: Lessons from the Wild for Domestic Horse Care.* Flagstaff: Northland, 1992.

James, Will. *Cow Country.* New York: Charles Scribner's Sons, 1927.

———. *Horses I've Known.* Cleveland: World Publishing, 1945.

———. "Pinon and the Wild Ones." *Saturday Evening Post,* May 19, 1923.

———. *Sand.* 1929. Reprint. Missoula: Mountain Press, 1996.

———. *Smoky the Cowhorse.* New York: Charles Scribner's Sons, 1926.

———. *The Three Mustangeers.* 1933. Reprint. Missoula: Mountain Press, 1999.

Johnston, Velma B. "The Fight to Save a Memory." *Texas Law Review* (May 1972): 1055–64.

King, Olephia. "Leafy." In *Western Poems.* Nevada: Fallon Publishing, 1965.

———. *Western Poems No. 2.* Nevada: Fallon Publishing, 1967.

Kirkpatrick, Jay F. *Into the Wind.* Minocqua: North Wind Press, 1994.

Klinkenborg, Verlyn. "The Mustang Myth." *Audubon* (January–February 1994): 34–42.

Knudtsen, Molly Flagg. *Here Is Our Valley.* Reno: University of Nevada Press, 1975.

Lang, Gerald, and Lee Marks. *The Horse: Photographic Images, 1839 to the Present.* New York: Harry N. Abrams, 1991.

Lawrence, Elizabeth Atwood. *Hoofbeats and Society: Studies of Human-Horse Interactions.* Bloomington: University of Indiana Press, 1985.

Laxalt, Robert. *Dust Devils.* Reno: University of Nevada Press, 1997.

——. *Nevada: A History.* New York: W. W. Norton, 1977.

Lindsay, Vachel. "The Bronco That Would Not Be Broken." In *Best Loved Poems of the American West,* ed. John J. Gregg and Barbara T. Gregg. New York: Doubleday, 1980.

Livingstone-Learmonth, David. *The Horse in Art.* London: Studio Publications, 1958.

Lord, Russell. *The Care of the Earth: A History of Husbandry.* New York: Thomas Nelson and Sons, 1962.

Mathis, Dave. *Following the Nevada Wildlife Trail.* Reno: Nevada Agricultural Foundation, 1997.

McDaniel, Jay, and Charles Pinches, eds. *Good News for Animals.* New York: Orbis Books, 1993.

McGuane, Thomas. *Some Horses.* New York: Lyons Press, 1999.

McInnis, Michael, and Martin Vavra. "Dietary Relationships among Feral Horses, Cattle, and Pronghorn in Southeastern Oregon." *Journal of Range Management* 40, no. 1 (January 1987): 60–66.

McPhee, John. *Basin and Range.* New York: Farrar, Straus and Giroux, 1984.

Menino, Holly. *Forward Motion: World Class Riders and the Horses Who Carry Them.* New York: North Point Press, 1996.

Morris, Desmond. *Horsewatching.* New York: Crown, 1988.

Muybridge, Eadweard. *Animals in Motion.* London: Chapman and Hall, 1925.

Nevada Commission for the Preservation of Wild Horses. "Plan of Goals, Strategies and Recommendations for the Preservation and Protection of the Wild Horses for the State of Nevada." January 1999.

Nelson, Barney. *The Wild and the Domestic: Animal Representation, Ecocriticism, and Western American Literature.* Reno: University of Nevada Press, 2000.

Perkins, Charles Elliott. *The Pinto Horse.* 1927. Lincoln: University of Nebraska Press, 1998.

Pierson, Melissa. *Dark Horses and Black Beauties.* New York: W. W. Norton, 2000.

Pony Boy, GaWaNi. *Horse Follow Closely.* Irvine: Bow Tie Press, 1998.

The Pony Express in Nevada. 1976. Carson City: Nevada State Museum, 1996.

"The Poor Boy and the Mud Ponies." In *American Indian Prose and Poetry*, ed. Margot Astrov. New York: Capricorn Books, 1962.

Price, B. Byron. "Wild Horses in Popular Culture." In *Unbroken Spirit*, ed. F. Clymer and C. Preston. Cody: Buffalo Bill Historical Center, 1999.

Proceedings of the National Wild Horse Forum, April 4–7, 1977. Cooperative Extension Service, University of Nevada, Reno, R-127, August 1977.

Rarey, J. S. *The Modern Art of Taming Wild Horses.* 1856. Reprint. Bedford: Applewood Press, 1995.

Rashid, Mark. *Considering the Horse.* Boulder: Johnson Books, 1993.

Reisner, Marc. *Cadillac Desert.* New York: Penguin Books, 1993.

Reiss, Bob. "Wild Horses: Our Runaway Heritage." *Equus* (June 1979).

Robertson, Alden. *The Wild Horse Gatherers.* San Francisco/New York: Sierra Club Books/Charles Scribner's Sons, 1978.

Roe, F. G. *The Indian and the Horse.* Norman: University of Oklahoma Press, 1955.

Rosenthal, C. P. *Elena and the Stars.* New York: St. Martin's Press, 1991.

Russell, Charles M. *Trails Plowed Under.* New York: Doubleday, 1927.

Ryden, Hope. *America's Last Wild Horses.* New York: Ballantine Books, 1970.

Sagebrush Trilogy: Idah Meacham Strobridge and Her Works. Reno: University of Nevada Press, 1990.

Scanlan, Lawrence. *Wild about Horses.* New York: Harper Collins, 1998.

Scully, Matthew. *Dominion.* New York: St. Martin's Press, 2002.

Sidney, Samuel. *The Book of the Horse.* 1880. Reprint. New York: Crown Publishers, 1985.

Sloan, John. "Darkness Itself." In *Nevada: True Tales from the Nevada Wilderness.* Salt Lake: University of Utah Press, 1993.

Smith, Regina C., Peggy McGuckian Jones, John R. Roney, and Kathryn E. Pedrick. *Prehistory and History of the Winnemucca District: A Cultural Resources Literature Overview.* Washington, D.C.: Bureau of Land Management, Cultural Resource Series 6, 1983.

Smythe, R. H. *The Mind of the Horse.* Lexington: Stephen Greene Press, 1965.

Spragg, Mark, ed. *Thunder of the Mustangs.* Hong Kong: Sierra Club/Tehabi Books, 1997.

Starrs, Paul F. *Let the Cowboy Ride.* Baltimore: Johns Hopkins University Press, 1998.

Steele, Rufus. *Mustangs and the Mesas.* Hollywood, Calif.: Murray and Gee, 1941.

———. "Mustangs, Busters and Outlaws of the Nevada Wild Horse Country."*American Magazine* 72 (1911): 756–65.

———. "Trapping Wild Horses in Nevada."*McClure's* 34 (1913): 198–209.

Steiner, Stan. *Dark and Dashing Horsemen.* New York: Harper and Row, 1981.

———. *The Waning of the West.* New York: St. Martin's Press, 1989.

Stong, Phil. *Horses and Americans.* New York: Garden City, 1939, 1946.

Symanski, Richard. *Wild Horses and Sacred Cows.* Flagstaff: Northland Press, 1985.

Taft, Robert. *Artists and Illustrators of the Old West.* New York: Charles Scribner's Sons, 1953.

The 10th and 11th Reports to Congress on the Administration of the Wild Free Roaming Horses and Burro Act, 1992–1995. Washington, D.C.: U.S. Department of the Interior, Bureau of Land Management; U.S. Department of Agriculture, Forest Service.

Thomas, Heather Smith. *The Wild Horse Controversy.* New York: A. S. Barnes, 1979.

Thompson, Paul B. *The Spirit of the Soil: Agriculture and Environmental Ethics.* London: Routledge, 1995.

Trenholm, Virginia Cole, and Maurine Carley. *The Shoshonis: Sentinels of the Rockies.* Norman: University of Oklahoma Press, 1964.

Trimble, Stephen. *The Sagebrush Ocean.* Reno: University of Nevada Press, 1989.

Turner, Frederick. "Roping a Dream." In *Of Chiles, Cacti, and Fighting Cocks.* San Francisco: North Point Press, 1990.

Turner, John W. "An Introduction to the Montgomery Pass Wild Horse Territory." Field notes, 1998.

Ulph, Owen. *The Fiddleback.* Salt Lake City: Dream Garden Press, 1981.

Van Dyke, John C. *The Desert.* 1901. Reprint. Salt Lake City: Peregrine Smith, 1980.

Vavra, Martin, and Forrest Sneva. "Seasonal Diets of Five Ungulates Grazing the Cold Desert Biome." In *Proceedings of the First International Rangeland Congress,* 1978, 435–37.

Vernon, Arthur. *The History and Romance of the Horse.* Boston: Waverly House, 1939.

Webb, Walter Prescott. *The Great Plains.* New York: Ginn and Company, 1931.

Welsch, Roger L. *Mister, You Got Yourself a Horse: Tales of Old-Time Horse Trading.* Lincoln: University of Nebraska Press, 1981.

Wheeler, Sessions S. *The Black Rock Desert.* Caldwell: Caxton Printers, 1978.

Wild Free-Roaming Horses and Burros: Ensuring the Legend Lives Free. Tactical Plan of the Bureau of Land Management, Nevada, May 1999.

Wissler, Clark. "The Influence of the Horse in the Development of Plains Indian Culture." *American Anthropologist,* n.s., 26 (1914): 1–25.

Woolley, Dale E. *The Dameles and the American Curly Horse.* Limited private publication, 1993.

Worster, Donald. *Under Western Skies: Nature and History in the American West.* Oxford: Oxford University Press, 1992.

Wyman, Walker D. *The Wild Horse of the West.* Lincoln: University of Nebraska Press, 1945, 1963.

Xenophon. *On Horsemanship.* Trans. M. H. Morgan. London: J. Allen, 1999.

Young, Cheryl, ed. *The Wild Horse in Nevada.* Carson City: Nevada State Museum, 1985.

Young, James A. "Haymaking: The Mechanical Revolution on the Western Range." *Western Historical Quarterly* 14, no. 3 (July 1983).

Young, James A., and Dave Mathis. "Remounts." *Rangelands* 4, no. 1 (February 1982).

Young, James A., and B. Abbott Sparks. *Cattle in the Cold Desert.* Logan: Utah State University Press, 1985.

CONTRIBUTORS

Bob Abbey is the former Nevada state director of the Bureau of Land Management, where he once supervised activities on forty-eight million acres of public lands with eight district field offices and an annual budget of about $51 million.

Glade Anderson was born and raised in Utah. He was involved with all aspects of the wild horse program until moving to Nevada in 2002. He now manages the Palomino Valley National Wild Horse and Burro Center in Nevada.

Jim Andrae grew up in Independence Valley, Nevada, and is a graduate of the School of Hard Knocks. He manages the historic IL Ranch on the Owyhee Desert where the nearest fence line is thirty miles away.

Leland Arigoni was born November 30, 1910, in Railroad Valley, the son of Swiss Italian immigrants. He was honored by the Nevada Cattlemen's Association for spending an estimated 124,000 miles in the saddle as a working buckaroo.

John L. "Jack" Artz worked for forty years as a natural resource educator and manager in the Great Basin. In 1977 he coordinated the National Wild Horse Forum with Wild Horse Annie, and in 1998 he was appointed by the secretary of the interior to serve on the National Wild Horse and Burro Advisory Board.

Katie Blunk, D.V.M. is field veterinary medical officer for the U.S. Department of Agriculture Animal and Plant Health Inspection Service (APHIS).

Bob Brown retired in 2001 after twenty-six years of service with the Bureau of Land Management in Nevada and Utah. For eighteen years Bob was the wild horse specialist for the Ely Field Office, where he coordinated the protection and management of twenty-five hundred wild horses on twenty-four herd management areas of more than four million acres.

Joyce Brown, a Nevada resident for thirty years, adopted her wild horse, Romeo, in 1998. She is a member of the National Wild Horse Association and the Henderson Saddle Club.

Stephen Budiansky, former editor of *Nature*, has authored several books dealing with the interconnection of humans, animals, and the environment, including *The Nature of Horses, The Covenant of the Wild*, and *Nature's Keepers*.

Wayne Burkhardt, Ph.D. is a professor of range management at the University of Idaho. His career spans nearly four decades in rangeland management, teaching, research, and extension. Wayne has served on advisory committees for several government agencies and was twice appointed to the National Wild Horse and Burro Advisory Board by the secretary of the interior.

Frank Cassas is a practicing attorney with a lifelong passion for performance horsemanship. He is a former chairman of the Nevada State Commission for the Preservation of Wild Horses, and the founding director of the National Wild Horse and Burro Foundation headquartered in Reno.

Al Cirelli Jr. is an assistant professor and state horse specialist at the University of Nevada, where he teaches courses in equine management and beginning through advanced horsemanship. His extension duties provide consultant services to horse trainers, veterinarians, and other organizations.

Dave Cattoor has been a professional wild horse gatherer for forty-five years and is considered by many to be a master of the humane art of capturing horses. He and his wife, Sue, are licensed contractors for federal roundups of wild horses.

Rex Cleary was raised in Carson Valley. During his thirty-two-year career with the Bureau of Land Management he served as district manager in Billings, Montana, and later in Susanville, California, where he managed the Modoc/ Washoe Experimental Stewardship Program.

Charlie D. Clements is a range scientist for the USDA Agricultural Research Service. He is the author or coauthor of more than fifty scientific papers and presentations in his field. His latest book, coauthored with James A. Young, is *Purshia: The Wild and Bitter Roses*.

Stacy L. Davies grew up in Utah and is the ranch manager for the Roaring Springs Ranch in Frenchglen, Oregon. He is an active member of the Oregon Rangeland Trust and the Steens Mountain Advisory Council and was instrumental in the formation and organization of the Steens Mountain Wilderness Area.

Steve Davis, Ph.D. is a professor emeritus and former chair of the Department of Animal Science at Oregon State University. Steve has researched and developed courses on the ethics of natural resource management on public lands and has written several articles on environmental and agricultural ethics.

Ed Depaoli grew up on a family horse ranch in Nevada's Pah Rah Mountains. He retired as manager for the BLM Lakeview, Oregon, District, where his crew conducted the last wild horse roundups on horseback in 1977.

Dave Dohnel and his brother operate Frontier Pack Train, one of two outfits permitted to guide pack trips to view mustangs in the U.S. Forest Service/Montgomery Pass Wild Horse Territory on the California-Nevada border.

John Falen grew up in Owyhee County, Oregon. He and his wife ranch in Orovada, Nevada. John is a past president of the Nevada Cattlemen's Association and serves on the board of directors for the National Wild Horse and Burro Foundation.

Dan Flores, Ph.D. is A. B. Hammond Professor of History at the University of Montana and is widely recognized for his work on the environmental history of the Southwest. He is the author of *Horizontal Yellow* and *Caprock Canyonlands*.

Jim Gianola is a senior wild horse and burro specialist with the BLM Carson City District. Jim grew up in Ely, graduated from University of Nevada, and began working for the BLM's Wild Horse and Burro Program in 1977.

Temple Grandin, Ph.D. is an assistant professor of animal science at Colorado State University, where she teaches livestock handling and consults on the design of livestock handling facilities. Dr. Grandin has autism, which helps her to understand animal behavior in a unique way. She is the author of *Animals in Translation* and *Thinking in Pictures*.

Ron Hall began his career with the Bureau of Land Management as a wildlife biologist. He has been involved with all phases of the wild horse program in Utah, Nevada, and Wyoming and is now attached to the national program office headquartered in Reno.

E. Ron Harding has been involved in all phases of wild horse management in Oregon since the 1970s and played a pivotal role in developing the Kiger mustang herd in the Steens Mountain territory.

Tom Hartgrove, D.V.M. operated an exclusively equine practice in Las Vegas for almost twenty years. Since 1990 he has donated his professional time and expertise to assist with the adoption, care, and treatment of wild horses and burros throughout southern Nevada.

Cliff Heaverne is the son of respected horseman Pat Heaverne and a third-generation Great Basin resident. An accomplished helicopter pilot, Cliff works exclusively with the humane capture and transport of wild horses and burros throughout the American West.

Larry Johnson was raised on a small ranch in the Sierra Nevada. He is a member of the National Wild Horse Advisory Board and has twice served as president of Nevada Bighorns Unlimited. Larry is the son of Ed Johnson, a Maidu horseman known for his record-setting endurance rides.

Ira H. "Hammy" Kent (1910–2000) was a Nevada rancher and outdoorsman widely recognized for a lifetime of regional and statewide achievements in agriculture and conservation.

Michael Kirk, D.V.M. practices equine medicine and surgery in Reno and has been reappointed three times to serve on the Nevada Commission for the Preservation of Wild Horses.

Sheldon Lamb (1916–2001) grew up ranching, riding, and gathering mustangs with his father and brothers in south-central Nevada. He and his wife, Isabel, raised cattle and registered Quarter Horses on their ranch in Dixie Valley.

Dawn Lappin and her husband, Bert, have contributed a lifetime of service to the protection of wild horses, burros, and other animals on the public lands. Since retiring, Dawn has continued her work as director of Wild Horse Organized Assistance (WHOA), the association founded by Wild Horse Annie. She is also a director of the National Wild Horse Foundation.

Irwin Liu, D.V.M., Ph.D. is a professor in the Department of Population Health and Reproduction of the School of Veterinary Medicine, University of Califor-

nia, Davis. Dr. Liu's research on equine reproduction led to a vaccine for immunocontraception that has been utilized to control excessive wild horse populations.

Sunny Martin (1913–2003) was a horse breeder, cowboy poet, rancher, and histo- rian from Ely, Nevada. In 1971 she founded the American Bashkir Curly Registry to commemorate a breed of curly-coated mustangs discovered in the remote high country of the central portion of the state.

Tom Marvel, a native Nevadan, is a rancher and accomplished horseman whose family has owned, bred, and trained high-quality horses for several gener- ations.

Dave Mathis was an information officer for the Nevada Department of Wildlife prior to joining the faculty at the College of Agriculture at the University of Nevada. He is the author of *Following the Nevada Wildlife Trail.*

Sam Mattise is a cowboy poet, balladeer, former rodeo performer, and trainer of polo ponies. Sam worked first as a wildlife biologist and recently retired as a BLM wild horse specialist for the Lower Snake River District in Idaho.

Gary McFadden has been a wild horse specialist with the Bureau of Land Manage- ment for thirty years. In the early 1990s, Gary managed the removal of excess wild horse populations on the Nellis Wild Horse Range.

Waddie Mitchell grew up in the Great Basin backcountry and is now recognized as one of the country's preeminent cowboy poets. In addition to an active tour- ing schedule Waddie also serves as a member of the board of trustees for the National Cowboy Poetry Gathering in Elko.

William A. Molini is a third-generation Nevadan and a former director of the Nevada Department of Wildlife. He presently chairs the board of Inter- mountain West Joint Venture, part of the North American Waterfowl Man- agement Plan.

Bob Morris is the president of Stormont Laboratories in Woodland, California. He formerly was a research associate and senior analyst for the veterinary genetics laboratory at the University of California, Davis.

Jan Nachlinger, a botanist, has for more than twenty years applied her insights into the rare plants of the high desert to work for their conservation. She is a senior conservation planner with The Nature Conservancy of Nevada.

Tina Nappe is a native Nevadan engaged with several national environmental organizations. Tina's father, Gus Bundy, made a historic series of photographs in the 1950s that contributed to the passage the 1971 Wild Free-Roaming Horses and Burros Act.

Bryan Neubert is a respected horse clinician who travels the United States and Canada giving demonstrations on horsemanship. Together with his wife and family he also trains wild and domestic horses at his home near Alturas.

Gene Nunn was raised in Montana and has worked with horses all his life. For thirty years he was involved with all phases of managing, gathering, training, and adopting wild horses for the Bureau of Land Management, first in the Pryor Mountain Wild Horse Range and later in the Susanville and Riverside districts in California.

Steve Pellegrini recently retired from teaching biology and zoology at Western Nevada Community College and Yerington High School. In 1971 he conducted the first research project on the territorial home range of feral horses. He later broadened his studies to include the changing behavior of wild horses due to increased herd size. He has testified on wild horse matters before Senate and House subcommittees in Washington, D.C.

Tom Pogacnik has worked for the wild horse program since 1984. For six years he was the senior supervisory wild horse specialist for the National Wild Horse and Burro Program headquarters in Reno.

Don Pomi has spent a lifetime working with horses, wild and tame. Through the 1950s he was involved with capturing and training wild horses for several Nevada ranches. In 1978 he was the manager of BLM's Palomino Valley Center. Don still trains horses for local youth groups at his home in Fallon.

Bruce Portwood grew up on a ranch in Wyoming and moved to Nevada to work as a watershed specialist for the Bureau of Land Management in 1973. After

transferring to the Wild Horse and Burro Program he remained the primary wild horse specialist for the Elko District until his retirement.

B. Byron Price is the director of the Charles M. Russell Center for the Study of Art and holds the Charles Marion Russell Memorial Chair at the University of Oklahoma. He has penned numerous books on the heritage of the American West, including *Cowboys of the American West, Imagining the Open Range: Erwin E. Smith, Cowboy Photographer,* and *Fine Art of the American West.*

Louis Provencher, Ph.D. is the director of conservation ecology for The Nature Conservancy of Nevada, where he provides science support for all projects of the state chapter. Louis also heads TNC's 11.4-million-acre Eastern Nevada Project, a cooperative effort with the BLM Ely Field Office and the Eastern Nevada Landscape Coalition.

Deloyd Satterthwaite runs cattle and sheep operations in Elko and its adjacent counties. Deloyd is a former president of the Nevada Woolgrowers Association and the Nevada Cattlemen's Association, and has served as a commissioner for both the Nevada Commission for the Preservation of Wild Horses and the Nevada Division of Wildlife.

Vern Schulze retired from a thirty-year career with the Bureau of Land Management in 1995, where he worked first as a range conservationist in Utah, Oregon, and Nevada and later as a supervisory resource specialist for the Washington office of the Wild Horse and Burro Program.

Richard Sewing is the executive director of the National Mustang Association, a nonprofit organization established in 1965 to perpetuate the survival of wild horses in a natural environment. In 2000, Richard was appointed to serve as a member of the National Wild Horse Advisory Board.

John Sharp, of Prineville, Oregon, came to the high desert in the 1930s. During his career he has worked with some of the best-known horsemen of southeastern Oregon. Together with his granddaughter John continues at age eighty-eight to give demonstrations on the gentle art of training mustangs with bamboo poles.

Richard Shrake grew up in Oregon's outback and is an internationally known judge, lecturer, instructor, and trainer of horses. He has coached numerous riders to win at major events, including the All American Quarter Horse Congress, Arabian Nationals, Santa Barbara Nationals, the Cow Palace, and the ACQHA and AJQHA world championships.

Dave Tattam hails from Australia, where his family has raised and trained horses for generations. Dave served as the field director of the National Wild Horse Association for fifteen years. He was involved with wild horse herd reduction operations on the Nellis Wild Horse Range in the 1990s, where he personally supervised private adoptions for more than five hundred abandoned leppy foals.

Mike Turnipseed has been a water resource manager in the Great Basin for thirty years. He is the present director of the Department of Conservation and Natural Resources for the state of Nevada.

Gracian Uhalde is a third-generation Basque rancher and sheepherder from Butte Valley, Nevada. Gracian served nine years on the Nevada Commission for the Preservation of Wild Horses and is past president of the Nevada Woolgrowers Association.

Marty Vavra, Ph.D. is a professor of rangeland resources and superintendent of the Eastern Oregon Agricultural Research Center in Burns. His primary research focus is the effect of ungulate grazing patterns on various ecosystems throughout the West.

John Winnepenninkx began his career with the Bureau of Land Management in 1979 and was involved with all aspects of the Wild Horse and Burro Program. He is now the assistant field manager of renewable resources for the Battle Mountain Field Office.

James A. Young, Ph.D. has spent more than thirty years devising methods to maintain and preserve the soils and plant communities that constitute the rangelands of the Great Basin. His book *Cattle in the Cold Desert* is considered a classic in the field of environmental and agricultural history.